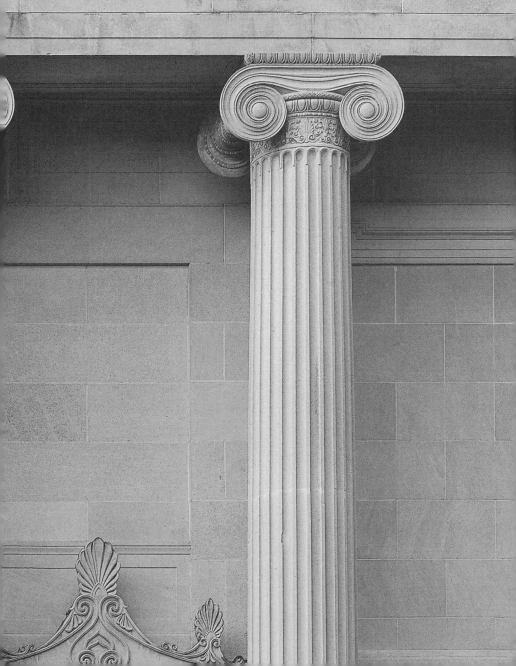

THE PEO

MFA**H**

*The Museum of Fine Arts, Houston*
*Visitor Guide*

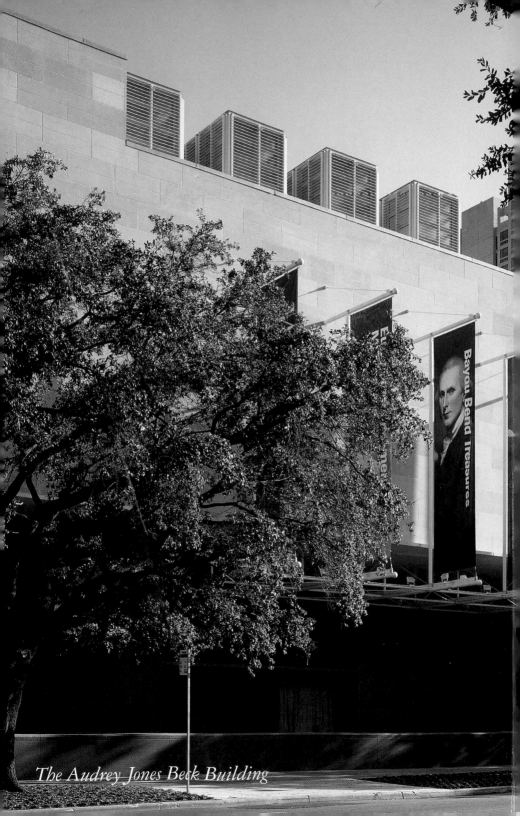

The Audrey Jones Beck Building

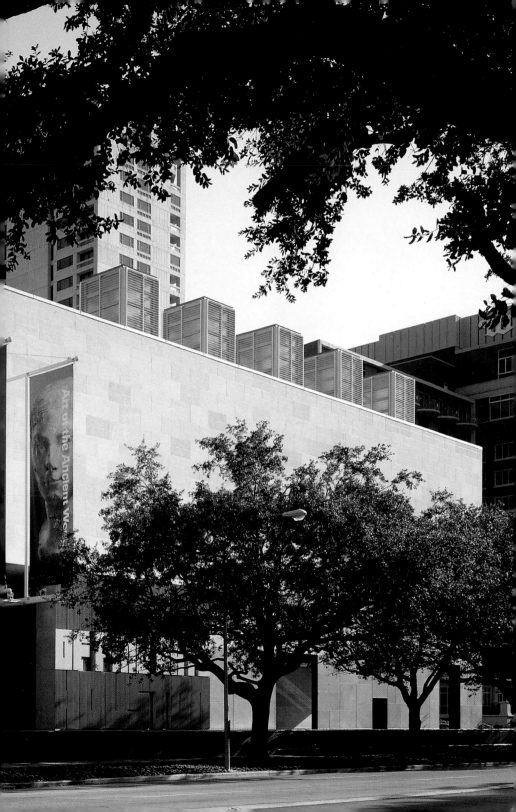

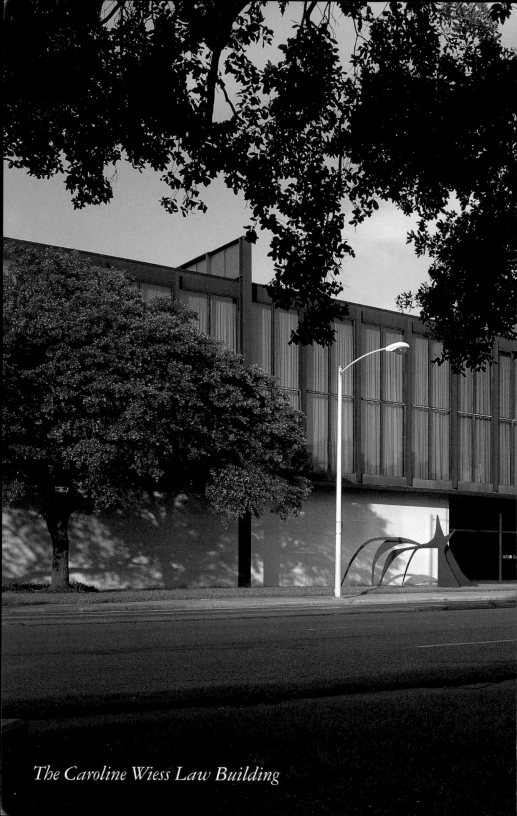

*The Caroline Wiess Law Building*

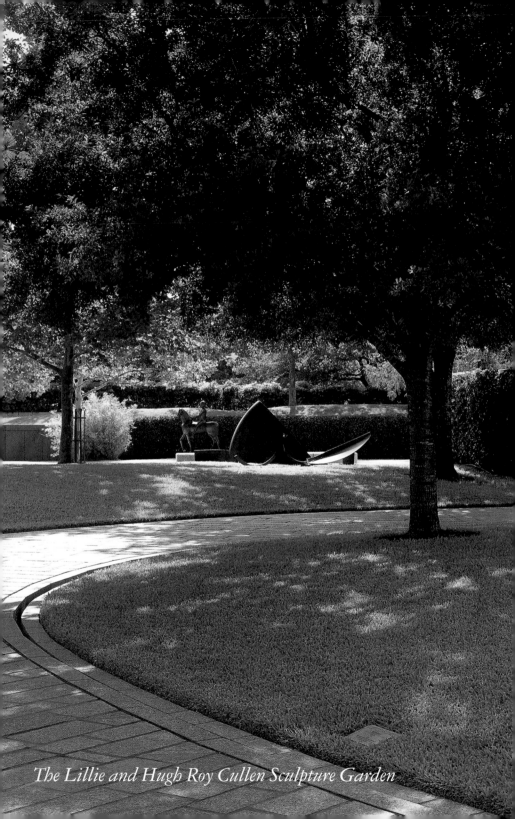

The Lillie and Hugh Roy Cullen Sculpture Garden

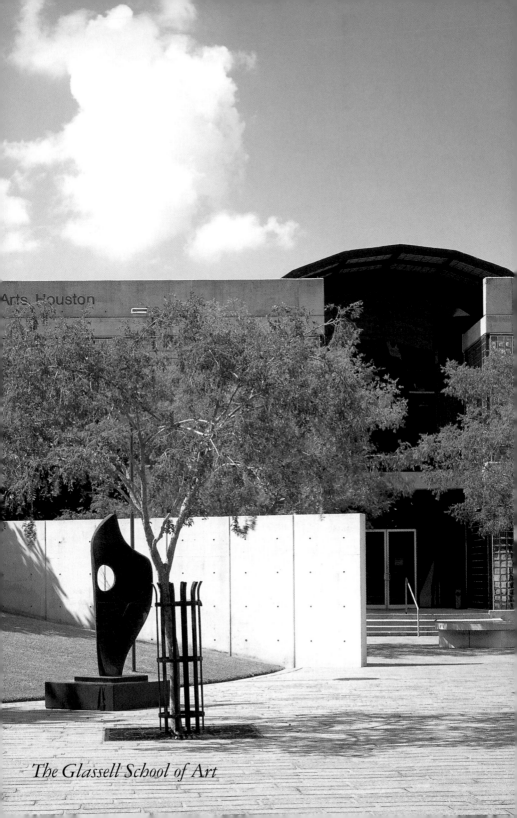

Arts Houston

*The Glassell School of Art*

The Glassell Junior School of Art and MFAH Central Administration

ilding

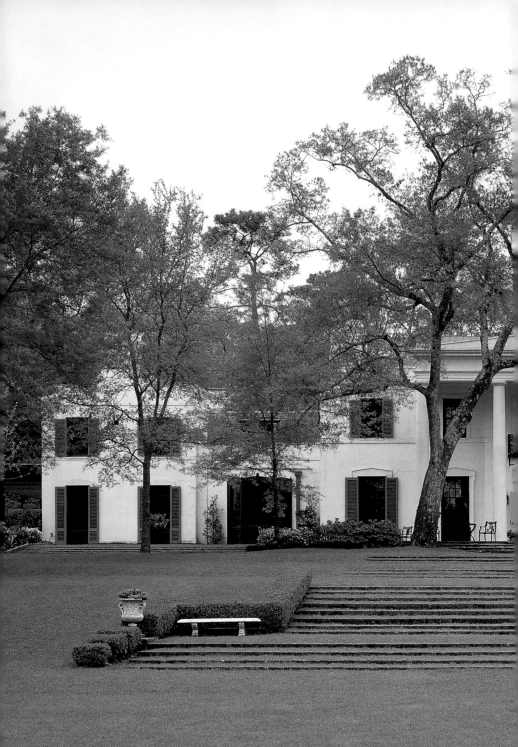

*Bayou Bend Collection and Gardens*

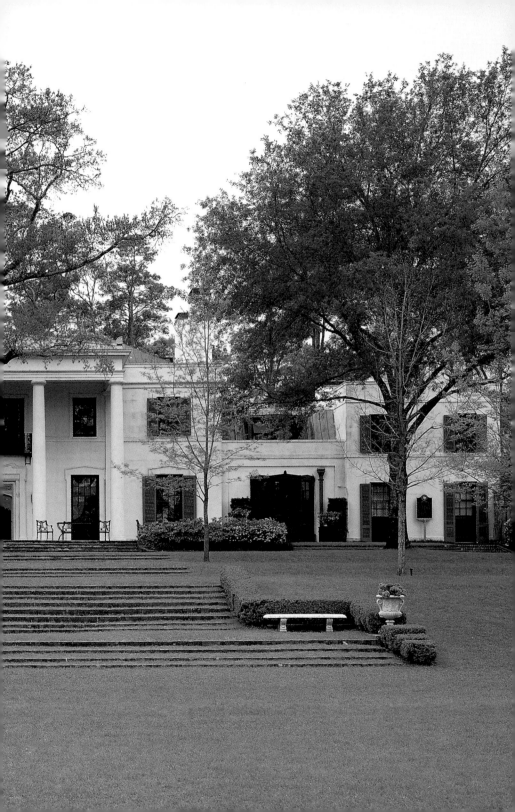

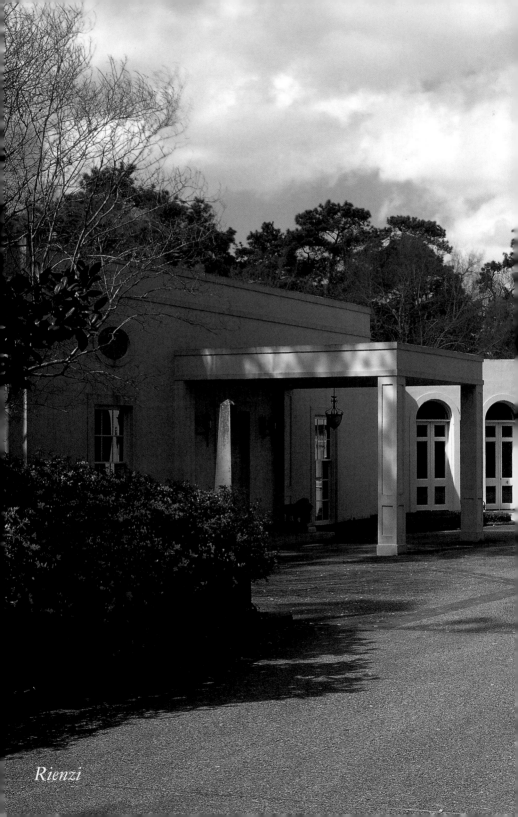

Rienzi

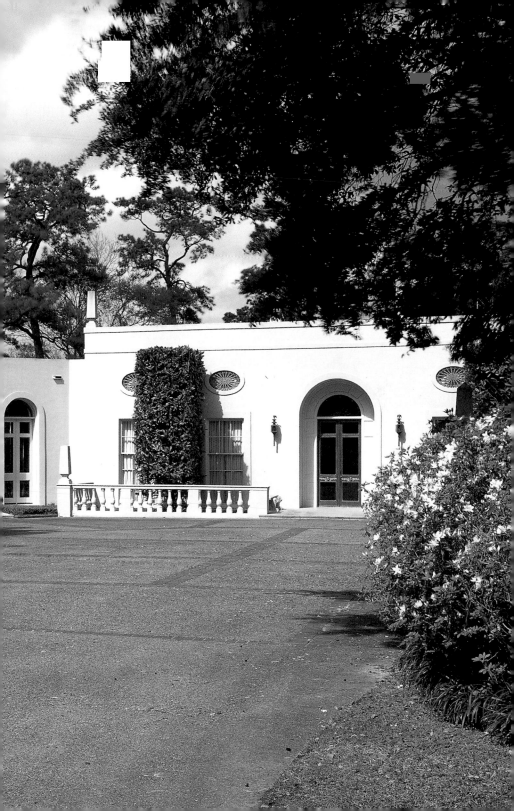

*This guide is dedicated
to the people who have created
the Museum of Fine Arts, Houston,
and to all the people who visit it.*

# MFA■ The Museum of Fine Arts, *Houston*
# Visitor Guide

by Janet Landay

**SCALA**

In association with
The Museum of Fine Arts,
Houston

*The publication of the MFAH Visitor Guide was made possible by
a generous gift from Charles Butt, with additional support from
the National Endowment for the Arts, a federal agency; the Henry
Luce Foundation; and the Edward and Betty Marcus Foundation.*

© *The Museum of Fine Arts, Houston, 2000*

*First published in 2000 by Scala Publishers Ltd
143–149 Great Portland Street, London W1N 5FB*

*Distributed outside the Museum of Fine Arts, Houston,
in the USA and Canada by Antique Collectors' Club,
Market Street Industrial Park, Wappingers Falls, NY 12590, USA*

*Museum edition ISBN 0-89090-091-4
Trade edition ISBN 1-85759-231-X*

*Library of Congress Cataloging-in-Publication Data
Museum of Fine Arts, Houston.
The Museum of Fine Arts, Houston: visitor guide / Janet Landay.
p. cm.
Includes index.
ISBN 0-89090-091-4 (pbk.)
1. Museum of Fine Arts, Houston Guidebooks.   2. Art—Texas—
Houston Guidebooks.   I. Landay, Janet, date- .   II. Title.
N576.H7A85 2000
708. 164' 1411—dc21            99-31022  CIP*

*Printed in Singapore by CS Graphics*

*Designed by Massimo Vignelli with Piera Brunetta*

*Photography by Thomas R. DuBrock, with Aker/Zvonkovic
Photography, Michael Bodycomb, Edward Bourdon, Rick Gardner,
Jud Haggard, Paul Hester, Hickey-Robertson, Scott McCue, Allen
Mewbourn, and Rob Muir for the Museum of Fine Arts, Houston*

*All photographs © The Museum of Fine Arts, Houston,
unless otherwise noted in the checklists on pp. 490–531*

*Front and back covers:
Constantin Brancusi, A Muse (details), 1917 (p. 318)
Inside front and back covers:
Inscription over the 1924 entrance to the MFAH*

# Contents

# Welcome to the Museum of Fine Arts, Houston

This guide to the Museum of Fine Arts, Houston, is published at an auspicious moment in the museum's history. In 2000, as the world faces a new century and millennium, the MFAH celebrates two milestones: the museum's centennial and the opening of an outstanding new building named for one of the institution's great patrons, Audrey Jones Beck. Since its founding by a visionary group of women 10 decades ago, the MFAH has amassed a collection of more than 40,000 works of art, encompassing examples made throughout the world, from the Stone Age to the present day. This encyclopedic collection is housed in two exhibition buildings, two house museums, and an outdoor sculpture garden. The museum's main campus, situated in the heart of Houston's museum district, is a cultural landmark distinguished by the work of three internationally renowned artists/architects: Ludwig Mies van der Rohe, designer of Cullinan Hall and the Brown Pavilion—the two monumental additions to the museum's original Caroline Wiess Law Building; Isamu Noguchi, creator of the Lillie and Hugh Roy Cullen Sculpture Garden; and Rafael Moneo, architect of the recently completed Audrey Jones Beck Building.

When you visit the museum, you will see wonderful works of art in all parts of the collection. Certain areas are especially strong. The Glassell Collection of African Gold is one of the finest in existence, as is the Bayou Bend Collection of American paintings, furniture, silver, porcelain, and glass. The museum's extensive collection of photographs provides a veritable history of the medium, and with a new gallery and study/storage area for works on paper, these works are now more accessible to the public than ever. The MFAH features many great works of European art from the Renaissance and Baroque periods, recently augmented by the installation of major paintings from the collection of the Sarah Campbell Blaffer Foundation. The collection of John A. and Audrey Jones Beck comprises beautiful Impressionist and Post-Impressionist paintings that are much loved by visitors. The museum's significant collection of 20th-century art is showcased in soaring spaces that Mies van der Rohe designed with just such large-scale works in mind.

Wandering through the MFAH galleries and discovering
new or unexpected artworks is one of the great pleasures
of a museum visit; however, the sheer size of the institution
can be daunting. This book is designed to help you enjoy
your visits here as much as possible. Illustrating more than
500 works of art from the museum's collection, the guide can
be used before, during, and after a visit. Discussions of styles
and themes in the history of art, quotations by artists and
writers, supplementary photographs, and explanations of
artistic techniques provide information about the historical
and cultural contexts in which the works were made.
Please note that because the museum's displays of artworks
change periodically, not every item featured in the book may
be on view when you visit.

The cover of this guide is graced by the museum's beautiful
sculpture *A Muse,* by the Romanian-born artist Constantin
Brancusi. In ancient Greece, nine goddesses called Muses
presided over artistic creation. Sisters, they were the
daughters of Zeus, ruler of the heavens, and Mnemosyne,
goddess of memory. As guiding spirits, keepers of memory,
and sources of inspiration, the Muses lent their name to the
word museum. I invite you to visit the MFAH with this
notion of a museum in mind. Even as it has become a busy
cultural, educational, and community center, the MFAH
remains a place for learning about the world and its history,
for connecting to the amazing creativity of people across
time and place, for understanding the human condition,
and for discovering ourselves. So come to the MFAH to be
inspired, and come back often.

Peter C. Marzio
*Director*

# Acknowledgments

This guide is the product of a long and close collaboration among several key individuals. I am particularly indebted to Massimo Vignelli, who conceived the book's beautiful design. Massimo's hands-on involvement and creative suggestions fulfilled and enlarged my original vision for the project. Kelly Erin Laskosky in the museum's publications department was remarkably careful and patient in editing the numerous drafts and page proofs. Freelance writer Michelle Nichols contributed excellent manuscripts for several sections of the book, including many of the wonderful literary quotations. Thomas R. DuBrock, MFAH staff photographer, applied his great skill to producing most of the guide's beautiful images. For two years, Jennifer King, curatorial assistant at the MFAH, was my right hand. In addition to her significant research, writing, and organizational skills, Jennie's thoughtful insights and enthusiasm sustained me on a daily basis.

The entire curatorial staff at the MFAH contributed to this guide. In addition to providing departmental files, the collection curators generously shared their expertise in hours of discussions about individual works of art. I would like to thank them as follows: Edgar Peters Bowron and Mary Morton (European art, including the collection of John A. and Audrey Jones Beck); James Clifton (the collection of the Sarah Campbell Blaffer Foundation); Elizabeth Ann Coleman and Tina Llorente (textiles and costume); Alison de Lima Greene (20th-century art, including the Cullen Sculpture Garden); Katherine S. Howe and Cindi K. Strauss (American and 20th-century decorative arts, and Rienzi); Alice R. M. Hyland (Asian art); Marian Luntz (film and video); Frances Marzio (the Glassell collections of African and Indonesian gold); Emily Ballew Neff (American painting and sculpture); Anne-Louise Schaffer (African, Pre-Columbian, Native American, and Oceanic art); Anne Wilkes Tucker (photography); Barry Walker (prints and drawings); and David B. Warren and Michael K. Brown (Bayou Bend Collection and Gardens). I am also grateful to MFAH curatorial assistants Britt K. Chemla, R. Eric Davis, Celia Martin, Robert Montgomery, Nicole O'Bryan, Kathleen Ottervik, Carrie Robinson-Cannon, Lisa Roth, and Tracy Stephenson for their important contributions.

Many other people worked to make this book a reality. At the MFAH, I would like to thank Charles J. Carroll, Kathleen B. Crain, Jeannette Dixon, Gwendolyn H. Goffe, Barbara H. Michels, Misty Moye, Wynne H. Phelan, Margaret C. Skidmore, Marty Stein, Lorraine A. Stuart, George G. Zombakis, and the wonderful staff members in conservation, the Hirsch Library, photographic services, preparations, publications, and the registrar's office. Special thanks go to Diane Lovejoy, publications director, for her work with our copublisher, Scala Publishers Limited; and to Beth B. Schneider, education director, for her constant support and helpful suggestions. My appreciation goes to Julia P. Henshaw for her invaluable advice throughout the writing of this book; to Kristen Arnett, who assisted in the early stages of the project; and to Merrianne Timko, who kindly reviewed the section on ancient art. I am also grateful to Piera Brunetta at Vignelli Associates for executing Massimo's designs so expertly; to Rolf Laub of Laub Graphic Design for carefully completing the final page proofs; and to Annabel Cary, Dan Giles, and Sarah McLaughlin at Scala for skillfully overseeing the production and printing of the book.

The director of the MFAH, Peter C. Marzio, has been *my* guide to this museum for many years. I am enormously grateful to him for sharing his deep understanding of the institution, for encouraging me to write this book, and for supporting my conception of it. Finally, I would like to thank my personal muses, Edward and Gabriel Hirsch, who fill me with wonder every day at the world of art.

*Janet Landay*

Janet Landay
*Curator of Exhibitions*

*The displays of art at the MFAH involve a great deal of preparation by specially trained staff members. Every work of art is carefully tended from the moment it is delivered to the museum. After assigning an identification number to a newly arrived work, registrars and conservators document the object's condition and make a record of where it is being placed in one of the museum's storage areas. Curators establish essential information about the artwork, such as who made it and when, the history of its ownership (called the work's provenance), and observations about its quality and significance. As the curators plan where to exhibit the work*

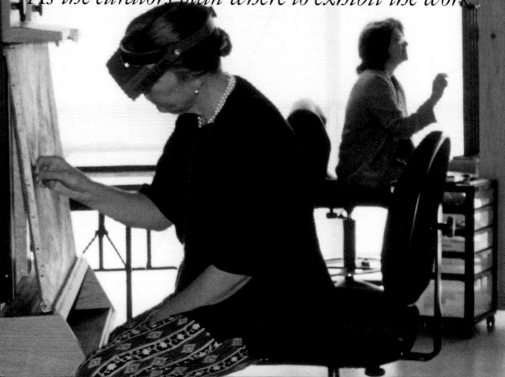

and write text for the accompanying labels,
conservators clean or repair the art (as seen in
the background photograph) and set guidelines
for the temperature, humidity, and light
conditions under which the work should be
exhibited. Other staff members reconfigure and
paint the gallery walls and prepare the art for
display. Once the object is installed, security
staff, building engineers, conservators, and
registrar staff ensure that it is cared for safely.
The following pages illustrate several examples
of conservation projects and aspects of preparing
art exhibitions, revealing fascinating museum
functions that visitors don't usually get to see.

## Behind the Scenes: Conservation Projects

**1** Italian,
The Meeting of Solomon and the Queen of Sheba,
c. 1470–73 (p. 50)
**a** *This Renaissance work had become dulled by old, discolored varnish and earlier restorations.*
**b** *Aided by a microscope, a conservator painstakingly cleans the painting's surface.*
**c** *The face of the central figure has been cleaned and begins to*
reveal the true colors of the painting.
**d** *After treatment, the women's delicate flesh tones and brilliant gold robes are now visible.*
**e** *Completely restored, the painting displays an array of brilliant colors.*

**2** Claude Monet,
The Windmill, Amsterdam,
1871
**a** *Before this painting entered the museum's collection, restorers had painted over the original work in order to disguise damage in the sky area.*
**b** *In the conservation department, the overpainting is gently removed.*

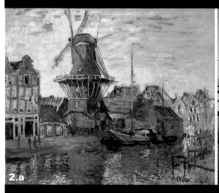
1.a
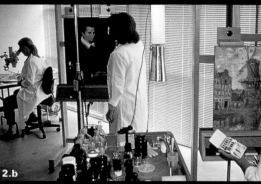
1.b

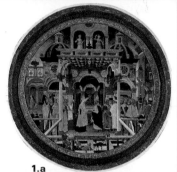
2.a
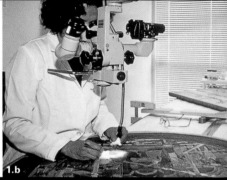
2.b

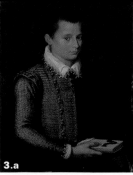
3.a

3.b
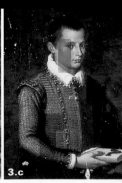
3.c

27

c When the painting had been partially cleaned, the damage in the upper right part of the sky became visible, as did the lighter, original colors. A conservator delicately retouched the damaged area.
d Now that the cleaning is finished, viewers can appreciate Claude Monet's original brush strokes and wonderful colors.

3 Italian, Portrait of a Boy Holding a Book, 1560s
a Before cleaning, old retouchings on this painting no longer matched the original paint.
b An X-ray revealed that the artist had previously painted another face on the canvas. This information helped

explain the pattern of cracks in portions of the painted surface.
c–d During cleaning, the delicate modeling of the boy's face began to emerge.
e After cleaning, the sitter's face is luminous, as is the color of the waistcoat.

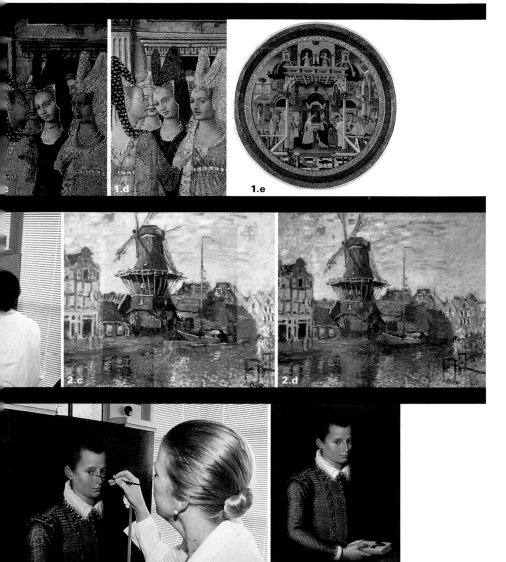

1.d

1.e

2.c

2.d

d

3.e

**4** Koei (Unkei IX),
Amida, 1472 (p. 248)
**a** *This sculpture was made out
of six pieces of wood joined to-
gether with wooden pegs, called
keys. Previous conservators had
replaced the original keys with
ones made of green, unstable
wood and had added heavy
metal braces to keep the sculpture
together. Also, the surface had
been overpainted.*

**b** *Over time, the new keys
expanded and contracted.
Together with the braces they
were causing the sculpture to
split apart.*
**c** *Conservators removed the keys
and braces, then rejoined the six
pieces of wood with keys made
of properly cured, stable wood.*
**d** *After the overpaint was
removed, the work's original
painted surface is revealed.*

**5** Probably New England,
Eagle, 1850–1900
**a** *When this wooden eagle
entered the Bayou Bend
Collection, paint obscured the
original carving and covered
a variety of repairs.*
**b** *By magnifying a cross section
of the eagle's surface, conserva-
tors could tell that the work had
originally been gilded (covered
in gold). Because no carved*

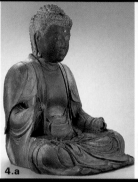

4.a

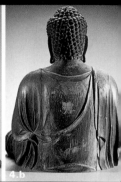

4.b

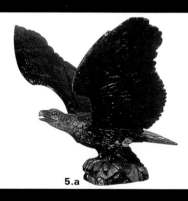

5.a

5.b

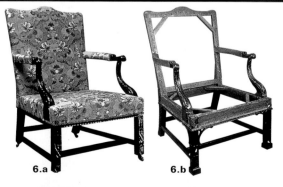

6.a

6.b

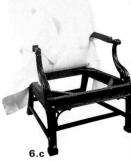

6.c

details were visible beyond the front edge of the wings, conservators also established that the work had been designed to be viewed from below. A lack of any water damage indicated that the work had been kept indoors.

**c** A conservator prepares new gilding for the surface.

**d** Viewers can now appreciate how the gold eagle once commanded a public interior.

**6 Philadelphia, Armchair, 1763–71**

**a** Until the mid-1990s, corner brackets were missing from this chair, as were portions of the front feet and back legs. The original upholstery had also been replaced.

**b** Conservators restored the missing feet and brackets. After removing the fabric, they saw the damage caused to the chair by repeated upholstering

with thousands of nails.

**c** Using new methods, conservators fabricated a more accurate upholstery without hammering a single nail into the chair. Dense foams were added to cover the arms, back, and seat.

**d–e** Using Velcro and snaps, conservators attached tufted silk damask to the new padding. They then glued brass nail heads to the fabric.

4.d

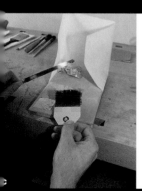

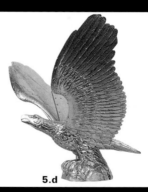

5.d

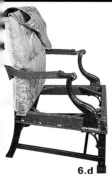

6.d

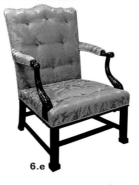

6.e

The primary function of a frame is to protect a painting and to conceal the untidy edges. Equally important, a frame helps viewers focus on a painting by isolating it from the surrounding space. A frame's width, color, and design greatly affect the way a painting looks, so MFAH curators carefully select frames that set off each work to its best advantage. Because tastes in frames have changed over time, the museum uses original frames from the same period as the paintings whenever possible. When such examples are not available, the MFAH has new frames made in appropriate styles. The 17th-century painting *Laban Searching the Belongings of Jacob,* by the French artist Sébastien Bourdon, appears here in three different treatments. Without a frame, the work looks unfinished, as shown at the bottom of this page. In a gallery, the unframed painting's delicate tones would be overwhelmed by the surrounding walls. *Laban Searching the Belongings*

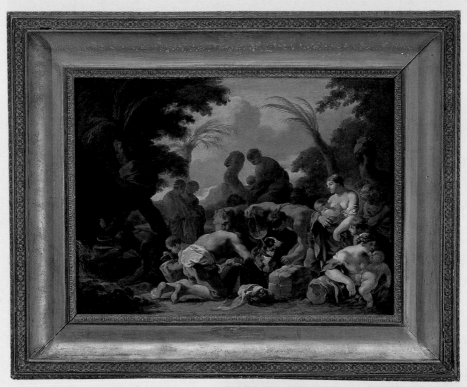

*of Jacob* came to the museum in a 19th-century frame, as it appears on the left. Although beautiful, the gilded frame is too broad and bright for the subtle colors of the painting. The MFAH eventually purchased a 17th-century, Louis XIII frame for the work, as seen on this page. The muted finish, narrower width, and carved ornaments on this frame perfectly suit the colors and style of the work. Rather than overpowering the painting, the frame enlivens it.

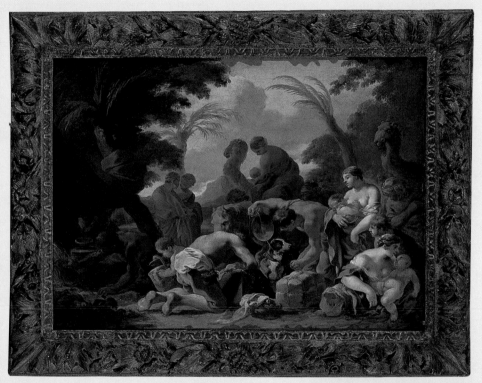

**1** *Every work of art that enters the museum is inspected by a conservator and a registrar. Detailed notes are made about the work's condition to assist the staff in monitoring the condition of the work.*

**2** *When works are not on view, they are carefully put away in the museum's storage areas.*

**3** *After selecting the art for a particular presentation,*

curators—*art historians in charge of each area of the museum's collection*—*work with exhibition designers to plan the arrangement of the gallery walls and the placement of the artworks.*

**4–6** *Construction crews build the gallery walls, while the design-shop staff builds cases.*

**7** *Preparators — the staff members who handle and*

*install the art*—*get the works ready for display. For example, small sculptures may require special mountings that must be custom-made by a preparator.*

**8** *Two-dimensional works will need frames, and those on paper*—*drawings, prints, and photographs*—*will also need mats.*

**9–12** *Once the galleries and art are ready, preparators begin*

moving the works into place. Sometimes, special—even heroic—efforts must be made to install particularly large or heavy artworks.

**13** Curators work with exhibition designers and preparators to fine-tune the installation.

**14** Meanwhile, back in the museum offices, curators, education staff members, and editors have been writing labels and other explanatory texts to accompany the presentation. The graphics department designs and produces these materials, which are then installed in the galleries.

**15** Once the gallery installation is complete, lighting technicians work with exhibition designers to illuminate the artworks for optimal visibility.

**16** Exhibitions take months or even years to prepare. When a show is finally ready to open, MFAH members are invited to a preview celebration.

## Second Floor
- *European Art from Ancient Greece to c. 1920*
- *The Collection of the Sarah Campbell Blaffer Foundation*
- *The Collection of John A. and Audrey Jones Beck*

## Mezzanine Level
- *Works on Paper Study/Storage Center*

## First Floor
- *Prints and Drawings*
- *Photography*
- *American Art to c. 1945*
- *Changing Exhibitions*
- *MFAH Shop*

## Lower Level
- *Changing Exhibitions*
- The Light Inside, *by James Turrell*
  *(in tunnel to Caroline Wiess Law Building)*
- *Café Express*

In 2000, the Museum of Fine Arts, Houston, opened a 192,000-square-foot building designed by Rafael Moneo and named in honor of MFAH Life Trustee Audrey Jones Beck. The capstone of Mrs. Beck's many gifts to the museum is the remarkable collection of Impressionist and Post-Impressionist paintings that she began acquiring with her husband, John. For more about Mrs. Beck and her collection, see pp. 98–113.

*John A. and Audrey Jones Beck, c. 1940s*

The museum's galleries of ancient and European art survey the major styles of European art from the ancient cultures surrounding the Mediterranean Sea to the modern era. The ancient collection introduces visitors to the styles and subjects that laid the foundations for subsequent European art. Highlights from the group of ancient Egyptian, Near Eastern, Greek, and Roman works include a rare Hellenistic gold wreath and a monumental bronze sculpture of a Roman ruler.

The MFAH contains fine examples of Early Christian art. An important ivory figure of God the Father and a Late Gothic representation of the Virgin and Child by the workshop of Niclaus Weckman the Elder are especially noteworthy. Thanks in large part to the vision and generosity of two great art collectors—Percy S. Straus and Samuel H. Kress—the museum's collection is strong in Renaissance and Baroque works. Among the Renaissance highlights are Italian examples by Fra Angelico, Giovanni di Paolo, Sebastiano del Piombo, Antico, and Scarsellino, as well as Flemish masterpieces by Rogier van der Weyden and Hans Memling.

Baroque strengths include notable works by Orazio Gentileschi, Guido Reni, Philippe de Champaigne, Luca Giordano, Frans Hals, and Jan van Huysum.

Immediately following the art of the Baroque is a sequence of galleries presenting paintings that belong to the Sarah Campbell Blaffer Foundation (pp. 84–97). Art from the 18th century comes next, with defining works by Jean-Siméon Chardin, Anton Raphael Mengs, and Canaletto, among others. These galleries also display a group of superb English silver pieces made between 1660 and 1760.

The 19th-century holdings feature significant works by Jean-Léon Gérôme, Francisco de Goya, William Adolphe Bouguereau, Camille Corot, and Théodore Rousseau. Supplementing the wonderful collection of Impressionist and Post-Impressionist paintings given to the museum by Audrey Jones Beck (pp. 98–113), the European art galleries additionally present signature works by Auguste Renoir, Paul Cézanne, Claude Monet, and Edgar Degas.

**1.1** Cycladic,
Female Figurine,
2800–2300 B.C.

During the Early Bronze Age,
sculptors living on the Cycladic
islands of the Aegean Sea
carved stylized male and female
figures from white marble.
The most prevalent type of figure
is a female with folded arms.
These distinctive abstracted and
elongated works were simply

carved but had painted
details indicating eyes, hair,
and sometimes jewelry.
Found primarily in graves,
these statuettes may have
represented fertility figures.
In the early 20th century, many
European artists, including
Constantin Brancusi (p. 318),
admired Cycladic sculpture for
its abstracted stylization.

**1.2** Greek,
Horse Figurine,
750–725 B.C.

By about 900 B.C., three
centuries after the collapse of
the Mycenaean civilization, the
Greek mainland began to exper-
ience a cultural rebirth. Small
village communities laid many
of the foundations of later Greek
culture, including the city-state.
During this time, small bronze

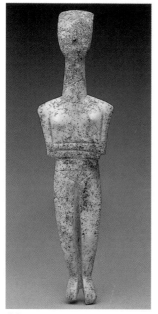

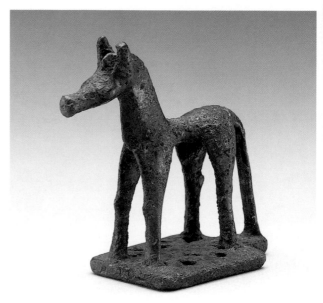

**1.1**

**1.2**

figurines of animals were dedicated at religious sanctuaries as offerings to the gods. The tubular body and muzzle of this example typify the way artists of the time simplified the animal shapes into abstract forms. Similar to the decorations on pottery of the same period, this abstract style has given rise to the name Geometric for this period of Greek art.

**1.3 Assyrian, Eagle-Headed Winged Figure, 875–860 B.C.**

In ancient times, Assyria was the name of an area in northern Mesopotamia, now part of Iraq. The Assyrians were powerful warriors who established a large empire that dominated the Middle East during the 9th and 8th centuries B.C. The mud-brick palaces of their kings were decorated with painted gypsum reliefs portraying religious subjects, siege scenes, and lion hunts. This relief, its paint worn away, depicts an eagle-headed winged figure standing near a stylized sacred tree. The figure, perhaps a deity or supernatural spirit, holds a cone and a bucket, used for magically sprinkling the tree to ensure the fertility of the land. His static pose is reminiscent of Egyptian art. Carved with remarkable skill, these relief sculptures are the most original achievement in Assyrian art.

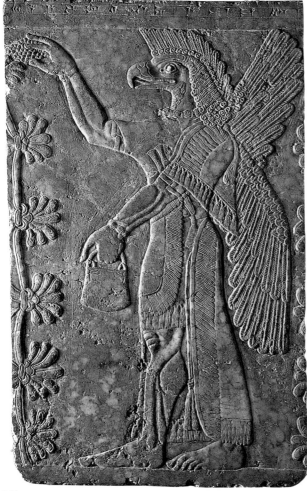

**1.3**

**1.4** Painter of the Yale Oinochoe, Hydria, 470–460 B.C.

*Greek vases from the 5th century* B.C. *provide a vivid picture of life at that time. Paintings on water jugs* (hydria) *typically portrayed scenes of daily life, such as women performing household chores. Here, the woman on the left passes a perfume or oil vessel to the* woman on the right, while the central woman stoops over a wicker basket to deposit or remove a bundle of wool. A heron—a popular pet bird in that society—quietly observes the domestic scene, which exemplifies the role women played in ancient Greek society. Although the name of this vase painter is unknown, scholars have identified *28 fragments or vases, including this one, that they believe he painted. They reached this conclusion by comparing the works to a wine jug, or* oinochoe, *belonging to the Yale University Art Gallery. The artist is thus called the Painter of the Yale Oinochoe.*

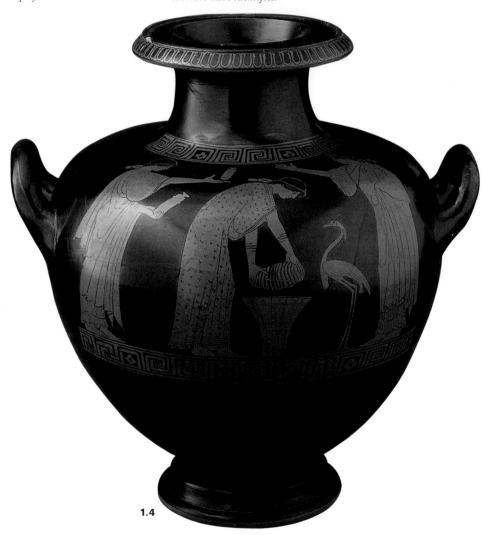

1.4

### 1.5 Greek, Myrtle Wreath, 330–250 B.C.

In ancient Greece, victorious soldiers, athletes, and participants in festival processions wore wreaths fashioned from intertwined leaves. Similar wreaths of gold and silver were designed for the same purposes or for religious functions. By the Hellenistic period (330–30 B.C.), the wreaths were made of gold foil; too fragile to be worn, they were created primarily to be buried with the dead as symbols of life's victories. The naturalistic myrtle leaves and blossoms on this example were cut from thin sheets of gold, exquisitely finished with stamped and incised details, and then wired onto the stems. A plant sacred to the goddess Aphrodite, myrtle was a symbol of love. Greeks wore wreaths made of real myrtle leaves at weddings and banquets, and received them as athletic prizes. Also a symbol of death, myrtle is among the types of plants depicted on gold wreaths found in graves.

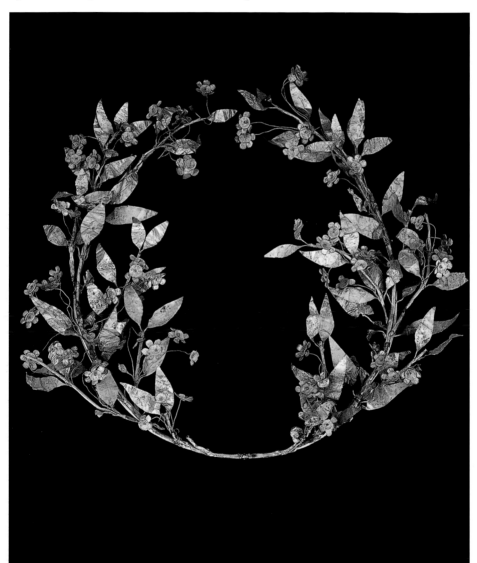

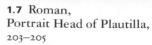

**1.6 Greek,
Fragment of a Grave
Stela, 375–370 B.C.**

This stela, or carved monument, marked the grave of the young woman at the left; her maidservant holds a swaddled infant. The scene suggests that the death occurred in childbirth. The artist created a poignant intimacy between the women by placing them closely adjacent, their

*heads symmetrically inclined. The missing part of the relief may have depicted a young child standing near the mother's knee. This work exemplifies the mature style of the Classical period in Greece. A balance between naturalism and idealism, the Classical style embodies a quality of serenity that is particularly evident in the head of the deceased woman.*

**1.7 Roman,
Portrait Head of Plautilla,
203–205**

*Many of Rome's great portrait sculptures were made in the 3rd century, when idealizing styles were disappearing in favor of more naturalistic and animated likenesses. The new realism is beautifully exemplified in this bust of Plautilla, the first wife of Emperor Caracalla. Through the sensitive carving of alert, intelligent eyes, delicately feathered eyebrows, a beguiling mouth, and a gently tilted head, the artist has created a tender portrait. Still a girl when she married the 14-year-old heir to the throne, Plautilla was banished a year later and eventually executed. Her political demise led to the destruction of most of her portraits and accounts for the intentional defacing of portions of this one.*

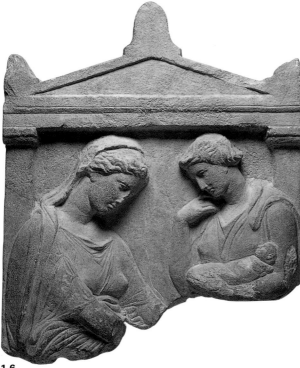

**1.6**

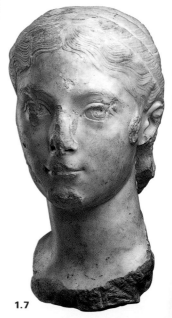

**1.7**

**1.8** Roman,
Portrait of a Ruler,
200–225
*The inspiration for the pose of this Roman nude may have been a famous 4th-century B.C. statue by the Greek sculptor Lysippos depicting Alexander the Great holding a lance. Lysippos made numerous portraits that emphasized Alexander's heroic power as a ruler and his image as a god. Roman rulers seeking to emulate Alexander commissioned portraits that portrayed them as physically perfect men in their prime, regardless of actual age and appearance. The elegant proportions and majestic ease of this larger-than-life bronze suggest that it represents just such an idealized ruler.*

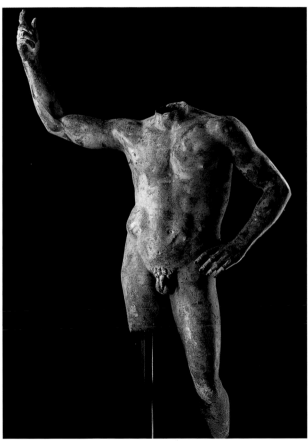

1.8

*[The Renaissance artist] Andrea [Mantegna] always maintained that the good antique statues were more perfect and beautiful than anything in Nature.... [They] combined in one figure the perfections which are rarely found together in one individual, and had thus produced single figures of surpassing beauty.*

Giorgio Vasari, *The Lives of the Most Eminent Painters, Sculptors, and Architects,* 1550

### 1.9 Byzantine, Plaque with the Koimesis, mid-10th century

*Carved ivory plaques and sculptures are among the great artworks of the Middle Ages. From the 9th to the 12th century, kings and emperors supported workshops of the best carvers. This tiny ivory plaque, just over 4 inches high, was masterfully carved by an artist at the* imperial court in Constantinople, capital of the Byzantine Empire and seat of the Eastern Christian (Orthodox) church. The scene presents the death of the Virgin Mary, an event called the Koimesis by the Orthodox church. The artist conveys Mary's importance by placing her at the center of the composition, surrounded by grieving apostles and welcoming angels.

### 1.10 French, Crozier Head, c. 1225–50

*In medieval Europe, church leaders defined their primary role as that of protecting their parishioners from evil. During services, the clergy swung censers and sprinkled holy water to keep people safe from the devil. As the spiritual shepherd of his flock, the bishop held a crozier, or pastoral staff, representing this protective role. The MFAH example, originally attached to a wooden pole, depicts Saint Michael slaying the serpent (Satan), symbolizing the* triumph *of good over evil. The gilded copper and enamel piece was made in Limoges, a town in northwestern France. Famous for their superior enameling techniques, Limoges metalworkers supplied liturgical objects throughout Europe.*

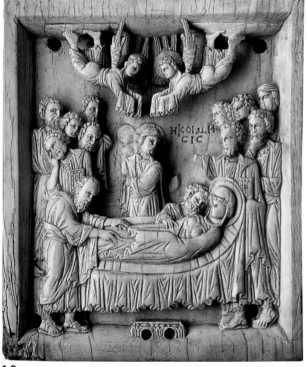

1.9

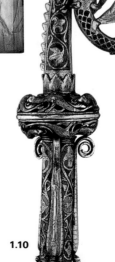
1.10

**1.11** French,
Head of an Apostle,
c. 1235

*This monumental head adorned the Cathedral of Thérouanne, an important ecclesiastical center in northeastern France until 1553, when the town and cathedral were destroyed by order of Emperor Charles V. So important were the sculptures of this cathedral that Charles V allowed the clergy of the nearby town of Saint-Omer to transfer some of the artworks to their church. In 1923, five additional sculptures believed to be from the destroyed cathedral were unearthed from a house in Saint-Omer, including this example. The apostle's expression of graceful dignity exemplifies the high period of French Gothic art.*

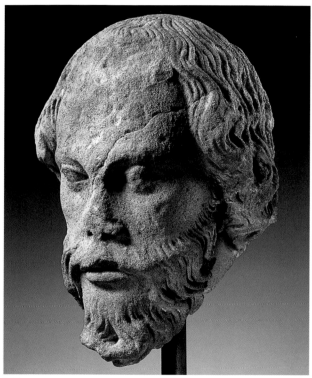

**1.11**

**1.12** Franco-Netherlandish, God the Father, early 15th century

The medieval desire for closeness to God—related to Franciscan teachings and the growing popularity of the Virgin as an object of prayer—led to the increasing practice of private devotion. As a result, artists produced more small objects for spiritual contemplation in the home. Ivory from African elephant tusks was the ideal material for such art. This rare and exquisite figure of God the Father—originally the central figure in a group depicting the Trinity (the Father, Son, and Holy Spirit)—displays brilliant carving in the graceful, spilling folds of the drapery and the expressive features of the face.

**1.13** Norman, Virgin and Child, early 14th century

In the history of European art, representations of the Virgin Mary and the Christ Child parallel significant changes in religious attitudes. A late 13th-century desire to be nearer to God prompted a gradual shift from formal, majestic depictions of the Virgin and Child to increasingly lifelike and accessible mother-and-child pairs. This work exemplifies the beginning of such a change. While still adhering to the mannered style of Late Gothic art—immediately identifiable by the S-curve pose, or "Gothic sway" of the Virgin—the artist conveys a tender human relationship between the figures through their gentle facial expressions.

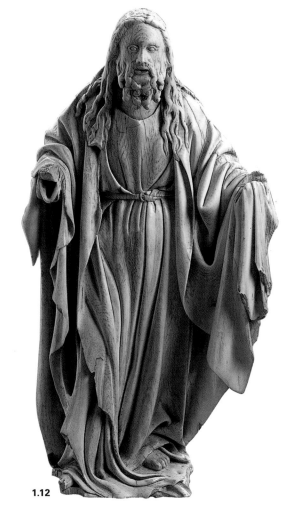

1.12

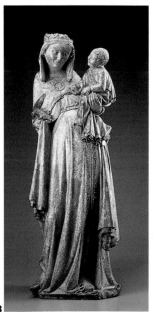

1.13

**1.14** Workshop of Niclaus Weckman the Elder, Virgin and Child, c. 1500–1510

*In southern Germany during the late Middle Ages, the imperial cities of Nuremberg, Strasbourg, and Ulm were the main commercial centers and were powerful magnets for artists. One of the most highly reputed sculptors in Ulm was Niclaus Weckman, whose workshop produced wooden altarpieces and related statuary in the twilight years of the Late Gothic period, just before the Protestant Reformation called for an end to the worship of such works. Collaborating with fine woodworkers and painters, Weckman and his workshop produced painted and gilded limewood figures designed to capture the flickering candlelight and the changing natural light in the region's churches. The carving and arrangement of the figures in this tender and lyrical Virgin and Child are characteristic of Late Gothic art, while the feeling of repose and the harmony of gesture and expression anticipate the arrival of the Renaissance.*

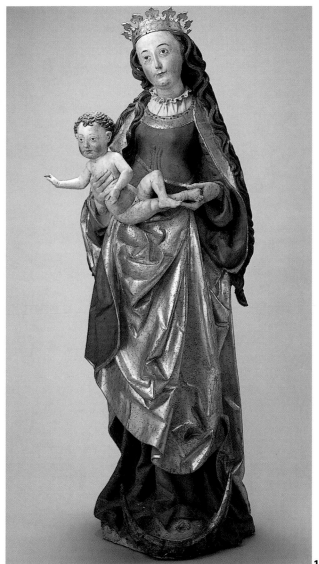

*When I see the Infant God in the arms of his mother, my heart melts with joy.*

Late medieval hymn

**1.14**

# The Italian Renaissance

Gradually emerging in the late 13th and 14th centuries, Italian Renaissance art flourished in 15th-century Florence under the patronage of the Medici family, and in 16th-century Rome under the domain of powerful popes. The term Renaissance means "rebirth" and originally described the revival of interest in ancient Greece and Rome that occurred at that time. As artists looked to the art of these civilizations for inspiration, they gradually shed the stylized conventions of medieval Christian styles in favor of more realistic depictions of the world around them. The groundbreaking innovation of linear perspective, in which objects in the foreground are depicted larger than objects in the distance, enabled Renaissance artists to create naturalistic representations of three-dimensional forms on two-dimensional picture surfaces. Combining this new technique with the use of shading and aerial perspective (in which color variations and blurring suggest distance), these artists created a style of painting that defined Western art until the beginning of the 20th century. The MFAH owns a number of works that display these new techniques, including paintings by Fra Angelico, Giovanni di Paolo, and a 15th-century master from Ferrara (1.16–1.18).

The Renaissance fascination with Greco-Roman traditions led to the growth of secular values and the increasing importance of the individual. In art, these developments prompted the revival of portraiture and non-Christian themes, especially subjects from classical history and mythology. Portraits by Sebastiano del Piombo, Bartolomeo Veneto, and a follower of Botticelli's, as well as a bronze mythological sculpture by Antico, exemplify these trends (1.19–1.21 and 1.23).

Above all, Renaissance artists produced glorious works in the service of Christianity. Portrayals of saints, Christ, and the Virgin Mary by such artists as the Master of the Straus Madonna, Antonio Susini, and Scarsellino (1.15, 1.22, and 1.24), as well as the previously mentioned works by Fra Angelico and Giovanni di Paolo, demonstrate the vitality born of a new appreciation of classical art and of the physical world.

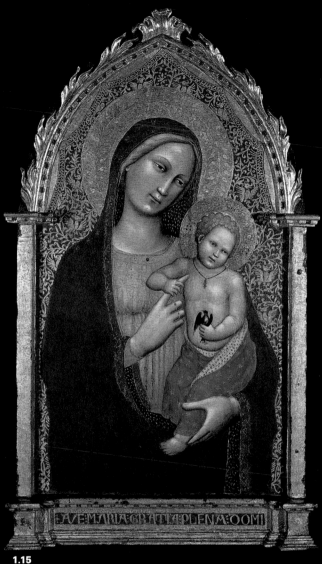

**1.15**

### 1.15 Master of the Straus Madonna, Virgin and Child, c. 1395–1400

*The anonymous artist who painted this private devotional image is considered by many scholars to be one of the leading painters in Florence during the late 14th and early 15th centuries. He worked during a period of stylistic transition, when the ornamental elegance of Late Gothic painting began to be replaced by the more naturalistic representations of the early Renaissance. While retaining a formal composition, he conveyed a tender relationship between the mother and child through the tilt of Mary's head and Christ's grasping of her finger. Formerly in the collection of Edith and Percy Straus, this painting has determined the name by which the artist is now known: the Master of the Straus Madonna. Approximately 50 altarpieces and smaller works are also attributed to him.*

### Symbolism

*Clothing, fruits, birds, and other familiar objects often appear as Christian symbols in religious paintings. For example, the Virgin Mary is traditionally cloaked in a blue robe to symbolize her role as the Queen of Heaven. The goldfinch held by the Christ Child in this Straus Madonna painting is a symbol of the Resurrection and, in pre-Christian times, of the soul that flies away as the body dies. A talisman that also predates Christianity, the coral pendant around Christ's neck is believed to protect the wearer against evil*

**1.16 Ferrarese School, The Meeting of Solomon and the Queen of Sheba, c. 1470–73**

The biblical story about the Queen of Sheba visiting King Solomon was a popular Renaissance subject for commemorating weddings and births. In this tondo (round painting), the artist transplanted the scene from ancient Jerusalem to an Italian palace much like the one in the northern Italian town of Ferrara where he worked. He also represented Solomon's splendid guests and attendants according to the artistic tastes and social customs of the powerful Este family, which ruled Ferrara in the 15th century. While the extensive use of gold leaf and patterned color recall earlier styles, the fresh, brilliant colors, complex design, and charming details typify Ferrarese painting at this time. The artist used the new system of linear perspective to make the buildings and figures appear to recede in space. Note how the underlying lines of the composition meet at the chalice at the very center of the painting.

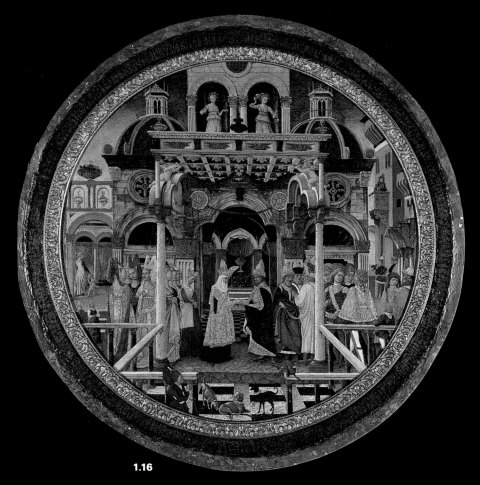

1.16

**1.17 Fra Angelico, Saint Anthony Abbot Shunning the Mass of Gold, 1430s**

*The Dominican monk Fra Angelico was famous in his own time as one of Florence's leading painters, a master of the new Renaissance style. Portraying Saint Anthony turning away from the devil's temptation of a mound of gold, he painted the saint's body with convincing solidity, standing realistically within the landscape. To depict the space receding into the distance, Fra Angelico made the far mountains smaller than those in the foreground, and he painted the horizon in luminous whites and blues. The bright colors and deep perspective are also hallmarks of the new style.*

**1.18 Giovanni di Paolo, Saint Clare Rescuing a Child Mauled by a Wolf, c. 1455–60**

*This panel comes from an altarpiece depicting the life of Saint Clare, the founder of the religious order known as the Poor Clares. In this scene, a mother entreats Saint Clare to help her child, who has been attacked by a wolf. Sienese painter Giovanni di Paolo includes dramatic details: the child's severed arm spouts blood; the kneeling mother pleads for help; and the sparse landscape isolates the helpless figures. Except for the grid of receding fields composed according to Renaissance perspective, the painting illustrates the naive style that gives this artist's work its mystical power.*

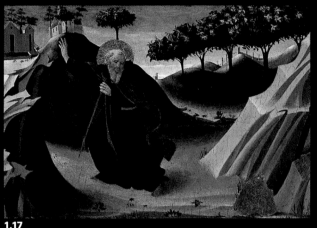

1.17

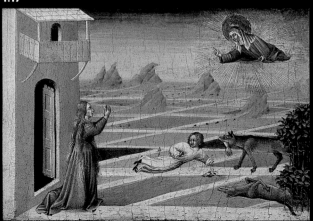

1.18

### 1.19 Sebastiano del Piombo, Anton Francesco degli Albizzi, 1525

One of the leading portrait painters of the High Renaissance (c. 1495–1520), Sebastiano del Piombo arrived in Rome from his native Venice in 1511 and became a close friend and protégé of Michelangelo's.

*[Sebastiano] portrayed Anton Francesco degli Albizzi . . . so that he seemed not painted, but alive. . . . The head and hands of this portrait were certainly a marvelous thing, not to mention the velvets, the linings, the silks, and all the other parts of this painting, and since Sebastiano was truly of the greatest skill and quality in doing portraits, more than anyone else, all Florence was amazed at this portrait of Anton Francesco.*

Giorgio Vasari, *The Lives of the Most Eminent Painters, Sculptors, and Architects*, 1550

Combining the opulent materials and vibrant light characteristic of Venetian painting with the monumentality of Michelangelo's Roman style, Sebastiano created this extraordinary portrait, immediately hailed as a masterwork. The subject has been identified as the Florentine diplomat Anton Francesco degli Albizzi, who commissioned the painting while on a visit to Rome. The elaborate robes, forceful gesture, and proud, intelligent expression give the sitter an aura of importance.

1.19

**1.20 Bartolomeo Veneto, Portrait of a Man, possibly 1512**

*In Venice—the richest Italian city of the early 16th century—the demand for portraiture increased as the form grew in artistic and social status. The bust-length portrayal of melancholy young gentlemen in luxurious dress, holding personal signs of status, became especially popular. Bartolomeo Veneto achieved great fame for boldly colored portraits of this type, and the museum's example demonstrates his considerable skill at rendering both textural surfaces and the play of atmospheric light.*

**1.21 Follower of Botticelli, Bust of a Young Woman, c. 1485–90**

*This work displays a profile pose typical of portraits created in 15th-century Florence. The clear drawing, soft and sensuous flesh, and delicate expression of the lips suggest that the artist was a follower of Botticelli's (p. 90).*

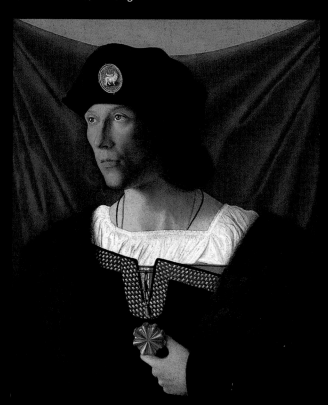

**1.20**

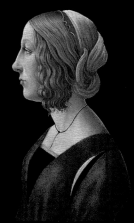

**1.21**

**1.22 Antonio Susini, Madonna and Child, c. 1600**

Antonio Susini was the chief assistant and one of the most gifted followers of Giambologna, the leading sculptor in Florence in the second half of the 16th century. In about 1600 Susini began producing his first independent work. A specialist in all aspects of bronze mold making, casting, and finishing, he was also known for his miniature versions of antique statues and compositions of his own invention. This Madonna and Child, with its beautifully posed figures and elegant drapery, testifies to Susini's artistic and technical proficiency.

**1.23 Antico, Hercules Resting after Slaying the Nemean Lion, c. 1500**

In the late 15th century, Isabella d'Este and her husband, Gianfrancesco Gonzaga, gathered poets, painters, and sculptors at their sophisticated court in Mantua to assist with their studies of ancient art. One such sculptor was Pier Jacopo Alari-Bonacolsi, who earned his nickname, Antico, for the remarkable small bronzes he made in the antique style. This example, one of the few in the United States, shows Hercules as an idealized male nude, just after slaying the Nemean lion, the first of his 12 labors.

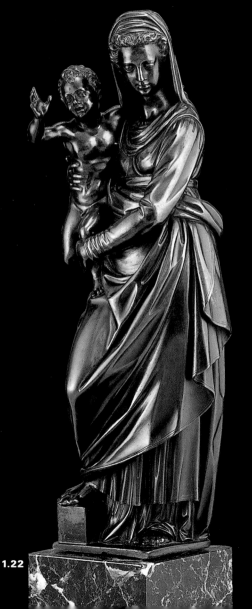

1.22

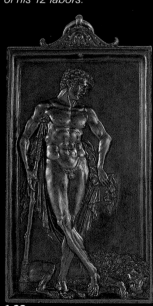

1.23

**1.24 Scarsellino,
Virgin and Child with
Saints Mary Magdalene,
Peter, Clare, Francis,
and an Abbess, c. 1600**
*Ippolito Scarsella, called
Scarsellino, was one of
the last important painters
working in the northern
Italian town of Ferrara
in the late 16th and early
17th centuries. At this time,*

*in response to the Protestant
Reformation, Catholic clergy-
men entreated artists to
make vivid pictures that
would bring alive the lives
and legends of Christ,
the Virgin, and the saints.
Scarsellino made many such
works, including this* sacra
conversazione *(holy conver-
sation), in which saints from
different historical periods*

*gather around the Virgin
and Child. By relying on the
identifying symbols that
Scarsellino included for each
figure, viewers could easily
recognize (clockwise from
bottom left) Saints Mary
Magdalene, Francis of
Assisi, Clare, and Peter. The
woman at far right is the
abbess of the convent that
commissioned the painting.*

Oh you who see and
worship these saints here
united in a single picture,
whose earthly lives were
led at different times, pause
and read these sacred
words and see the truth as
if in heaven, face to face,
for holier and more lively
than paradise is this image.

Inscription at the
bottom of the painting

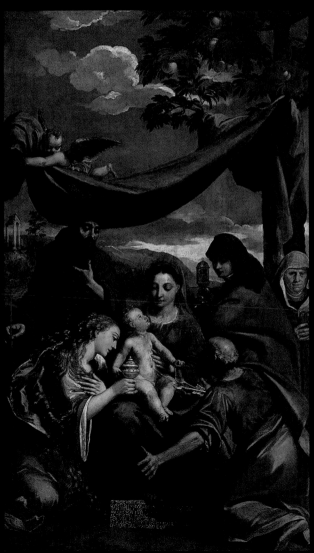

Paralleling the dramatic changes taking place in Renaissance Italy were equally radical—if less cohesive—transformations in the art of northern Europe, from late Gothic styles to more naturalistic representations of both secular and religious subjects. While perspective was perhaps the greatest technical innovation of Italian painters, the major artistic development in the north was oil painting, first mastered by the Flemish painter Jan van Eyck. Flanders (now Belgium), under the rule of the powerful dukes of Burgundy, was the commercial and artistic center in northern Europe in the 15th and early 16th centuries.

**1.25 Rogier van der Weyden, Virgin and Child, after 1454**

*The most important artist of mid-15th-century Flanders, Rogier van der Weyden was the prized artist of the dukes of Burgundy and the dominant influence on northern European painting for decades after his death. His genius lay in his ability to convey the emotional intensity of his subjects, be they contemporary citizens of Brussels or biblical Christian martyrs. Here, Rogier portrays Mary and the Christ Child devoid of halos or other Christian symbols, emphasizing the personal and human aspect of their relationship.*

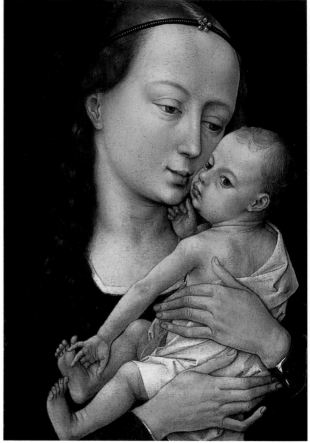

**1.25**

*Flemish painting will, generally speaking, please the devout better than any painting in Italy, which will never cause him to shed a tear, whereas that of Flanders will cause him to shed many.*

Michelangelo

**1.26** Hans Memling, Portrait of an Old Woman, 1468–70
*Born in Germany, Hans Memling probably apprenticed with Rogier van der Weyden in Brussels before moving to Bruges in 1465, the year after Rogier died. Able to render a sitter's character with sensitivity and grace, Memling became a respected and wealthy artist,*

*creating altarpieces as well as portraits for the town's leading citizens. This sympathetic portrayal of a middle-class, elderly woman is believed to belong to a pair of portraits of a husband and wife. X-ray analysis reveals that the woman's veil—typical of the large wimples worn by widows at that time—was added later, after her husband had died.*

**1.27** Corneille de Lyon, René de Batarnay, Comte du Bouchage, c. 1535–40
*Corneille de Lyon painted small, refined portraits of aristocrats as court painter to the French king Henri II. In this example, de Lyon skillfully captured the sitter's facial expression and textured beard in exquisite detail.*

**1.27**

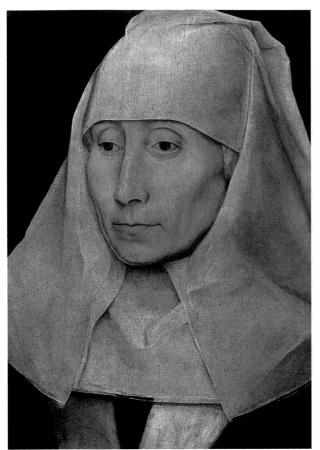

**1.26**

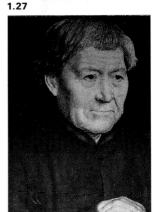

**1.26a** *Hans Memling's mate to the MFAH painting belongs to the Metropolitan Museum of Art, N.Y.*

In the late 16th and the early 17th centuries, the Netherlands, or Low Countries, consisted of two separate parts. In the north, the Dutch Republic was an independent, largely Protestant, commercial and maritime power; in the south, Flanders remained under the rule of Spain, a Catholic and aristocratic culture. Where Bruges and Brussels had been the centers for northern European art in the 15th century, the great Dutch cities of Haarlem and Amsterdam dominated this part of the art world through the 17th century. Religious and intellectual tolerance fostered artistic freedom and experimentation, while the Dutch Reformed Church's opposition to religious images prompted a growing interest in secular subjects. Prosperous towns-people became the new art patrons, and they enjoyed pictures of the world that their recently acquired wealth afforded them, from still lifes, cityscapes, and landscapes, to modest interior views, domestic scenes, and portraits.

**1.28 Frans Hals, Portrait of an Elderly Woman, 1650**

*One of the great 17th-century Dutch artists was Frans Hals, who achieved some renown early in his career but died an impoverished man. Not until the 19th century, when artists began to appreciate his unprecedented manner of applying thick paint with spontaneous, free brush strokes, was his reputation secured. A wonderful painter of portraits and scenes of everyday life, Hals is best remembered for his bravura studies of the Dutch bourgeoisie, including a series of nine group portraits of Haarlem civic guards. In the 1630s, Hals's paintings became more somber, as in this penetrating portrait, one half of a husband-and-wife pair.*

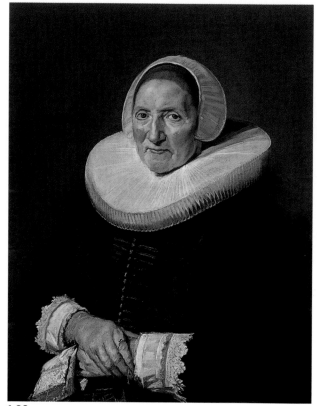

**1.28**

**1.29** Willem Claesz. Heda, Banquet Piece with Ham, 1656

The Dutch invented the term "still life" in the 17th century to describe paintings of food, flowers, and dead game, a genre at which their artists excelled. Although ancient antecedents existed, the subject emerged as an independent category of art only with the rise of secular painting in the Protestant Netherlands. Willem Claesz. Heda was a leading Dutch still-life painter who specialized in what were called monochromatic breakfast pieces — detailed portrayals of vessels and food painted in a close range of grays, browns, and whites. In this example, the pink ham, blue decoration of the Delft bowl, and acid yellow rind of the half-peeled lemon subtly counter the subdued colors. The objects are arranged as if a real breakfast had been abruptly interrupted: a beaker is upset, plates are piled up, and the lid of the silver pitcher is left open. The luscious depiction of expensive silver and crystal wares—and oysters instead of herring—attests to the wealth of the Dutch Republic.

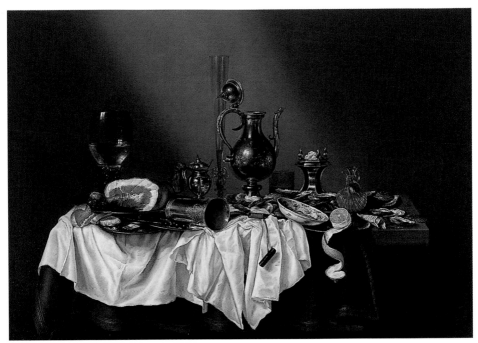

**1.29**

*In Willem Heda's pictures in particular, the objects are so subtly disposed, their relationship with each other so delicately measured, that the least dislodging collapses the whole. The cunning intrusion of the upturned glass or the casually prostrated flagon acts to reinforce the sense of fragility with which this miraculous equilibrium is sustained.*

Simon Schama, *The Embarrassment of Riches: An Interpretation of Dutch Culture in the Golden Age*, 1988

**1.30** Ferdinand Bol, Woman at Her Dressing Table, c. 1645

*Ferdinand Bol moved at an early age to Amsterdam, where he became the pupil and close friend of Rembrandt van Rijn (p. 116). Using the master's characteristic dark background and dramatic highlights, Bol devoted special attention in this work to the play of light on the sitter's face, as well as the glistening jewelry and gold brocade on the dress. The woman is shown looking at a mirror that stands on a jewel-laden table. Like other 17th-century portrayals of elegant ladies admiring themselves in mirrors, this oil painting is a* vanitas *picture, an allegory of the vanity of life, reminding the viewer of the transitory nature of earthly goods and experience. The dramatic work is one of Bol's most successful achievements.*

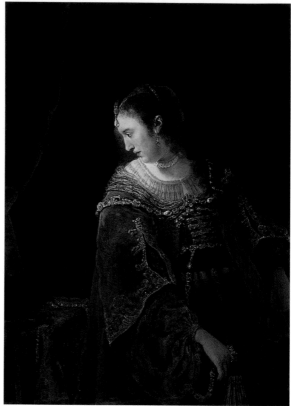

**1.30**

**1.31** Jan van Huysum, Still Life of Flowers and Fruit, c. 1710–15
*The most successful Dutch flower painter, Jan van Huysum is famous for the technical virtuosity with which he painted luxuriant arrangements of fruit and flowers. Faithful to extreme standards of realism, van Huysum conveyed such details*

*as the veins of individual petals, drops of water, and minuscule insects. In this superb example, a profusion of flowers overflows its stone vase and reaches beyond a ledge toward the viewer. Woven in and out of the densely packed bouquet of roses, morning glories, hyacinths, auriculas, and narcissi are the rhythmically flowing stems and blossoms of tulips, poppies, and carnations.*

*The glistening bunch of grapes adds to the sense of abundance, and a snail and insects animate the composition. Van Huysum's still lifes were enormously popular in his day and entered the collections of many important patrons in the Netherlands and throughout Europe. He is reportedly the most highly paid Dutch artist of all time.*

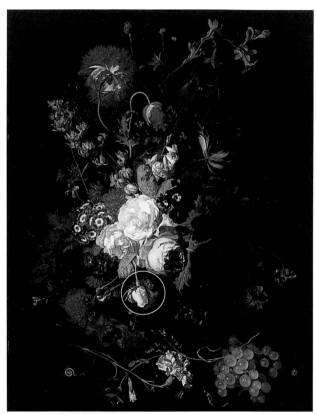

**1.31**

The Baroque style began in Italy around 1600. The term is used broadly to describe the art and architecture of Europe and its Latin American colonies in the 17th and first half of the 18th centuries. Baroque painters characteristically depicted religious subjects with a powerful realism, incorporating strong emotional content, dynamic compositions, and dramatic contrasts of light and shade. During this period, the Catholic Church continued to counter the Protestant Reformation by reemphasizing its own traditional spiritual doctrines. The vivid and compelling images supplied by Baroque painters served this purpose well.

**1.32 Carlo Dolci, Virgin and Child with the Infant Saint John the Baptist, c. 1635**

*In 17th-century Florence, Carlo Dolci was the only painter with a European reputation. A deeply religious man, Dolci excelled at meticulously rendered devotional images that he painted to inspire spiritual feeling in all who saw them.*

*The religiosity of the works earned him numerous commissions from devout Florentine patrons, whose reverence for John the Baptist as the patron saint of Florence explains the saint's inclusion in this picture. The delicate gestures and the keen attention to detail in the MFAH's work show Dolci's skill at its finest.*

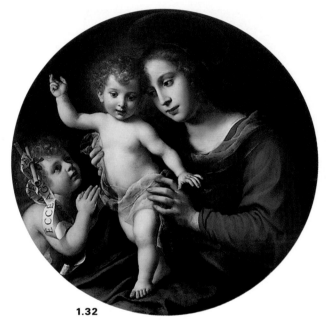

**1.32**

*He [Carlo Dolci] made for Gio. Francesco Grazzini, a rich gentleman and great lover of painting, a Madonna with Jesus and Saint John, on wood, of circular shape, which was reknown in that time, and he received much credit and requests from others for similar works, although he lacked the time to satisfy even a few of these. [He] used the face of Maria Maddalena, my sister, 12 years old at the time, for the face of the Virgin.*

Filippo Baldinucci, c. 1640–50

**1.33** Bernardo Strozzi, The Guardian Angel, c. 1630

Bernardo Strozzi was one of the leading painters in Genoa at a time when the city was a vital commercial center linking various parts of Italy with northern Europe. Genoa's cosmopolitan atmosphere, open to foreign artistic influences, is evident in Strozzi's eclectic style.

*The dramatic contrast of dark shadows to lighted areas in this major painting, for example, shows the artist's knowledge of Caravaggio, the influential Roman painter, whereas the glowing color suggests Strozzi's indebtedness to Rubens, the leading Flemish artist of the time. Created for the private chapel of a wealthy family, the painting depicts the family's* daughter with her guardian angel. While never part of official Catholic Church dogma, the belief that each human being has his or her own divine protector was a popular one at that time.

*[Jesus said:] See that you despise not one of these little ones; for I say to you that their angels in heaven always see the face of My Father who is in heaven.*

Matthew 18:10

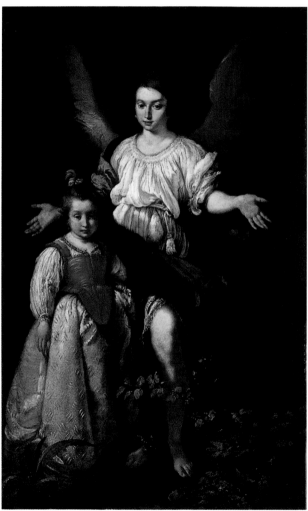

**1.33**

**1.34** Orazio Gentileschi, Portrait of a Young Woman as a Sibyl, c. 1620

*This painting of a young woman portrays her as a sibyl holding a scroll of prophecies. A frequent subject in Baroque art, sibyls were first identified in ancient Greece as women with the gift of prophecy. Painted with sumptuous colors, the work characterizes Orazio Gentileschi's style at its best. A skillful follower of Caravaggio's, Gentileschi used similar dramatic lighting to depict subjects that required few figures, placing them close to the picture plane to create a sense of immediacy. The woman in this painting is probably the artist's daughter, Artemesia, herself a renowned painter who gained notoriety when she was allegedly raped by the artist Agostino Tassi.*

*Posing her as a sibyl would have had a special meaning for both father and daughter. During the rape trial in 1612, Artemesia submitted to a tortuous test in which metal rings were tightened about her fingers. This device for determining the truth was called sibille (Italian for sybils).*

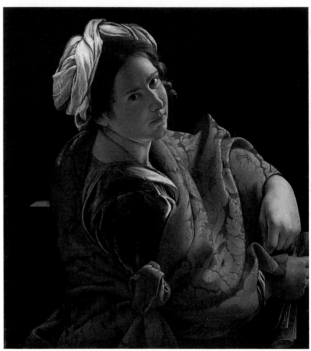

**1.34**

**1.35** Guido Reni, Saint Joseph and the Christ Child, 1638–40

*Guido Reni was the most famous Italian painter of his day, revered for the grace and naturalness of his serenely balanced compositions. Working during the Catholic Counter-Reformation, Reni depicted images of saints and holy figures in the humanized and accessible form Catholic leaders requested. This intimate portrayal of Joseph demonstrates Reni's skill at rendering the foster father of Christ as a simple man tenderly holding his infant son. Because the story of Joseph contributed to a more personal — and therefore more approachable — characterization of the Holy Family, images of the saint became increasingly popular during the Counter-Reformation. By the 17th century, Saint Joseph had become a cult figure in Italy and Spain. In this work, Jesus is holding what appears to be an apple, a symbol of the Fall of Man and an allusion to the infant Christ's future mission as Redeemer of mankind from Original Sin.*

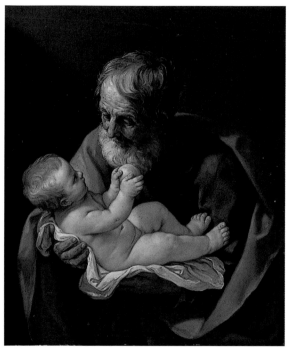

**1.35**

*Great is the Infant's tenderness, and the Saint Joseph who very well expresses the devotion and affection he had for the Redeemer of the world.*

Description of Guido Reni's *Saint Joseph and the Christ Child* in a 1677 guide to Florence

**1.36** Philippe de Champaigne, The Repentant Magdalen, 1648

*This painting illustrates the religious fervor that lies at the heart of Philippe de Champaigne's work. A man of intense piety, Champaigne studied in his native Brussels before moving to Paris in about 1621. Striking a note of restraint in contrast to the more flamboyant Italian styles of the Counter-Reformation, his works after 1646 evoke a world of private devotion in keeping with his adherence to Jansenism, a severely ascetic religious sect centered near Paris. Made for a Parisian convent in 1648, The Repentant Magdalen was painted the year Champaigne became a founding member of the French Royal Academy of Painting and Sculpture. Its crisp lines and icy colors contribute to the work's tone of pious sobriety.*

**1.37** Mattia Preti, The Martyrdom of Saint Paul, c. 1656–59

*Mattia Preti is one of the founders of the Neapolitan Baroque style. Born in Calabria in southern Italy, he worked in Rome and then moved to Naples in about 1656, at a cosmopolitan period in that city's artistic history. One of a set of three paintings commissioned by a*

*Flemish merchant living in Naples, this work demonstrates Preti's powerful style. He depicts the beheading of Saint Paul at its most tense moment: the saint bows his head just as the executioner begins to unsheathe the sword. The close placement of twisted figures in the foreground, heightened by sharp contrasts of light and shadow, creates the scene's dramatic immediacy.*

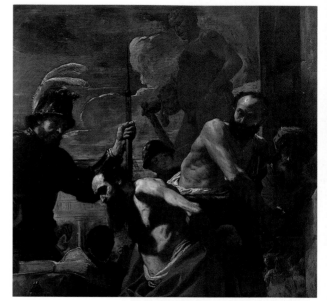

**1.37**

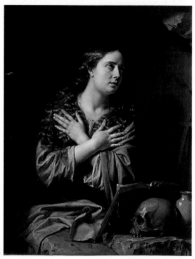

**1.36**

**1.38** Luca Giordano, Allegory of Prudence, 1682

*This canvas was created by the leading Italian artist in the second half of the 17th century, Luca Giordano. A prolific painter whose nickname was* Luca fa presto *("Luca works quickly"), he became particularly famous for his large paintings on ceilings. Giordano seldom made preparatory drawings, but, like many Baroque artists, he did make fully realized oil paintings for large-scale works. This is one such canvas, for a major commission in the Medici-Riccardi Palace in Florence. It presents an allegory of Prudence, who, along with Justice, Fortitude, and Temperance, is one of the four Cardinal Virtues. Personified as a woman, Prudence is shown with her usual attributes: a mirror, signifying that wise people can see themselves as they really are; and a serpent, from Matthew 10:16: "Be ye wise as serpents." (*Prudentes is the Latin word for wise.*)*

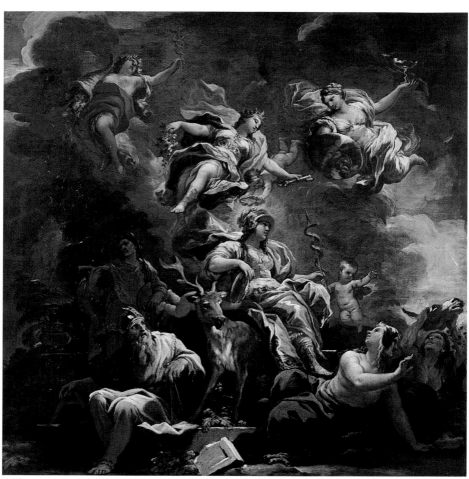

**1.38**

**1.39** Jean-Baptiste Pater, A Pastoral Concert, c. 1725

In France during the 17th and 18th centuries, the fête galante (courtship party) was a frequent subject in painting. Artists depicted upper-class men and women conversing and flirting, usually outdoors, at gatherings defined by elaborate rules of aristocratic etiquette. Jean-Antoine Watteau was the first painter to make the fête galante popular, creating canvases that have come to define the grace of 18th-century French art. Another painter of such scenes was Jean-Baptiste Pater, a student of Watteau's. Pater earned admittance into the French Academy of Painting in 1728 based on works such as this one. Three figures make merry in a garden appropriately containing a bust of Bacchus, the spirited Roman god of wine and ecstasy. According to the conventions of fête galante paintings, the inclusion of a musician — who tries to find the sounds that will move his listeners — means this work depicts a first encounter between the man and woman.

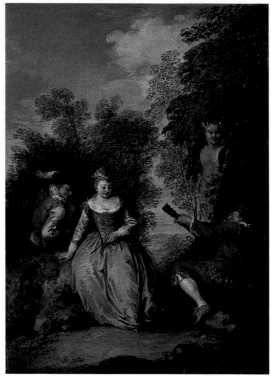

**1.39**

*Well-pleased to grace the park and play,
And dance sometimes the night away, . . .
And there, beneath some silent grove,
Delight in poetry and love.*

Soame Jenyns, "The Choice," mid-18th century

**1.40** Charles-Joseph Natoire, Bacchanal, 1749
An acclaimed member of the French Academy, Charles-Joseph Natoire was one of the most successful painters in mid-18th-century Paris. This bacchanal, or celebration of Bacchus, was commissioned for the wedding of the distinguished art collector La Live de Jully.

Under a late afternoon sky turning orange with the setting sun, a voluptuous follower of Bacchus's serves her master some wine. Bacchus, wearing nothing but his usual panther skin and wreath, gazes adoringly at her, while the assembled angels, nymphs, and fellow revelers look on. Natoire skillfully varies the application of paint according to each form in the work,

rendering the foliage and sky with feathery touches and the figures in more linear strokes. All are painted with a luxurious sense of color that only his rival, François Boucher, could match. Natoire's fluid and sensuous style, containing elaborately decorative designs and atmospheric pigments, epitomizes the Rococo period in painting.

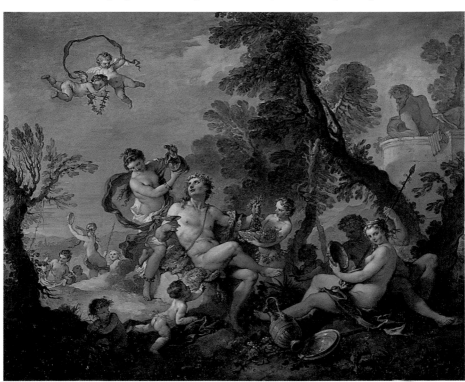

**1.40**

**1.41** Jean-Siméon Chardin, The Good Education, c. 1753

*First known for his exquisite still-life paintings, Jean-Siméon Chardin today is recognized also as a master of genre subjects (scenes of daily life). In the 1730s, in response to the French interest in 17th-century Dutch and Flemish genre paintings, he began creating small canvases depicting the domestic life of the middle class. Dramatically set in a spare, dark room, The Good Education shows a mother or governess putting aside her embroidery to listen attentively to a young girl, whom 18th-century viewers understood to be reciting from the gospels. Chardin delighted in recording his subjects' facial expressions: the girl worrying about an apparent lapse in her recitation and the woman showing gentle concern. The light streaming through the window bathes the figures with an almost material presence, conferring on them a psychological and spiritual union. This inspired use of light characterizes Chardin's late work and is the key to his evocative style. For another painting by Chardin, see p. 94.*

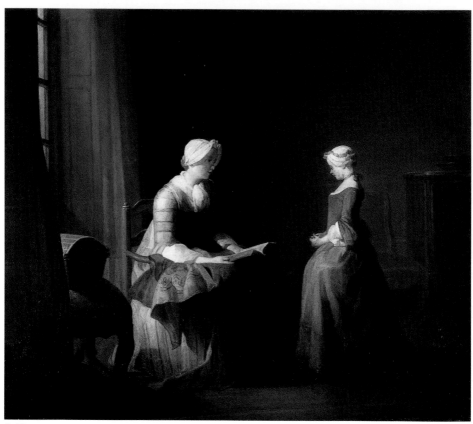

**1.41**

It is necessary to prevail upon young ladies to read the Gospel. Accordingly, select for them a good time of day to read the word of God, just as one prepares them to receive through communion the flesh of Jesus Christ. Above all, inspire young girls with that sober and restrained wisdom which Saint Paul commends.

François de Salignac de la Mothe Fénelon, *On the Education of Girls*, 1693

**1.42** Anton Raphael
Mengs, Truth, 1756

*Anton Raphael Mengs received
his early training from his
father, a court painter in
Dresden. He later studied in
Rome, where he became close
to the German archaeologist
Johann Joachim Winckelmann,
the theoretician of the return
to classical ideals known as
Neoclassicism. Mengs eventually*
*became one of Europe's leading
Neoclassical painters. At an
early age, he mastered the
technique of pastel, a medium
similar to colored chalks that
combines the fluidity of painting
with the immediacy of drawing.
In this work, Mengs depicts the
allegorical figure of Truth as a
beautiful young woman holding
a peach with a single leaf, an
ancient symbol of the heart and*
*tongue which, when united,
speak the truth. Having nothing
to hide, Truth is shown naked,
covered only partially by a
thin veil. Beginning in the
16th century, Father Time
was frequently portrayed in the
act of removing a veil from the
naked figure of Truth. Although
the figure of Time is absent here,
the veil symbolizes the idea that
Truth is revealed by Time.*

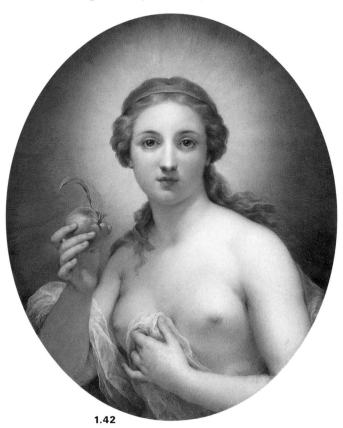

**1.42**

**1.43** Canaletto, The Entrance to the Grand Canal, Venice, c. 1730

In the 18th century, cultivated gentlemen visiting Venice bought scenic paintings as souvenirs much the way tourists buy picture postcards today. A work by the fashionable and famous Canaletto, who skillfully captured the luminous colors and vivid life of Venice, was frequently their first choice. This depiction of the entrance to the Grand Canal, with the Church of Santa Maria della Salute on the left, may be among the earliest of Canaletto's many versions of this popular site. The detailed rendering of the many figures, architectural facades, and boats—all carefully arranged in the painting's composition—demonstrates Canaletto's close observation of daily life. Note how even the figures ascending the stairs of the church are painstakingly articulated. For an etching by Canaletto, see p. 119.

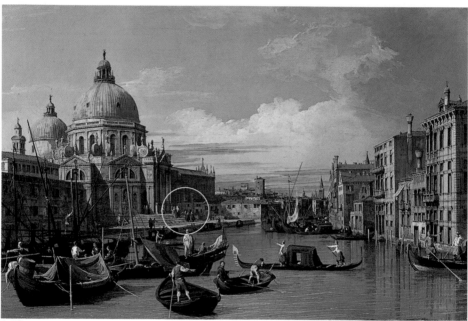

1.43

**1.44** Angelica Kauffman,
Ariadne Abandoned by
Theseus on Naxos, 1774
*Born in Switzerland, trained
in Italy, and made famous in
England, Angelica Kauffman
was one of Europe's leading
Neoclassical painters. Like
Pompeo Batoni (1.45), she was
a popular portraitist of wealthy
aristocrats, tourists, and celebri-
ties. Also a painter of historical*

*and mythological subjects,
Kauffman was fascinated by
the classical frescoes then being
excavated at Pompeii. In the
Greek myth of Theseus and
the Minotaur, Theseus escapes
the Minotaur's labyrinth with
the help of his lover, Ariadne,
whom he later abandons.
Here, Kauffman portrays the
forsaken woman at the moment
Theseus's ship sails away.*

**1.45** Pompeo Batoni,
William Fermor, 1758
*In the mid-18th century, Pompeo
Batoni was known throughout
Europe as the most famous
portraitist in Rome. British
tourists were his most enthu-
siastic patrons. The incisive
drawing and vivid color in
this portrait of an Oxfordshire
gentleman characterize Batoni's
compelling style.*

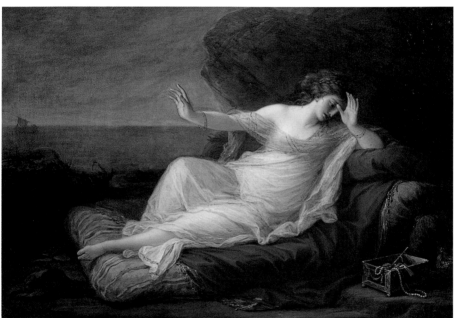

**1.44**

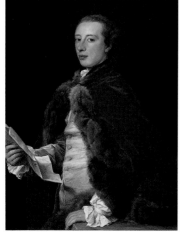

**1.45**

A superb collection of English silver, largely made in London between 1660 and 1760, is on display in the MFAH's European galleries. The objects illustrate the history of English silver design during a prosperous period that saw the building of great town homes and country houses replete with lavish furnishings, tableware, and fine art.

**1.46** Jacob Bodendieck, Covered Ginger Jar, 1677
*German-born Jacob Bodendieck typifies the cosmopolitan milieu in which silversmiths thrived in late 17th-century London. At work there by 1661, Bodendieck modeled this masterful silver vase on the form of a Chinese porcelain ginger jar, decorating it with Baroque floral designs and four masks.*

**1.47** Edward Wakelin, Candlestick, one of a pair, 1755–56
*By the time Edward Wakelin's shop made this candlestick, he was already very familiar with the exuberant Rococo style that was then popular in England. The shaft of the candlestick appears to have been twisted in one direction, surrounded by a spiraling garland of grapes*

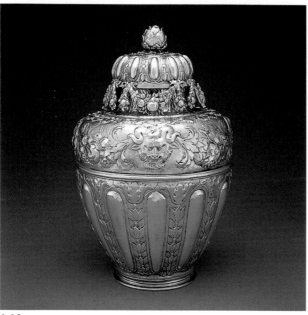

**1.46**

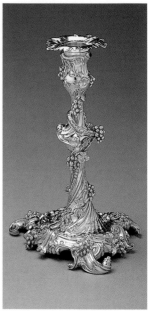

**1.47**
*moving in the opposite way. Created about the same time Thomas Chippendale published his influential book of Rococo-style furniture designs (p. 441), the candlestick's asymmetry, naturalistic forms, and diagonal movement epitomize the English Rococo style.*

**1.48 Paul de Lamerie, Ewer, c. 1735**

In 1685, King Louis XIV of France revoked the Edict of Nantes, which had permitted religious freedom to Protestants for nearly a century. During the next few years, more than 400,000 Huguenots (French Protestants) fled their country. Among them were a number of talented silversmiths who went to London, bringing with them highly ornamented Baroque designs quite different from the plain surfaces then favored in England. Paul de Lamerie, a second-generation English Huguenot, became one of London's most prominent silversmiths. In this outstanding ewer, Lamerie demonstrates the Huguenot style of the 1730s: a deep, Roman-helmet-shaped bowl, a bold handle, and complex decorations of scrolls, leaves, shells, and other natural forms. Ewers and basins had long been used at the English dining table for washing hands, but with the introduction of forks at the end of the 17th century, such vessels became largely orna-mental. This impressive example would have decorated a sideboard and served to demonstrate the owner's affluence and taste.

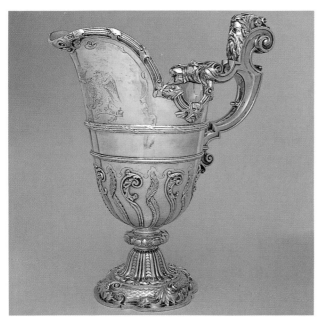

**1.48**

*Last Thursday died Mr. Paul de Lamerie of Gerrard Street much regretted by his Family and Acquaintance as a Tender Father; a kind Master and an upright Dealer.*

General Evening Post, London, August 1–3, 1751

**1.49** Francisco de Goya, Still Life with Golden Bream, 1808–12

*One of Spain's greatest painters, Francisco de Goya documented the dark undertow of a country ravaged by war. In incisive royal portraits, satirical caricatures, and terrifying scenes of war, Goya defined the expressive and heroic spirit of his people. During the worst years of Spain's conflict with France (1808–14), while creating many of his masterpieces about the war, Goya made 12 haunting still-life paintings. In this one, he depicted wet, scaly bream, their staring eyes reflecting the moonlit sky. Goya invested the dead fish with great poignancy, symbolically linking their demise with the slaughter of people in war.*

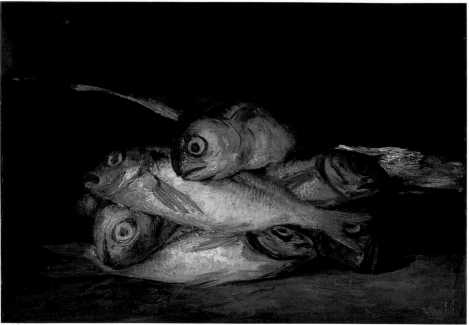

1.49

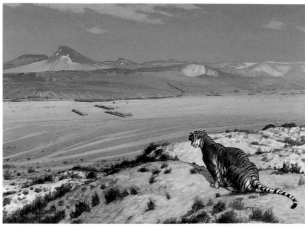

1.50

**1.50** Jean-Léon Gérôme,
Tiger on the Watch,
c. 1888
*Born in 1824, Jean-Léon
Gérôme came of age during the
Romantic period, when artists
were championing emotion over
reason in expressive paintings
often set in exotic locales. A
classically trained artist
acclaimed for his history
paintings, Gérôme also created*
*romanticized panoramas of
faraway lands. He particularly
liked to paint lions and tigers in
dramatic settings that contrasted
the animals' ability to survive
in nature with that of human-
kind, for whom the vast terrain
was a hostile environment.
Here, the powerful tiger views
a distant military formation,
inviting a comparison between
human and animal predators.*

**1.51** William Adolphe
Bouguereau,
The Elder Sister, 1869
*William Bouguereau trained
at the École des Beaux-Arts
in Paris, where he pursued
an academic curriculum rooted
in drawing and the classical
figurative style. Highly skilled,
Bouguereau went on to win
membership in the French
Academy and election to
the Legion of Honor. Equally
impressive was Bouguereau's
commercial success. In the 1860s,
he began to paint popular scenes
of idealized childhood and
family life, as well as female
nudes. Consequently, the market
for Bouguereau's work bur-
geoned, not only in his native
France, but also in Holland,
England, and the United States.
The Elder Sister exemplifies
the pretty and sentimental
quality of these new works.
The painting presents two rosy-
cheeked children (modeled after
the artist's own daughter and
son) wearing faux-peasant
costumes in an idyllic setting.
Reminiscent of Madonna
and Child paintings, the scene
is suffused with sweetness,
innocence, and natural
affection. Although attacked
by the Impressionists as relics
of an obsolete tradition,
Bouguereau's paintings have
remained popular with the
public, and they are receiving
renewed interest from scholars.*

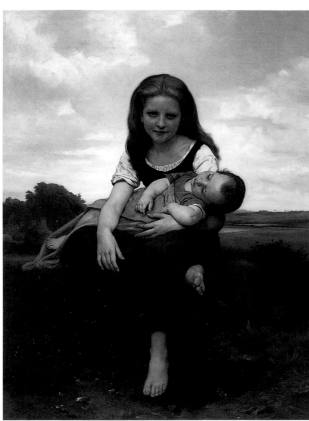

**1.51**

**1.52** Camille Corot, Orpheus Leading Eurydice from the Underworld, 1861

One of the first artists to paint outdoors, Camille Corot formed a crucial link between traditional landscape painting and Impressionism. In the annual salons of mid-19th-century Paris, subjects from history, mythology, and the Bible were considered more worthy than landscapes. Here, Corot disguised what is essentially a landscape by fusing it with a mythological story. The work depicts Orpheus just before he looks back and loses Eurydice to the underworld forever. Rendered in subdued hues, the scene's misty atmosphere and feathery brushwork are hallmarks of Corot's poetic late style.

**1.53** Théodore Rousseau, The Great Oaks of Old Bas-Breau, 1864

In the mid-1800s, Théodore Rousseau was a leader of the group of landscape painters who took their name from the French village of Barbizon, near where they lived. His somber pictures convey both the melancholy solitude and profound joy of being in nature.

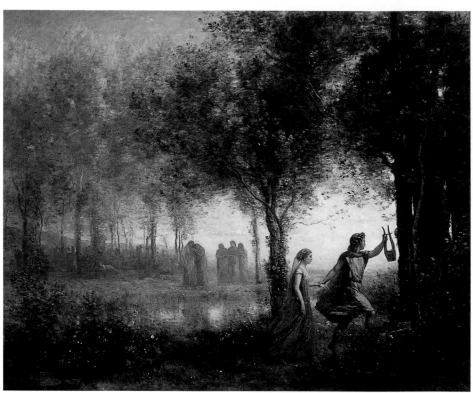

1.52

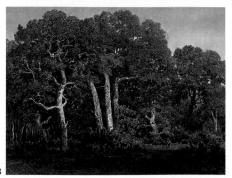

1.53

**1.54** Auguste Renoir,
**Still Life with Bouquet,**
1871
*In the 1860s and the 1870s,
Auguste Renoir joined Frédéric
Bazille and Claude Monet, as
well as Alfred Sisley and other
young artists who gathered in
Paris around the great pioneer
of modern painting, Édouard
Manet (pp. 100, 121). Made when
Renoir was still defining his style,*

*Still Life with Bouquet con-
tains many items that recall
the interests and lifestyles of
the painters in this circle. The
Japanese fan and Chinese vase
refer to their passion for the art
of those cultures, and the books
and floral bouquet call to mind
the artists' intellectual and
amorous activities. The print on
the back wall is Manet's etching
after a work by the 17th-century*

*Spanish painter Diego Velázquez.
Paying homage to these two
masters of realism, Renoir also
shows his interest in Impressionism
by his loosely brushed rendering
of the effects of light on the objects.
Created the year after the
cataclysmic Franco-Prussian
War, the still life also contains
an element of nostalgia for the
disrupted community of artists
it symbolically evokes.*

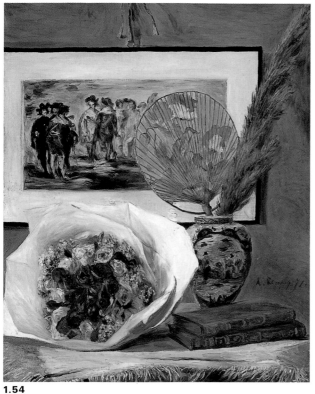

**1.54**

*It is not enough for
a painter to be a
clever craftsman; he
must love to caress
his canvas too.*

Auguste Renoir, as quoted
by Ambrose Vollard,
*Renoir, An Intimate Record*,
1930

**1.55  Paul Cézanne, Madame Cézanne in Blue, 1888–90**

*Although Paul Cézanne initially embraced the Impressionists' loosely brushed, light-filled images of daily life, by the 1880s his interest in the underlying structure of a painting led him to investigate shapes and forms with the more detached eye of a scientist. His famous remark that the painter must "treat nature in terms of the cylinder, the sphere, and the cone," lies at the heart of his work. In this grave portrait of his wife — one of 44 he completed during their three decades together — something of Cézanne's objective analysis can be seen in the simplified forms of her arms, torso, and head. Madame Cézanne's self-contained stolidity provides further evidence of the painter's primary interest in the canvas's colors, shapes, and composition. The work derives dramatic impact from its small disjunctures — the off-center tilt of the picture axis, the mix of straight and curved lines, the ambiguous space — balanced by the harmonious colors and statuesque figure.*

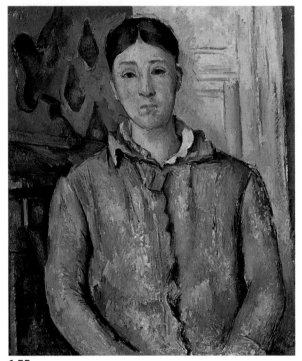

**1.55**

*I am progressing very slowly, for nature reveals herself to me in very complex forms; and the progress needed is incessant. One must see one's model correctly and experience it in the right way; and, furthermore, express oneself forcibly and with distinction.*

Letter from Paul Cézanne to Émile Bernard, 1904

**1.56** Claude Monet,
Water Lilies, 1907
*In 1890, the 50-year-old Claude
Monet was already a very
successful artist. That year,
he purchased a home in
Giverny, France, and over
the next 12 years he developed
the surrounding property into
his now famous gardens. Until
his death in 1926, the lush
setting provided the subject*

*for almost all of Monet's
remarkably varied paintings.
This work is a late example
from a series of 48 water lily
canvases that he made between
1895 and 1909, when they were
exhibited in Paris. By painting
numerous works of the same
scene, Monet recorded the effects
of different light conditions
on its appearance in widely
ranging colors and textures.*

*The pleasures of* Water Lilies
*deepen in stages. The immediate
impact of the picture's beauty
leads to the slower absorption
of its subtle color harmonies
and brushwork, while the
initial impression of water lilies
in a shimmering pond shifts
to an intriguing puzzle of
three-dimensional trees and
sky contained within the two-
dimensional water surface.*

*The richness I achieve comes
from nature, the source of
my inspiration. Perhaps my
originality boils down to my
capacity as a hypersensitive
receptor, and to the expediency
of a shorthand by means of
which I project onto a canvas,
as if onto a screen, impressions
registered on my retina.*

From an interview with
Claude Monet about his
water lily paintings, 1909

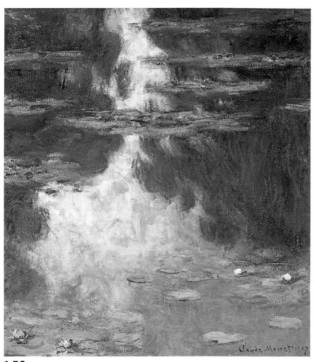

**1.56**

**1.57** Paul Sérusier, Landscape at Le Pouldu, 1890

*Paul Sérusier was a leading member of a group of painters called the Nabis, after the Hebrew word for prophet. Modeling their artistic beliefs on those of Paul Gauguin, the Nabis included Pierre Bonnard (p. 111), Maurice Denis, and Édouard Vuillard (1.58).*

*Like Gauguin, they were drawn to the simple life of Brittany, in northwest France. In 1890, Sérusier painted with Gauguin in the rustic village of Le Pouldu. This work depicts a peasant in her native landscape. The swirling lines, flattened perspective, and expressive color characterize the Nabis' stylized reinterpretations of nature.*

**1.58** Édouard Vuillard, The Promenade, 1894

*Like Paul Sérusier, Édouard Vuillard was an active member of the Nabi group of artists. Rejecting the Impressionist focus on external perception, the Nabis emphasized internal meaning and beauty in decorative paintings filled with rhythmic designs and patterns. This canvas is one of nine panels that Vuillard*

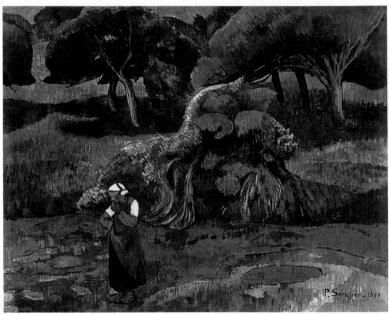

**1.57**

made to decorate the family
dining room of Alexandre
Natanson, copublisher of the
Parisian intellectual journal
La Revue Blanche. *Each panel
portrays scenes of people enjoying
the public gardens of Paris.
Arranged in flat blocks of sub-
dued color, and textured like
fabric, the panels were intended
to provide a pleasing background
to daily life.*

**1.59  Edgar Degas,
Woman Drying Herself,
c. 1905**
*The most accomplished drafts-
man of the Impressionists, Edgar
Degas was also the most urbane;
he preferred to depict the dancers
and laundresses of Paris, or
its suburban horse races, rather
than the French countryside. In
his last years, he focused more
exclusively on dancing and*

*bathing women, exploring their
myriad forms in movement and
at rest, whether nude, semi-
clothed, or fully costumed. This
late, masterly work is one of
a group of charcoal-and-pastel
drawings that Degas made on
tracing paper. Deftly varying
the weight and texture of the
lines, he describes the laboring,
bending posture of the woman
in an utterly private moment.*

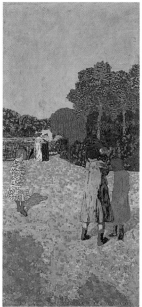

**1.58**

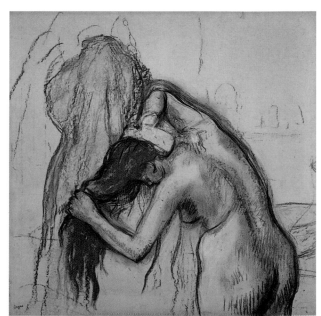

**1.59**

*Remember that
a picture—before
it is a battle horse,
a nude woman,
or an anecdote—
is in essence a plane
surface covered with
colors put together
in a certain order.*

Nabi painter Maurice Denis,
"Definition of
Neotraditionalism," 1890

Sarah Campbell (1885–1975) grew up in turn-of-the-century Texas, where masterpieces of painting and sculpture were virtually nowhere to be seen. On her 1909 honeymoon in France with her husband, Robert Lee Blaffer, she visited the Louvre in Paris—and a lifelong devotion to art was born. Not only did she decide to collect art, she resolved to share her joy in art with others. She began by giving many important works to the Museum of Fine Arts, Houston, including paintings by Canaletto, Paul Cézanne, Frans Hals, Giovanni di Paolo, and Auguste Renoir.

Mrs. Blaffer's desire to share the beauty of great works of art with fellow Texans eventually expanded to encompass residents who live far away from major museums. In 1971, she and the other trustees of the Sarah Campbell Blaffer Foundation dedicated the bulk of the foundation's resources to forming an art collection that would circulate throughout the state.

*After her death, the trustees focused the collecting efforts on European paintings made between the 14th and early 19th centuries in four regions: northern Europe, Italy, England, and France. The foundation's goal has been for each area of the collection to be fully representative of its place and period.*

*The Blaffer Foundation collection comprises more than 150 paintings and several hundred works on paper, most of which are Old Master prints. In 1993, foundation trustees agreed to place some of the finest works on long-term exhibition at the MFAH while continuing to exhibit portions of the collection around Texas. With the opening of the Audrey Jones Beck Building, five galleries present these beautiful European Old Masters to museum visitors.*

Sarah Campbell Blaffer, c. 1930

**2.1 Lucas Cranach the Elder, The Suicide of Lucretia, 1529**

In the early 1500s Lucas Cranach was court painter to the Saxon princes at Wittenberg, Germany, the birthplace of the Protestant Reformation. The influential artist painted religious altarpieces, court portraits, classical subjects, and nudes, increasingly relying on a large workshop to carry out his numerous commissions. Cranach frequently depicted his close friend Martin Luther in paintings and prints. In fact, Cranach illustrated Luther's landmark translations of the Bible into German. Cranach made this painting of Lucretia, the legendary heroine of ancient Rome, in the delicate, minutely

detailed style the artist then favored. According to Livy's Histories, in 509 B.C. the virtuous and beautiful Roman matron Lucretia was raped by Sextus Tarquinius, son of the oppressive Roman king Tarquinius Superbus. After exacting a promise from her husband and father to avenge the crime, Lucretia plunged a dagger into her heart.

A revolution ensued, and with the overthrow of the Tarquin dynasty, Rome became a republic. Cranach painted Lucretia numerous times, transforming the tragic tale into a sensuous study of female beauty. The delicately rendered, fanciful landscape, seen in the distance through a window, recalls scenery along the Danube river.

**2.1**

*Even here she sheathèd in her harmless breast*
*A harmful knife, that thence her soul unsheathed.*
*That blow did bail it from the deep unrest*
*Of that polluted prison where it breathed.*

William Shakespeare, *The Rape of Lucrece*, 1594

**2.2  Jan van Goyen,
View of Dordrecht from
the Northeast, 1647**

As the 16th century turned to the
17th, Jan Brueghel and other
Dutch landscape painters began
eliminating religious and myth-
ological figures from their work,
leaving imaginary nature scenes
conventionally divided into
horizontal planes of foreground,
middle ground, and a back-
ground of sky. As the century
progressed and Holland emerged
from years of Spanish rule,
artists started painting carefully
observed depictions of real
places, suited to the secular
tastes of the emerging class of
bourgeois Protestant art patrons.
Working primarily in The
Hague, Jan van Goyen was a
prolific painter of this new type
of landscape. His comparatively
loose, delicate brush strokes and
restrained colors made him a
master at capturing atmosphere,
especially that of a grayish day.
In this work, van Goyen
returned to a subject he had
depicted before, the commercial
and artistic center of Dordrecht.
Painting the picturesque town in
muted tones, low on the horizon,
van Goyen balances the choppy
water with a cloud-filled sky.

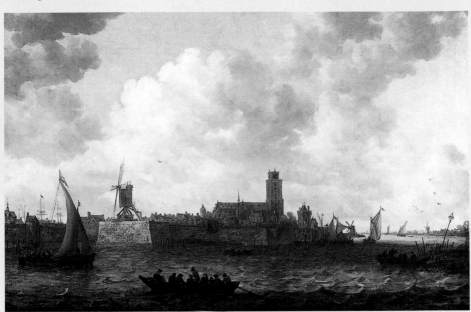

2.2

**2.3** Adriaen van Ostade, Interior with Drinking Figures and Crying Children, 1634

*Adriaen van Ostade was a leading genre painter in Haarlem, a flourishing artistic center in 17th-century Holland. In his early career, van Ostade made pictures of daily life among the lower classes, using delicate colors and refined brushwork to portray lively scenes of drinking, gambling, and brawling. Painted when*

*the artist was just 24 years old, this work shows one child beating another amid the general carousing of amused or oblivious adults. Middle-class collectors eagerly purchased such finely painted scenes of coarse peasant life until mid-century, when tastes changed and van Ostade turned to more tranquil domestic scenes.*

2.3

**2.4** Sir Anthony
van Dyck,
Portrait of Antoine Triest,
Bishop of Ghent, c. 1627

*By the 17th century, portraits were in great demand among Europe's merchant and militia classes as well as its nobility. Born in Flanders, Sir Anthony van Dyck was one of the leading portraitists of the time, famous for creating flattering but incisive character studies. Imbuing his subjects with dignity and refinement, van Dyck became particularly popular among*

*aristocrats during his sojourns in England in the 1630s. His grand style influenced English portrait painting for two centuries. This sympathetic work depicts Antoine Triest, a bishop of Ghent who was also an art collector. The bold brushwork is indebted to Rubens, with whom van Dyck worked as a young man, while the pose and color derive from the Italian painter Titian.*

2.4

**2.5** Sandro Botticelli, The Adoration of the Christ Child, c. 1500
*Sandro Botticelli was one of the most prominent painters in Renaissance Florence. Best known for* The Birth of Venus *and* Primavera—*paintings in keeping with the Renaissance interest in ancient mythology —Botticelli was, in fact, a prolific painter of Christian subjects. Here, the artist used his elegant,*

*linear style to present several stories from the infancy of Christ. In the central scene, the gracefully arched bodies of Mary and Joseph echo the contours of the round picture format. In the middle distance at right, an ox, an ass, and two shepherds with a lamb suggest an Adoration of the Shepherds. In the distance at left, the painting shows the* Flight into Egypt.

**2.6** Bartolomeo Bettera, Still Life with Musical Instruments, c. 1680s
*Although popular in antiquity, still life did not reemerge as an independent subject for artists until the 16th century. In Italy, it became a specialty of the Bergamo School of painting to which Bartolomeo Bettera belonged. This complex composition includes a profusion of instruments and other luxury*

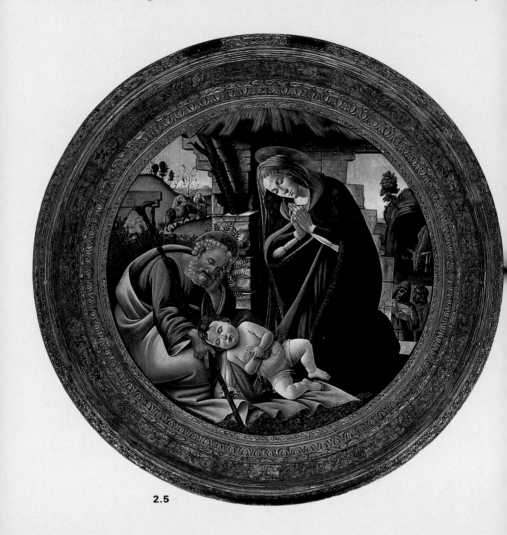

2.5

objects. A celebration of the artist's astonishing virtuosity, the painting is also replete with symbolism. Musical instruments suggest the vanity of human pleasures, while the broken guitar string, scattered books, and fluttering sheet music allude to the transience of life. An armillary sphere represents human ambition, and an apple recalls Original Sin.

**2.7 Pietro Longhi, The Display of the Elephant, 1774**
*Pietro Longhi's charming paintings form a remarkable record of Venetian manners and mores. In the 18th century, exotic animals were rarely seen in Europe — thus a carnival exhibition of wild beasts attracted great curiosity. The artist's inscription records that he*

painted the elephant from life, but it is not quite accurately rendered. Relying solely on his own immediate impressions, Longhi has invested his elephant with a tooth at the tip of its trunk. Other vivid details include the masquerading spectators and a gentleman in red — probably the patron who commissioned this work.

6

7

**2.8** Sir Joshua Reynolds, Portrait of Mrs. Jelf Powis and Her Daughter, 1777

*An important 18th-century English portrait painter, Sir Joshua Reynolds almost single-handedly elevated portraiture and portraitists to a new status. In his paintings and in lectures he gave as first president of the Royal Academy of Arts, Reynolds advocated a grand style based on great art of the past, particularly that of ancient Greece and Rome,*

*16th-century Rome, and 17th-century Bologna, Italy. This portrait depicts a beautiful woman, the daughter of a miller, in the pose of an antique statue and wearing a classically draped gown. With a classical urn in the background, Reynolds confers on the nonaristocratic woman and her child the assurance and poise of nobility.*

*Our first great gift is in the portraiture of living people — a power already so accomplished in both Reynolds and Gainsborough that nothing is left for future masters but to add the calm of perfect workmanship to their vigor and felicity of perception.*

John Ruskin, "English Art," 1870

2.8

**2.9** Thomas Gainsborough, Coastal Scene with Shipping and Cattle, c. 1781–82

*Although he was the most popular portraitist of the 18th century, Thomas Gainsborough much preferred to paint landscapes. His highly personal style was indebted to 17th-century Dutch art. Like most of the artist's mature landscapes, this evocative painting represents an invented rather than an actual view. Instead of relying on the vagaries of nature for these compositions, Gainsborough used coal, glass, twigs, weeds, and other props to construct ordered miniature landscapes in his studio. By diluting his paint with turpentine, he achieved the translucent effects of watercolor.*

**2.10** George Stubbs, Truss, A Hunter, c. 1802

*Portraiture was the economic mainstay of 18th-century English artists. Patrons commissioned images not only of themselves and their families, but also of their prized horses and dogs. An essentially self-taught artist who became one of the greatest painters of his time, George Stubbs specialized in portraits of animals. He spent years studying animals, even dissecting them in a laboratory to learn more about their anatomies. His unrivaled mastery of the equine form is apparent in the depiction of the horse's muscles and veins. By portraying the horse in a relatively large scale, Stubbs infused this work with a feeling of monumentality, despite the small size of the canvas (approximately 20 x 24 inches).*

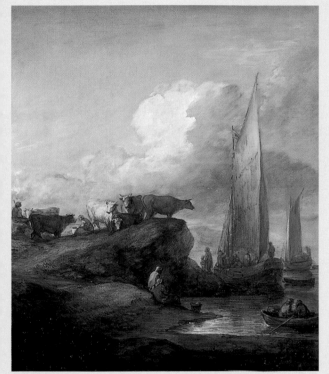

**2.9**

**2.10**

**2.11** Jean-Siméon Chardin, Still Life with Joint of Lamb, 1730

*Preferring the sober to the spectacular and the everyday to the exotic, Jean-Siméon Chardin endowed ordinary objects with extraordinary dignity. Thickly painted to render the materiality of each object, this still life is free of sentimentality and displays the artist's signature sense of order and quietude.*

*Here is the real painter; here is the true colorist. . . . When I look at other artists' paintings, I feel I need to make myself a new pair of eyes; to see Chardin's I only need to keep those which nature gave me and use them well.*

Denis Diderot, 1763

**2.12** Nicolas de Largillière, Portrait of Pierre Cadeau de Mongazon, c. 1720

*Nicolas de Largillière, the favorite portraitist of France's upper middle class, produced more than 1,500 likenesses during his career. Many of Largillière's clients were members of parliament or the legal profession. This elegant portrait of a magistrate beautifully reconciles grandeur and liveliness. The grandeur derives from the sumptuous, gold-embroidered black jacket and impressive wig. The liveliness comes from the sitter's forthright pose, engaging expression, and manifest intelligence. A superb colorist, Largillière created official portraits that were also intimate, appealing works of art.*

**2.11**

**2.12**

**2.13** Jean-Baptiste Oudry, Allegory of Europe, 1722
*Although Jean-Baptiste Oudry was accepted into the French Academy in 1719 as a history painter, he was more drawn to still-life subjects. Adapting to the Academy's position that still life was an inferior genre, Oudry disguised his still life paintings as allegories, as in this lively arrangement of objects presented as an allegory of Europe. The marble bust of Minerva — the Roman goddess of wisdom, invention, the arts, and military prowess — is an appropriate symbol for this continent, while the horse's head on her helmet is another traditional attribute of Europe. The brilliantly colored work is one of four Oudry paintings that represent various continents.*

**2.13**

**2.14** Albrecht Dürer,
Six Soldiers, c. 1495–96
Engraving

*A prodigiously gifted drafts-
man, Albrecht Dürer was the
presiding genius of the Northern
Renaissance. He perfected
the new art of engraving by
exploiting the expressive
capabilities of pure line.
Dürer made this example early
in his career, soon after he
returned home from his first
visit to Italy. The print shows
the young artist's awareness*

*of Italian Renaissance
perspective. In the late 15th
century, Europe was in a state
of almost perpetual warfare,
reflected in art by frequent
scenes of soldiers and battles.
This engraving may represent
an envoy who is attempting
to hire mercenaries for his town.
For more about Dürer and
engraving, see p. 116.*

2.14

**2.15** William Hogarth,
Beer Street, 1750–51
**Etching and engraving**
*Despite his talents as a painter,
William Hogarth is best
remembered for his superb
satirical prints. This engraving
and its underlying poem
celebrate the wonders of beer.
From the pavements to the
rooftops, the denizens of
Beer Street are joyous and*

*prosperous—except perhaps for
the pawnbroker, whose house
is falling apart, and the ragged
French artist. The print's com-
panion,* Gin Lane, *describes the
disastrous effects of alcoholism.
But in* Beer Street, *the greatest
horror is merely a tendency
toward obesity.*

**2.16** Thomas Girtin,
A Windmill, c. 1800
**Watercolor over pencil**
*Thomas Girtin was a masterful
late 18th-century English
watercolorist whose promising
career was cut short by his death
at the age of 27. Another great
watercolorist, J. M. W. Turner,
once commented on his con-
temporary's talent by saying,
"If poor Tom had lived, I should
have starved." Created toward
the end of Girtin's life, this
work depicts a windmill from
a low viewpoint, dramatically
silhouetted against a blank sky.
The pencil underdrawing
indicates Girtin's training in
traditional watercolor techniques.
The variety of paint application,
however, from wet and diluted
to dry and more opaque, testifies
to Girtin's bold virtuosity, as
does the freedom with which he
simplifies details and forms.*

**2.15**

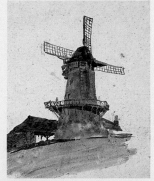

**2.16**

*Beer, happy Produce of our Isle
Can sinewy Strength impart,
And wearied with Fatigue and Toil
Can chear each manly Heart....*

From the poem engraved at the bottom of *Beer Street*

On her first trip to Europe, at the age of 16, Audrey Jones fell in love with Impressionism. "Works by these avant-garde artists, who had rebelled against the academic tradition of the day . . . were not only the epitome of artistic freedom, but also a visual delight," she would later write. The granddaughter of Houston philanthropist Jesse Jones, she married John A. Beck during World War II. After the war, Mrs. Beck set about fulfilling her dream of collecting a representative group of Impressionist works for Houston. Focusing on the artistic innovations of late 19th-century Paris, the Becks acquired remarkable examples of Impressionism, Post-Impressionist styles, and early Modernism.

Students, scholars, and other visitors could view these paintings in the Becks' home until 1974, the year after Mr. Beck's death, when Mrs. Beck lent the works to the MFAH. Gradually, she gave these paintings to the museum, completing her munificent gift with the balance of the collection in 1998. Guided by a desire to form a collection that instructs as well as delights, Mrs. Beck has gathered together paintings that demonstrate the diversity of avant-garde styles in

the late 19th and early 20th centuries. For example, representations of nature vary from Impressionist scenes by Gustave Caillebotte and Camille Pissarro to Post-Impressionist landscapes by Paul Cézanne and André Derain. Portraits document the evolution from mid-19th-century Realism to Impressionism and beyond, with examples by Honoré Daumier, Mary Cassatt, and Amedeo Modigliani. Representations of the human figure are equally diverse, including works by Edgar Degas, Henri Matisse, and Pierre Bonnard. Finally, the breakthrough into abstraction is captured in a number of stylistically distinct canvases by such dissimilar artists as Vassily Kandinsky and Georges Braque.

The collecting philosophy that Mrs. Beck shared with her husband continues to inspire. "We worked together," she once explained, "to tell the story of Impressionism [with the] hope that everyone who views the collection may find in it his or her special painting." Housed within the new Audrey Jones Beck Building at the Museum of Fine Arts, Houston, the 70 splendid artworks assembled by Mr. and Mrs. Beck form the centerpiece of the galleries devoted to European art.

**3.1** Édouard Manet,
The Toilers of the Sea,
1873

*In the second half of the 19th century, Édouard Manet transformed old traditions of representation into a radical new style. Combining an insistence on realistic depictions of everyday events with the Impressionists' freer painting techniques, Manet produced canvases that frequently shocked viewers with unorthodox subjects and confrontational*

*immediacy. This vivid picture of fishermen at work probably was painted at the scene, during one of the artist's regular visits to the French coast in Normandy. Positioned as if casually captured in a photograph, the fishermen are depicted with bold brush strokes. The bracing colors masterfully evoke the sensation of sailing through waves and fresh sea air.*

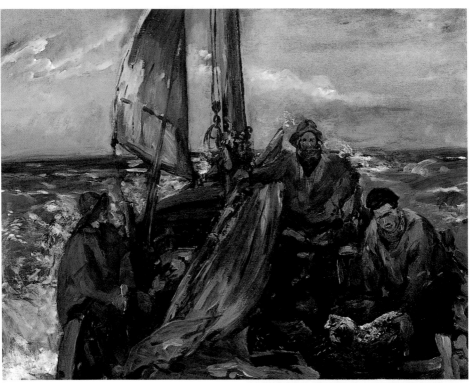

3.1

3.2

**3.2** Honoré Daumier, Lawyers' Meeting, c. 1860
*Beloved by 19th-century Parisians, Honoré Daumier's satiric cartoons of politics and society appeared by the thousand in French periodicals. His frequent and scathing attacks on the legal profession—such as this disdainful depiction of lawyers—originated with his early job as a court bailiff and his ensuing awareness of the injustices perpetrated in the courts. Here, the faces of the lawyers form a satirical critique of their characters. Displaying emotions ranging from arrogance to craftiness, the faces demonstrate Daumier's skill at capturing expressions — a talent he honed by studying physiognomy, the art of judging character from facial features.*

**3.3** Gustave Caillebotte, The Orange Trees, 1878
*This tranquil domestic scene depicts Gustave Caillebotte's brother Martial and young cousin Zoë relaxing in the family garden, while their dog lies sleeping in the distance. Quintessentially Impressionist in its study of the effects of sunlight and shadow, the painting captures a moment of fashionable leisure. Caillebotte compressed the many elements in the painting into a tight, relatively flat composition, showing his awareness of Japanese prints. A painter of considerable originality, Caillebotte was also one of Impressionism's earliest patrons and promoters. Using his large fortune to acquire works by his fellow artists, he later bequeathed the collection to his native country of France.*

**3.3**

**3.4** Vincent van Gogh, The Rocks, 1888

*In 1886 Vincent van Gogh moved from the Netherlands to Paris, where he fell under the intoxicating influence of Impressionism. The somber realism of his earlier work gave way to paintings that pulsate with color and energy. Not until van Gogh reached Arles in 1888, however, did his turbulent personality find its utmost expression. There,*

*in the blazing light of southern France, the artist produced more than 200 paintings in 15 frenetic months. In this vibrant example, van Gogh used a variety of energetic brush strokes to render the particular character of rocks, grass, tree, and sky. The Rocks is one of the few paintings that his devoted brother, Theo, chose to have framed.*

**3.4**

*Yesterday at sunset I was on a stony heath where some very small and twisted oaks grow.... It was romantic... the sun pouring bright yellow rays on the bushes and the ground, a perfect shower of gold. And all the lines were lovely, the whole thing nobly beautiful.... I brought back a study, but it is very far below what I tried to do.*

Letter from Vincent van Gogh to his brother, Theo, 1888

**3.5** Paul Cézanne,
Bottom of the Ravine,
c. 1879

*Camille Pissarro introduced
Paul Cézanne to the bright
palette and outdoor painting
methods of Impressionism. But
although Cézanne exhibited
with the Impressionists in 1874
and 1877, he never completely
identified with the group.
The artist was less interested
in the superficial sensations
of color and light than in the
underlying structure of the
visible world. He painted this
landscape in the countryside
of southern France, near his
family's home in Aix-en-
Provence. The painting is a
harmony of glowing blues,
greens, and tans. Cézanne
treated each element of the scene
with equal weight, resulting
in a balanced organization of
forms and colors. For another
work by Cézanne, see p. 80.
For works by Pissarro, see pp.
105, 123.*

*I became increasingly interested in the art of Cézanne...
and I gradually recognized that what I had hoped for as a
possible event of some future century had already occurred,
that art had begun to recover once more the language of design
and to explore its so long neglected possibilities.*

Roger Fry, 1920

**3.5**

**3.6** Mary Cassatt,
Susan Comforting
the Baby, c. 1881
*Mary Cassatt pursued painting
as a profession at a time when
few women considered a career
of any kind. At age 22, the
Pennsylvania-born artist moved
to France, where she spent the
rest of her life. She was the
only American—and, with
Berthe Morisot, one of only two*

*women—to be included in the
Impressionist exhibitions of the
1870s and 1880s. Her greatest
subject, the interaction between
mothers and children, she
depicted candidly and unsenti-
mentally. In this early example,
a young woman named Susan
tenderly soothes a distressed
child. Susan was the cousin
of Mathilde Vallet, Cassatt's
loyal companion and maid.*

**3.7** Edgar Degas,
Russian Dancers, c. 1899
*Edgar Degas began painting
dancers in the early 1870s and
became increasingly fascinated
by the representation of move-
ment. When troupes of Russian
folk dancers performed in his
Paris neighborhood in the late
1890s, he executed a small
series of pictures that vividly
captured the colorful costumes*

**3.6**

*Nothing in art must
seem an accident,
not even movement.*

Edgar Degas

**3.7**

and lively performances. In this pastel study of three folk dancers, Degas replaced the stage setting with a landscape, heightening the women's exuberant energy, breathless speed, and calculated balance. Although he achieved an effect of spontaneity that is intensified by the shimmering pastel medium, such pictures were, in fact, carefully composed. For another work, see p. 83.

**3.8** Camille Pissarro, The Goose Girl at Montfoucault (White Frost), 1875
The oldest member of the Impressionists, Camille Pissarro provided inspiration, training, and support to his younger colleagues. Painted just one year after the first Impressionist exhibition in 1874, this engaging scene depicts a farm girl tending

her flock of geese. At the time, the impoverished artist was a guest at the farm of a wealthy friend. A concern with space and structure underlies the canvas's richly textured surface, perhaps indicative of Pissarro's close working relationship with Paul Cézanne (3.5). At the same time, keenly observed colors show an Impressionist's interest in recording subtle nuances of light.

3.8

**3.9** Kees van Dongen, The Corn Poppy, c. 1919
*Kees van Dongen's distinctive style of painting was influenced both by the bright colors of Fauvism (p. 108) and by the satirical drawings he had made for newspapers earlier in his career. After World War I, the Dutch-born artist became a fashionable portraitist for members of Europe's café society.*

**3.10** Amedeo Modigliani, Léopold Zborowski, c. 1916
*Amedeo Modigliani moved to Paris in 1906, at the onset of one of the most revolutionary periods in the history of art. Largely impervious to the flowering of avant-garde painting, the Italian-born artist was influenced by such diverse sources as Botticelli (p. 90), Cézanne (3.5), African sculpture, and*

*ancient art. Modigliani's finest portraits—characterized by their elegant elongation—were painted between 1915 and 1920, the last years of his brief, 36-year life. This portrait is one of his many paintings of Léopold Zborowski, the Polish poet who was so moved by Modigliani's beautiful works that he became the artist's friend, champion, and art dealer.*

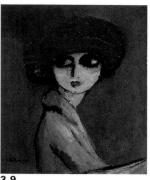

**3.9**

*I remember her coming into my studio. She was something of a little simpleton, but putting on that red hat was entirely her idea. You might say it was her instinct. The majority of women are painters in their own individual fashion.*

Kees van Dongen

**3.10**

**3.11** František Kupka, The Yellow Scale, c. 1907
*A pioneer of 20th-century abstraction, František Kupka explored the expressive and decorative power of color. Growing up in Bohemia, a region steeped in mysticism, may have contributed to the artist's interest in the spiritual significance of art. Between 1905 and 1910 he painted a series of self-portraits that convey both his external appearance and the intensity of his inner self. This riveting example is rendered almost entirely in tones of yellow. The title suggests that Kupka considered the painting primarily an investigation into color theory. A few years later, he would begin to develop a wholly abstract style of painting.*

**3.11**

*Atmosphere in a painting is achieved through bathing the canvas in a single scale of colors.... Thus one achieves an* état d'âme *(state of being) exteriorized in luminous form.*

František Kupka

**3.12** André Derain, The Turning Road, L'Estaque, 1906

*In 1905, André Derain, Henri Matisse, and several other artists showed their works at a major avant-garde exhibition in Paris, the Salon d'Automne. Horrified by the brash colors and distorted forms, a critic derided these painters as* fauves, *or wild beasts, thereby naming the*

*first major art movement of the 20th century. This large painting is one of the great masterpieces of Fauvism. Unconstrained by naturalism, Derain used color for its decorative rather than descriptive possibilities. The dazzling landscape is ablaze with aberrant colors: flame-colored trees, pink and blue earth, and a brilliant yellow arc of road.*

**3.13** Alexei Jawlensky, Portrait of a Woman, 1910

*Alexei Jawlensky, a Russian émigré, dominated avant-garde art in Munich, his adopted city. His unique style blended Fauvist colors and Expressionist vigor with the direct power of Russian icons. This bold head is among the pre-World War I portraits he considered his most successful works.*

**3.12**

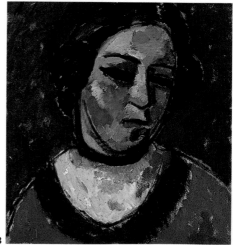

**3.13**

**3.14** Henri Matisse, Woman in a Purple Coat, 1937

*The first Fauve exhibition, in 1905, propelled Henri Matisse to the forefront of the Parisian avant-garde. But by the 1920s, the artist was spending most of his time in the French city of Nice, pursuing his dream of "an art of balance, of purity and serenity devoid of troubling or disturbing subject matter." Inspired by the decorative art of the Middle East, he used lively colors and sinuous lines to paint voluptuous still lifes, interiors, and reclining women. Here, he portrays his secretary and companion, Lydia Delectorskaya, wearing a lavish Persian coat. Set in a richly patterned room, the scene projects an air of languorous exoticism. See also p. 319.*

3.14

**3.15** Paul Signac,
The Bonaventure Pine,
1893

*In 1884 Paul Signac met the painter Georges Seurat (3.16), who was already developing the principles of Neo-Impressionism, or Pointillism. Signac became the chief theorist of the technique, which sought to replace the spontaneity of Impressionism with something more rigorous and disciplined. According to Neo-Impressionist principles, carefully arranged*

*dots of unmixed color—blended in the viewer's eye rather than on the artist's palette—achieved a more vibrant effect. Signac moved to the sun-baked Mediterranean village of Saint-Tropez in 1892. Using small dabs of pure pigment, he portrayed the region's umbrella pines, including this majestic example on the property of a Mr. Bonaventure.*

3.15

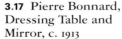

### 3.16 Georges Seurat, Young Woman Powdering Herself, 1889

*While the Impressionists used color intuitively, Georges Seurat applied scientific theories of visual perception to his highly formal compositions. This small work, a study for a much larger painting, is an excellent example of the artist's painting method. Thousands of tiny dots combine to create a radiant image of Seurat's mistress, Madeleine Knobloch, at her dressing table.*

### 3.17 Pierre Bonnard, Dressing Table and Mirror, c. 1913

*Like many late 19th-century artists, Pierre Bonnard was influenced by Japanese prints. At an exhibition of Japanese art held in Paris in 1893, images of women at their dressing tables featured cropped figures and flattened compositions. This richly subtle still life has similar features. Within the cramped reflection of a mirror, Bonnard depicts the truncated body of his mistress, his dachshund, a bed, and a window, all rendered in different tones than the rest of the canvas. To distinguish between real and reflected elements, he painted the dressing table in delicate pastel colors. The vivid flowers exist in both spaces and unite the composition.*

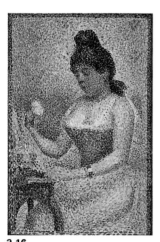

**3.16**

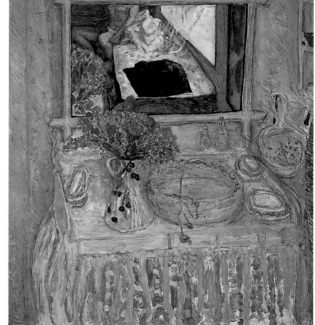

**3.17**

*. . . by the exclusive use of the optical mixture of pure colors, . . . the Neo-Impressionist insures a maximum of luminosity, of color intensity, and of harmony. . . .*

Paul Signac, 1899

**3.18** Vassily Kandinsky, Sketch 160A, 1912

*Born in Russia and trained as a lawyer, Vassily Kandinsky spent most of his life in Germany, where he became a pioneering abstract artist. Kandinsky believed that abstract art could reveal the spiritual rather than the material world. He developed an elaborate symbol system of colors and shapes that included correlations between specific colors, emotions, and musical sounds. Striving to communicate the chaos of his time, Kandinsky filled Sketch 160A with a jumble of recognizable forms, abstract shapes, and vibrant colors. An image of a mounted horseman, Kandinsky's symbol of transcendence from the material to the spiritual realm, appears at the upper right of the painting.*

**3.18**

**3.19** Georges Braque, Fishing Boats, 1909
*By the time he met Pablo Picasso in 1907, Georges Braque had already moved beyond Fauvism to an exploration of perspective and geometry that was grounded in the work of Paul Cézanne (pp. 80, 103). Over the next seven years, Braque and Picasso worked closely together. The two artists invented Cubism, a radical approach to painting that analyzed the relationship of forms both to space and to the flat surface of the canvas. This painting is one of the first true manifestations of Cubism. Braque rejected the illusion of three-dimensional space, instead reducing boats and buildings to a series of interrelated planes. For more Cubist works, see pp. 314–17.*

*Color is the keyboard, the keys are the hammer, the soul is the piano with many strings.... The artist is the hand that plays, touching one key or another purposively, to cause vibrations in the soul.*

Vassily Kandinsky,
*Concerning the Spiritual in Art,* 1910

**3.19**

*Spanning 500 years of history, from the 15th century to the present, the museum's collection of prints and drawings comprises approximately 5,000 prints and 650 drawings. The early works are chiefly European. Starting with the second half of the 19th century, the collection becomes progressively more American. Of particular interest are 100 early German woodcuts and engravings, including 35 by Albrecht Dürer, and groups of prints by Rembrandt and by Jacques Bellange. Rarities include superb first-state impressions of etchings by Pieter Bruegel the Elder, Canaletto, and Camille Pissarro; the deluxe edition of Max Klinger's portfolio* A Love; *and an early impression of the 1895 Edvard Munch lithograph* Self-Portrait. *The master drawings date from the 17th century to the present and include works by Edgar Degas, Jean-Honoré Fragonard, Paul Klee, Adolphe Menzel, Pablo Picasso, and Odilon Redon.*

*The museum also holds a strong collection of Mexican prints from the 1920s to 1950s featuring works by José Clemente Orozco, Diego Rivera, and David Alfaro Siqueiros. Populist traditions*

in the United States are reflected in more than 1,500 wood engravings by Winslow Homer, Thomas Nast, and Frederic Remington published in the 1860s and 1870s. The MFAH collection also contains a large number of prints and drawings by Texas artists, beginning with the work of the Lone Star Regionalists in the 1930s.

In the mid-1990s the museum began to acquire significant drawings by Abstract Expressionist painters, including 12 by Jackson Pollock and 15 by Robert Motherwell, as well as examples by William Baziotes, James Brooks, Arshile Gorky, Adolph Gottlieb, Franz Kline, and Richard Pousette-Dart. Another focus is works on paper by 20th-century sculptors, among them Aristide Maillol and David Smith. The core of the contemporary collection is a large group of prints made in the United States and Europe in the 1980s and early 1990s. Works by artists such as Louise Bourgeois, Enzo Cucchi, Eric Fischl, David Rabinowitch, and James Turrell illustrate the eclectic range of subjects and styles explored during this fertile period for printmaking.

**4.1** Albrecht Dürer,
Virgin and Child
with the Monkey, 1498
Engraving
*Albrecht Dürer, the most*
*important Renaissance artist*
*in Northern Europe, was largely*
*responsible for bringing the*
*Italian Renaissance to Germany.*
*Made after Dürer's first trip*
*to Italy, this image reflects the*
*classicizing influences of Italian*

**4.2** Rembrandt van Rijn,
An Old Man with
a Beard, Fur Cap,
and Velvet Cloak, c. 1632
Etching
*Rembrandt was consistently*
*innovative in his prints. In*
*this early image, the complex*
*rendering of textures, seen best*
*in the sitter's beard and cloak,*
*provides a visual contrast*
*of delicacy and richness —*

*an effect heightened by this*
*beautifully printed early*
*impression. Although Rembrandt*
*was probably just 26 years old*
*when he made this print, his*
*astonishing ability to capture*
*subtle psychological states is*
*already evident. Here, he conveys*
*the poignant vulnerability of*
*old age through the details of*
*the sitter's gaze and frail hand.*

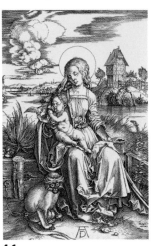

**4.1**

*art while retaining a Germanic*
*interest in detail and surface*
*complexity. The symbolism*
*incorporated in the print is also*
*complex. The monkey represents*
*carnal desires, chained and*
*thus under control, and the*
*bird on the Christ Child's*
*finger represents the soul as the*
*voluntary captive of the Savior.*

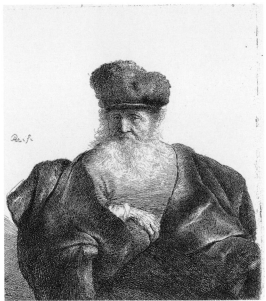

**4.2**

Printmaking Techniques:
Engraving
*The technique of engraving*
*originated in Germany during*
*the mid-15th century. A design*
*is carved into a metal plate*
*using a burin, a diamond-*
*shaped tool that pushes away the*
*displaced metal (burr) as it cuts.*
*The plate is then inked and*
*wiped, leaving ink only in the*
*engraved furrows. Damp paper*
*is then laid over the plate and*
*both are run through a press,*
*allowing the paper to absorb*
*the ink in the engraved lines.*

States in Printmaking
*A first-state is the earliest*
*known version of a print.*
*Every subsequent version created*
*by one or more changes in the*
*plate constitutes a new state.*
*Because engraved furrows flatten*
*with repeated runs through the*
*press, first-state and other early*
*impressions have the crispest*
*lines and richest tonal contrasts.*

**4.3** After Pieter Bruegel the Elder,
The Fair on Saint George's Day,
c. 1559–60
**Etching and engraving**
*Pieter Bruegel the Elder was among the first artists to portray peasant life with sympathy and humor. Whereas many of his paintings are landscapes, his graphic work more often depicts scenes of daily life. Through engravings issued by Antwerp's leading publisher, Bruegel's exuberant images reached an emerging middle class. This example combines a celebration of local customs with a gently satiric approach to human follies, foibles, and fancies — subjects that held great interest for the circle of leading humanists, with whom Bruegel was associated.*

*This extremely rare first-state is a technical masterpiece. The variety of textures, high tonal contrast, and linear intricacy contribute to the liveliness of the scene. This image is the largest single-sheet image for which Bruegel made a drawing specifically to be translated into an engraving.*

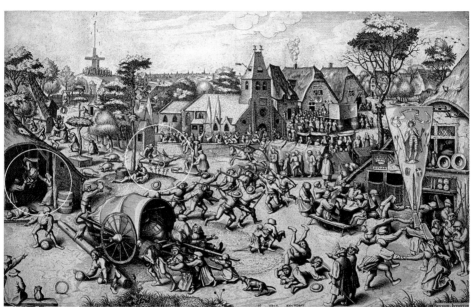

**4.3**

**4.4** Jacques Bellange,
The Adoration of
the Magi, c. 1614–17
Etching with engraving
*Although Jacques Bellange
worked for many years as court
painter to the duchy of Lorraine
in France, no paintings firmly
attributed to him survive. He
can be studied only through a
limited number of idiosyncratic
and compelling drawings and*

*prints. Here, in the largest of
Bellange's etchings, striking
tonal contrasts and a bravura
handling of line provide visual
and emotional impact. The
complexity of the composition,
with its twisting, elongated
figures, reflects Bellange's
important role in Mannerist
art — a style that rejected
Renaissance adherence to tra-
dition and nature, in favor of*

*an interior vision of the world.
Derided for three centuries
as a distortion of Renaissance
aesthetics, Mannerism is now
appreciated as an independent
style in which dynamic move-
ment and emotional power are
valued over naturalism. The end
of the Mannerist period is defined
by the death of Bellange in 1617.*

*Bellange is one of those painters
whose licentious manner,
completely removed from a
proper style, deserves great
distrust. It nevertheless had its
admirers, and Bellange had a
great vogue.... Several pieces
by him are known, which one
cannot bear to look at, so bad
is their taste.*

Pierre-Jean Mariette,
*An Alphabet Primer and Other
Unedited Notes by this Amateur
on the Arts and Artists,* 1853

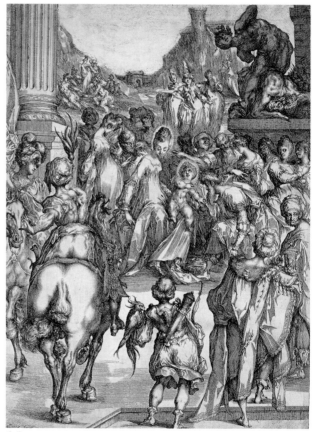

**4.4**

### 4.5 Canaletto, Imaginary View of Padua, c. 1741–44
### Etching

*Canaletto was the preeminent view painter of his time. British travelers on their grand tours of Europe avidly collected the artist's dramatic and meticulous panoramas of his native Venice. In the early 1740s, Canaletto, in an effort to reach an ever wider audience, created 31 etchings of real and imaginary scenes. After printing a small number of first-state impressions, presumably for his own pleasure, he reworked the plates, eliminating strong contrasts so that a large, uniform edition could be printed. In this superb early impression, the first of three states, Canaletto's original graphic style is readily apparent.*

*Note how he captures the play of light and atmosphere with a simple pattern of long, trembling lines that sparkle against the pale paper. For a painting by Canaletto, see p. 72.*

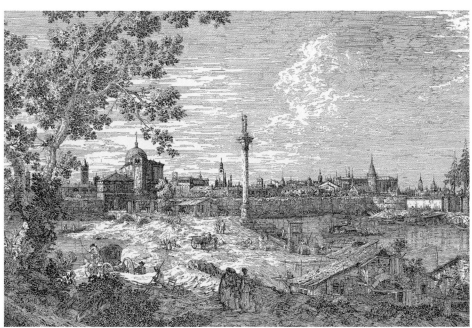

**4.5**

### Printmaking Techniques: Etching

*Like engraving, etching is a method of incising an image into a metal plate. First, the plate is coated with a resinous substance that is impervious to acid. A design is then drawn into the dried coating with a needle, exposing the metal plate beneath. The plate is next immersed in acid, which bites into the metal wherever it has been bared by the needle. Variety in line quality can be achieved by removing the plate as soon as the faintest lines have been bitten. Areas that are to remain light are then "stopped out," or varnished, and the plate is again bathed in acid. The process can be repeated more than once to create a range of tones. Finally, the coating is removed, and the plate is inked and printed.*

**4.6** Camille Corot,
Young Man in front
of a Great Oak, c. 1840
Graphite on tan paper
*Many mid-19th-century artists
attempted to merge realistic and
romanticized views of nature,
but few attained the kind of
lyricism that Camille Corot
achieved in his landscapes.
Corot, a leading member of
the Barbizon School (p. 78),*
*championed the then-radical
idea of working directly from
nature. In this drawing—
conceived as a fully real-
ized work rather than as
a preparatory sketch—he
demonstrates his astonishing
draftsmanship. Notice how
he records more detail in the
tree trunk to contrast with
the delicately rendered upper
branches that seem to sway*
*in the air. Gouache (opaque
watercolor) highlights increase
the dynamic movement of the
composition while the small
human figures emphasize the
monumentality of nature.*

**4.6**

**4.7** Édouard Manet,
The Execution of
Maximilian, c. 1867–68
Lithograph
In 1864, Napoleon III in-
stalled the Austrian archduke
Maximilian as emperor of
Mexico. Although French forces
controlled much of the country,
they withdrew soon after
Maximilian took office.
The new emperor refused to

abdicate to the Mexican gov-
ernment and, after a sham
trial, he was executed in 1867.
Édouard Manet interpreted the
event in four paintings, as well
as in this powerful lithograph,
created the same year as the
execution. Only a few impres-
sions were made before the print
was banned because of its con-
troversial subject matter. In
fact, Manet barely managed

to prevent the printer from
erasing and resurfacing the
lithographic stone. The work
was eventually editioned—
due in part to the efforts of
the author Émile Zola—and
published just after Manet's
death in 1883. This impression
is probably one of only a few
produced during his lifetime.
For a painting by Manet,
see p. 100.

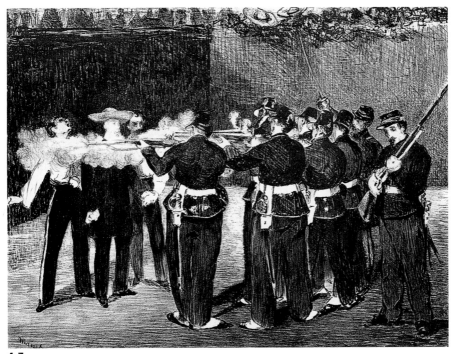

**4.7**

Printmaking Techniques:
Lithography
Invented in 1798, lithography
is based on the principle that
oil and water do not mix.
A design is drawn onto a slab
of Bavarian limestone with a
greasy crayon. After the image
is etched, or fixed, the stone is
sponged and rolled with greasy
ink, which adheres to the
already greasy areas but not
to the other parts of the stone.
A sheet of paper is placed on
the stone and both are passed

through a press, creating a
reverse image of the original
drawing. Color lithography
requires a separate stone for
each color. Today, metal plates
are used more commonly than
are cumbersome stones.

**4.8 Édouard Manet, The Races, 1864/65–72 Lithograph**

The art of Édouard Manet (4.7) spans both the Realist and Impressionist traditions of 19th-century France. If The Execution of Maximilian is considered Manet's greatest Realist image, The Races is his most important Impressionist lithograph. Indeed, it is generally considered the quintessential Impressionist print. Daily life in Paris was a frequent theme in Impressionist art, and Manet searched for ways to capture the city's fleeting events on canvas and on paper. Here, the artist conveys the energy of the race through the two converging diagonal lines of the track and the seemingly spontaneous handling of the lithographic crayon. Manet often went to horse races with Edgar Degas, (pp. 83, 104), and this work has the immediacy of an impromptu sketch made on the spot.

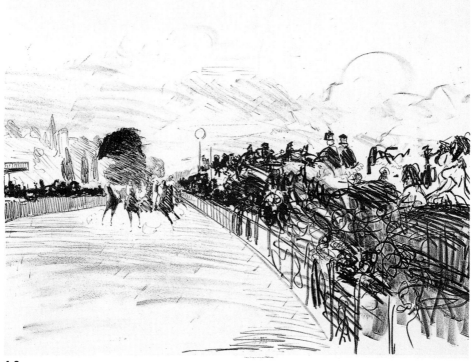

**4.8**

The spectators in the stands had climbed on to the benches. The others, standing in their carriages, followed the jockeys' manoeuvres through field-glasses.... At a distance their speed did not appear to be exceptional.... However, coming back quickly, they increased in size; they cut the air as they passed; the earth shook; pebbles flew; the wind, blowing into the jockeys' jackets, puffed them out like sails; and they lashed their horses with their whips as they strained toward the winning-post.

Gustave Flaubert,
Sentimental Education, 1869

**4.9** Henri de Toulouse-Lautrec,
The Jockey, 1899
Lithograph

*Inspired by Japanese woodblock prints—a pervasive influence in French art of the late 19th century—Toulouse-Lautrec developed a pictorial style that featured bold compositions, flat areas of color, and strong outlines. Here, Lautrec places the horses in parallel positions along a strong diagonal axis to propel the movement forward. Despite the complex multiple-color printing process, the work retains the appearance of a spontaneous sketch. When inscribing the date in the lower right corner of the plate, Lautrec neglected to reverse the numbers; note that the printed date reads backward.*

**4.10** Camille Pissarro,
The Vegetable Market
at Pontoise, 1891
Etching and aquatint

*Of all the Impressionist painters, Camille Pissarro, patriarch of the group, and Edgar Degas were the most committed to printmaking. Both artists made prints not for profit but for personal fulfillment, often giving works to friends. Pissarro printed this rich and subtle impression himself. It is one of only three known impressions of the first-state. The artist preferred to do his own printing, varying the inking, so that no two impressions are exactly alike. As a result, Pissarro's own impressions display great individuality and energy, whereas the more widely available impressions printed after his death are often comparatively lifeless. For a painting by Pissarro, see p. 105.*

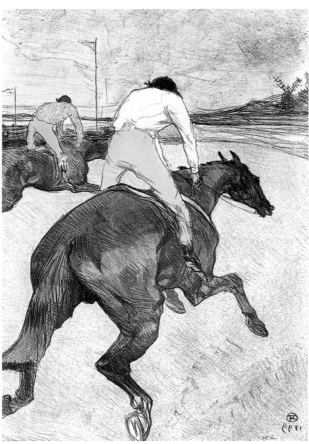

**4.9**

**4.10**

### 4.11 Emil Nolde, Prophet, 1912
### Woodcut

*This haunting woodcut is a classic print of German Expressionism—a style characterized by emphatic distortions of line and shape, and by the use of color for emotional, rather than descriptive, impact. From the beginning of the movement in 1906, the Expressionists treated printmaking as seriously as they did painting. They were particularly drawn to woodcuts, reflecting a deep interest in pre-Renaissance German art. Emil Nolde carved* Prophet *while recovering from a serious illness, as part of his attempt to regain creative and emotional strength by invoking a powerful mythic figure. The sunken eyes, hollow cheeks, strong nose, and solemn mouth impart a dramatic, ascetic quality. The artist himself printed, or supervised his wife in printing, each impression, constantly varying the inking. Because the block is so deeply cut, impressions of* Prophet *appear almost three-dimensional.*

### Printmaking Techniques: Woodcut

*The woodcut is the oldest of all printmaking techniques. A relief design is made by cutting away those areas of the image meant to remain white. The raised area is then inked and pressed against a sheet of paper, creating a mirror image of the design. Characteristically, the ink picks up the grain of the wood. Wood engraving is a later refinement of the woodcut and differs in the use of material. Rather than cutting along the grain, the wood engraver cuts across the grain of a block of very hard wood. Using finer carving tools, the artist is able to produce more highly detailed and intricate work than is possible in a woodcut.*

**4.11**

**4.12** Edvard Munch,
Self-Portrait, 1895
Lithograph
*Edvard Munch found graphic
art well suited to his forceful
visual style. His prints explore
the same themes of love and
death that dominate his
paintings. This intensely probing
psychological self-portrait, one
of the Norwegian artist's first
lithographs, is universally*
*considered an icon of the medium.
The skeletal arm across the bottom
of the print is a melancholy
memento mori (reminder of
mortality or death). This very
early impression of* Self-Portrait
*shows all the striation in the
background, a feature that dis-
appears in later impressions.
This example is the only
known impression on heavy
gray-green paper.*

**4.12**

**4.13** Odilon Redon,
The Trees, 1890s
Charcoal

*Never part of an artistic group,
Odilon Redon pursued a highly
individual style and range of
subject matter. His early work
consists almost exclusively of
eerie and often fantastical
lithographs and charcoal
drawings. This haunting
drawing depicts an intensely
mysterious forest scene. The trees,
cropped to human proportions,
are strangely anthropomorphic*

*in character. The complexity
and textural variety of the
surface convey the artist's careful
attention to botanical detail.
The tonal richness and odd
cropping of the drawing,
however, reflect Redon's private
and symbolic vision of nature.*

**4.13**

**4.14** Max Klinger, Shame, 1903
Etching, engraving, and aquatint

*Although Max Klinger enjoyed immense success as a sculptor and painter, he is best remembered for his print series. Shame is part of the suite* A Love, *the story of an aristocratic woman's affair with a younger man. In this, the next-to-last image, the woman is pregnant, unmarried, and spurned by society. The shadow she casts seems more corporeal than her actual figure, while her companion, a symbolic representation of her conscience, casts no shadow at all. In the final image, the woman dies in childbirth, and death takes the child as well. The MFAH's set is one of only 12 deluxe editions printed on special paper.*

**4.15** Adolphe Menzel, Study of a Man with a Beard, His Hand in His Pocket, 1885
Graphite

*Adolphe Menzel, a pioneer in German Realism, is considered one of the great draftsmen of the 19th century. He drew constantly and compulsively, and his incisive drawings chronicle Germany from the*

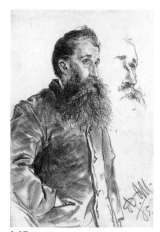

**4.15**

*1840s until his death in 1905. Although Menzel was most acclaimed in his own time for his cycle of paintings of the court of Frederick the Great, today's collectors prefer the spontaneity of Menzel's drawings. In this compelling portrait, the additional sketch of the man's slightly turned face at the upper right allows the viewer to see the artist's process.*

**4.14**

To **draw** everything is good;
to draw **everything** is better still.

Adolphe Menzel

**4.16** Pablo Picasso,
Portrait of Françoise
in a Suit, c. 1946
Drypoint

With characteristic energy and
intensity, Pablo Picasso brought
his extraordinary powers of
invention to an array of
printmaking techniques.
This elegantly spare drypoint
portrays the painter Françoise
Gilot, one of Picasso's mistresses

**4.17** Pablo Picasso,
Three Women at
the Fountain, 1921
Pastel

Picasso had entered his Classical
phase in the 1920s. After the
abstractions of Cubism, the artist
returned to the relatively realistic
representation of the human
figure and to a greater sense of
order. Picasso had traveled to
Rome in 1917, and soon after,

*perhaps inspired by the Classical
and Renaissance works there, he
developed his own interpretation
of antiquity. The three statuesque
women in this pastel drawing
have faces and costumes borrowed
from Greek art, but Picasso
portrays them with oddly
exaggerated arms and hands.
Their forms, emphasized by black
contour lines, convey both grace
and monumentality.*

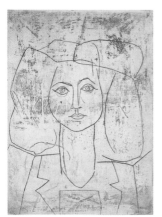

**4.16**

*and the mother of his children
Claude and Paloma. Turning
postwar shortages of metal to his
advantage, Picasso first etched
an image on the polished side of
a copperplate. He then engraved
this portrait on the rough side.
For additional works by Picasso,
see pp. 314–17 and p. 334.*

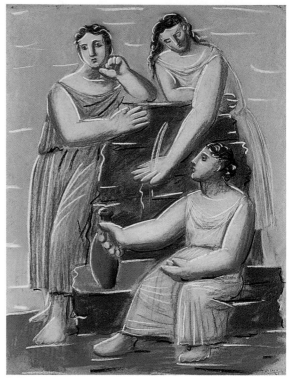

**4.17**

### Printmaking Techniques: Drypoint

*Drypoint is an engraving process
in which a design is scratched
directly onto a metal plate with
a needle. The wonderfully
sensitive line that is typical of
drypoint derives from the burr,
the metal shaving raised from
the plate like the ridge of earth
displaced by plowing. The burr
holds the ink and provides the*

*drypoint print with its
characteristic velvety line.
(In normal engraving, the
burr would be removed in the
process of cutting.) Because the
printing process flattens the
burr, only a limited number of
rich impressions can be produced.*

**4.18** Amedeo Modigliani, Caryatid, c. 1914
Gouache

*Renowned today for his richly colored and gracefully elongated paintings of women, Amedeo Modigliani was initially interested in sculpture and architecture. This drawing is a study for a monumental sculpture, part of his unrealized architectural project for a "temple of love." Although*

*many studies for the project exist, this drawing is one of the largest and most fully realized. It depicts a caryatid—a carved female figure that served as a supporting column in Greek architecture. Sensual and sophisticated, the image is one of Modigliani's most beautiful early drawings. For a painting by Modigliani, see p. 106.*

**4.19** Aristide Maillol, Standing Nude, Marie, c. 1931
Pastel

*Although primarily a sculptor, Aristide Maillol was also a painter and printmaker whose favorite—and almost exclusive — subject was the female nude. Working in the classical tradition of ancient Greek sculpture, Maillol rejected the expressionistic*

**4.19**
*romanticism of his great predecessor, Auguste Rodin (p. 425). Maillol displayed little interest in the psychological or erotic aspects of his subjects, instead depicting the female figure as a rhythmic arrangement of line and shape.* Standing Nude, Marie *is one of only about eight nearly life-size drawings of nudes that Maillol made toward the end of his career. For a sculpture by Maillol, see p. 419.*

**4.18**

**4.20** Arshile Gorky,
Virginia—Summer, 1946
Pencil and crayon

*The Armenian-born American
painter Arshile Gorky was a
brilliant draftsman who absorbed
the lessons of Paul Cézanne,
Joan Miró, Pablo Picasso, and
Paolo Uccello before developing
his own boldly original style in
the early 1940s. Gorky formed a
crucial bridge between European
Surrealism and American
Abstract Expressionism. Although
his mature style always referred*

*to nature, it did so in a frag-
mented, allusive way. This
satisfyingly integrated drawing
was created at the Virginia farm
where he was recovering from an
operation. Not strong enough to
paint, Gorky created perhaps
his most remarkable body of
drawings—some 300 sheets—
in that summer of 1946.*

4.20

**4.20a** *Arshile Gorky, c. 1935*

### 4.21 Joan Miró, Composition, 1930 Charcoal

Although Joan Miró never considered himself a Surrealist, to André Breton—the movement's chief theorist—Miró was probably "the most Surrealist of us all." Like other artists who are identified with the group, Miró sought to free the subconscious mind from the restraints of rational thought. The erasures in this drawing, however, clearly demonstrate that he reworked certain lines to achieve classical balance and symmetry. Miró developed a system of personal hieroglyphics that was inspired by children's art as well as by the art of so-called primitive cultures. Here, Miro's totemic figure incorporates both male and female characteristics.

### 4.22 Eva Hesse, Untitled, 1964 Gouache

Although Eva Hesse has become known mainly for her sculpture, she did not begin to work in that medium until 1965, only five years before her death from a brain tumor at the age of 33. She spent her early career as a painter, having studied at several New York art schools and Yale University. After a period of working principally in somber tones of gray, brown, and black, Hesse returned to vibrant color in 1963. In this light-filled drawing from the following year—her last as primarily a painter and draftsman—she demonstrated her affinity with such pioneering Abstract Expressionist painters as Adolph Gottlieb, organizing the surface in an irregular grid containing universal symbols and natural forms with no depiction of artificial depth.

**4.21**

© The Estate of Eva Hesse

**4.22**

In 1996, the MFAH mounted an exhibition of works by Jackson Pollock, the most important American artist of his generation. Pollock was the leading painter of Abstract Expressionism, the first American art movement to be accepted on an international scale. As his colleague Willem de Kooning said, "Pollock broke the ice," by demonstrating that American painters finally could compete with their European counterparts. The museum acquired four paintings, twelve drawings, and two of Pollock's five surviving free-standing sculptures from the exhibition. Together with two Pollock works already in the collection and two later additions, these acquisitions gave the MFAH a wonderfully complete representation of all periods of this important artist's career. For additional works by Pollock, see pp. 320–23.

**4.23** Jackson Pollock, Untitled, c. 1947
**Ink wash and encaustic**
*This large, untitled drawing dates from the early period of Jackson Pollock's mature style, when he had just made the breakthrough into his signature dripped-and-poured technique. Although abstract, it contains compositional elements that recur throughout the artist's career, particularly the vertical divisions of the picture surface by three dark columns. These totem-like figures reflect his early interest in the art of Northwest Native American cultures.*

**4.23**

## 4.24, 4.25, 4.26
## Jackson Pollock,
## Three Untitled Drawings,
## c. 1946–47, Ink

*From a scholarly point of view, the most important component of the museum's Pollock holdings is a notebook of nine drawings in pen and various inks. This remarkable group of drawings, three of which are illustrated here, represents simultaneously*

*a summation of Pollock's career up to that point and a fore- shadowing of his imminent breakthrough into all-over poured paintings. These drawings can be seen as Pollock's manifesto that he had made the lessons of Picasso (4.16, 4.17) and Miró (4.21) his own while creating a new pictorial language, which he described as "energy made visible."*

*Technique is the result of a need —new needs demand new technique —total control— denial of the accident — State of Order —organic intensity —energy and motion made visible —memories arrested in space, human needs and motives —acceptance —*

Jackson Pollock, 1949

**4.24**

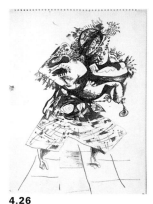

**4.26**

**4.25**

**4.27** Richard Diebenkorn, Untitled, 1972 Mixed media, including acrylic, gouache, charcoal, and pasted paper

In 1966 Richard Diebenkorn moved his home and studio from Berkeley, in western California, to Santa Monica, on the southern coast of the state. The distinctive colors of this different region

profoundly inspired the artist, and by 1967 he had begun his Ocean Park series of paintings. These paintings are abstracted aerial landscapes, characterized by a high horizon and an arbitrary division of space, usually rendered in careful juxtapositions of subtly veiled colors. This triptych is Diebenkorn's Ocean Park imagery pared to the bone,

almost austere in the subtle colors of each component. For many years, the triptych hung in Diebenkorn's Santa Monica home as the touchstone of his Ocean Park series. For another work by Diebenkorn, see p. 349.

**4.27a** In 1984, the artist Leo Holub photographed his friend Richard Diebenkorn seated in front of this triptych.

**4.27**

**4.27a**

**4.28** Jasper Johns,
Untitled, 1991
Etching and aquatint with
scraping and burnishing
*Fascinated by the processes of
creation and alteration, Jasper
Johns constantly reconfigures
and revises his work. This
image began as three component
plates that were printed on top of
each other to form a multicolored
etching. The somewhat altered*

*plates were then printed separately in black, each with a tone
plate, to create related prints.
Next, Johns made three
paintings based on the three
prints, which he eventually
came to view as a triptych.
Finally, the artist returned to
the three plates, reworked them
extensively, placed them side by
side, and published them as a
single composition in black and*

*white. This impression is one
of a series of trial proofs that
explores various combinations
of the primary and secondary
colors. In this proof, the etched
areas of each plate were printed
in one of the secondary colors,
and the unetched areas were
inked in black. Only two
impressions of each color
combination exist. For a
painting by Johns, see p. 351.*

**4.28**

In the 1980s, the art market in the United States became more international, expanding to include work by a new generation of artists from Germany and from Italy. Peter Blum was one of the first print publishers to feature the graphic work of European artists such as Francesco Clemente and A. R. Penck, as well as Asian artists like Yukimori Yanagi. Blum also commissioned prints by some of America's leading sculptors and painters. His genius lies in his ability to persuade conceptual artists such as James Turrell (pp. 380–81) to make their first graphic works, with masterful results. The MFAH acquired all of the prints and books produced by the fine arts publisher Peter Blum Edition from its founding in 1980 through June 1994, along with all existing preliminary drawings, proofs, plates, and blocks. The complete archive consists of some 1,200 objects, and it documents one of the most fertile periods in American printmaking.

### Printmaking Techniques: Aquatint

*Aquatint is an etching process in which tone is created by treating areas of the plate with fine particles of acid-resistant material (such as powdered resin or spray lacquer). The acid bites into the plate between the grains of resin and, when printed, the mass of tiny dots produces a textured area rather than a line. This technique creates tonal effects similar to a watercolor wash.*

**4.29** Eric Fischl,
Year of the
Drowned Dog,
1983
Aquatint,
soft-ground etching,
drypoint, and scraping

*Eric Fischl's* Year of the
Drowned Dog *is an icon of
printmaking from the 1980s.
Publisher Peter Blum paired
Fischl, one of the leading artists*

to revive figurative imagery in
vanguard American painting,
with the Swiss printer Peter
Kneubühler. This international
collaboration resulted in a new
type of print in which the owner
determines the complexity of the
image. In this work, three sheets
form the background. Any com-
bination of three smaller sheets
can be laid on top, adding fur-
ther characters and narrative

incident to the image. The sub-
ject is typical of Fischl's work of
the 1980s: on a Caribbean beach,
American tourists interact un-
easily with native residents
and each other. The Peter Blum
Edition archive has more than
40 proofs documenting this
complex project, from test plates
through compositional proofs to
final proofs, in which color
balances were perfected.

**4.29a** *Eric Fischl*

*The Museum of Fine Arts, Houston, has exhibited photographs throughout its history. Early presentations included images by Edward Weston (1930), František Drtikol (1932), and László Moholy-Nagy (1948). In 1976, the MFAH established a department of photography and began collecting photographs in a systematic way. Seeking both individual masterpieces and in-depth holdings by certain artists, the museum has amassed a comprehensive collection of more than 10,000 works dating from the mid-19th century to the present day.*

*The collection illustrates the evolution of early 20th-century photographic styles beginning with photographs that imitate romantic painting styles, such as Edward Steichen's early images. Very different works from the same period include experiments in abstract photography by Alvin Langdon Coburn, Christian Schad, Moholy-Nagy, and Man Ray. The MFAH has especially important works made in the 1920s and 1930s by American, French, English, German, Czech, and Soviet artists. Emblematic examples by such masters as Paul Strand, Edward Weston, Brassaï, André Kertész, Henri Cartier-Bresson,*

John Heartfield, Joseph Sudek, and Alexander Rodchenko trace the distinctive development of modern styles from country to country.

American documentary photography is well represented and includes a number of Lewis W. Hine's extraordinary pictures of the construction of the Empire State Building; photographic essays by W. Eugene Smith; and images of African-American life by Roy DeCarava and James VanDerZee. The American West lives on in masterly images by Ansel Adams and Frederick Sommer, among others. Photographs from throughout the Americas include many works by Mexican photographers such as Manuel Alvarez Bravo.

The MFAH's collection is strongest in the new approaches to photography that emerged in the second half of the 20th century. These ideas range from Robert Frank's radical redefinition of the photo essay to the conceptually based works of John Baldessari, Robert Cumming, and Lorna Simpson. Toward the century's close, the museum began to acquire photographs by Japanese artists including Toshio Shibata and Hiroshi Sugimoto.

Ever since the photographic process was invented in the mid-19th century, practitioners have been investigating its infinite visual possibilities. To make sense of the myriad subjects, styles, and techniques that comprise the history of photography, consider three essential approaches to the art form—documentary, pictorial, and conceptual—while bearing in mind that a given photograph often combines aspects of more than one approach. The camera's capacity to document people, places, and events was the primary impetus for early photographers such as the Meade Brothers, who took this rare daguerreotype (5.1) of Texas statesman Sam Houston in 1851. Wishing to make a portrait appropriate for a man contemplating a run for the presidency of the United States, they showed Houston in a pose of relaxed confidence. Placing him next to a column evoked institutional importance and emphasized Houston's leadership qualities. The photographer Edward Steichen, on the other hand, chose to downplay the recording function of the camera. He believed that for photography to be art, it must resemble painting. Working in a style called Pictorialism, Steichen intentionally minimized the details of the scene. In this 1905 photograph of trees (5.2), dense black tones frame a luminous chestnut tree, on which flowers appear with the imprecision of dabs of paint. The work demonstrates a type of photography in which the maker's personal, pictorial style is paramount. This approach persisted long after the specific style of Pictorialism ended.

**5.1** Meade Brothers (Charles Richard and Henry William Matthew), *Samuel Houston*, 1851

In the second half of the 20th century, a number of artists began to use photographs to visualize their ideas, rather than as a tool to interpret the physical world. This conceptual form of photography sometimes records ephemeral works of art, and often documents staged events. In the 1970s, Gordon Matta-Clark partially demolished condemned buildings to explore spatial ambiguities in architecture. The photographs he made (5.3) both document and promote altered perceptions of space.

*In order to make sense of photographs one must look at them as encounters between physical reality and the creative mind of man — not simply as a reflection of that reality in the mind but as a middle ground on which the two formative powers, man and the world, meet as equal antagonists and partners, each contributing his particular resources.*

Art theorist Rudolph Arnheim, 1974

**5.3** Gordon Matta-Clark, Caribbean Orange, 1978

**5.2** Edward Steichen, Trees, Long Island, 1905

At the beginning of the 20th century, about the same time that painters were creating the first abstract canvases, four photographers took on the challenge of making abstract photographs. The first, American artist Alvin Langdon Coburn, attached prisms and mirrors to his camera prior to photographing bits of crystal and wood, producing pictures of reflected and refracted light (5.4). When he exhibited the photographs in London in 1917, his friend, the poet Ezra Pound, dubbed them *vortographs*, after a Cubist-influenced English art movement called Vorticism. German-born Christian Schad was a member of Zurich Dada, a group of young artists who called for anti-art, nonsensical creations in the wake of World War I. In 1918, Schad improvised a variation on a technique invented by H. Fox Talbot, one of photography's pioneers. Schad placed cutout paper, fabric, and objects on light-sensitive paper, and then exposed them to light. The photographic paper registered the patterns and shapes without involving a camera, resulting

**5.4** Alvin Langdon Coburn, Vortograph, 1917

**5.5** Christian Schad, Schadograph No. 10, 1919

n *schadographs* (5.5) that resemble Cubist collages. About 1921, Man Ray, an American painter in Paris, and László Moholy-Nagy, an Austro-Hungarian-born painter in Berlin, independently developed methods similar to Schad's. Taking the cameraless approach one step further, they projected light onto three-dimensional objects of varying translucency that were arranged on light-sensitive paper, recording not only abstract shapes but also shadows and textures. For this *rayograph* (5.6), Man Ray held an opaque object above the

surface of the paper, yielding a blurred, indecipherable image. By disrupting the viewer's perceptions, the image stimulates associative flights of fantasy, in keeping with Man Ray's Dada-Surrealist sensibility. Moholy-Nagy, by contrast, retained the geometric shapes of the objects in his *photograms* (5.7), producing architectonic compositions out of light and form.

The MFAH is one of only two museums in the world to own examples by all four of these avant-garde artists.

**5.6** Man Ray,
Rayograph, 1923

**5.7** László Moholy-Nagy,
Untitled, 1925

*. . . why should not the camera artist break away from the worn-out conventions . . . and claim the freedom of expression which any art must have to be alive?*

Alvin Langdon Coburn, 1913

Reacting to the prevailing soft-focus aesthetics of Pictorialist photography, a number of early 20th-century practitioners called for "photographs that look like photographs." Attempting to define the essence of the medium, they made "straight" pictures, avoiding as much as possible the manipulation of images in the darkroom. This new, American approach to Modernism was championed by Alfred Stieglitz (p. 203), who introduced the style at his Gallery 291 and in the journal *Camera Work*. Another photographer, Paul Strand, summarized the prerequisites for his profession as "honesty, . . . intensity of vision, . . . [and] the photographer's 'real respect for the thing in front of him.'" Strand's beginnings as a Pictorialist photographer are evident in the subtle tones and soft contours of the transitional photograph illustrated here (5.10). However, the tilted perspective and tight composition of this still life, where the objects read as semiabstract shapes, indicate a Modernist approach. Stieglitz published

**5.8** Paul Outerbridge, Jr., Advertisement for George P. Ide Company, 1922

5.9

5.10

**5.9** Edward Weston, Tina Modotti, 1924

**5.10** Paul Strand, Ceramic and Fruit, 1916

ɔtrand's photographs in the last issue of *Camera Work* in 1917, a sign of the shift away from Pictorialism to Modernism. Edward Weston's portrait of the Italian photographer Tina Modotti (5.9) displays his Pictorialist roots also. Yet his intense scrutiny of a single subject—the hallmark of his mature style—is apparent in the way he isolates Modotti's head to focus attention on her strong features and rapturous expression. Love of abstract form combined with "respect for the thing in front of him" informs Paul Outerbridge, Jr.'s,

advertisement for a shirt collar (5.8). The curved lines of the collar are contrasted with the straight lines of the checkerboard in a direct and elegant composition. Charles Sheeler recorded the beauty of man-made America in precise, detailed photographs (5.11) that often served as subjects for his paintings. More ironically, Morton Schamberg suggests that Americans worship industrial technology in this photograph—titled *God* (5.12)—of a sculpture that he made from a piece of pipe and a tool called a miter box.

**5.11** Charles Sheeler, New York, 1920

**5.12** Morton Schamberg, God, 1917

Like Modernist artists everywhere, photographers working in France and England in the 1920s and 1930s embraced a rapidly changing world. The artists represented here shared with their American counterparts a passion for capturing that world in pictures, and they left a remarkable record of the people, places, and lifestyles of their time. However, perhaps because of their fine arts training (with the exception of André Kertész, they all studied painting or sculpture), these artists' abilities to transform specific scenes into works with larger metaphorical meanings resulted in photographs that transcend the categories of documentary photography and photojournalism. Brassaï, Bill Brandt, and Eugene Atget exhaustively documented the cities in which they lived. Brassaï (in Paris) and Brandt (in London) sometimes staged their scenes in order to arrive at quintessential images. Frequently with humor and always with respect, these photographers recorded workers, prostitutes, shopkeepers, maids,

**5.14**

**5.13**

**5.15**

**5.13** Brassaï,
Watchmaker, Dauphine Alley, Paris,
c. 1932–33

**5.14** André Kertész,
Chairs, the Medici Fountain, 1926

**5.15** Eugene Atget,
Pont Marie, 1926

ɔvers, children, artists, and aristocrats in a quest to define the essence of these great cities (5.13, 5.17). The MFAH's extensive holdings of Brassaï's work span his entire career. Atget concentrated on the monuments and streets of Paris with an unsurpassed reverence for the way that past and present cultures coexist. He produced thousands of images before he died in 1927, just a year after making the lyrical work pictured here (5.15). Kertész's photographs, which reflect his skill at finding significant details to

communicate the essence of a subject, also reveal his love of delicate, formal compositions. Here (5.14), the beautiful pattern of dappled light and shade produced by trees and chairs conveys the peaceful, cool atmosphere of a Paris park. Henri Cartier-Bresson sought what he called the "decisive moment" when he took pictures. By snapping the shutter at that split second when all the elements of a scene are in balance, he created images that are both visually and emotionally compelling (5.16).

**5.16**

**5.17**

**5.16** Henri Cartier-Bresson, Seville, Spain, 1933

**5.17** Bill Brandt, Maid Preparing the Evening Bath, 1932

Like his contemporaries Brassaï, Brandt, and Atget (pp. 146–47), the German photographer August Sander devoted his life to a massive documentary project. In 1910 Sander began "Man in the Twentieth Century," a collective portrait of the German people. Dividing society into 45 "types" ranging from poor workers to aristocrats, he made penetrating, often haunting, studies of hundreds of his fellow citizens (5.19). Four other German photographers pursued a distinctive approach to Modernism, probing the aesthetic boundaries of photography by pushing the medium beyond existing uses and methods. John Heartfield and Hannah Höch, both early members of the politically and artistically rebellious German Dada movement, made pioneering use of photocollage techniques. When he made this 1934 work (5.18), Heartfield was directing the full force of his creative intelligence against the Nazi rise to power. Adolf Hitler's "Thousand Year Reich" is revealed as a house of cards, and Hitler, whose face is on the card at the

**5.18** John Heartfield,
The Thousand Year Reich, 1934

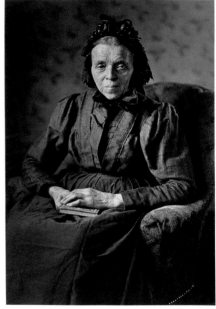

**5.19** August Sander,
The Intellectual, 1914

**5.20** Hannah Höch,
Broken, 1925

**5.21** László Moholy-Nagy,
At Coffee, c. 1926

**5.22** Charlotte (Lotte) Stam Beese,
Bauhaus Weavers, 1928

bottom right of the work, is searingly reduced to a mere drummer boy. Höch's piece (5.20) reflects her defiant Dada roots. A lyrical mix of dolls, it challenges disturbing stereotypes of women and mass-produced consumer culture. Lotte Beese and László Moholy-Nagy were members of the Bauhaus, the visionary German art school established in 1919. In the photographs presented here, they each explored unconventional vantage points in search of new visions for photography. Beese positioned herself above a group of women lying like spokes of a wheel to make this abstracted aerial view (5.22) of members of the Bauhaus weaving department. Moholy-Nagy, whose experimental photography is discussed on p. 143, also took "straight" photographs, still with the purpose of expanding the medium's range. Here (5.21), he created an evocative scene of morning coffee by training his camera on the shoes and cups of the coffee drinkers. The MFAH is especially rich in the works of Heartfield, Moholy-Nagy, and the Bauhaus School.

**5.20**

**5.21**

**5.22**

For two decades—after Czechoslovakia became an independent republic in 1918 and before it fell to Nazi Germany during 1938 and 1939—Czech culture experienced a thrilling period of creative activity. Artists in the city of Prague rapidly absorbed the latest styles, from French Cubism and Surrealism to German Expressionism and Soviet Constructivism. At the same time, freedom from Austro-Hungarian rule fueled a desire among Czech artists to make art that would be unique to their culture. A distinctive

synthesis of styles resulted, in which international currents in art were modified by indigenous traditions. In photography, one of the earliest 20th-century masters was František Drtikol. Initially incorporating an Art Nouveau look into a Pictorialist style, Drtikol produced soft-focus yet stylized landscapes, nudes, and portraits. The Pictorialist mode is still evident here in Drtikol's tender 1920s study of his wife (5.23); however, the elegant symmetry and subtly repeated patterns of lights and darks show

**5.23** František Drtikol, Portrait of Errina Kupferova, c. 1925

**5.24** Josef Sudek, Untitled, 1954

**5.25** Jaromír Funke, Composition, 1923

ophisticated use of Modernist forms. sef Sudek bridged the worlds of Pictorialism nd Modernism. Retaining an affection for moody, half-lit pictures throughout his life, Sudek was also a leader of Czech avant-garde photography. He chronicled Prague's aged beauty for years, until fear of the Nazis forced him to retreat indoors. Thereafter he made exquisite studies of his backyard and of still-life objects. This simple (5.24) still-life photograph (one of 66 Sudek works owned by the MFAH), in which a face can be read

into the flesh of the watermelon, illustrates the fantastical, Surrealist strain that weaves in and out of his work. In 1924, Sudek had been a founding member of the avant-garde Czech Photographic Society, along with Jaromír Funke and others. At that time, Funke simultaneously explored several photographic styles, ranging from nonfigurative records of light and shadows (influenced by Man Ray, p. 143) to abstracted still lifes of geometric, often utilitarian objects, such as this photograph of metal bowls (5.25).

**5.24**

**5.25**

After Vladimir Lenin led the Bolsheviks to power in Russia in 1917, artists eagerly joined in the effort to promote the new government's idealistic goals. Faced with a largely illiterate population, Lenin called on photographers to create a new form of visual journalism appropriate to the country's needs for education and propaganda. This new field developed in two directions: photojournalism, in which photographers documented the daily progress of their young country; and experimental photography, in which avant-garde artists used photographs, often combined with innovative typography, to further the aims of the state. One of the great photojournalists of this period was Max Alpert, who covered everything from current events to the building of steelworks and railroads. His image (5.26) of a horsewoman in the Kirghiz Republic conveys the joyous vitality of a woman whose way of life remained untouched by industrial society. In 1931, Alpert began taking pictures for *USSR in Construction*, a graphically innovative

**5.26** Max Alpert,
Kirghiz Horsewoman, 1936

**5.27** USSR in Construction, 1935

magazine published in Russian and three other languages to spread propaganda abroad. Among the avant-garde artists who worked on the magazine was Alexander Rodchenko, editor of the issue illustrated here (5.27). An early proponent of the purely abstract art movement known as Russian Constructivism, Rodchenko came to reject abstract painting and sculpture, deeming them irrelevant to real life. He had turned to the camera in about 1920, creating powerful photographs, photomontages, posters, and

book covers, all in the service of the state. In 1924 he made many portraits of friends, including this one (5.28) of the famous poet Vladimir Mayakovsky. The avant-garde artist El Lissitzky, who also contributed to *USSR in Construction*, organized the Soviet display at the 1928 International Press Exhibition (Pressa) in Cologne, Germany. An angled photograph (5.29) he took there of the back view of his sculpture of a worker demonstrates his commitment to personal expression over purely propagandistic goals.

**5.28** Alexander Rodchenko, Portrait of V. V. Mayakovsky, 1924

**5.29** El Lissitzky, Sculpture at Pressa, Cologne, 1928

In the 19th century, U.S. artists viewed the vast American wilderness as an emblem of their country's infinite capabilities, its untamed nature a metaphor for freedom. (See pp. 174–75.) With the invention of the camera, photographers began to accompany explorers on trips to the West. The Western landscape has been a subject of photography ever since, fostering an aesthetic tradition that continuously defines the beauty, grandeur, and human connection to this part of America. By the first half of the 20th century, the early epoch of exploration had ended, and photographers were among the growing number of people who became dedicated to appreciating and preserving America's natural beauty. The most famous nature photographer from this period is Ansel Adams. During a career spanning more than 50 years, Adams made dazzling images of mountains, lakes, rivers, and trees, and he actively participated in the conservation efforts of the Sierra Club. This dramatic, 1940 aerial view of a seacoast (5.30)

**5.30** Ansel Adams,
Untitled (#2) from Surf Sequence, 1940

**5.31** Frederick Sommer,
Arizona Landscape, 1945

**5.32** Robert Adams,
Near Willard, Utah, from the series
The Missouri West, 1978

xemplifies Adams's passion for transient aspects of nature such as water, light, and weather. The Surrealist photographer Frederick Sommer departs from the convention of representing landscapes that contain a horizon line dividing land and sky. Without such a line to provide a sense of scale, Sommer's picture (5.31) foregoes recording the classic Western expanse in favor of rich patterns created by subtle variations in desert landscapes. The absence of a focal point and traditional foreground-background composition in Sommer's work parallels developments in abstract painting. In the 1960s, a number of photographers began to study the uneasy relationship between people and America's vanishing wilderness. In contrast to Ansel Adams, who captured vast landscapes that are pristine, Robert Adams tempers his views of nature with reminders of the human presence. Here (5.32), Robert Adams subtly introduces a telephone pole into a view of Utah mountains.

5.31

5.32

In the period between the world wars, documentary photographers created a remarkable record of the American experience. Documentary projects were commissioned by government agencies and by magazines and were also initiated by private groups and individuals. In 1930, Lewis W. Hine accepted the job of photographing the construction of the Empire State Building in New York City. Joining the workers on their precarious scaffolds, the 56-year-old photographer celebrated their enormous skill and courage (5.33). Hine's work prefigured several important projects sponsored by the U.S. government in the 1930s. One agency, the Work Progress Administration, sponsored Berenice Abbott's record of the complex and changing city of New York. In detailed photographs such as this one of Wall Street (5.34), Abbott conveyed the city's massive scale by taking, in her words, "bird's eye views and worm's eye views." About the same time that Abbott published her New York

**5.33** Lewis W. Hine, Riveters, 1932

**5.34** Berenice Abbott, Exchange Place, c. 1934

5.34

photographs, W. Eugene Smith began working for *Life* magazine, founded in the mid-1930s to publish photo essays taken with a "mind-guided camera." In 1948, with his Country Doctor series (5.35), Smith created a new kind of photo essay that added an interpretive dimension to the traditional narrative content. The photographs not only documented what the doctor did, they also profoundly explored the emotional dimensions of his profession. Just a few years later, the Swiss-born American artist Robert Frank

(pp. 392–95) changed the nature of the field yet again. On a photographic tour of the United States in 1955 and 1956, Frank recorded his personal, sometimes cynical, reactions to the country, such as this image of the vast and lonely desert highway (5.36). Published as a book titled *The Americans*, his photographs presented an unromanticized portrait of the nation that acutely impacted subsequent photographers. The MFAH owns more than 320 works by Frank, including all the images from *The Americans*.

**5.35** W. Eugene Smith, Untitled, from the series Country Doctor, 1948

**5.36** Robert Frank, U.S. 285, New Mexico, from the series The Americans, 1955

*I was looking at the landscape. I knew I was in America. What am I doing here, I asked myself. There was no answer. The landscape didn't answer me. There was no answer.*

Robert Frank, discussing *The Americans*

One of the first important African-American photographers, James VanDerZee lived and worked in New York City's Harlem during that community's great cultural flowering in the 1920s, a period that became known as the Harlem Renaissance. Depicting the major religious, political, and artistic figures of the time, as well as the celebrations and everyday life among Harlem's middle class, VanDerZee created an insightful and sympathetic record of his contemporaries that included this richly detailed study (5.39) of Daddy Grace, a popular local religious leader. Born just as the Harlem Renaissance was beginning, Roy DeCarava followed VanDerZee's model, photographing the vibrant life not only of Harlem, but also of New York City as a whole. With haunting images of jazz musicians, workers, and people young and old, DeCarava's works convey the baffling, melancholy, tender, and joyous experiences of daily life. Here (5.37), graduation day yields a surreal moment when juxtaposed against the detritus of an abandoned lot.

*© Roy DeCarava, 1996*

**5.37** Roy DeCarava,
Graduation, New York, 1949

**5.38** Earlie Hudnall, Jr.,
Hip Hop, 1993

**5.38**

Earlie Hudnall, Jr., creates most of his photographs in the Houston community in which he lives. Camera in hand, Hudnall regularly walks around his neighborhood and records the people and events he encounters. The local insight that he brings to his work is evident in this image (5.38) of a young man whose stance is equal parts self-conscious pride and unself-conscious grace. In 1990, 50 African-American photographers were commissioned to visit all parts of the United States to create a "self-portrait of the African-American community through its own eyes." The project, titled *Songs of My People*, culminated in a book and a touring museum exhibition. At the end of the tour, the entire collection of photographs, including this compelling portrait (5.40) of three physicians by D. Michael Cheers—one of the project's organizers—was acquired by the MFAH.

**5.39** James VanDerZee, Daddy Grace, NYC, 1938

**5.40** D. Michael Cheers, Doctors Karen Ambrose, Paula A. McKenzy, and Deborah Arrindell, 1990

**5.39**

**5.40**

After the 1910 revolution that won Mexico's independence, artists such as Frida Kahlo, Diego Rivera, and David Alfaro Siqueiros celebrated the traditional arts of their country during a period that would be called the Mexican Renaissance. The father of 20th-century Mexican photography, Manuel Alvarez Bravo, became friends with these artists early in his career, and he photographed many of them, including Frida Kahlo (5.41). During the remainder of the century, Alvarez Bravo set the standard for other Latin American photographers by capturing the essence of Mexican life and culture in landscapes, portraits, and records of historical events. Two younger artists who worked with Alvarez Bravo are Flor Garduño and Graciela Iturbide. Garduño, a woman of mixed Indian and Spanish extraction, seeks out the complex layering of native customs and Catholic rituals brought to Mexico by the Spanish. In the eloquent *Basket of Light* (5.42), an Indian peasant carries a basket that spills over with white lilies, the quintessential

**5.41** Manuel Alvarez Bravo,
Frida Kahlo in
Manuel Alvarez Bravo's Studio,
1930s

**5.42** Flor Garduño,
Basket of Light, 1989

**5.43** Graciela Iturbide,
Angel Woman, 1979

**5.44** Gerardo Suter,
Tlapoyahua, 1991

symbol of Christian purity and the Virgin Mary. Iturbide spends a great deal of time in small villages, documenting the evolving customs of Mexico's native people. In this gently humorous image (5.43) of a peasant woman carrying a boom box, Iturbide takes note of the presence of modern technology in an otherwise traditional scene of rural life. Gerardo Suter focuses on yet additional aspects of Mexico's hybrid culture. Fabricating props based on Mayan rituals, Suter integrates the ancient history of Mexico with its 20th-century Surrealist tradition, as in this ominous photograph (5.44) of a hand with long, pointed, metal fingernails. The MFAH, which has already acquired more than 250 photographs by Mexican artists, actively collects photographs by artists from other Latin American countries as well, including Argentina, Brazil, Cuba, Guatemala, Peru, and Venezuela.

**5.43**

**5.44**

With its ability to accurately record a person's appearance and, in the hands of a skilled photographer, to convey aspects of the subject's personality, the camera has long been a powerful medium for portraiture. For magazines such as *Harper's Bazaar*, *Vanity Fair*, and *Vogue*, the four masters of portrait photography presented here have created arresting images that are remembered long after publication. Richard Avedon's portraits are characteristically confrontational, deprived of any setting other than a blank background, and lit with a harsh, raking light that reveals a sitter's every wrinkle and pore. The aging Duke and Duchess of Windsor (5.45) appear weary and ravaged by years of living in the glare of public scrutiny focused on them ever since the duke abdicated the throne of England to marry the American divorcée in 1937. No stranger to the camera, Greta Garbo sat for this portrait (5.46) by Edward Steichen (pp. 140–41) during a break on a movie set. Steichen's dramatic approach, in which the face of the glamorous film star

**5.45** Richard Avedon,
The Duke and Duchess of Windsor,
1957

**5.46** Edward Steichen,
Greta Garbo, 1928

*A photographic portrait is a picture of someone who knows he's being photographed, and what he does with this knowledge is as much a part of the photograph as what he's wearing or how he looks. . . . The way someone who's being photographed presents himself to the camera, and the effect of the photographer's response on that presence, is what the making of a portrait is about.*

Richard Avedon

barely emerges out of the dark mass of her body, perfectly captures Garbo's seductive yet elusive persona. Irving Penn's images of artists are among his best portraits, a fact Penn believes comes from the artists' understanding of the creative nature of his work. In this elegant picture (5.47) of the painter Barnett Newman, the low vantage point, cropped head, and piercing gaze create the powerful sensation that Penn, and by extension the viewer, has invaded the sitter's personal space. In contrast to these three photographers, Annie Leibovitz confirms the sitter's public persona but in fresh ways, through the arrangement of settings and props. When she took this picture of the comic actor and art collector Steve Martin (5.48), she posed him in a white suit covered with strokes of black paint that mimic the painting by Franz Kline (p. 324) behind him. The self-mocking stance, juxtaposed against the artwork from Martin's own collection, captures both the actor's humor and his love of art.

**5.47** Irving Penn, Barnett Newman, 1966

**5.48** Annie Leibovitz, Steve Martin, Beverly Hills, 1981

Formal elegance and an affinity for European aesthetics link photographers Harry Callahan, Ray K. Metzker, and George Krause, all of whom are represented extensively in the MFAH's collection. Harry Callahan was deeply influenced by the work of László Moholy-Nagy (pp. 143, 149), who, by the time Callahan began taking pictures in the late 1930s, had founded the New Bauhaus School in Chicago. Callahan wedded Moholy-Nagy's emphasis on formal experimentation with his own interest in recording the "life within me

and around me." Over the next 60 years Callahan repeatedly explored the themes of nature, city life, and his beloved wife and daughter, all the while creating innovative new images based on technical experiments. This multiple-exposure photograph of a tree (5.51) eloquently conveys the rhythmic movement of bare branches in the wind. In 1946, Callahan had begun teaching at the New Bauhaus, by then renamed the Institute of Design. A decade later Ray K. Metzker went there to study with him and with

**5.49** Ray K. Metzker, Frankfurt, Germany, from the series Europe, 1961

photographer Aaron Siskind. Metzker shares with Callahan a dual interest in formal invention and humanistic concerns. While traveling in Europe in 1960 and 1961 Metzker made this refined image of a man in a scull (5.49). The perfect symmetry of the composition and the pure contrast of the light boat against the dark water exemplify Metzker's interests in photographing "events," by which he means moments of tension when moving things "arrive into place." The same tension can be seen in the evocative

photograph of a nude woman (5.50) by George Krause, who captured the exact moment when the unfurled cloth over the woman's head formed a perfectly arched canopy. One of a series of nudes Krause made while living at the American Academy in Rome, it displays the artist's love of ancient Greek and Roman art. Inventively combining the classic female form with a soaring symbol of the spirit, the photograph also embodies the themes of sensuality and spirituality central to his work.

**5.50** George Krause,
Swish, from the series I Nudi, 1976

**5.51** Harry Callahan,
Multiple Trees, 1949

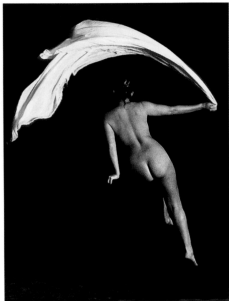

**5.50**

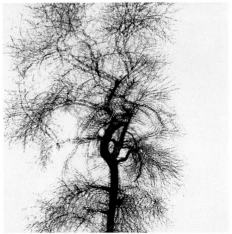

**5.51**

In the mid-1960s, some artists began making art in which the idea behind the work was considered the real art, and the art object merely the record of the idea. Certain of these Conceptual artists initially relied on photographs to document their projects, and photography soon became viewed as a medium with enormous potential for translating complex ideas into visual form. Although the degree to which photographs are merely records of ideas varies among the conceptually based artists, a lack of investment in the technical aspects of fine art photography has been a common trait allowing for great experimentation within the medium. One of the first artists to alter photographs radically in the service of an idea was Robert Heinecken, a printmaker by training who relies on photography to root his imagination in the real world. In this composite photograph (5.52), Heinecken explores the subject of human sexuality by literalizing the metaphor of woman as "mother nature." Intertwining multiple

**5.52** Robert Heinecken,
Space/Time Metamorphosis #1, 1975

**5.53** Robert Cumming,
Watermelon/Bread, 1970

images of a woman and a rocky landscape, he creates a provocative and unsettling scene of metamorphosis, as the woman's body and details of the landscape merge. Robert Cumming also transforms visual appearances, exploring the difference between the idea of something and the thing itself. In *Watermelon/Bread* (5.53), Cumming playfully inlays a slice of white bread into the side of a watermelon. By physically connecting two unrelated items, he startles the viewer into questioning the association.

Unlike Cumming's photography, which drolly documents staged ideas, the work of Esther Parada evolves over time. *Past Recovery* (5.54) incorporates scores of family snapshots, taken between 1920 and 1978, into a photograph of a 1920 family banquet enlarged to life size. Parada juxtaposes images of her father at three different ages and compares the physical resemblance between a niece and an aunt who never met. The artist thus compresses time, as human memory does, to link visual references never linked in reality.

**5.54** Esther Parada, Past Recovery, 1979

Since the emergence of Pop art in the 1960s (pp. 344–47), the worlds of advertising, television, and the movies have been fertile subjects for artists. Familiar images of celebrities, consumer products, and wartime atrocities provide many conceptually based artists with fodder for commenting on the nature of art and the values of modern society. Basing his art in everyday experiences, John Baldessari initially appropriated photographic fragments and words from billboards, truck logos, magazines, and movies into his work. In composite pictures, he exposes clichés and conventions in both art and society. Here (5.55), the artist juxtaposes framed photographs of a rock star, an emaciated child, and a happy baby with toys. By obscuring the visible faces with colored dots, Baldessari appears to suggest that the steady barrage of such images— the famous, the horrific, and the banal— has rendered them generic and thus without impact. Cindy Sherman also confronts prevalent images from popular culture, and

**5.55** John Baldessari,
Two Cages (Similar) with
Another Person Choosing, 1991

this work (5.56) is from an early series of photographs in which she posed herself in the guises of stereotypical American women. Here, Sherman perfectly captures the sultry glamour of the stars of Hollywood's B-movies, succinctly demonstrating the power of media-driven images to subsume individual identities. Commenting on a different aspect of society, Bernd and Hilla Becher record common and generic images from industrial culture. The Bechers have transferred the cataloguing project of their artistic forebear, August Sander (p. 148), from a study of the German people to that of industrial architecture (5.57). They typically present a certain type of structure—in this case, water towers— in a grid of photographs, thereby noting similarities and differences between examples. The serial nature of their inventories mimics the mass-production techniques of the very subject they study: the unrelenting, impersonal presence of the machine-made world.

**5.57** Bernd and Hilla Becher, Water Towers, 1980

**5.56** Cindy Sherman, Untitled, 1982

In the second half of the 20th century the boundaries between photography and other art forms blurred. Increasingly, traditionally trained artists would take pictures or use photographs in their artworks. A landmark crossover work (5.58) was created in 1969 by Lee Friedlander and Jim Dine. Friends, the two artists collaborated on a 16-page portfolio that paired a photograph by Friedlander with an etching by Dine on every page. The equal weight given to the images helped legitimize the inclusion of photographs in traditional forms of art and also heralded a new freedom for artists to employ any and all media when making art. Lorna Simpson is an artist who creates evocative works that examine how combinations of pictures and texts create new meanings that do not exist in the images or words alone. Typically, Simpson's conceptually based works are austere and elegant, yet their cool aesthetic masks a brutal directness about such issues as race, gender, identity, memory, and language.

5.58

**5.58** Lee Friedlander and Jim Dine, Untitled, from Work from the Same House, 1969

**5.59** Lorna Simpson, 2 Frames, 1990

**5.60** Hiroshi Sugimoto, Bass Strait, Table Cape, 1997

*2 Frames* (5.59) presents the image of a head with a severed braid arranged in a square and the word "undo." The artist invites multiple interpretations of this enigmatic pairing, from the formal contrast of round (head) and square (braid), to the verbal pun of (hair)do and undo, to the more profound idea that certain losses cannot be regained, such as a braid once cut or an identity curtailed. The seascape photographs of Hiroshi Sugimoto (5.60) likewise transcend traditional categories. Recalling soft-focus photographs of 100 years earlier, Sugimoto's images are also Minimal and Conceptual. ("If I already have a vision," the artist has stated, "my work is almost done.") Sugimoto travels around the world to record the sublime and timeless qualities of the sea. Sometimes holding the camera's shutter open for an hour or more, the artist subverts the traditional purpose of photography: to preserve fleeting moments in time. Instead, Sugimoto suggests, the most transcendent moments are those that last forever.

**5.59**

**5.60**

*The galleries of 19th- and early 20th-century
American art in the Beck Building continue
the story of art in the United States where the
Bayou Bend Collection (pp. 426–67) leaves off,
around the mid-19th century. Using select pieces
from Bayou Bend to introduce important themes
that carry over from the 18th into the 19th
century, these galleries feature paintings,
sculptures, and works of decorative art
(furniture, metalwork, ceramics, and glass).*

*Reflecting the allure that the nation's wilderness
held for many artists, a particular strength of
the American art collection is 19th-century
landscape painting. Designers of decorative arts
objects shared this fascination, evident in the
museum's magnificent furniture and silver pieces
that are ornamented with images of animals
and plants. The MFAH also owns one of
the most important collections of works by
Frederic Remington, originally acquired by
Will Hogg in the early 20th century.*

*The post-Civil War period is well represented
at the museum in both fine and decorative arts.*

Lavish international expositions and the collecting activities of the newly rich fueled a growing cosmopolitan art scene during this era. Numerous painters, from John Singer Sargent to Childe Hassam, lived or studied abroad, creating sophisticated portraits for wealthy clients, and pursuing the styles and subjects of French Impressionism in paintings of everyday life. Also at this time, a fascination with everything Japanese informed paintings and decorative arts, as exemplified in the museum's fine examples of Herter Brothers furniture, Tiffany silver, and paintings by Frederick Carl Frieseke and William Merritt Chase. The American Arts and Crafts movement is another of the museum's strengths, as is a major stained-glass window by Louis Comfort Tiffany.

The holdings in early 20th-century American art include wonderful Ashcan School paintings and important early abstract works. Paintings by Georgia O'Keeffe and other Taos artists are another highlight. The American galleries surround a sculpture court that features works by Adolph Alexander Weinman and Paul Manship.

During the 19th century, artists and writers sought to create a style of art that could be called uniquely American. The country's vast and varied landscape came to symbolize the infinite promise of the new nation. This potential was inherent in the theory of Manifest Destiny, which held that the United States had a divine right to expand its territory all the way to the Pacific Ocean. At the same time, with the increasing exploitation of the land, Americans began to appreciate the native beauty of their great, unspoiled wilderness.

**6.1 Thomas Cole, Indian Pass, 1847**
*The English-born artist Thomas Cole brought landscape painting to prominence in America. Cole became the center of the Hudson River School, a group of artists who imbued their landscapes with a reverence for nature. This painting celebrates the beauty and grandeur of the Adirondack Mountains.*

*Cole reimagines the scene before the arrival of white settlers. He erases all traces of tourism and includes a "noble savage," even though Native Americans had vanished from the area. Cole was deeply troubled by the progressive destruction of the wilderness, and his paintings warn of the imminent loss of America's natural heritage.*

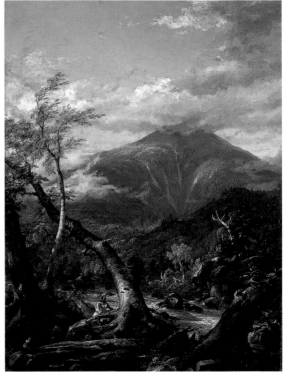

6.1

6.2

**6.2 John Frederick Kensett, A View of Mansfield Mountain, 1849**
*This painting depicts Mount Mansfield in Vermont—a favorite destination for artists and tourists alike during the mid-19th century. The figure in front of the easel in this painting is probably Kensett himself, representing the ideal of the artist at work in nature.*

**6.3** Frederic Edwin Church, Cotopaxi, 1855
*Inspired by the strange and the spectacular, Frederic Church painted geological wonders few Americans had ever seen. In 1853 he traveled to the remote mountains and forests of South America, following in the footsteps of Alexander von Humboldt and other great naturalist-explorers. While on*

*location, Church made small oil sketches to which he could later refer when painting large-scale canvases back in his studio. This panoramic view of Cotopaxi, the cone-shaped Ecuadoran volcano, encompasses its snowcapped peak as well as nearby tropical palms, a placid lake, and a thundering waterfall. The drift of smoke emanating from the volcano hints at Cotopaxi's devastating*

*potential, while the tiny figures in the foreground suggest the insignificance of humanity against the vastness of nature.*

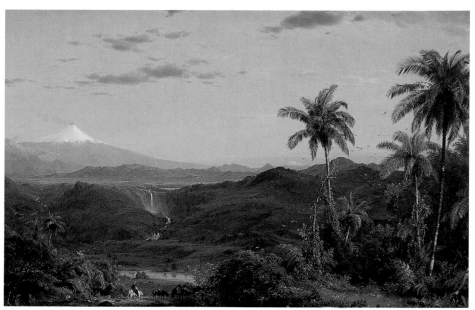

**6.3**

*The United States themselves are essentially the greatest poem. In the history of the earth hitherto the largest and most stirring appear tame and orderly to their ampler largeness and stir. Here at last is something in the doings of man that corresponds with the broadcast doings of the day and night.*

Walt Whitman, preface to *Leaves of Grass*, 1855

**6.4** Severin Roesen,
Victorian Bouquet,
c. 1850–55
The tradition of painting fruit
and flowers dates back to 16th-
and 17th-century Dutch and
German artists (pp. 59, 61).
By the 18th century, still-life
painting had fallen from
fashion, only to be revived in
Germany during the 1830s.
Severin Roesen was among
the many German artists
who studied the genre before
immigrating to America.
Following James and Raphaelle
Peale (p. 461), these artists
contributed to the growing
popularity of still-life paintings

in mid-19th-century America.
Here, the lush profusion of
natural bounty seems to suggest
the richness of an American Eden
and its promise of prosperity.
With a meticulous attention to
detail and skillful replication
of texture, this painting forms
a convincing illusion—never
mind that the flowers shown
blooming together here do not
do so in nature.

**6.5** Edward C. Moore
for Tiffany & Co.,
Coffee and Tea Service,
1856–59
Characterized by its exaggerated
naturalism, the Rococo revival
was a signature style in opulent
American houses of the mid-
19th century. This silver service
is embellished with ivy vines, a
subject also popular in Rococo
revival furnishings and ceramics.

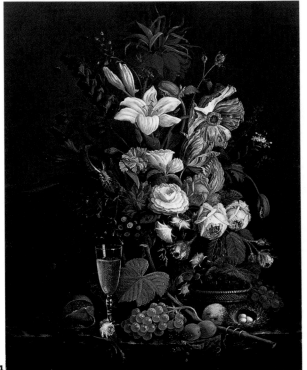

**6.4**

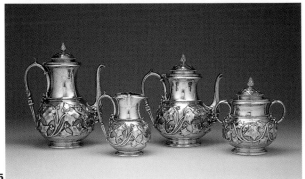

**6.5**

**6.6** Possibly New York, Sideboard, c. 1855

*Like Severin Roesen's meticulously rendered still-life painting (6.4), this extraordinary sideboard celebrates the lushness of the American wilderness. A stag, rabbits, fish, lobsters, eels, and grouse—all the bounty of field and stream—are sumptuously carved in astonishing detail. Focusing on a different aspect of America's Eden than the flower painting and the Hudson River landscapes on the preceding pages, this massive, elaborate showpiece commemorates man's perceived triumph over nature, a fitting theme for the wealthy urban dwellers for whom it was made.*

While other artists celebrated all that was beautiful in the American landscape, Frederic Remington (1861–1909) concentrated on the stark and the barren. Yet in forging a vision of the West that embraced America's notions of Manifest Destiny and an evolving national identity, Remington was a rightful heir to the great landscape tradition of the Hudson River School (p. 174). Himself a Yale-educated Easterner, Remington painted his nostalgic and romanticized images of the West for a predominantly urban market. At the same time, he created a myth about masculinity and the West that would become a mainstay of American culture.

**6.7 Frederic Remington, Aiding a Comrade, 1889–90**
*By the end of the 19th century — thanks in part to Remington himself — the American cowboy had become a national folk hero. This action-filled painting captures the dramatic moment during a Native American attack when a wounded cowboy falls from his horse. With the*

**6.7**

*Westward the course of empire takes its way....*

George Berkeley, "Verses on the Prospect of Planting Arts and Learning in America," c. 1726

enemy in hot pursuit, two comrades make a heroic rescue attempt. While Remington's cowboys remain typically stoic, the flared nostrils and panicked postures of the horses convey the fear and danger inherent in the scene. The painting is filled with incidental details of clothing and equipment that reveal the artist's fascination with the minutiae of frontier life.

**6.8** Frederic Remington, Fight for the Water Hole, 1903
As white Americans laid claim to the continent, their routes across the West were determined by the locations of water holes. Attacks from Native Americans often came when caravans stopped to rest. In this painting, five cowboys take part in a life-or-death struggle over a small pool

of water in an otherwise arid plain. Remington had begun to adapt Impressionist techniques to the Western landscape, as can be discerned in the loose brush strokes, blurred forms, strong shadows, and bright colors of this painting.

**6.8**

**6.8a** *Frederic Remington's work served as a model for many Hollywood westerns, including director John Ford's classic film* She Wore a Yellow Ribbon (1949).

**6.8a**

Mark Twain coined the term "Gilded Age" in 1873 to describe the period of unbridled, and at times unscrupulous, acquisitiveness that followed the Civil War. It was an extravagant era in which great fortunes were rapidly made and lavishly spent. Reveling in their sudden wealth and striving to outshine each other, the exultant American entrepreneurs of banking and industry embarked on a massive spending spree. Aiming to appear every bit as fashionable as their European counterparts, they filled their magnificent mansions with the finest classically inspired furnishings that money could buy. The Gilded Age soon became a golden age for American decorative arts.

**6.9 Attributed to Pottier & Stymus, Parlor Cabinet, c. 1862**
*Parlor cabinets—popular fixtures in fashionable houses of the Gilded Age—were intended as much for display as for storage. The prestigious New York cabinetmaking and decorating firm of Pottier & Stymus worked in a highly eclectic style that borrowed from Roman, Egyptian, and Renaissance sources. With its extravagant ornamentation and luxurious materials, this cabinet is a dramatic example of mid-19th-century classical design. The elaborate marquetry (inlaid wood) panel depicting Bacchus, the Roman god of wine, was made in France by the specialist craftsman Joseph Cremer.*

**6.9**

*Everybody was going to Europe—I, too, was going to Europe. Everybody was going to the famous Paris Exposition—I, too, was going to the Paris Exposition.*

Mark Twain, *The Innocents Abroad,* 1869

**6.10** Herter Brothers, Desk, 1869–71
*Gustave and Christian Herter were preeminent among the designers and cabinetmakers who helped nouveau-riche Americans outfit grand residences. The two German-born immigrants formed a company called Herter Brothers and designed furniture and interiors for the sumptuous*

*homes of such clients as Jay Gould, J. Pierpont Morgan, and William H. Vanderbilt. In this exquisite piece of furniture, Herter Brothers combined an admiration for ancient architecture with the shape of the traditional French writing desk for women.*

**6.11** Gorham Manufacturing Company, Compote, c. 1863–68
*Along with Tiffany & Co., the Gorham Manufacturing Company was one of the most innovative and influential style-setters of American silver. The restrained classical ornament of this elegant silver compote can be seen in the winged sphinxes that support the bowl, the Greek key banding around the rim, and the bearded masks on the sides and handles.*

**6.10a** *Herter Brothers' greatest Gilded Age commission was the William H. Vanderbilt house in New York. This room view is illustrated in* **Mr.** Vanderbilt's House and Collection, *a rare, 1883–84 four-volume portfolio in the MFAH library.*

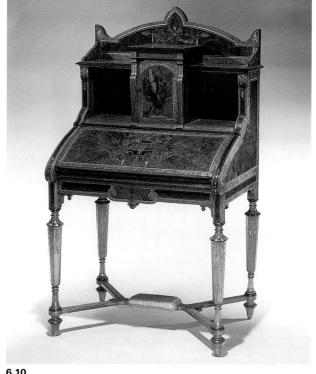

**6.10**

**6.10a**

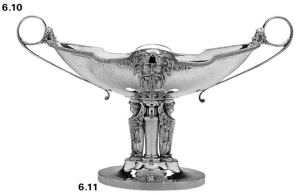

**6.11**

**6.12** John Singer Sargent, Mrs. Joshua Montgomery Sears, 1899

With his brilliant brushwork and stylish settings, John Singer Sargent became the favorite portraitist of the rich and famous not only in America, but in England and France as well. His paintings brilliantly captured the elegance and opulence of life in turn-of-the-century high society. This remarkable portrait of Sarah Choate Sears shows Sargent at his best. A painter, photographer, philanthropist, and patron of the arts, Sears was also the artist's friend. Her face reveals intelligence and intensity while her pose—at once casual and alert—embodies what one contemporary critic termed "the nervous tension of the age."

**6.12a** *John Singer Sargent in his Paris studio (detail), c. 1885*

**6.12**

We worked very hard—he with his magical brush, I with my determination to control fidgets and the restless instincts to which sitters are prone when forced to remain still for any length of time, for the most part we were silent. Occasionally I heard him muttering to himself. Once I caught: "Gainsborough would have done it! . . . Gainsborough would have done it!"

Account of an unknown sitter's experience with John Singer Sargent, 1902

**6.13** Thomas Eakins,
Portrait of John B. Gest,
1905
Thomas Eakins often produced
uncompromising and unflat-
tering portraits. As a result, he
received few portrait commissions,
thus limiting his subjects
primarily to friends, family
members, and people he admired.
In 1905, however, the Fidelity
Insurance and Safe Deposit

Company of Philadelphia
commissioned the 61-year-old
artist to create a portrait of its
president, John B. Gest. Somber
and austere, the penetrating
portrait is unrelieved by any props
that might deflect attention
from the sitter's superbly painted
face and hands. More poignant
than powerful, this rendering
of Gest shows the frailties and
anxieties of age as well as a

subtle trace of arrogance. His
strong features, contemplative
gaze, tightly clenched hands,
and tense posture convey a
complex psychological presence.

**6.13**

**6.13a** *Thomas Eakins (detail),*
*1880*

**6.14** Willard Leroy Metcalf, Sunlight and Shadow, 1888

*America's first major exhibition of French Impressionist paintings was held in New York in 1886 and included works by Edgar Degas, Édouard Manet, Claude Monet, and Auguste Renoir. Impressionism had been steadily ridiculed in France since its emergence in the 1860s, but the exhibition in America met with critical and popular acclaim. In fact, some American artists had already begun to experiment with the revolutionary style. William Metcalf was one of several Americans who, beginning in the mid-1880s, made pilgrimages to Monet's home in Giverny, France. Learning from the master, Metcalf abandoned preparatory sketches and began painting spontaneously from nature. This small study of brilliant light and deep shadow was painted in Giverny.*

**6.14a** *Postcard with photograph of Giverny, late 19th century*

6.14

6.14a

**6.15** William Merritt Chase, Sunlight and Shadow, Shinnecock Hills, c. 1895

*William Merritt Chase, celebrated in his own time for his remarkable talent and devotion to teaching, was among the most important artists of turn-of-the-century America. He was a flamboyant, generous,* *and charismatic art figure in New York, where he operated from two bases: his elegantly appointed Tenth Street Studio and the outdoor school of art in Shinnecock, Long Island. It was at Shinnecock Hills between 1891 and 1902 that he painted his greatest series of landscapes. In this example, Chase transformed the relatively flat, sandy, and ordinary* *countryside into a light-filled landscape where sky and land are pierced with a sliver of blue sea, white boats, and pink dunes highlighted by a streak of red. For another painting by Chase, see p. 189.*

**6.15a** *William Merritt Chase gives a landscape demonstration, probably at Shinnecock Hills, c. 1902.*

**6.15**

**6.15a**

**6.16** Henry Ossawa Tanner, Flight into Egypt, 1921

*An accomplished painter, illustrator, and photographer, Henry Ossawa Tanner struggled for acceptance as a black artist in America. He left for Europe in 1891, when he was 31, and he soon found success in Paris. A bishop's son, Tanner often painted religious scenes that transcend their biblical sources. With its themes of persecution, escape, and new beginnings,*

*the New Testament story of Mary and Joseph's Flight into Egypt resonated with the plight of African-Americans. Tanner painted the episode about 15 times, infusing each work with mystery and passion.*

**6.16a** *Henry Ossawa Tanner, c. 1900*

**6.16**

**6.16a**

**6.17** Childe Hassam, Evening in New York, 1890s

Childe Hassam discovered Impressionism during a trip to Europe in the late 1880s. He masterfully adopted the spontaneous brushwork, sparkling light, and everyday subject matter of the French artists, incorporating their methods into a style uniquely his own. The city was Hassam's favorite theme, and the wonderful chaos of New York provided him with unlimited inspiration. In this nocturnal view of Manhattan, quick strokes of paint capture the flickering reflections of lamplight on the rain-drenched sidewalk. Note how the hunched form of the cabbie is rendered with great economy and effectiveness.

6.17

*I paint from cabs a good deal. I select my point of view and set up my canvas, or wooden panel, on the little seat in front of me, which forms an admirable easel.... There is no end of material in the cabbies.*

Childe Hassam, 1892

In 1854, the American naval officer Matthew Calbraith Perry negotiated a treaty that ended Japan's 250-year isolation from the West. Japan began exporting prints, textiles, screens, porcelains, fans, kimonos, and more. The impact on Western culture was profound, and in America it was reinforced by the overwhelming public reaction to the Japanese pavilion at the 1876 Centennial Exhibition in Philadelphia. Responding to the elegance and exoticism of Japanese style, artists and designers in Europe and America began adapting Japanese designs to their work. With its connotations of a more refined way of life, Japanism soon became a vital component of 19th-century style.

**6.18 Frederick Carl Frieseke, Girl Reading, c. 1900**

*Japanese woodcuts flooded the European market in the late 19th century, finding an especially appreciative audience among French Impressionist and Post-Impressionist painters. Many artists became collectors, and some even included Japanese art in the backgrounds of their own paintings, as Frederick Frieseke did here. This American Impressionist painter probably first fell under the spell of Japanese design while he was studying in Paris. The compressed perspective, flattened color, and linear embellishment seen in this painting are borrowed from Japanese aesthetics.*

**6.18**

**6.19** William Merritt Chase, Mother and Child (The First Portrait), c. 1888

*William Merritt Chase was fascinated by Japanese culture. This lovingly painted study of the artist's wife and daughter is dominated by a traditional kimono. The subtle black tones of the robe and the background create a dramatic foil for the spectacular slashes of white and red.*

*The grand, full-length portrait was exhibited at the 1889 Exposition Universelle in Paris, where it represented the finest achievement in American art. Chase later hung the painting in his Shinnecock studio, and it remained there throughout his life. Incidentally, the child holds a whistle with coral similar to one in the Bayou Bend Collection (p. 442).*

*How shall you be made to feel, except before the picture itself, the beauty of two tones of black, one upon the other, the charm of the warmer carnation of the mother, or the tingling pleasure that one receives from the one note of vivid scarlet that cuts through this quiet harmony like a knife? How shall you be made to understand the sense of power that is conveyed by these broad, sure sweeps of the brush which delude you for the moment into the belief that painting is as easy as walking?*

Kenyon Cox, *Harper's New Monthly Magazine*, 1889

6.19

**6.20  Herter Brothers, Side Chair, c. 1876–79**
In contrast to the flamboyance of much 19th-century design, Japanese-inspired furniture was distinctive for its elegant simplicity. Influenced by Japanese ornament, the Herter Brothers company (p. 181) began producing its own interpretations of Japanese style in the early 1870s. Beautifully crafted and

perfectly proportioned, this side chair is decorated with a restrained design of inlaid blossoms. The cherry-wood frame was ebonized (stained or painted black), to resemble Japanese lacquer.

**6.21  Tiffany & Co., Napkin Clips, 1879**
When John Mackay struck the Comstock Lode, a vast reserve of Nevada silver, in 1873, he and his wife became two of America's wealthiest people. The Mackays shipped half a ton of their silver directly to Tiffany & Co. in New York, where it was transformed into one of the most luxurious dinner services ever

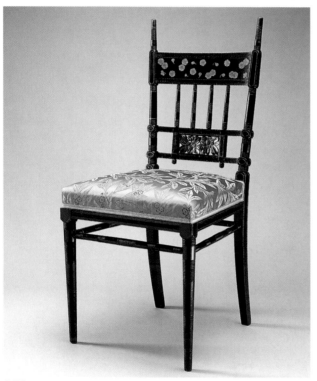

**6.20**

**6.21**

assembled. The service comprised more than 1,200 pieces, including 24 fantastical silver, gilt, and enamel butterfly napkin clips, eight of which now belong to the MFAH. Concealed in each butterfly's torso is a strong spring. When the insect's wings are raised, the legs part and then close to "grip" a napkin.

**6.22** Tiffany & Co., Punch Bowl, 1884

By the 1880s, yachting had become a favorite pastime of the very rich in America. The New York Yacht Club commissioned some of the finest examples of American presentation silver as prizes for its yacht races. Made by Tiffany & Co., this sterling silver and gilt bowl was won by the cutter Oriva in the Commodore's Cup race of 1884. The bowl's hammered surface and applied decoration were inspired by Japanese metalworking techniques. Wonderfully complex and creative in design, this punch bowl is abundantly embellished with images of shrimp, kelp, shells, and coral.

**6.22**

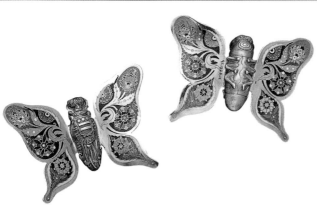

In the first decade of the 20th century, a new art movement emerged that would challenge traditional notions of what constituted appropriate subject matter for artists. Referred to as the Ashcan School because of its attention to the sordid side of city life, this movement centered around the artist Robert Henri. Fights, street scenes, and even portraits were painted with a freedom and directness considered by Henri appropriate to express "… the great fresh ideas with which our nation is teeming."

**6.23 Robert Henri, Antonio Baños, 1908**

*Believing that the artist must also be a force for social reform, Robert Henri developed a technically adventurous style that was nonetheless grounded in realism. With bold brush-work and pure color, he painted dramatic but unidealized portraits of ordinary people. Henri made several trips to*

*Spain and became fascinated with bullfighting. This dashing portrait depicts the picador Antonio Baños. While the matador personifies the glamour and heroism of the bullfighting ritual, the picador plays only a supporting role: his job is to goad the bull. In choosing this subsidiary character as his subject, Henri rejected the more elitist traditions of portraiture.*

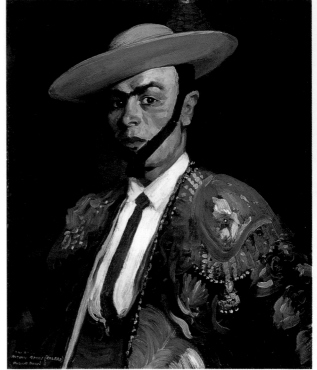

**6.23**

*Picadors suffer broken arms, jaws, legs, and ribs frequently, and fractured skulls occasionally. Few are killed in the ring in proportion to matadors, but many suffer permanently from concussion of the brain. Of all ill-paid professions in civil life I believe it is the roughest and the most constantly exposed to danger of death....*

Ernest Hemingway, *Death in the Afternoon*, 1932

**6.24** George Bellows, Portrait of Florence Pierce, 1914

*Although best known for his electrifying images of boxers, George Bellows also painted portraits, landscapes, and city scenes that vividly capture the vitality and variety of American life in the early 20th century. In 1913 Bellows helped organize the Armory Show, the*

*first major exhibition of Modernist art to be held in America. Perhaps inspired by the brightly colored Fauvist (p. 108) paintings included in the exhibition, he began using heightened color for its purely expressive qualities. This oil portrait is especially striking, with its vibrant color, dramatic lighting, and bold brushwork.*

**6.25** George Bellows, A Stag at Sharkey's, 1917

*Bellows saw his first boxing match at Sharkey's Athletic Club, located across the street from his Broadway studio. Sharkey's operated as a private club in order to bypass New York's prohibition against boxing at the time. By paying a fee, anyone could become a member for the night. A variation of a 1909 oil painting, this dramatic print of two anonymous pugilists celebrates the savage energy of the brutal sport.*

**6.26** George Bellows, Dempsey and Firpo, 1923–24

**6.25**

**6.26**

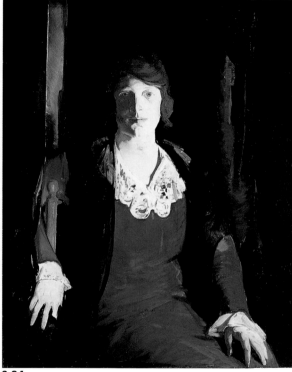

**6.24**

*. . . when [Jack] Dempsey was knocked through the ropes he fell in my lap. I cursed him a bit and placed him carefully back in the ring. . . .*

George Bellows

**6.27 Augustus Welby Northmore Pugin, made by John Webb, Chair, c. 1847**

*The architect and designer A. W. N. Pugin was one of the early reformers who inspired the English Arts and Crafts movement. His beautifully carved chair, a variation of one he designed for London's House of Lords, demonstrates an affinity for the Middle Ages that influenced American Arts and Crafts designers.*

# The Arts and Crafts Movement

Led by the visionary designer William Morris, the Arts and Crafts movement evolved in England during the mid-19th century, a period of increasing industrialization and mass production. Reacting against the tyranny of the machine and fearing a decline in the quality of design, many English artists and writers began demanding social as well as artistic reform. The aesthetics of the movement spread to America by the end of the century, leading to a revival of craftsmanship in cities and towns across the nation.

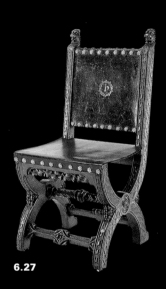

**6.27**

**6.28**

### 6.28 Charles Rohlfs, Desk, c. 1899

*Working from a small shop in Buffalo, New York, Charles Rohlfs created some of the most eccentric and inventive furniture of the Arts and Crafts movement. Like other Arts and Crafts furniture makers, Rohlfs used quarter-sawn oak and left the joints visible. But the exuberant addition of carved and pierced decoration gave his designs a vitality seldom seen in the more restrained furniture made by his contemporaries. Designed to rotate, this ingenious combination of fall-front desk and bookstand is a superb example of Rohlfs's creativity.*

*Have nothing in your houses that you do not know to be useful, or believe to be beautiful.*

William Morris, "The Beauty of Life," 1880

### 6.29 Cabinet design attributed to Benn Pitman, carving to Mary Madeline Nourse, and plaques to Artus Van Briggle, Wall Cabinet, 1887–93

*As the Arts and Crafts movement spread across America, so too did an effort to cultivate the artistic skills of women. This intricately carved wall cabinet was made in Cincinnati, a flourishing center of American Arts and Crafts activity. The cabinet was designed by one of the leaders of the city's art furniture movement, Englishman Benn Pitman, who relied on Gothic revival imagery for much of his work. The cabinet was then carved by Mary Madeline Nourse, in keeping with Pitman's philosophy: "Let men construct and women decorate."*

**6.29**

### 6.30 Roycroft Shop, Side Chair, c. 1905–12

The Roycroft colony was founded in East Aurora, New York, by a charismatic soap salesman named Elbert Hubbard. Neither a designer nor a craftsman, Hubbard saw himself as a social reformer. He established his own press and began publishing his philosophies—which owed much to the writings of William Morris—in beautifully bound books. Before long, Hubbard was employing innovative designers and skilled craftsmen to produce leatherware, metalwork, lighting, and furniture. Embellished with only the Roycroft name, this oak chair has the straightforward construction, pegged joinery, and beautiful austerity that characterize much American Arts and Crafts furniture. Although Hubbard died on the British ocean liner *Lusitania* when it sank in 1915, the Roycroft shop survived until 1938.

### 6.31 John Scott Bradstreet, Table, c. 1905

By the turn of the century, Minneapolis was a prosperous community with its own thriving Arts and Crafts industry. The city's leading proponent of "artistic" design was John Scott Bradstreet, whose cooperative craft center, closely modeled on the utopian ideals of William Morris, produced imaginative interiors for a select clientele.

One of Bradstreet's most original works, this table takes the form of a lotus, an aquatic plant. Bradstreet simulated a Japanese technique for artificially aging wood, and he decorated the table with Japanese-inspired lotus leaves. The triumphant result is a combination of a traditional 18th-century tea table form, Japanism, and American Art Nouveau design.

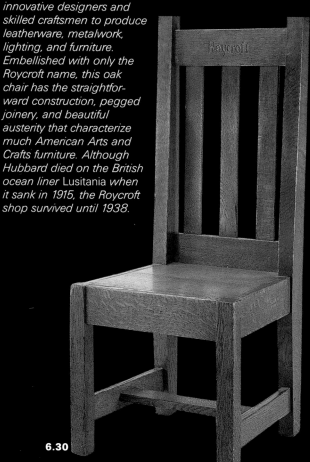

**6.30**

**2 Artus Van Briggle, 1de at 0okwood Pottery, /ase, 1896**

Rookwood was among the most innovative and influential of American art potteries. It was founded in 1880 by Maria Longworth Nichols, one of many upper-class Cincinnati women who dabbled in china painting as a hobby. Using new and traditional glazing techniques, the company achieved rapid artistic and commercial

success. This graceful vase was created at Rookwood by Artus Van Briggle after his return from a three-year, company-sponsored study trip to Europe. The Art Nouveau style and the Asian ceramics that he saw abroad deeply influenced him. In this work, the delicate design of flying cranes and the elegant shape of the vessel are both inspired by Japanese art. Van Briggle gave the vase to friends as a Christmas gift the year he made it.

**6.32**

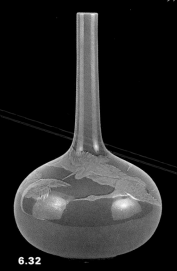

**6.31a** *John Scott Bradstreet (center) in Japan, c. 1905*

In America, Louis Comfort Tiffany's last name is virtually synonymous with beautiful glass. He began experimenting with glass production in the late 1870s, developing an infinite variety of rich texture and subtly modulated colors. Soon, Tiffany was creating vases, lamps, and windows of astonishing beauty and virtuosity. By 1900, stained-glass windows had become

the primary focus of his genius. Many of Tiffany's great windows were inspired by nature, as opposed to the religious subjects of church windows. His creations were thus more suitable for private homes. This spectacular window is a unified forest scene spanning three panels. Tiffany achieved remarkable pictorial effects by combining different textures, thicknesses, and colors of glass. Virtually a painting in glass, A Wooded Landscape is a testament to Tiffany's unqualified mastery of the medium. For a vase by Tiffany, see p. 385.

**6.34** Morgan Russell, Synchromy, c. 1914

*By 1912, the French artist Robert Delaunay was painting nonobjective works in which color became both form and subject. At around the same time in Paris, the American artists Morgan Russell and Stanton Macdonald-Wright were conducting their own experiments in color theory. They founded Synchromism— literally, "with color"—in 1913. Synchromism was an attempt to translate the laws of optics into a form of abstraction governed by color. The movement dissolved after less than a year, but both artists continued their color studies independently. In this small but ambitious painting, Russell arranges patches of color solely for their expressive properties. According to scientific theory, the placement of each color influences the hue and value of its adjacent colors.*

**6.35** Marsden Hartley, Abstraction, c. 1914

*When Marsden Hartley traveled in 1912 to Paris and to Munich, he met some of the champions of European Modernism. Before long, he had developed his own nonrepresentational style that was indebted to Robert Delaunay's circles of pure color and Vassily Kandinsky's (p. 112) theories of Expressionism.*

*Hartley returned to America in 1913 and exhibited his geometric abstractions at the Armory Show (p. 193). With its emblematic arrangement of circles and bands and its emphasis on pure color relationships, Abstraction is typical of Hartley's work at this time. In 1917 he abandoned abstract art to concentrate on landscapes and seascapes.*

**6.34**

**6.35**

**6.36** Stanton
Macdonald-Wright,
Arm Organization, 1914
*In this abstract painting,*
*Stanton Macdonald-Wright*
*uses color as a means of*
*arranging the composition.*
*Yet* Arm Organization *is*
*not entirely abstract. The*
*painting suggests a curving*
*torso, shoulder, and flexed*
*arm —possibly inspired by*

*Michelangelo's sculpture* Slave,
*which Macdonald-Wright had*
*seen in the Louvre and greatly*
*admired. Using* Slave *as a*
*framework, Macdonald-Wright*
*placed his wedges of color sys-*
*tematically, creating a dynamic*
*harmony of color and form.*

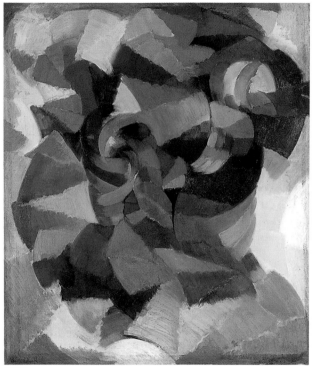

**6.36**

*Yet color is just as capable as music of*
*providing us with the highest ecstasies and*
*delights. By having liberated ourselves from*
*certain impediments and ties and plunged*
*boldly into the unknown, we have wrested*
*from nature the secrets necessary for bringing*
*painting to this highest degree of intensity.*

Morgan Russell and Stanton Macdonald-Wright, 1913

**6.37** Ernest Martin Hennings, Passing By, c. 1924

About 1900, the artists Ernest Blumenschein and Bert Phillips broke a wagon wheel in Taos, New Mexico, and decided to settle there permanently. Lured by the stunning desert landscape and pueblo culture, other artists soon followed. The Taos Society of Artists was formed in 1915, and by the 1920s the town was well known as an art colony. A transplanted Chicagoan,

Ernest Martin Hennings found endless inspiration in the landscapes and lifestyles of Taos. In this glorious painting, three Native Americans pass through the blazing autumn woods on horseback. Respectful of indigenous culture, Hennings portrays these men as dignified individuals.

6.37

**6.38** Georgia O'Keeffe, Red Hills with White Shell, 1938
*Born in Wisconsin, Georgia O'Keeffe discovered the compelling colors and forms of the Southwest while teaching in the Texas panhandle in 1912. Bridging abstraction and representational art, O'Keeffe sought images in nature that would symbolize her emotions.*

*This painting depicts a serene spiral shell enveloped by a vivid red landscape that swells to accommodate it. O'Keeffe invests the image with a psychological intensity, presenting the juxtaposition of hill and shell as something mysterious and monumental. Intimate and emblematic, the image suggests a spiritual connection between the human psyche and the natural*

*world. O'Keeffe painted this work in New Mexico, her winter residence beginning in 1930 and her permanent home from 1946 until her death in 1986.*

**6.38**

**6.39** Alfred Stieglitz, Portrait of Georgia O'Keeffe, 1933
*Alfred Stieglitz photographed this remarkable psychological study of his wife in New York, but the woven blanket O'Keeffe wears as a shawl represents her spiritual home in the Southwest.*

**6.40** Winslow Homer, Eight Bells, 1887

*In spectacular paintings and prints, Winslow Homer captured the seductive beauty and awesome power of the sea, his favorite subject. A masterwork of American printmaking, this superb etching reinterprets an 1886 painting of the same name. Using pure line, Homer sets two bearded sailors against a*

*turbulent sea and sky. Simple and heroic, these men symbolize the classic struggle between the fortitude of man and the forces of nature. By placing the figures to the right in the composition, Homer emphasizes the vastness of the ocean.*

**6.41** John Marin, The Little Sailboat, 1924

*The Maine coast was a favorite subject for John Marin, one of the great masters of American watercolor painting. Marin modified the Cubist technique invented in 1907 by Georges Braque and Pablo Picasso (pp. 314-17) to give structural form to his reverence for the natural world. In this vibrant*

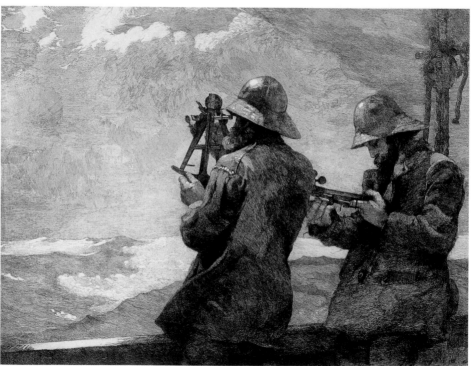

**6.40**

**6.41**

watercolor, he distills the elements of nature into geometric shapes and bold lines. Although Marin presents a multifaceted view of objects and forms, the overall effect is one of harmony and not fragmentation. The white paper becomes an important component of the composition, contributing to the freshness of the image.

**6.42 Stuart Davis, Gloucester Harbor, 1938**
Stuart Davis resolved to become a "modern" artist after visiting the Armory Show (p. 193) in 1913. Combining an interest in Cubism with an insistence on realism, Davis searched for abstract patterns in everyday scenes. In this lively view of a bustling harbor, he transforms boats, buildings, land, and sea into a rhythmic arrangement of stylized shapes and brilliant color. The painting takes the form of a ship's flag, an image that recurs throughout the work. Davis was among the first visual artists to appreciate jazz, and his work comes alive with the energetic syncopations and improvisations of this indigenous American music.

**6.42**

But as in landlessness alone resides the highest truth, shoreless, indefinite as God— so, better is it to perish in that howling infinite, than be ingloriously dashed upon the lee, even if that were safety!

Herman Melville, *Moby-Dick*, 1851

During the 1930s, the economic depression and related societal conflicts prompted some American artists to turn away from abstract, internationalist art (pp. 200–201) to celebrate rural and urban life at home. Regionalists like Thomas Hart Benton and Grant Wood rejected European influences, believing that the true expression of American art would be found in the simple life of towns and farms. At the same time, photographers —many sponsored by the Federal Arts Project— documented life across rural America. The photographs of Russell Lee and Walker Evans, for example, candidly depict daily life in America; when compared to the paintings, they show how idealized or emblematic these works by Benton and Robert Spencer really were.

**6.43 Thomas Hart Benton, Haystack, 1938**
*While America was suffering from a devastating drought and depression, Thomas Hart Benton painted idyllic scenes of agrarian life. Having begun his career as an abstract painter, Benton abandoned what he called the "modern experiment" to instead chronicle the quiet*

*heroism of life on the land. This painting portrays three field workers harvesting summer hay. Dynamic brush strokes animate the peaceful, fertile landscape, and even the haystack is charged with energy. The swirling rhythms that characterize Benton's painting are also present in the work of his most famous pupil, Jackson Pollock (pp. 132–33, 320–23).*

© T. H. Benton and R. P. Benton Testamentary Trusts/Licensed by VAGA, New York, NY

**6.43**

**6.44 Russell Lee, Mailbox, 1930s**

**6.45 Walker Evans, 6th Avenue at 42nd Street, New York City, 1929**

**6.46** Robert Spencer, The Exodus, 1928

*Favoring urban rather than landscape scenes, Robert Spencer reconciled a highly personal Impressionist technique with the contemporary social concerns of the Ashcan School (pp. 192–93). In this painting, he depicts the biblical theme of Exodus within a modern setting. A dense architectural background — perhaps representing factories, mills, and tenements — looms over the departing people. Created at a time when much of the world was in political turmoil, the painting suggests that a better life was to be found away from the crowded city and offers a sympathetic view of the predicament of refugees.*

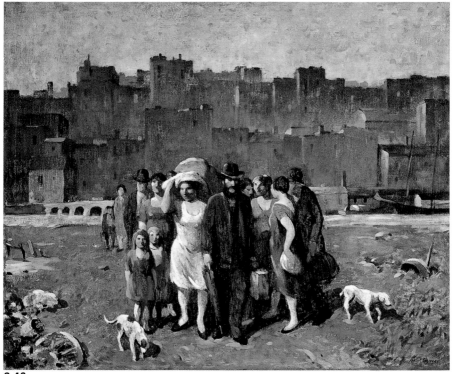

**6.46**

*... painting has declared its independence from Europe, and is retreating from the cities to the more American village and country life. ... It all constitutes ... an American way of looking at things, and a utilization of the materials of our own American scene.*

Grant Wood, *Revolt Against the City*, 1935

**6.47** Paul Manship, Hercules Upholding the Heavens, 1918

*Finding inspiration in the stylized forms of archaic Greek art, Paul Manship created elegant sculptures that anticipated the streamlined aesthetics of Art Deco design. Although his work was later eclipsed by the more sensational developments of the Modernist movement, Manship was the most celebrated American sculptor of his time. He designed this monumental work for the Pennsylvania estate of steel magnate Charles Schwab. The sculpture, over 10 1/2 feet tall, depicts the episode from the 12 labors of Hercules in which the Greek hero relieves Atlas of the task of holding up the heavens. By Renaissance times, the myth had been transformed into an allegory of astronomy, wherein Atlas taught the celestial science to Hercules. Manship therefore represented the heavens as an armillary sphere, an ancient device for plotting the heavens, which here performs the more commonplace task of a sundial.*

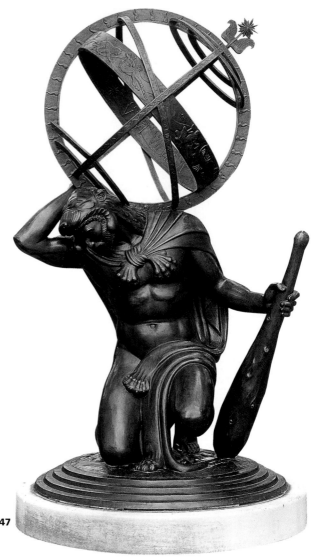

6.47

**6.48** Elie Nadelman,
Tango, c. 1918–24

*In 1914, the Polish-born artist Elie Nadelman emigrated to the United States and immediately established himself as the nation's leading avant-garde sculptor. Drawing inspiration from the folk-art dolls that he collected, Nadelman created witty and sophisticated sculptures that are at once delightfully nostalgic and strikingly modern. In this masterly work, two doll-like figures perform the tango. Nadelman playfully captures the seductive grace of the dance and the exaggerated posturing of the dancers. Carved from the humble medium of cherry wood, the painted sculpture was rubbed and sanded so that it resembles aged folk art.*

**6.48**

### Second Floor
- *African Art, including the Glassell Collection of African Gold*
- *Asian Art*
- *Pre-Columbian Art*
- *20th-Century and Contemporary Art*

### First Floor
- *20th-Century and Contemporary Art*
- *Oceanic Art*
- *Changing Exhibitions*
- *Hirsch Library*
- *MFAH Shop*

### Lower Level
- *Brown Auditorium*
- The Light Inside, *by James Turrell (in tunnel to Audrey Jones Beck Building)*

*Caroline Wiess Law, 1998*

*Nina Cullinan, 1958*

*Alice Pratt and George R. Brown, 1972*

The original 1924 museum building designed
by William Ward Watkin, with additions
by Watkin, Kenneth Franzheim, and Ludwig
Mies van der Rohe, is named in honor of
MFAH Life Trustee Caroline Wiess Law.
Mrs. Law's extraordinary contributions
of numerous works of art, along with
her generous gifts of funds and property,
have been instrumental to the growth of
the Museum of Fine Arts, Houston.

Within the Law Building is Cullinan Hall,
a 1958 addition designed by Mies and named
in honor of Joseph Stephen and Lucie Halm
Cullinan, parents of the MFAH's great
benefactor and trustee of almost 50 years,
Nina Cullinan. Another Mies addition,
1974's monumental Brown Pavilion, honors the
enduring support of The Brown Foundation, Inc.,
and the personal contributions of George R. and
Alice Pratt Brown. During 26 terms on the
MFAH board of trustees, Mrs. Brown was
centrally involved in the expansion of the
museum's buildings and art collection, and
she was a key force behind the creation of the
Lillie and Hugh Roy Cullen Sculpture Garden.

Sahara Desert

Sudan

East Africa

7

4

13

15

16 5

6 3 1 10

8

Guinea Coast 9 2

Equatorial Forest

11

14

Southern Savanna

Southern Africa

12

Cultural Groups
1   Asante
2   Bamileke
3   Baule
4   Bobo
5   Chamba
6   Dan
7   Dogon
8   Edo
9   Ekpeye
10  Ibo
11  Lega
12  Ndebele
13  Nok
14  Sala Mpasu
15  Senufo
16  Yoruba

Akan Peoples of
Ghana and
Côte d'Ivoire

The African art collection at the Museum of Fine Arts, Houston, focuses on works created by people living south of the Sahara in the grasslands and the rain-forest regions of western and central Africa. The galleries present the most important collection of African gold in the world, donated to the museum by Alfred C. Glassell, Jr., in 1997. Comprising more than 800 pieces, the Glassell Collection contains exquisite works primarily from the royal courts of the Akan peoples of Ghana and Côte d'Ivoire.

The masks, figures, hats, and knives that dominate the adjacent galleries span some 2,500 years, from Nigeria's Nok culture — which produced the earliest sculpture known south of the Sahara — to the mid-1900s. This part of the collection is strong in works from the Western Sudan and Guinea Coast regions, with particular depth in materials from the Yoruba and Akan peoples. The map at left identifies the cultural groups that created the art illustrated in this section, along with the ecological zones that shaped their lifestyles and art.

# The Glassell Collection of African Gold

*Alfred C. Glassell, Jr., 1999*

From ancient times, gold has been a highly prized metal throughout the world. In sub-Saharan West Africa, where gold is found in both rivers and fields, the art of the gold-smith has flourished for centuries at the courts of royal chiefs. Still used today to demonstrate power and prestige, and to promote political unity, beautifully crafted gold objects are an essential part of African court ceremonies.

The royal courts of the Akan peoples in Ghana are the most spectacular in Africa. Lavish processions and ceremonies relate the history, beliefs, and power of the state. Court regalia, worn or carried by the chief and his attendants, includes gold jewelry, headdresses, swords, and sword ornaments, as well as colorful textiles and umbrellas—all invested with special meaning and all relating to a combination of visual and verbal traditions. These objects belong to the state treasury, which each chief controls only during his reign. The style of the regalia has changed little since the 15th century, and new works continue to be made to replace items or to enlarge the treasury.

In addition to royal and military leaders, the Akan peoples confer special rank on linguists, who play the important roles of adviser, historian, and spokesman for the chief in a society rich with oral tradition. A carved and gilded staff is the most important symbol of the linguist's office and is a political art form that combines both visual and verbal symbols.

The peoples of West Africa are both inventors and bor-rowers. They have produced original designs and have created forms inspired by local and European imagery, freely mixing motifs from different cultures. Today, few ancient African gold works survive. War, trade, and local traditions of recycling and recasting gold all contributed to the loss and transformation of most gold artworks. The remaining objects, like those on view at the MFAH, date mainly from the 19th and 20th centuries.

The Museum of Fine Arts, Houston, is fortunate to have received the extensive collection of African gold formed by Alfred C. Glassell, Jr., a Life Trustee of the museum. Assembled over many years, the Glassell Collection is considered the finest of its kind anywhere in the world. It is the only substantial collection of African gold in an American museum.

**7.1**

### 7.1 Fly Whisk

*During Akan ceremonies of state, court attendants carry elaborately carved fly whisks covered in gold leaf. Symbolizing the wealth of the state and the high status of the individual attendant, fly whisks traditionally have also been used as funerary displays.*

### 7.2 Linguist Staff with Elephant Finial

*Owned by the Akan chief, elaborately carved gold staffs are carried at public events by linguists and represent the ruler's status and authority. A chief communicates with his subjects via the figurative ornaments adorning the top of each staff. These ornaments relate to proverbs about the chief's power and responsibilities. Here, the staff comments on the supremacy of the chief, as in this proverb: "After the Elephant there is no other Animal as big and as strong."*

### 7.3 Drum Figure

*This female figure once adorned a master drum, the largest and most important part of a traditional drum ensemble. The gold stool denotes her high status and thus the importance of the master drummer. Until the mid-20th century, drum ensembles performed at festivals and ceremonies throughout Ghana.*

**7.3a** *Drum with female figure*

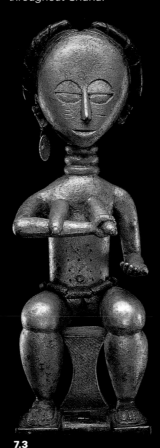

7.3

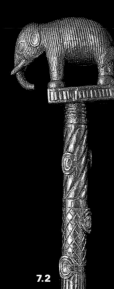

7.2

**7.4a** *Swordbearer*

**7.4 Chief Swordbearer's Headdress**
*An eagle-feather headdress is the largest and most ornate of the helmets worn by Asante swordbearers in Ghana during ceremonial occasions. The golden ram's-horn ornament, associated with the proverb "The ram fights with its heart not with its horn," implies that strength of spirit is more important than physical might.*

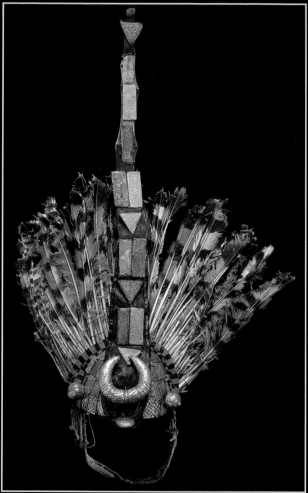

**7.4**

**7.5**

### 7.5 Sword with Sheath
*Second only to stools as essential items of an Akan chief's regalia, swords play a critical role in Akan rituals, including oath-of-office ceremonies and purification rites for the chief's soul. The handle of this elaborately carved sword is covered with gold leaf, and the blade is encased in a ray-skin sheath. The monkey ornament, suggesting the animal's intelligence and cleverness, is associated with chiefs.*

**7.6a** *A swordbearer wears a gold pectoral similar to the one illustrated below.*

### 7.6 Pectoral
*Akan royalty and other high-ranking officials wear gold pectorals, or chest ornaments, indicating their status. This magnificent example is called a soul washer's disk. Made of solid gold, it identifies the **okra** (soul washer), an appointed official responsible for purifying the chief's soul. This disk, over 7 inches in diameter, is one of the largest known, and it is cast in relief with a crocodile in the center of a starburst. Because crocodiles can live and even dominate both on land and in water, they often represent chiefs. As one proverb states, "The crocodile lies in the water but it also breathes air."*

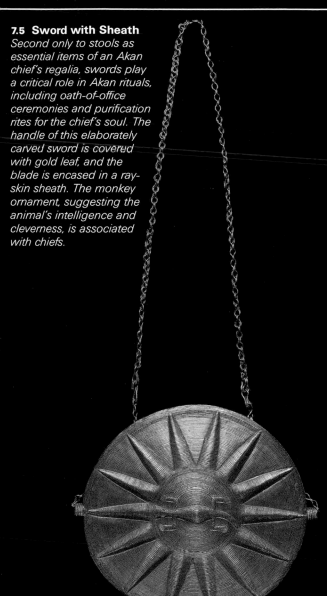

**7.6**

**7.7a** *A woman of Côte d'Ivoire wears jewelry similar to the pieces on these two pages.*

**7.7 Necklace**
*This exquisite necklace represents the exceptionally fine workmanship of Akan goldsmiths. Each pendant is formed of beeswax threads that are finely coiled and then cast in gold, a process requiring great skill. The rectangular beads are called bamboo doors and symbolize the chief. Just as a bamboo door faces both inside and outside the house, a chief knows everything inside and outside his village.*

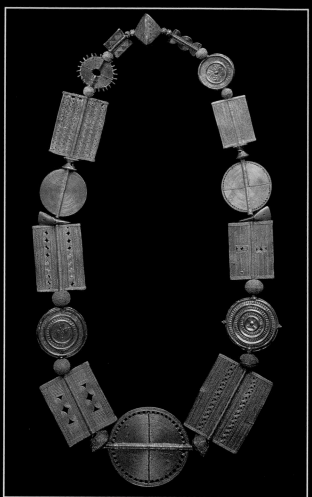

**7.7**

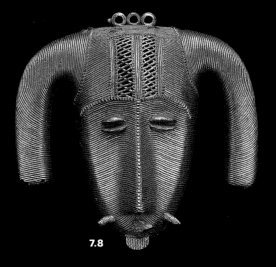

**7.8**

### 7.8 Ram's Head Pendant

*As early as the 17th century, the Lagoon people of Côte d'Ivoire adorned their hair and foreheads with great numbers of pendants cast in gold. They believed that these pendants would protect them from harm. This finely worked example in the shape of a ram's head with long horns is associated with the proverb "My strength is in my horns."*

### 7.9, 7.10 Combs

*Akan women own gold-leaf wooden combs that are delicately carved with multifaceted surfaces to capture and reflect light. Figures of domestic birds are popular motifs. Associated with the daily activities of guiding and nourishing children, images of hens evoke ideas of cooperation and the well-being of others. Because the cock announces the beginning of the day, it is a frequent symbol of the chief's power. The comb at near right illustrates a cock's head, and the comb at upper right takes the form of two cocks.*

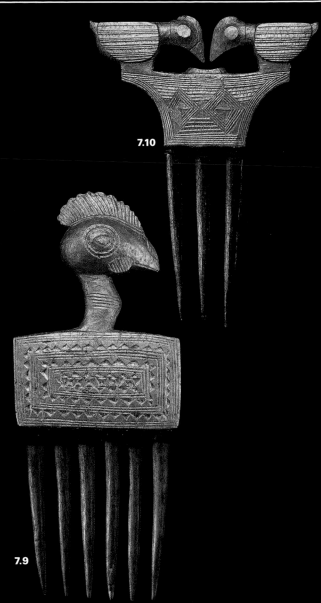

**7.10**

**7.9**

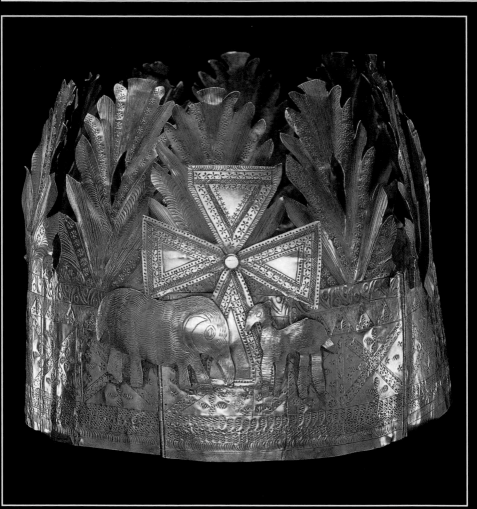

**7.11**

### 7.11 Crown

This exceptional crown represents a confluence of styles seen frequently in Akan art. The form is fashioned after a style of crown popular in 19th-century Europe, whereas the palm leaves and animals represent native motifs. An elephant and a dyker (a small type of antelope), facing each other in the center, symbolize the chief's authority and intelligence.

**7.11a** An Akan chief

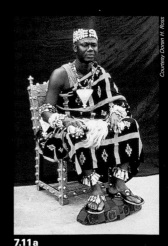

**7.11a**

## 7.12 Ring with Cocoon
## 7.13 Ring with Mudfish

*In Ghana, ornate gold rings are the prerogative of the wealthy and powerful. As with other Akan objects, a chief's rings function on verbal and visual levels that pertain to his wealth and his right to rule. The ring covered in gold spikes represents an insect's cocoon and relates to a traditional riddle: "Did the insect build the cocoon before entering it, or did the insect build the cocoon around itself?" In other words, a person's character is not easily determined from appearances. The exquisite ring in the form a mudfish, a prized food source that lives in the same rivers in which gold is found, symbolizes the chief's wealth.*

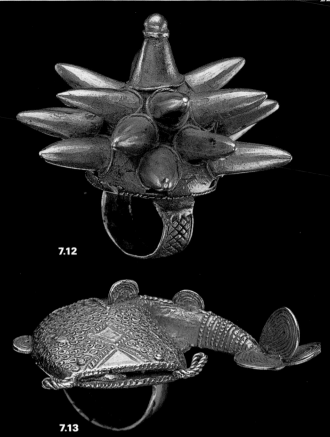

**7.12**

**7.13**

*An area of nearly a mile in circumferences was crowded with magnificence and novelty. The king, his tributaries, and captains were resplendent in the distance surrounded by attendants of every description, fronted by a mass of warriors. The sun reflected with a glare from the mass of gold ornaments, which glistened in every direction.*

British envoy
Thomas Bowdich
describing the Akan chief
of the Asante state, 1819

**7.14** Nok, Nigeria, Jos Plateau region, Head and Torso of a Female Figure, 500 B.C.–A.D. 200

The rich artistic heritage of the African region now known as Nigeria dates back at least 2,500 years. The Nok culture is the oldest in Nigeria and the first in all of sub-Saharan Africa to produce sculpture.

This little-known civilization was not discovered until 1943, when tin miners unearthed the first hollow terra-cotta figurines. These sculptures have haunting facial expressions, pierced eyes and nostrils, elaborate hairstyles, and lavish jewelry. Scholars believe that such a sophisticated style indicates the existence of an even older cultural tradition. Though now missing the lower body and part of the left arm, this elegant figure retains a powerful and imposing presence.

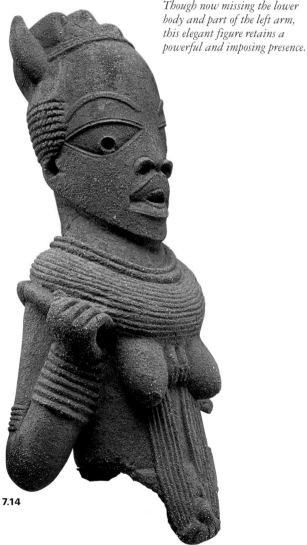

7.14

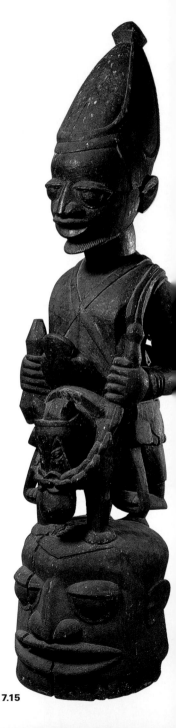

7.15

**7.15** Possibly Agbonbiofe, Adeshina School, Yoruba (Ekiti subgroup), Nigeria, Efon-Alaye town, Helmet Mask with Equestrian Figure, 1900–1950

*Every two years, the north-eastern Yoruba people hold a festival called Epa, during which they honor ancestors who were kings, queens, chiefs, and warriors. Family members commission artists to memorialize these relatives in large wooden masks that are then worn by dancers in the Epa masquerade. Equestrian figures are common on these masks because horses indicate wealth, power, and prestige. This rider wears the traditional conical crown of a Yoruba ruler and holds a fly whisk, another symbol of status, in his left hand. From the famous Adeshina school of carvers, this mask may have been created by the master himself, Agbonbiofe.*

**7.16** Edo, Nigeria, Benin City, Plaque with Court Retainer, 1550–1680

*In the powerful warrior kingdom of Benin (located in present-day Nigeria), all art was created to glorify the king and state. Brass plaques adorned the wooden pillars of the royal palace and depicted a range of figures from court life, such as the high-ranking royal*

*dignitary seen here. His large ceremonial sword, leopard-skin skirt, and leopard-fang necklace signify his status. The leopard was a symbol of leadership, embodying qualities of courage, strength, ferocity, and cunning. The royal guild of metalworkers in Benin mastered the art of brass casting by the 15th century, producing works that are unsurpassed in symbolic power and technical skill.*

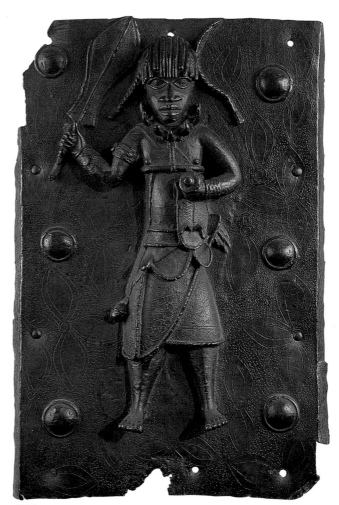

**7.16**

**7.17** Yoruba (Ekiti subgroup), Nigeria, Mother and Child Figure, late 19th century

*Throughout Africa, large families are both a practical necessity and a source of pride. Children provide additional labor during harvest times and then later, as adults, support the elders who can no longer work. Descendants also take care of the funeral rites that the Yoruba believe ensure the arrival of a deceased person's soul in the spirit world. Not surprisingly,*

*therefore, much African art alludes to procreation. The theme of mother and child is particularly prevalent in the art of the Yoruba. Like much Yoruba art, this shrine figure combines strong forms with a sensitive humanism. Note how the pensive gaze of the steadfast mother contrasts with the active posture of the distracted child.*

**7.17a** *A Yoruba woman carries an infant on her back. She also holds a plastic doll that she uses as a twin figure (see 7.18).*

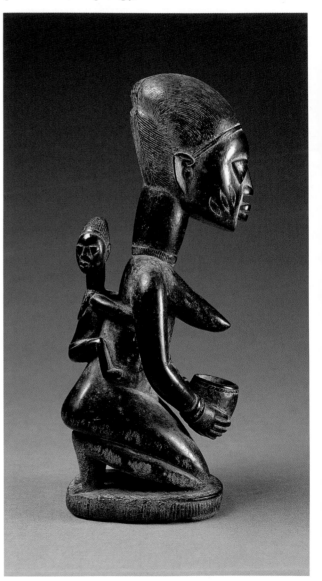

**7.17**

**7.18** Yoruba (Igbomina subgroup), Nigeria, Ila-Orangun town, Female Twin Figure, late 19th–early 20th century
*The Yoruba have the highest rate of twin births in the world. If one twin dies, an* ere ibeji *(wooden figure) is carved to represent his or her soul. The mother washes, dresses, and otherwise*

cares for this figure as if it were a living being. If she neglects these observances, the Yoruba believe that the deceased twin may take revenge upon its surviving twin or upon the entire family. With its rigid stance, compact body, and large head, this sculpture is typical of Yoruba twin figures. It is not a portrait; rather, it represents the child as an adult in the prime of life.

**7.19** Asante (Ashanti), Ghana, Fertility Figure, early 20th century
*Asante fertility figures are cared for by women wishing to conceive and by pregnant women hoping to ensure the birth of healthy children. The dolls embody Asante ideals of beauty: a high forehead, a small mouth, and a neck ringed with rolls of fat, symbolizing material well-being.*

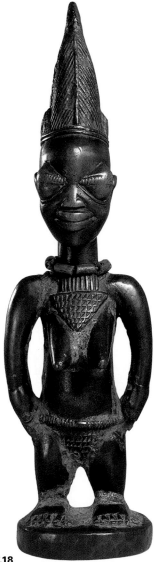

**7.18**

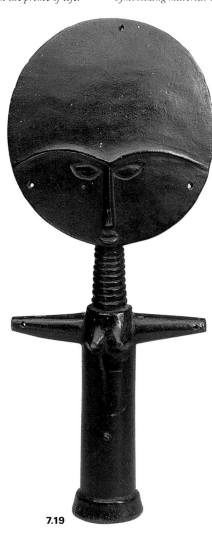

**7.19**

Ceremonies and rituals that involve masks are important in many societies throughout west and central Africa. These events honor ancestors and deities, ensure abundant harvests, placate angry spirits, enforce social rules, promote human fertility, entertain the community, and mark major transitions in life. Whereas some masked events are held in secret, major public masquerades involve masked dancers, attendants, musicians, singers, and the audience in exuberant festivities. Typically, only men make and use masks, and they must earn the privilege of wearing particular kinds.

**7.20** Ibo (Igbo), Nigeria, Helmet Mask of a Maiden Spirit, late 19th–early 20th century

*Much of northern Ibo art is produced for the Mmwo, a secret men's society dedicated to ancestral spirits. The maiden spirit mask, which represents a beautiful young woman, is worn at funerals and at the annual harvest festival. Here, the flam-boyant structure atop the head exaggerates the hairstyles worn by late 19th-century British women (familiar to the Ibo through Britain's occupation of Nigeria). The face is painted white, a color the Ibo associate with goodness, beauty, wealth, and the spirit world. Scarification marks—another sign of beauty—are carved in relief and highlighted with orange paint.*

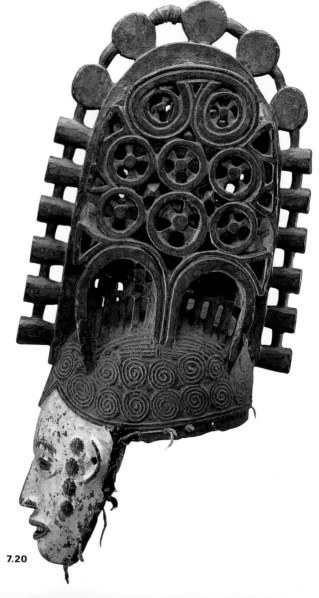

7.20

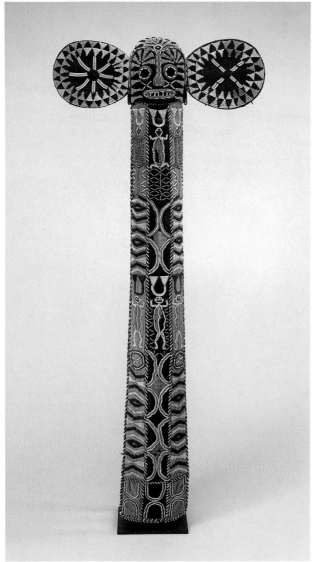

**7.21**

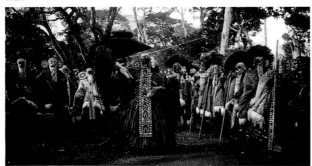

**7.21a**

**7.21** Bamileke,
Cameroon, Grasslands,
Elephant Mask, 1900–1950
*In the Bamileke culture,
the power of the king is
complemented by the Kuosi
society, a group of wealthy,
titled men who serve the king as
warriors and administrators.
Only the highest-ranking men
of this society are entitled to
wear masks representing the
elephant, a quintessential royal
symbol of force and strength.
While most African masks are
carved of wood, the elephant
masks of western Cameroon are
spectacular creations of beaded
cloth that involve considerable
time and skill to make. The
extravagant use of imported
glass beads indicates wealth.
This magnificent mask is
unusual for its muted colors
and images, which include
humans, chameleons (harbingers
of death), double gongs (repre-
senting the Kuosi society), and
frogs (symbols of fertility).*

**7.21a** *Kuosi society members
wear elephant masks in
Bandjoun, Cameroon, 1930.*

**7.22** Sala Mpasu, Congo (Kinshasa), Kwilu-Kasai region, Male Helmet Mask, 1925–50
*For the fiercely independent Sala Mpasu, warfare and hunting are prized pursuits. All Sala Mpasu men belonged to a secret society of warriors that survived until the early 1960s. Within this society, different masks signified different titles, each of which had to be earned or purchased. Masks worn by killers were the most prestigious, especially the* mukish *mask, worn by a man who had killed four specific individuals, including his wife. This* mukish *mask displays a bulging forehead, slit eyes, cylindrical nose, long raffia beard, and imposing feather crest, designed to intimidate all who see it.*

**7.23** Bobo, Burkina Faso, Bobo Diulasso region, Helmet Mask with Buffalo Horns, early 20th century
*In the Bobo culture, blacksmiths form a hereditary caste of artisans who not only forge iron but also carve masks. In African societies, a mask is not usually worn by its maker, but Bobo blacksmiths do enjoy the privilege. This wooden nature-*

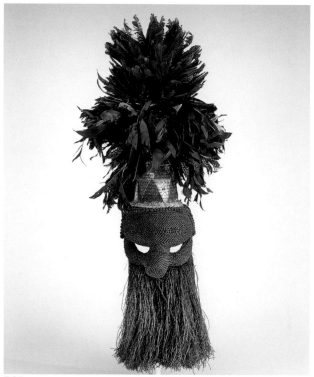

**7.22**

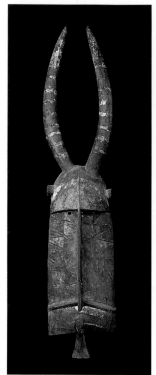

**7.23**

spirit mask, combining a stylized human face with buffalo horns, is covered entirely with geometric designs that would be freshly painted for each performance. Although very prestigious, this large and heavy mask was extremely difficult to wear. The tab at the bottom was probably grasped by the wearer in order to help balance the mask while he danced.

**7.24** Chamba, Nigeria, Helmet Mask of a Bush Cow, late 19th century
Secret societies in northern Nigeria and western Cameroon use horizontal masks representing bush cows (Cape buffaloes) and other animals to help control the fate of crops, humans, and communities. The Chamba produce some of the most abstract examples. Members of the Vara

society wear such masks to harness the spirits of these powerful bush animals into serving the needs of human society. Although unruly and at times dangerous, the bush cow is respected for its strength and cunning. It is also considered the protective ancestor of the earth.

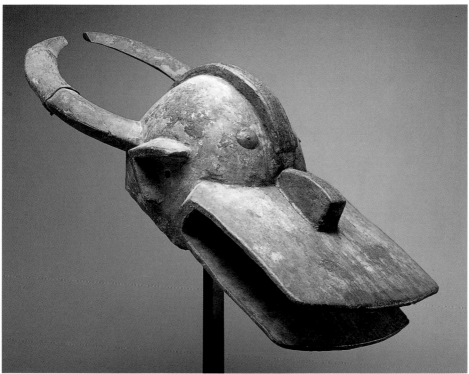

**7.24**

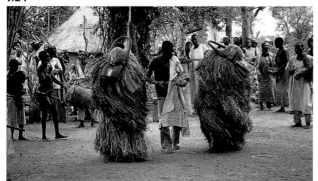

**7.24a** *Masked dancers perform at the annual royal death rites in Yeli village on the Nigeria-Cameroon border.*

**7.25** Dogon, Mali, Bandiagara region, Ceremonial Trough, 18th–early 19th century

*According to Dogon myth, eight nommos—or water spirits—were the ancestors of the first humans. The nommos descended from the sky to earth in an ark, but along the way one nommo was sacrificed to the heavens. One of the remaining nommos—a blacksmith—led the ark and its passengers to earth, bringing tools, grains, and animals. In one version of the story, the ark had the head of a horse. This trough represents that ancient ark. All eight nommos appear on one side of the trough, but only the seven who survived the journey appear on the other side. These primordial figures are represented as androgynous, each having the beard of a man and the breasts of a woman.*

**7.26** Ekpeye, Nigeria, Pangolin Headdress, 1925–50

*During the dry season each year, the Ekpeye people participate in a three-day festival full of feasting and vigorous, masked dancing. Among the many creatures represented in masks and headdresses is the pangolin, a scaly anteater found in Africa and Asia. Because it resembles both reptile and mammal, the pangolin is considered a special creature and a symbol of transformation. Whereas most traditional African sculpture is carved from a single block of wood, this headdress is constructed from individually fashioned scales and claws that are pegged into the pangolin's body and feet.*

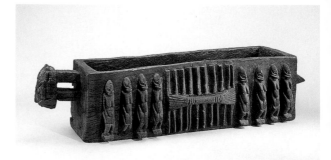

**7.25**

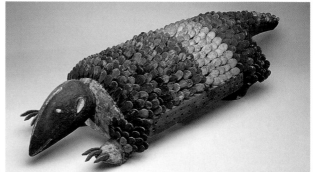

**7.26**

**7.26a** *A white-bellied pangolin from the jungle in Cameroon.*

**7.26a**

**7.27** Senufo, Côte d'Ivoire, Anthropomorphic Hornbill, early 20th century

*Senufo families perform rituals in secluded groves outside their villages. Some groups carve monumental sculptures of hornbills—considered divine in Senufo belief—to stand guard in the houses of the overseers who protect those groves. Like many African masks, this classic hornbill sculpture is a combination of animal and human elements. Although recognizably a bird, the creature has an upright posture, thick legs, narrow armlike wings, and overall proportions that are human. The form of the figure symbolizes both human fertility and agricultural abundance: the long beak meeting the swollen belly denotes both the male and female components of procreation, while the large stomach also represents a plentiful food supply.*

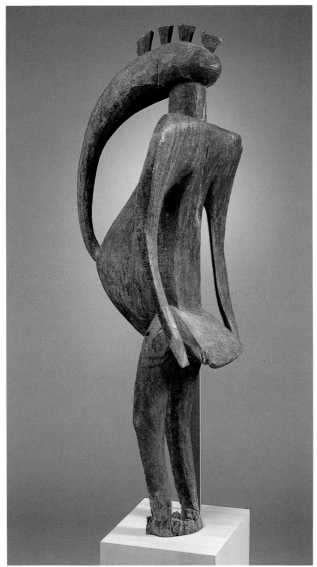

**7.27**

**7.28** Senufo, Côte d'Ivoire, Korhogo region, Champion Cultivator Staff, late 19th–early 20th century

*Young Senufo men compete regularly in hoeing contests, and the most skillful tiller of soil is awarded a champion cultivator staff. Such a staff is topped by a carving of a seated young woman, as seen in this elegant* example. *The figure promises its owner a beautiful wife, many children, and abundant harvests. The equation of agricultural bounty with human fertility is prominent in the art of sub-Saharan Africa. Also common in African art is the addition of accoutrements —such as the horn and cowry shells here— to increase an object's power and significance.*

**7.29** Dan, Liberia or Côte d'Ivoire, Spoon, late 19th–early 20th century

*Among the Dan, large wooden spoons are awarded to the most generous and hard-working married women from each section of a town. Called* wunkirles, *these highly respected women gain their reputations by extending hospitality to others, especially strangers. Only those industrious women whose husbands are successful farmers can accumulate enough grain to practice such generosity. These women are honored at a special "feast of merit," during which all of the town's wunkirles carry their spoons through the streets, dancing and scattering food and money. Many of these spoons— including this fine example— have handles in the shape of a woman's lower body.*

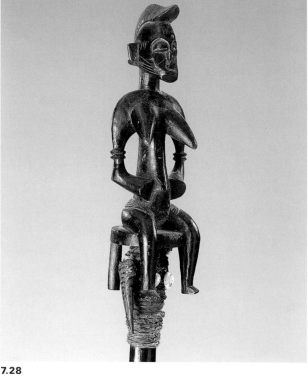

**7.28**

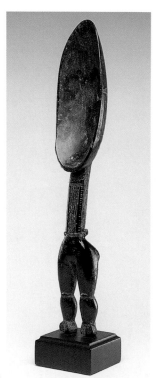

**7.29**

**7.30** Baule, Côte d'Ivoire, Nature Spirit, late 19th century

The Baule believe that many problems are caused by asie usu (disgruntled nature spirits) who roam the wilderness. A person seeking a diviner's help in placating such a spirit might be told to carve a symbolic spirit figure. The person would then keep the figure in a private shrine and regularly offer it food and libations for the remainder of the person's life. This example features extensive scarification, an elaborate hairstyle, a braided beard, and a stool, all indications of high social rank. The worn and pigmented surface of this finely carved figure attests to its frequent ritual use.

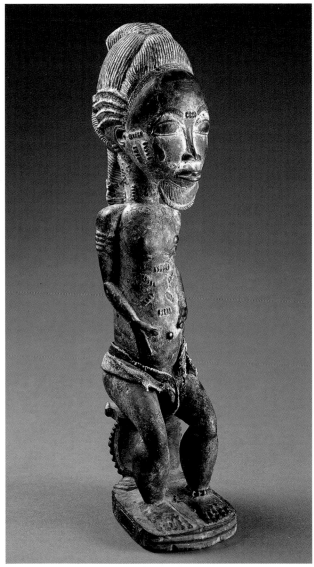

**7.30a** The scarification patterns of a Baule woman in Kouassikouassikro village, Côte d'Ivoire.

7.30

**7.31, 7.32, 7.33** Lega, Congo (Kinshasa), Hats

*The Lega create only small-scale art, all of which is produced for the Bwami society. This powerful association, open to both men and women, dominates Lega society. Members progress through a series of graded ranks, five for men and three for women. Each rank is distinguished by specific insignia, such as masks, figurines, and hats. These three hats all belonged to men of the highest rank, the* kindi. *Each hat consists of a conical basketry base that is covered with small, repeated elements and topped by a dramatic ornament made of animal parts.*

  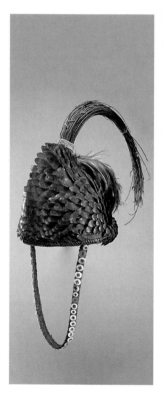

**7.31** Hat with Elephant Tail, 1925–50

*This hat features a base covered with cowry shells, and a crest made of an elephant tail. For the Lega, who live far from the sea, cowry shells are objects of value and therefore prestigious. Throughout Africa, the elephant is a symbol of power and wisdom.*

**7.32** Hat with Hornbill Skull, 1925–50

*The hornbill beak atop this hat represents pride and ambition; the mussel shells are associated with status, wealth, respect, and continuity. The red plastic disks were made in Europe for the central African trade and therefore are also objects of wealth and status.*

**7.33** Hat with Pangolin Skin, 1925–50

*This hat resembles a pangolin (p. 230) curled into its defensive position. The pangolin scales signify piety and respect, while the feathers are symbols of the wearer's newly strengthened heart created by initiations. A flourish of elephant hair adorns the top.*

**7.34** Yoruba (Owo subgroup), Nigeria, Kingdom of Owo, Ceremonial Knife with Scabbard, late 19th–early 20th century

*The Yoruba kingdom of Owo is justly famed for its fine ivory carving and sumptuous beadwork. Throughout sub-Saharan Africa, objects made from ivory and glass beads indicate the power, wealth, and status of their owners. This knife, worn by the Owo king during major festivals, hung from his left hip over a wrap skirt. The green bush-cow head on the scabbard represents strength and cunning, attributes also ascribed to chiefs and kings. The brass bells, another status symbol, announce the presence of a high-ranking individual.*

**7.35** Ndebele, South Africa, Transvaal, New Bride's Ceremonial Apron, 1900–1950

*In southern and eastern Africa, a woman's most important item of clothing is an apron, because it covers the most private parts of her body. For the Ndebele, different types of beaded aprons indicate marital status. This form, with five lappets, or flaps, at the bottom, is made for a bride by her new mother-in-law. The creation of such elaborate beadwork involves a laborious process requiring thousands of glass beads imported from Bohemia at considerable expense. Beadwork is a primary means of artistic expression in this region, where no tradition of masking or wooden figural sculpture exists.*

**7.34**

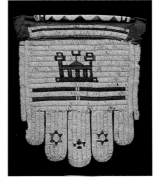

**7.35**

Gandhara

China

Korea      Japan

Pakistan

Tibet

India

Burma

Thailand

Cambodia

Indonesia

Java

Asian art at the MFAH comes primarily from four geographic areas—China, Japan, India, and Indonesia—with smaller holdings from Korea, Tibet, Burma, Thailand, and Cambodia. The museum's galleries present approximately 300 works that span more than 4,000 years of history, from a Chinese vessel made about 2400 B.C. to contemporary Japanese ceramics made in the 1990s. Among the Chinese works, a neolithic funerary jar, a 5th-century B.C. ritual vessel, and Tang dynasty tomb figures are particularly important. Significant Japanese holdings include a Jomon pot and a graveside sculpture from pre-Buddhist Japan. Chinese and Japanese scroll paintings showcase the rich painting traditions in those cultures. Early relief sculptures from India portray Buddhist and Hindu gods, and rare, well-preserved Indian textiles rotate periodically with fine examples of Indian miniature painting. The centerpiece of Indonesian art at the Museum of Fine Arts, Houston, is the magnificent Glassell Collection of Indonesian Gold, comprising ceremonial jewelry and other objects worn as symbols of status.

**8.1 Funerary Jar,**
**c. 2400 B.C.**
*When this large pot was made in northwest China more than 4,000 years ago, the people of the region were in transition from a hunter-gatherer society to a more settled way of life. They had no metal tools or technology and*

*made this vessel by coiling thin rolls of clay in successive layers to achieve the desired shape. The outside was then beaten with a wooden paddle and smoothed with diluted clay. Finally, the pot was painted and fired in a kiln. This example displays a spiral pattern that is one of the*

*earliest known uses of the brush in China's ancient artistic tradition.*

8.1

8.2

**8.2** Ritual Vessel, early 5th century B.C.

*Rounded, three-legged bronze containers decorated with abstract and animal designs are called* ding *in Chinese. Originally used in ancestor-worship ceremonies to hold ritual sacrifices of meat, ding were also used at banquets at home and at war during the period this example was made. Because bronze was an expensive material, ding were symbols of prestige, given as diplomatic gifts and included in dowries. Historical texts report that the emperor used nine ding in his sacrifices while the upper classes used only three. This unusually large ding is elaborately decorated with stylized dragons (one of which is outlined by the white circle) and finely curved scroll patterns. Horned monster heads adorn the knees of the three legs.*

**8.3** Tomb Brick,
206 B.C.–A.D. 9

At *about the same time that the Roman Empire ruled in the West, the powerful Han dynasty controlled north central China. The Han, like the ancient Romans, are remembered for their military skills and cultural contributions. Over the course of four centuries, Han emperors unified the region, revived classical learning, and established trade with the West,* including Rome. Tombs during the early part of this period were constructed of decorated, baked-clay bricks. This example depicts a dragon mounted by a warrior who brandishes a sword and a shield. The design was made by pressing stamps of the figure and dragon into wet clay. A different stamp created the border pattern.

**8.3**

### Dragons in Chinese Art

*Throughout history, the Chinese have considered the dragon to be a benevolent creature, giver of the heavenly rain that makes crops grow. As a ruler of beasts and a creative power, it was an ancient symbol of the emperor. The dragon's pearl—which it was believed to keep in its throat—represented wisdom and the perfection of the emperor's words. As Chairman Mao once said, "You do not argue with the dragon's pearl." In Chinese art, dragons appear in ceramics, sculptures, architectural decoration, and paintings.*

**8.4** Guardian Figure, 618–906
*This fierce-looking figure was made during the Tang dynasty (618–906) to stand guard in the tomb of a wealthy noble. According to Tang practices, tomb figures were displayed during funerary processions and were buried with the dead to serve as escorts to the heavenly realm. The status and wealth of the deceased person determined the number, quality, and size of the tomb sculptures. Derived from one of four Buddhist celestial kings, this superb guardian figure wears 8th-century armor that is embellished with fantastic dragons' heads and monsters to emphasize its otherworldly power. Finished with a unique three-color glaze developed by Tang potters, the work exemplifies the unequaled artistic splendor of the period.*

8.4

**8.5** Vase,
1736–96

In China, jade has been cherished as a symbol of wealth and status for more than 6,000 years. This vase was made when the production and quality of jade were at their height. Because it is a hard gemstone that cannot be carved in a traditional sense, jade requires the use of special grinders, drills, and abrasives. The artist who created this

beautiful vase from a single piece of jade exploited the stone's capacity to be worked in great detail. Basing the shape and decoration on an archaic bronze vessel, he carved the vase's side rings to hang freely from the handles. The soft chime produced when the rings hit the vase symbolizes wisdom, one of nine human virtues associated with jade.

**8.5**

### 8.6 Bian Shoumin, Geese Descending on a Sandbank, 1730

One of the great subjects of Chinese painting is nature, from majestic mountain landscapes and intimate flower studies to depictions of mythical dragons and household cats. Man is considered relatively insignificant compared to the grandeur and beauty of the world, and it is the goal of the artist to capture the spiritual essence of nature in brush and ink. This hanging scroll (see p. 254) by Bian Shoumin, a leading painter of the 18th-century Qing (pronounced ching) dynasty, demonstrates that period's delight in bird-and-flower studies. Bian was so dedicated to the subject of geese that he lived along their migratory route in order to study the birds' every movement. Because changes cannot be made once ink or color is applied, Chinese painting requires confident brush strokes. Bian used his strokes to good effect here, capturing the lively movements of the preening, pecking, and flying geese.

Poem inscribed by the artist on the painting

*Just now wild geese came into the sky,*
*as I waved my brush before the master of the ch'in.*
*Autumn sounds meld with autumn thoughts,*
*as I stand beside I know not who.*

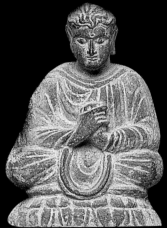

**8.7**

# Buddhism and the Arts of Asia

Buddhism is the major religion of China, Tibet, Korea, Japan, and the countries of southeast Asia. Since its inception in India in the 6th century B.C., Buddhism has been a key subject and source of patronage in the visual arts. The religion was founded by Siddhartha Gautama (c. 563–483 B.C.), a prince who abandoned his worldly belongings to devote his life to understanding the cause of human suffering. He became known as the Buddha, or the Enlightened One (8.7), and he taught that freedom from suffering can be achieved only with renunciation of all worldly desires. Buddhists believe that with proper conduct, correct beliefs, and dedicated meditation, people can break the cycle of rebirths that ties them to the material world, thus achieving eternal bliss (*nirvana*).

For the first 400 years, the Buddha was worshiped as an earthly teacher, and he was represented only by symbols such as an empty throne or his footprints. Other common Buddhist images were the lotus, symbolizing purity, and the lion, representing the Buddha, who sat on a lion throne and preached the truth with a lion's voice. By the end of the 1st century A.D., sculptures portrayed the Buddha in human form. The radical change rose from a split in the religion: some worshipers had come to believe that the Buddha was a god, supported by other enlightened figures (*bodhisattvas*) who had delayed their departures from earth in order to help and comfort suffering humankind (8.8). This new sect was called Mahayana, as compared with the older Hinayana sect.

As a god, the Buddha had become more remote and abstract, much like the god of a rival religion, Hindu's Brahma. To give Buddhists a more approachable image to worship, the Mahayana sect created humanlike images of their god. They also believed that the historical Buddha, Shakyamuni, was only one of thousands of Buddhas. Among those other Buddhas, two soon became popular: Amitabha, Lord of the Western Paradise (a heavenly place where worshipers of Amitabha believe they go when they leave earth), and Maitreya, the bodhisattva who believers say will descend to earth in the future bringing universal salvation and happiness. In China, Maitreya (8.9) became the pot-bellied "god of wealth" who sits grinning in front of many temples.

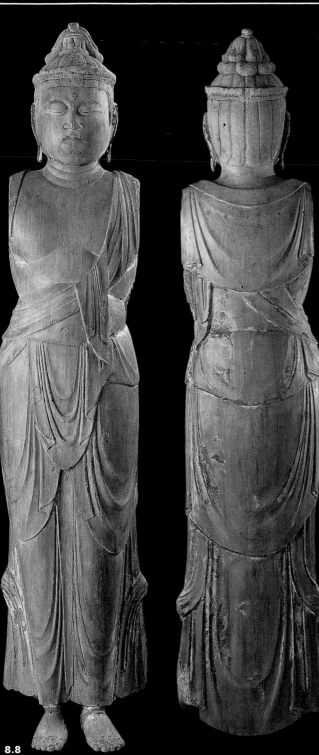

**8.8 Japanese, Bosatsu, mid-12th century**
Bosatsu *is the Japanese word for bodhisattva, the class of Buddhist deities who delay their state of nirvana in order to save humankind's souls. Sculptures of bosatsus decorate Japanese Buddhist temples.*

8.8

This architectural fragment
shows Maitreya, identifiable
by the flask he holds in his
hand. He is surrounded
by celestial attendants while
preparing for his descent
to earth in human form.
Maitreya's classical features
and wavy hair reflect
influences from Graeco-
Roman art that reached this
region (called Gandhara)
during the time of Alexander
the Great.

8.9a Buddhism is widely
practiced throughout Asia.
Here, Thai monks participate
in an ordination ceremony.

As Buddhism spread from India into China, Korea, and
Japan, the arts flourished. Temples and pagodas were
built to honor the Buddha in all his forms. Guardian
figures, sometimes in the form of lions, were placed
inside and at the entrances (8.10, 8.11). Worship was
enhanced by sculptures, paintings, ritual objects (8.13), and
architectural reliefs. Distinctive features made the Buddha
easy to recognize (8.12): He is always portrayed wearing
a long, skirtlike garment covered by a full shawl; a dot
on his forehead represents a unique curl of hair (*urna*)
between the brows. His long earlobes refer to his early
life as a prince when the weight of heavy earrings pulled
on his ears, and the bump (*ushnisha*) on top of his head
symbolizes wisdom. Ritual hand gestures (*mudras*) refer
to specific events in the Buddha's life, or indicate which
particular Buddha is represented.

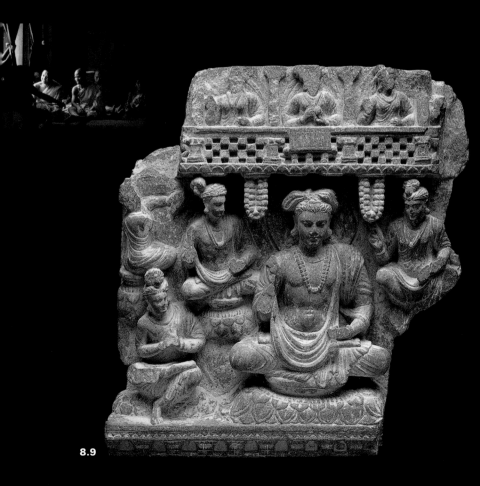

8.9

**8.10 Chinese,
Guardian with Attendants,
14th century**
*This scroll was made to
hang inside a Buddhist
temple. It portrays a fierce*
*guardian figure dressed
as a heavenly general in
gold armor and surmounted
by a fiery halo. Two equally
fierce-looking attendants
stand behind him to the left.*

**8.11 Japanese,
Guardian Lion,
14th century**
*Originally, sculptures
of fierce lions (shishi),
symbolizing the Buddha,
guarded the entrances
to Buddhist sanctuaries.
By the time this work was
made, the shishi had lost
its Buddhist identification
and was used strictly as
a universal guardian figure.*

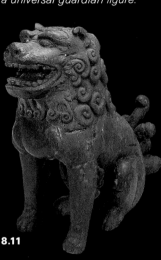

**8.11**

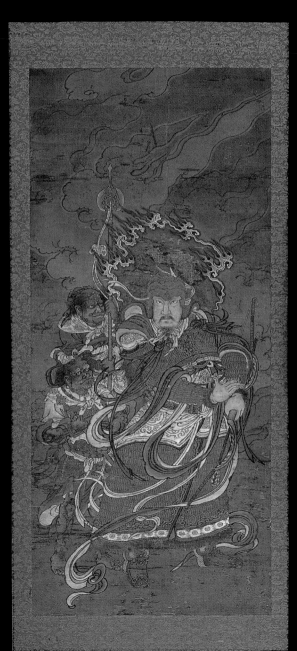

**8.10**

### 8.12 Koei (Unkei IX), Japanese, Amida, 1472

*Amida* is the Japanese name for Amitabha, *the Buddha who rules over the Western Paradise, where the souls of devout Buddhists reside after death. Amida became popular in Japan in the 11th century, when the concept of a Buddha promising universal salvation gained a wide following.*

### 8.13 Korean, Ritual Sprinkler, 12th-13th century

*This type of sprinkler came to Korea from India and China, where Buddhist monks used it to sprinkle water for ritual purification.*

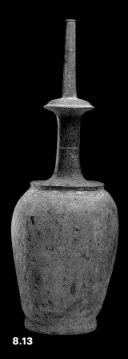

8.13

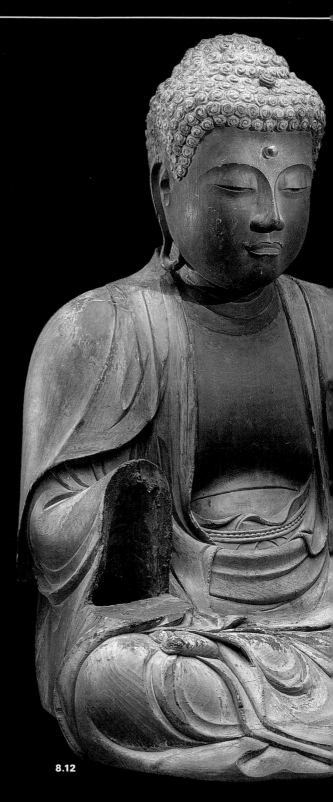

8.12

Over the centuries, Buddhism continued to evolve into an increasingly complex religion, with many variations and regional differences. As it spread eastward to Korea and Japan, and southeastward to Burma, Thailand, and Indonesia, its artistic expression blended native styles with imported ones, producing distinctive hybrids in each culture (8.14). At times serene and remote, at times gentle and human, the Buddha in art conveys the spiritual power of his teachings.

**8.14 Indonesian, Head of a Deity, 9th century**

*This image is based on the classical Indian style called* Gupta, *which traveled to Java with the Buddhist religion. Sculptures such as this were made for hundreds of shrines surrounding the temple of Borobudur, a massive, truncated pyramid built in the 9th century. For Buddhists who visited this important site, seeing the profusion of sculptures must have made them feel that they had reached the home of the gods.*

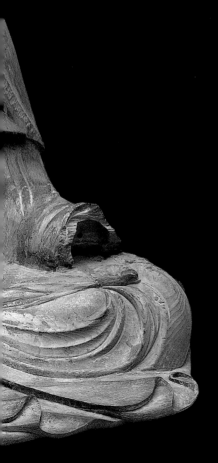

**8.14**

**8.14a** *Borobudur, Java*

### 8.15 Pot with Whorl Design,

c. 10,500–300 B.C.

*This neolithic work was hand-built and fired in an open-pit kiln. It is an example of a type of pot called* Jomon, *meaning "cord," after the impressed cord patterns on the vessels. Although scholars have established that pots like this were used for cooking, storing,* or serving food, research continues into why the pots were made with such elaborate designs and flamboyant shapes. The Jomon pottery culture existed for at least 7,000 years and created some of the earliest ceramics in the world.

**8.15a** *Cord-marking patterns*

*Courtesy Lindquist Studios, Quincy, Florida*

8.15a

8.15

**8.16**

## 8.16 Haniwa Warrior, late 6th century

*Before Buddhism introduced to Japan the practice of cremation, burial customs in that island nation were closely connected to those of Korea. The Japanese constructed burial mounds, often surrounded by moats, and placed clay sculptures of farmers, women, horses, and warriors in a circle on and around the graves to guard the deceased. The sculptures are called* Haniwa *(circle of clay). This erect warrior, wearing armor, a sword, and helmet, powerfully evokes the equestrian age of early Japan and the warrior code so integral to Japanese culture. Because Haniwa sculptures were left outside, they disintegrated over time, leaving few examples today.*

**8.16a** *Diagram of a tomb showing placement of Haniwa sculptures. House-shaped Haniwa were placed directly over the deceased in the center of the circular mound. Figural sculptures bordered the curve of the keyhole shape and the straight edge of the mound.*

**8.16a**

**8.17** Tosa School, The Tale of Genji, late 17th–early 18th century

*Lady Murasaki Shikibu wrote The Tale of Genji in the early 11th century. It is the first novel in world literature. The book colorfully describes the lives and loves of the royal court in Kyoto, focusing on the escapades of the young Prince Genji. Ten scenes from the novel have been painted on this pair of screens with a traditional Japanese ink outline technique. Painted screens were introduced to Japan from China and Korea and functioned as room partitions as well as paintings.*

*The contrast between the snow on the bamboo and the snow on the pines was very beautiful.... Into this austere scene he sent little maidservants, telling them that they must make snowmen. Their dress was bright and their hair shone in the moonlight. The older ones were especially pretty, their jackets and trousers and ribbons trailing off in many colors, and the fresh sheen of their hair black against the snow.*

Murasaki Shikibu, *The Tale of Genji*, c. 1000

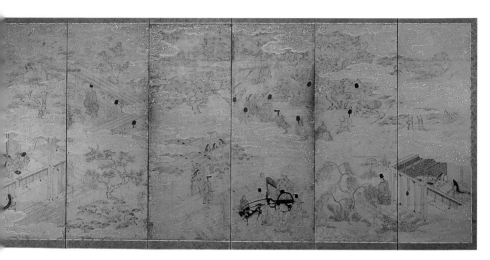

This section of the screen portrays a scene from Chapter 20, in which Prince Genji visits Murasaki, the novel's heroine, to reassure her of his devotion. Together they watch as young maidservants build snowmen. Murasaki's beauty reminds Genji of his first love, who has now died.

## How to Read a Folding Screen or Hanging Scroll

Screens and hanging scrolls from Japan and China are designed to be viewed from right to left and from bottom to top. Elements in a painting are often shown in different perspectives: from above, at eye level, and from below. To represent three-dimensional objects on a flat surface, Asian artists place nearby objects low down in the painting and distant ones higher up, in contrast to the traditional Western system, in which nearby objects are depicted larger than distant ones. In Asian screens and hanging scrolls, the viewer "travels" from the foreground to the middle ground and background by looking from bottom to top.

8.18

**8.18** Aigai,
Tiger and Bamboo,
early 19th century

*In Japanese art, the tiger often represents the warrior class while bamboo symbolizes resilience. Depicted together in this hanging scroll, the two symbols convey a picture of fierce strength and bravery as the menacing tiger crouches beneath the bamboo. Although tigers are not found in Japan, they were favored subjects of Japanese painters like Aigai, who admired them in Chinese paintings. Like the Chinese, Aigai emphasized the close relationship between painting and calligraphy, apparent here in his adept brushwork using multiple ink tones.*

**8.19** Miyashita Zenji,
Domed Vase, 1994

*Since World War II, Japan has experienced a lively growth in ceramic arts. In a culture where ceramic artists have always been esteemed, today the most successful ceramists are wealthy celebrities, often designated as Living National Treasures. The MFAH has a growing collection of contemporary Japanese ceramics. This vase by Miyashita Zenji exemplifies a popular interest in combining traditional styles with new techniques and forms. Using a modern, undulating shape, the artist applies bands of colored clay progressing from dark to light*

*to suggest hazy mountain ranges, reflecting the traditional interest in capturing natural beauty.*

**8.19a** *Miyashita Zenji works in his studio, 1997.*

**8.19**

The Fish, *carved into the top left of this work, is Vishnu's first avatar. When the world was formed, Manu, the founder of the human race, one day met a baby fish that asked him for protection. As the fish grew, Manu realized that it was actually Vishnu, come to warn him about a flood. When the flood occurred, Vishnu, as the now-giant fish, towed Manu to safety, thus saving humankind.*

**8.20 Vishnu and His Avatars, c. 10th century**

*Hinduism is the major religion of India. Its three main gods are Brahma, the creator of the universe; Vishnu, the preserver; and Shiva, the destroyer. This large relief sculpture, which originally decorated a temple, presents a central figure of*

*Vishnu, flanked by Brahma and Shiva to his upper left and right, respectively. Surrounding them are Vishnu's 10 avatars, or forms that Vishnu assumes when he comes to save the world in times of trouble. They are the Fish, Tortoise, Boar, Man-lion, Dwarf, Parashurama, Rama, Krishna, Buddha, and Kalki.*

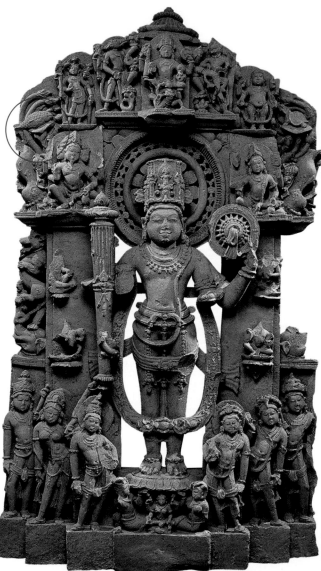

8.20

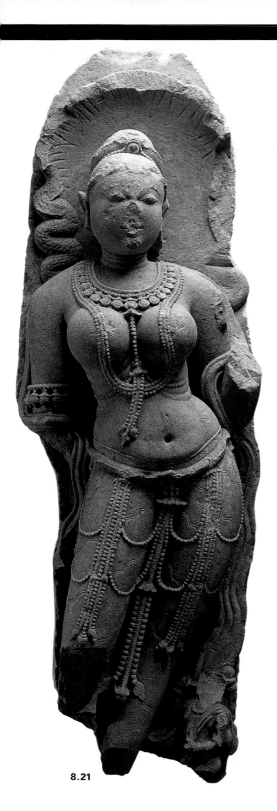

**8.21**

**8.21** Nagini, 9th century
*An ancient Indian water spirit,
the nagini derived from early
fertility goddesses and later was
worshiped as a Hindu deity.
Sculptures of this provocative
figure adorned medieval Hindu
temples. This example typifies
the sensuousness of much Indian
art. The nagini is posed in an
S-curve, giving her a voluptuous
sense of movement. Her soft flesh
yields to the harder-textured
jewelry. Her large breasts, small
waist, and broad hips represent
the Indian ideal of female beauty.*

**8.21a** *William Henry
Rinehart's 19th-century sculpture
of Thetis (also a water spirit)
from the MFAH's American
collection offers an interesting
comparison between Western
and Indian ideals of beauty.*

**8.21a**

**8.22** Shiva Nataraja, 13th century

*In the Hindu cosmos, time is an unending cycle of creation, destruction, and re-creation. Shiva, the god of destruction, also contains the seeds of creation, for out of death comes new life. This temple sculpture portrays Shiva as Nataraja, "Lord of the Dance," performing an ecstatic dance of bliss. Symbolizing the end of one universe and the beginning of another, the dance's dual meaning is made clear by Shiva's gestures and the objects he holds in his hands. The fire in his back left hand represents destruction, while the drum in his back right beats the rhythm of creation. His front left hand points toward a defeated demon of ignorance even as his front right hand gestures reassurance. Created in southern India during a flourishing period for bronze casting, the sculpture would have been ornamented with jewelry and flowers, dressed in fine silks, and carried in processions on poles inserted through the holes in its base. The sculpture originally included a flaming halo.*

*I come as Time, the waster of the peoples, ready for that hour that ripens to their ruin....*

Bhagavad-Gita, xi:32

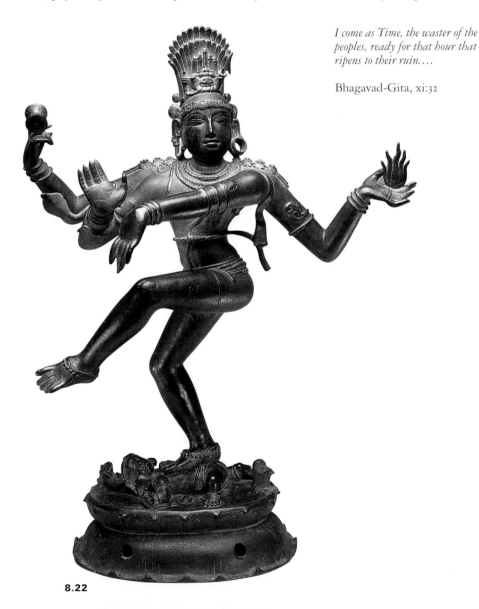

8.22

**8.23** Maharana Jāgat Singh II and Nobles Watching the Raslila Dance Dramas, c. 1736–40

This painting depicts an evening at the palace of an Indian ruler, the Maharana Jāgat Singh II. On the night of a full moon in the year 1736, Jāgat Singh and his nobles watch religious dance dramas in the upper courtyard of his palace. The lead performer enacts various stories about several Hindu gods. In order to illustrate the evening's entertainment within a single painting, the artist portrays the performer three times (outlined by the white circles). During the reign of Akbar, the great 16th-century ruler and patron of the arts, Indian artists were introduced to the delicate art of Persian miniature painting. This work reflects the detailed rendering adapted from Persian painting, combined with an Indian love of didactic religious narratives.

**8.23**

**8.24 Java,
Funerary Mask**
*Dating to about the 5th
century, this mask is among
the oldest gold objects
found in Indonesia. It was
made from a sheet of ham-
mered gold that was slashed
and punctured with a sharp
instrument to form the facial
features. Scholars believe
that the work was part of a
prehistoric burial custom in
which the face of a deceased
person was covered with a
precious mask.*

**8.24**

# The Glassell Collection
# of Indonesian Gold

On the islands of Southeast Asia, gold jewelry and ritual
objects are crucial to the structure and meaning of life.
Together with weaving and sculpture, gold is the medium
these cultures use to express their most important beliefs,
and it is the source of their most vital designs. As a portable
form of wealth, gold is a sign of high social rank and a
symbol of its owner's place in the world. Traditionally
exchanged in the socially important rituals of gift-giving
and receiving, in ancient times gold was also buried with
the dead (8.24).

Two types of jewelry are considered precious objects in
Indonesia: jewels given at marriage, and heirloom pieces
retained by the family as house treasures. At elaborate
weddings, the bejeweled and crowned bride and groom
exchange treasures. The bride's family gives soft, or
feminine, objects like precious textiles, and the groom's
family gives hard, or masculine, objects like gold (8.25).

Heirloom pieces, which form the "treasury" of aristocratic
families, are not exchanged and are worn only on cere-
monial occasions (8.27, 8.28). On the island of Nias,
well represented in the Glassell Collection, the most
important ceremonies were *owasa* feasts for the dedication
of gold, in which newly created gold regalia were worn
to secure the continued benevolence of the gods (8.26).
The Glassell Collection of Indonesian Gold contains rare
and outstanding objects from the most important island
cultures of Indonesia. It is one of the largest collections
of Indonesian gold displayed in an American museum.

Nias

Borneo

Sumatra

New Guinea

Flores

Indonesia

Java

Bali

Luang

## 8.25 Bali, Singaraja Court, King's Necklace

*This necklace was commissioned by a royal family in North Bali about 1890 to be worn by the king at an important wedding ceremony. The necklace is made of 22-karat gold, indicating the great wealth of the family.*

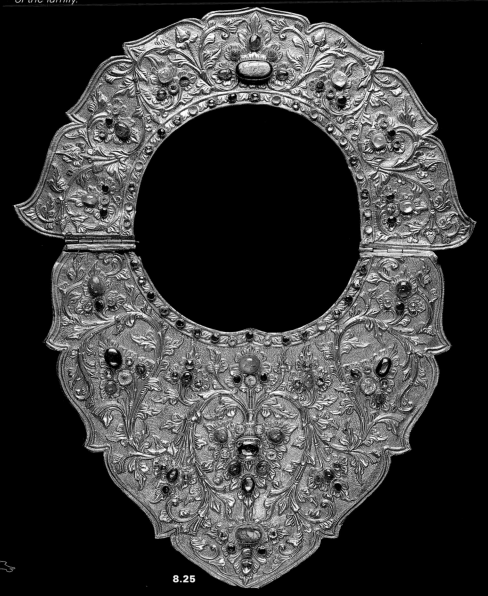

8.25

**8.26 Nias,
Man's Crown**

*Worn mounted on a hatlike fiber base, this extremely rare crown from Nias would have been worn at an owasa ceremony, during which participants would dedicate gold jewelry at prescribed intervals in order to progress to the next level of status.*

**8.27 Moluccas,
Luang Island,
Ancestral Crown
and Mask**

*This unique gold crown contains two ancient Indonesian symbols— an ancestral face (bottom center) and a tree of life, representing the lineage of a clan. Both symbols indicate the crown's connection to ancestor worship. Crowns like this one traditionally were worn by noblewomen.*

8.26

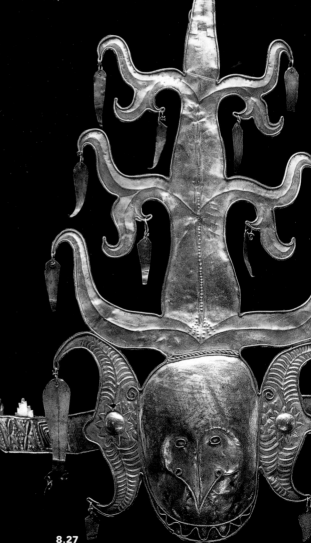

8.27

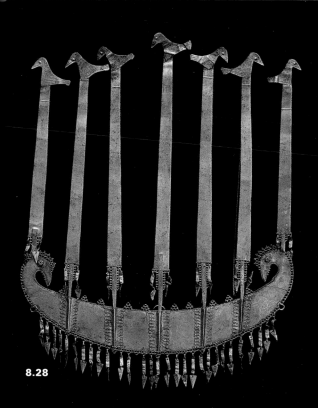

**8.28**

## 8.28 Flores, Nage Region, Man's Headpiece with Seven Birds

*According to oral tradition, this magnificent crown is 10 generations old. It was a sacred heirloom ritually used by Nage noblemen to ensure the continued prosperity of the clan and village. The crescent-shaped section may represent a mythical ancestral ship, whereas the seven masts derive from ancient feathered headdresses.*

**8.28a** *Raja Yoseph Djoewa Dobe Ngole (1902–1972) of Boawae, Flores, wears ornaments of state including a headpiece similar to the one shown at left.*

**8.28a**

Koninklijk Instituut voor de Tropen

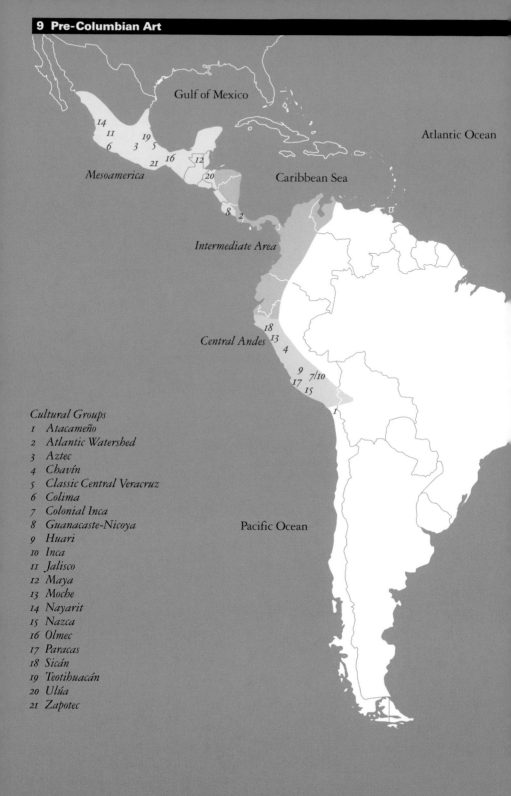

Gulf of Mexico

Atlantic Ocean

*Mesoamerica*

Caribbean Sea

*Intermediate Area*

*Central Andes*

Pacific Ocean

*Cultural Groups*
1   Atacameño
2   Atlantic Watershed
3   Aztec
4   Chavín
5   Classic Central Veracruz
6   Colima
7   Colonial Inca
8   Guanacaste-Nicoya
9   Huari
10  Inca
11  Jalisco
12  Maya
13  Moche
14  Nayarit
15  Nazca
16  Olmec
17  Paracas
18  Sicán
19  Teotihuacán
20  Ulúa
21  Zapotec

*The term* Pre-Columbian *refers to the many cultures that came and went over several thousand years in Central and South America prior to the arrival of Europeans, beginning with Christopher Columbus in 1492. Artistically, the three most important Pre-Columbian regions are Mesoamerica, the Central Andes, and the Intermediate Area. Most of the Pre-Columbian objects that have survived come from burials, indicating the importance of furnishing the deceased with provisions for the afterlife.*

*The MFAH's Pre-Columbian collection is strongest in works from Mesoamerican cultures, especially the Maya and the cultures of West Mexico. Of particular note are Maya ceramic vessels, limestone reliefs, and exquisite works in jadeite and flint. Other highlights from Mesoamerica include a large stone Aztec figure, a rare Ulúa marble vase, and an elaborate lid for a Teotihuacán incense burner. Key works from the other two regions include volcanic stone carvings from Costa Rica, ceramic vessels from coastal Peru, and beautiful small objects for personal use made of gold, silver, and inlaid bone and wood.*

### 9.1 Olmec, Mexico, Seated Figure, 1200–900 B.C.

*The Olmec culture created the first complex civilization in Mesoamerica. Ruled by powerful lords, the Olmec developed extensive trade routes, undertook massive public works projects, and built major ceremonial centers. So-called baby figures account for a large number of human representations found in Olmec art. Believed by scholars to represent the regeneration of life, these figures were placed in tombs, possibly to symbolize the deceased's spirit. The obstinate pose and animated face on this lively example typify the realism of Olmec art.*

### West Mexican Shaft-Tomb Art

The people who inhabited the West Mexico states of Colima, Jalisco, and Nayarit 2,000 years ago carved out subterranean tomb chambers reached by vertical shafts, some of which were 45 feet deep. Families deposited their dead within these multichambered tombs over several generations, equipping their relatives with terra-cotta vessels and figures for the afterlife. Among such funerary offerings are sculptures representing people, animals, and even fruits. Crafted from clay without molds or interior structural supports, these figures demonstrate a mastery of ceramic techniques. Their highly expressive forms range from very realistic to semiabstract in style.

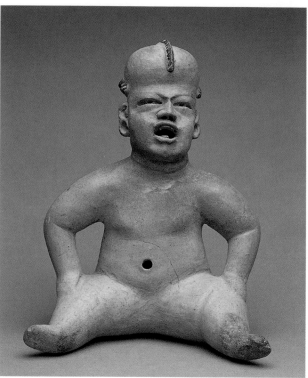

9.1

**9.2** Colima, Mexico,
Seated Musician,
200 B.C.–A.D. 250
*Musicians were a favorite theme
of Colima artists, who made
sculptures like this one to be
buried in shaft tombs. West
Mexican performers used many
different musical instruments,
from shell trumpets and clay
whistles to gourd rattles and
drums made from hollowed logs.*

*Captured in the act of banging
his drum, this musician holds
two round rattles in his left hand
and wears another percussive
instrument—a turtle shell—
around his neck. A highly
polished waistband separates the
matte surfaces of his short pants
and sleeveless shirt. The single-
horned headdress in West
Mexican art is often associated
with warriors and shamans.*

**9.3** Colima, Mexico,
Half-Seated Dog,
200 B.C.–A.D. 250
*Portrayed as if it had just
turned its head in response
to a sound, this lifelike dog
exemplifies the quality of move-
ment characteristic of many
Colima sculptures. Figures
of dogs appear frequently in
Colima shaft tombs, perhaps
providing companionship to the
dead in the afterlife. For the
living, dogs served as pets,
protected the home, and helped
in hunting. Some dogs were
bred and fattened specifically
as food for humans. The
burnished red-brown clay of
this dog is typical of Colima
art, with surface detail created
by incised lines rather than
painted decoration.*

**9.2**

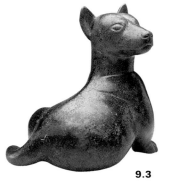

**9.3**

### 9.4 Jalisco, Mexico, Kneeling Woman Nursing a Baby,

200 B.C.–A.D. 250

*Many hollow clay Jalisco figures depict women, sometimes with infants. The women's faces are highly distinctive: long and narrow, with high foreheads, pointed noses and chins, and face painting. Typically—as in this example—the women wear only wraparound skirts, jewelry, and headbands. Texture and color provide surface interest, with painted decoration still evident over most of the figure. The circular nodules on the shoulders, present on many of these figures, represent scarification marks or tattoos.*

### 9.5 Nayarit, Mexico, Emaciated Seated Man,

200 B.C.–A.D. 250

*Like their Colima and Jalisco contemporaries, Nayarit artists also produced large, hollow figures that were buried with the dead. These sculptures portrayed members of Nayarit society, from nursing infants to old men and women bent with age and wasted by disease.*

**9.4**

**9.5**

**9.5a**

Together these figures form a rich picture of the daily life and habits of the Nayarit people. This emaciated man wears a nose ring and multiple arm and ear ornaments, and his hair is finely delineated into individual strands. The quiet, meditative pose and the curved back with prominent ribs (9.5a) sensitively portray an elderly man.

### 9.6 Maya, Mexico, Seated Woman, 550–800

Between the 6th and 9th centuries, while the Maya civilization was at the height of its splendor, the small island of Jaina off the east coast of the Yucatán Peninsula served as a burial ground for the social elite. Terra-cotta tomb figures found there are among the most appealing examples of Maya art.

In this dignified work, the seated woman has an elaborate hairdo, and she wears a skirt and a traditional upper garment called a quexquemitl. The Maya, along with the Moche, were the only two peoples in the ancient Americas to practice true portraiture, and the specificity of this example suggests that it may represent an actual person.

**9.6a** A kneeling Huastec woman wears a quexquemitl over a modern blouse.

**9.6**

**9.7** Maya, Guatemala, Covered Bowl, 250–550
*During the Early Classic period (250–550), fine Maya ceramics were deposited as offerings in the tombs of important people. Whereas some vessels are brilliantly embellished with multicolored decoration, others, like this example, have a burnished black surface with incised and modeled designs.*

*Animal images are often incorporated into the shapes of these imaginative vessels. The handle of this bowl is in the shape of a bird's head, probably a vulture. The bowl rests on four legs representing the heads of peccaries (wild, piglike animals) with their snouts to the ground. The peccary heads are very stylized, and only their eyes are indicated in low relief.*

**9.8** Maya, Guatemala, Covered Bowl, 250–550
*This bowl is referred to as a basal-flanged bowl because of the ridge that extends around the base. Such bowls were a favorite form for Maya vessels in Early Classic times. Often, Maya artists ingeniously combined two and three dimensions, as in this example. The fully modeled head of a man serves as the handle of the lid, but his three-strand necklace is painted on the flat surface of the lid itself. As on much Maya pottery, the remainder of the painted decoration is divided into rectangular panels — three on the lid and two on the bowl. Each panel is filled with a lavishly decorated head of a lord facing downward, perhaps an allusion to the underworld.*

**9.7**

**9.8**

**9.9** Maya, probably Guatemala, Vase, 550–800
*Simple, cylindrical vases provided uninterrupted surfaces on which Maya artists painted elaborate narrative scenes during the Late Classic period (550–800). Many of these scenes depict events from the* Popol Vuh, *the sacred book of the Quiché Maya (p. 277) that*

*recounts the epic adventures of the Hero Twins. Here, the twins are shown hunting waterbirds with blowguns. The playful scene depicted first shows a twin shooting a stone pellet at an evil-looking bird with a fish in its beak. In the image that follows, the pellet has struck its prey, and a bird waiting nearby snatches up the released fish.*

**9.9a** *A rollout image shows the second scene painted on this vase.*

**9.9**

*Now we shall tell how the two youths shot their blowguns at Vucub-Caquix [a great monster bird] . . . they lay in ambush at the foot of the tree, hidden among the leaves. Vucub-Caquix came straight to his meal of nantzes. Instantly he was injured by a discharge from [a] blowgun, which struck him squarely in the jaw, and, screaming, he fell straight to earth from the treetop.*

Popol Vuh

**9.9a**

**9.10** Maya, Guatemala, Bowl, one of a pair, 500–700

Maya bowls with painted stucco decoration are exceedingly rare. The Maya borrowed the technique from Teotihuacán artists (9.12), who painted complex designs on earthenware containers that had first been coated all over with white lime. Inventive Maya artists initially used the technique only on portions of their vessels, contrasting the colored stucco with the natural black clay. This bowl is decorated with six birds—pink spoonbills and mint green quetzals—set within interlinked rings. Feathers from these birds were used on headdresses, capes, and other regalia of the Maya elite.

**9.11** Maya, Guatemala, Bowl, 500–700

This bowl depicts a cross section of life in a lake or swamp, both beneath and above the water. Unpainted black clay provides a dramatic foil for the stuccoed forms of spoonbills, fish, and water lilies, while bubbles and sinuous forms add ambiance to the scene.

9.10

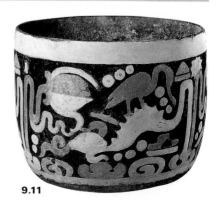

9.11

**9.12** Teotihuacán, Mexico, Tripod Vase, 550–650

*Teotihuacán, located 45 miles northeast of present-day Mexico City, was the largest and most influential city in Mesoamerica during the Classic period. At its peak, between A.D. 450 and 650, 120,000 to 200,000 people lived there. This tripod cylinder vase, a shape invented by Teotihuacán artists, depicts a painted stucco scene of two blowgunners hunting quetzal birds in cacao trees. Like all Mesoamericans, Teotihuacanos prized the quetzal for its feathers and the cacao tree for its beans, the source of chocolate today. In reality, quetzals and cacao trees do not coexist, but this contradiction may have been unknown to Teotihuacán artists, who lived far from the jungle habitats of either.*

**9.12a** *A rollout image shows half of the scene illustrated on this vase.*

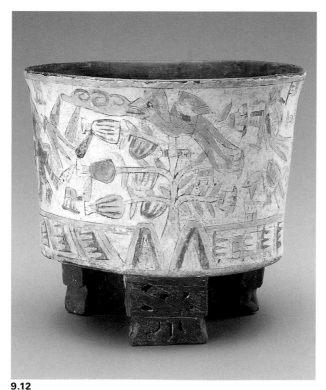

**9.12**

**9.12a**

**9.13a** *The palace at the Maya city of Palenque was decorated with stone and stucco relief panels like the MFAH example (9.13). Palenque flourished between the 6th and 8th centuries.*

**9.13** Maya, Mexico, Seated Male, 702–64
*The fine workmanship and elaborate subject matter characteristic of Maya art are especially apparent in the stone architectural relief panels from the city of Palenque. This elegant carving once formed the lower left-hand section of a three-figure panel, additional portions of which survive in other collections.*

*Together, the fragments depict two seated men making offerings to a central, standing lord. The man shown in this portion, probably an ancestor of the lord, wears the feathered headdress of God L, a lord of the underworld. The other imagery in the relief also relates to death, the underworld, and rebirth.*

**9.13a**

**9.13**

**9.14** Maya, Guatemala, Ceremonial Flint, 550–800

*The Maya imbued flint with enormous sacred power, believing it to be a godly creation hurled to earth in bolts of lightning. While most flint was used for practical objects such as knife blades, some was formed into elaborate works of art. This ceremonial flint is among the finest of what scholars call eccentric flints. The complex silhouette depicts three voyagers traveling by monster-headed canoe to the watery underworld. Flanked by two lords is the important underworld figure God K, who wears a serrated headdress and has a smoking tube protruding from his forehead. The scalloped design at the bottom denotes the choppy waters of the underworld.*

**9.15** Maya, Mexico or Guatemala, Headdress Ornament, 550–800

*This two-sided jadeite carving was probably attached to the center of a lord's ceremonial headdress. It depicts an underworld deity called the Jester God, who symbolized rulership. Like other Maya gods, this grotesque creature has a large eye, a gnarled nose, and sharp teeth.*

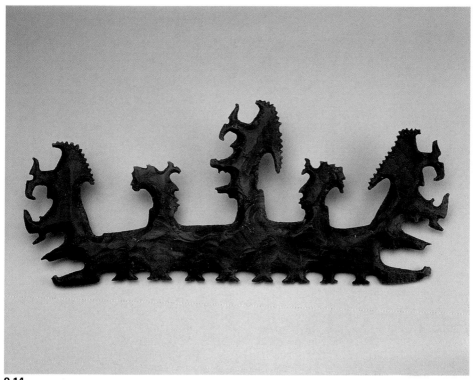

9.14

9.15

**9.16a** *The Quetzalpapalotl palace at Teotihuacán is decorated with many of the same symbols found on the MFAH incense burner at right (9.16). Such burners, called censers, were probably used in family shrines located in the courtyards of palaces and other elite homes. When offerings were burned, the smoke that wafted heavenward honored the family's ancestors.*

**9.16** Teotihuacán, Mexico, Incense Burner Lid, 200–650
*Incense burners were used in religious rituals throughout Mesoamerica. At Teotihuacán, these vessels had elaborate, conical lids, each adorned with a central mask or figure and a profusion of separately made ornaments. The serene face on this example probably represents*

*the dead ancestor of an important family. The butterflies, flowers, and seashells—symbols of transformation, the soul, water, and fertility—are appropriate for a funerary vessel. When an offering was burned beneath this lid, smoke would emanate from the eyes of the face and from the mouth of the feathered serpent at the top.*

9.16a

9.16

*Will I have to go like the flowers that perish?*
*Will nothing remain of my name?*
*Nothing of my fame here on earth?*
*At least my flowers, at least my songs!*

From a Nahuatl (Aztec) poem

**9.17** Maya, Guatemala, Funerary Urn, 550–950

*The Maya vision of the underworld is epitomized by the frightful imagery found on funerary vessels. On the cylindrical base of this urn, the head of a grotesque god emerges from the gaping mouth of a fanged serpent, who symbolizes both the earth and the entrance to the underworld. Sprawled across the lid with teeth bared and claws outstretched is a jaguar, an exclusively nocturnal hunter and thus the ultimate creature of the dark underworld. The urn was made by the Quiché people (p. 271), who had the most powerful highland Maya city-state when Spanish explorers arrived in the early 16th century.*

**9.18** Zapotec, Mexico, Funerary Urn, 200 B.C.–A.D. 200

*The Zapotec people of Oaxaca are known for grayware urns of seated gods wearing elaborate masks and pendants, found primarily in tomb chambers. This example represents the God with the Serpent Mouth-Mask, named for the snake-head mask that covers the lower face.*

**9.17**

**9.18**

**9.19** Classic Central
Veracruz, Mexico,
Palma, 900–1200
*Throughout ancient Meso-*
*america, and especially in*
*Veracruz, a sacred ball game*
*was a part of an important*
*religious ritual. Using only their*
*hips, feet, and elbows, players*
*struggled to propel a rubber*
*ball—representing the sun—*
*down a long, narrow court.*

*The game culminated in the*
*sacrifice of one or more of the*
*players. Stone palmas, named*
*for their resemblance to palm*
*fronds, imitate protective*
*wooden objects that the players*
*wore at their waists. This tall*
*palma is decorated with the*
*form of a waterbird that has*
*a fish in its beak, surrounded*
*by decapitated heads floating*
*in swirling water or blood.*

**9.20** Ulúa,
Honduras,
Tripod Vase, 800–1000
*The Ulúa Valley was*
*strategically positioned along*
*a trade route that linked the*
*peoples of Central America*
*in ancient times. Ulúa artists*
*developed a unique vessel type*
*that was traded as a prestige*
*item from Guatemala to Costa*
*Rica. Of the 100 or so of these*

**9.19**

**9.20**

**9.20a**

marble vases that are known, this example is one of the largest and most elaborate. The Ulúa propensity for symmetry and repetition is evident in the elegant scrolls filling the spaces between the central deity head and the two profile animal heads that flank it. The handles (9.20a) are birds' heads carved fully in the round; the birds' bodies are carved on the vessel's sides.

**9.21** Aztec, Mexico, Standard-Bearer, 1425–1521
*At the time of the Spanish conquest in the early 16th century, the Aztecs dominated what is now central Mexico. These former nomads voraciously assimilated the lifestyle and traditions of the preexisting cultures in that region. Standard-bearers were first sculpted by the Aztecs' powerful*

*predecessors, the Toltecs. Characteristically rigid and austere, the sculptures — originally holding standards or banners — stood guard at entrances and stairways. This example has a crescent-shaped nose ornament associated with the gods of drunkenness and pulque, an alcoholic beverage made from the fermented juice of the maguey plant.*

**9.21a** Drawing of an Aztec Pulque God
*As recorded in the Aztec* Codex Mendoza, *drunkenness was a privilege enjoyed exclusively by the elderly. Only they had the "freedom to drink wine [pulque] in public or private and intoxicate themselves because they were very old and had children and grandchildren." In contrast, young people were executed for such conduct.*

**9.21**

**9.22** Guanacaste-Nicoya, Costa Rica, Ceremonial Grinding Stone, 300–700
*Throughout Central America, three-legged stone slabs called* metates, *commonly used for grinding maize and other plant foods, were buried with the dead. The metates buried with ordinary people are plain and mundane, but those found in the*

*graves of wealthy individuals are intricately carved. The most elaborate metates were made in the Guanacaste-Nicoya region of Costa Rica. Carved from a single block of basalt, this jaguar-headed example is extraordinary for its delicate cutwork. Zigzags, scrolls, and interlaced straps decorate the solid surfaces, and two small felines form the ears.*

**9.23** Guanacaste-Nicoya, Costa Rica, Jaguar Vessel, 1200–1400
*Revered for its stealth, strength, and savagery, the jaguar is the largest land animal in tropical Central America and thus is depicted often in Costa Rican art. This pear-shaped vessel was cleverly converted into a jaguar through the additions of a head, arms, legs, and a tail.*

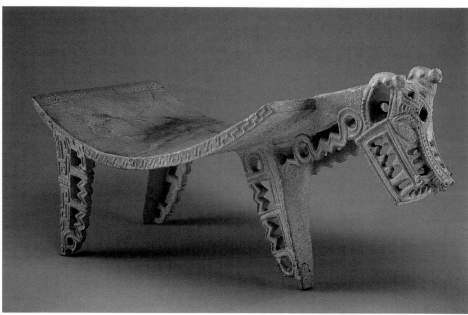

**9.22**

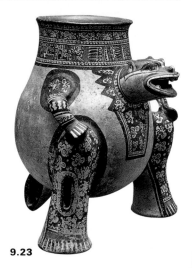

**9.23**

The intricate patterns painted on its surface are, predominantly, small animal heads. Despite the realistic modeling of the expressive face and powerful hind legs, the diminutive forelegs rest on the knees in a human gesture. Clay pellets contained within the hollow head and legs transform this vessel into a rattle when it is shaken.

**9.24** Atlantic Watershed, Costa Rica,
**Standing Warrior,** 700–1100
At the time that this volcanic stone sculpture was carved, the Atlantic Watershed region of Costa Rica was in an almost constant state of warfare. Not surprisingly, images of warriors, prisoners, and human trophy heads dominate the art of the area. Warrior figures usually

brandish an axe in one hand and, as in this example, a trophy head in the other. Stiff and formalized, with expressionless faces, such sculptures represent archetypal warriors rather than individual heroes. The diamond pattern carved in relief down the torso of this figure denotes tattooing, which distinguished warriors from ordinary people.

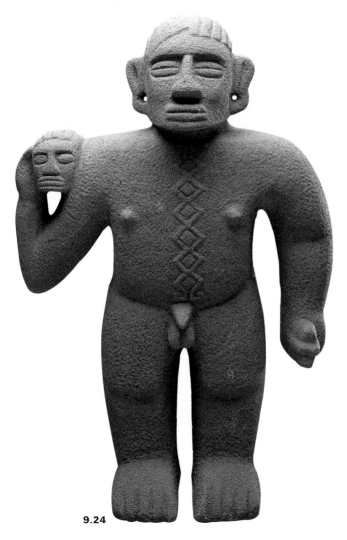

**9.24**

**9.25** Paracas, Peru,
Falcon Vessel,
300–200 B.C.
*In ancient times, on the desert
coast of Peru, two distinctive
pottery traditions developed that
culminated in the finest wares
ever produced in the Central
Andes region. Along the south-
ern coast, potters made simply
shaped vessels with rounded
bottoms, multicolored painted*

*surfaces, and two small spouts
connected by a flat bridge.
Within this southern tradition,
the Paracas culture was the
earliest to develop a distinctive
style. Blackware vessels were
decorated with incised motifs
that, after firing, were filled in
with thick resin paint. On this
vessel, the eye markings, narrow
pointed wings, and spotted
plumage denote a falcon.*

**9.26** Nazca, Peru,
Killer-Whale Vessel,
100 B.C.–A.D. 100
*This dynamic vessel from the
later Nazca culture takes the
form of a killer whale. Its prom-
inent, sharp teeth are bloody
from its last meal, a human
whose trophy head is painted
on the whale's belly. The trophy
head cult was a key element of
religion on Peru's south coast.*

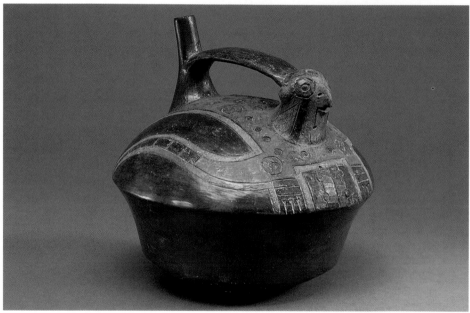

9.25

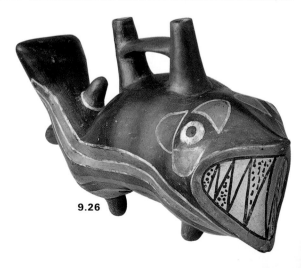

9.26

**9.27** Nazca, Peru, Vessel with a Caped Woman, 300–600
*During the last centuries of the Nazca culture, south coast pottery reached technical perfection. Extremely thin clay walls were covered with complex designs in up to 13 colors — a very difficult feat to accomplish. This double-spouted vessel in the shape of a woman is a fine*

*example of this Late Nazca style. The woman's white cape is decorated with two elaborate deity figures representing killer whales, identifiable by their blood-filled mouths and long bodies edged in fins. The extreme abstraction of these images, with their profusion of tentacle-like extensions, is also characteristic of Late Nazca art.*

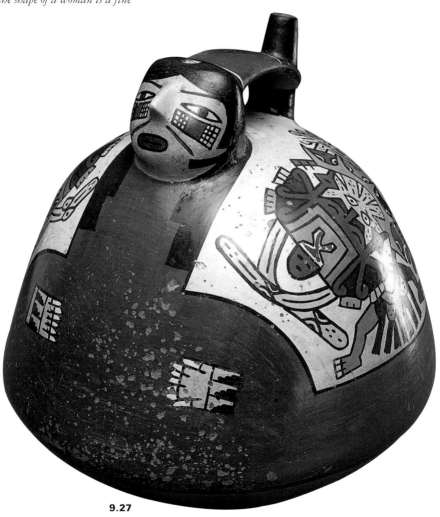

**9.27**

**9.28** Chavín, Peru,
Fish Vessel, 450–200 B.C.
*Contemporaneous with the*
*development of a distinctive*
*pottery tradition on the south*
*coast of Peru was a very dif-*
*ferent one on the north coast.*
*There, pottery was characterized*
*by flat bottoms, complex forms,*
*the use of only one or two colors,*
*and a stirrup-shaped spout.*
*The Chavín culture was the first*

*to fuse these various elements*
*together. This vessel, in the form*
*of a flatfish lying on its side, is*
*typical of Chavín pottery except*
*for its straight spout, a feature*
*found in only one region. Incised*
*lines delineate the gills, scales,*
*fins, and tail, whereas the*
*facial features are rendered*
*in relief. Although animals*
*appear frequently in Chavín*
*art, fish are rare.*

**9.29** Moche, Peru,
Portrait-Head Vessel,
400–600
*Following the Chavín culture,*
*the Moche culture was the*
*dominant force on Peru's*
*northern coast. Moche artists*
*created finely crafted pottery*
*of compelling naturalism.*
*The best-known type of Moche*
*vessel is the portrait head, an*
*art form that reached its apex*

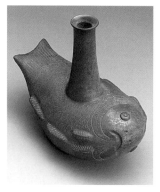

**9.28**

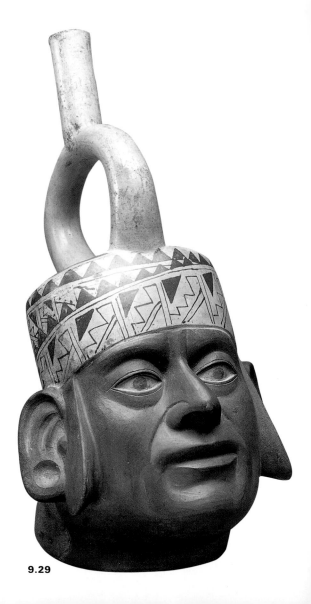

**9.29**

in the 5th and 6th centuries. The individualized faces of these vessels indicate that the Moche practiced true portraiture. Some faces recur many times and may represent rulers or other men of high status. The burnished surfaces of the headdress and of the stirrup-shaped spout on this example contrast with the matte finish of the face.

**9.30** Moche, Peru, Stirrup Jar with Owl-Warriors, 400–600

*During the last centuries of the Moche culture, ceramic artists departed from the normal, complex forms to concentrate on simple shapes painted with fine-line images and often depicting narrative scenes. This jar is decorated with two owl-warriors armed with large*

*clubs, shields, and helmets. The Moche associated owls and other animals of prey with military power. Anthropomorphic owls — creatures with bird heads and wings, but with human bodies — were sacrificers of prisoners, and thus were associated with death. The stirrup-shaped spout on this vessel, impractical for pouring liquid, was a ritual form characteristic of north coast art.*

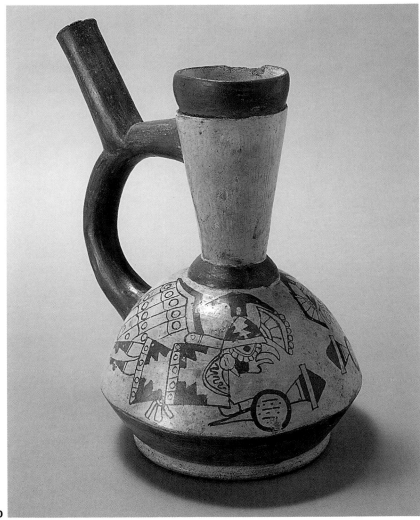

**9.30**

**9.31** Huari, Peru,
Pair of Earplugs, 600–1000
*In the Central Andes region,*
*small personal items worn and*
*used by men of high status were*
*often fashioned from organic*
*materials — wood and bone —*
*decorated with colorful inlays*
*of precious materials imported*
*from afar. These Huari earplugs*
*are exquisite examples of this*
*art form. Each earplug is carved*

*from a single piece of wood in*
*the shape of a human head.*
*The headdress, eyes, "tears,"*
*and petal-like forms framing*
*the face are inlaid with dark*
*green stone, shell, and lustrous*
*mother-of-pearl. Found in the*
*waters off Ecuador, the pink*
*shell is* Spondylus, *a valuable*
*and symbolically important*
*substance in demand through-*
*out the Central Andes.*

**9.32** Moche, Peru,
Ritual Spatula, 1–700
*The military imagery commonly*
*found in Moche art (p. 285) is*
*prominent on this bone spatula,*
*which is about 5 1/2 inches long*
*and was used for removing lime*
*from a container during coca-*
*taking rituals. Only about*
*a dozen of these spatulas are*
*known to exist. One end of this*
*example is carved in the form of*

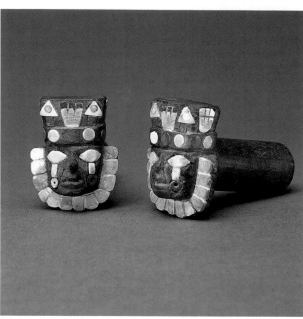

**9.31**

**9.32**

a clenched fist, and the other end is pared down into a flat blade. The handle, covered with designs thought to represent tattooing, is inlaid with tiny pieces of shell, stone, and even turquoise, which came from high in the Andes Mountains. Each finger is decorated with a club-and-shield motif, suggesting that a Moche warrior owned this spatula.

**9.33** Atacameño, Chile, Snuff Tablet, 900–1100

The Andes Mountains are the home of the Andean condor. Its 10-foot wingspan makes it the largest bird of prey in the world. A majestically soaring bird with a regal white neck ruff, the condor has been invested with important symbolic meaning in Andean art for thousands of years. Because it feeds on dead

and injured animals, the Andean condor is associated with death, and its image often adorns metal knives used in ritual sacrifice. Here, a male condor perches on one end of a wooden tablet that is inlaid with green stone. Made by the Atacameño people, the tablet was used to hold powdered hallucinogenic substances in-haled during religious rituals.

**9.33**

**9.34** Sicán, Peru,
Janus-Faced Beaker,
850–1050
On the north coast of Peru, the
Sicán culture bridged the period
between the Moche and the
Chimú. At the site called
Batán Grande, members of the
Sicán elite were buried with
hoards of gold objects, most
of which were beakers. Many
of these beakers were made

specifically for burial, but finely
executed ones such as this were
probably used first by the living
in chicha-drinking rituals
(9.35). The distinctive face, with
comma-shaped eyes and sharp
teeth, represents the principal
deity known as the Sicán Lord.
Rendered upside down on both
sides of the vessel, the faces would
appear upright when the empty
beaker was placed on its rim.

**9.35** Inca, Peru,
Stepped Beaker, 1470–1532
At the height of its power in
the early 16th century, the Inca
empire stretched from Ecuador
in the north to central Chile in
the south. Spaniards arriving
in 1532 were amazed at this
advanced society with sophisti-
cated metalworking traditions.
Among the objects crafted by the
Inca were gold and silver cups

**9.34**

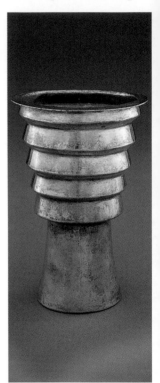

**9.35**

that high-ranking officials used on ceremonial occasions to drink chicha, *a fermented maize beer. Such vessels were made in pairs, because Inca etiquette required that two men exchange cups after each of the many toasts. This beaker was skillfully shaped from a single sheet of silver. The simple, stepped form of this vessel exemplifies the elegance of Inca art.*

**9.36** Colonial Inca, Peru, Ceremonial Pouring Vessel, 1675–1725
*Although their empire ended with the Spanish conquest, the Inca continued to make objects for certain rituals over the following centuries. This vessel, called a* paccha, *was used for pouring chicha beer onto the ground to promote crop fertility. It is the largest, most elaborate*

*colonial-era example known. The imagery includes spiders, snakes, macaws, and other creatures, as well as the Inca ruler standing beneath a rainbow. Four jaguars decorate the rim, their spots formed by nails. When the bowl was filled, chicha flowed through the jaguar head at the bowl's base, down the diamond-shaped channels, and out the spout.*

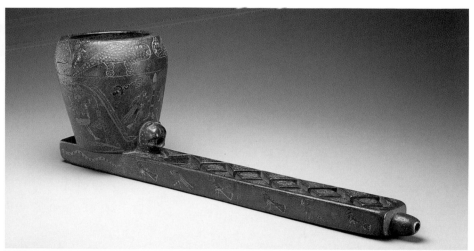

**9.36**

**9.35a**
*Cuciuanchire, an important Inca military captain, instituted the practice of drinking in honor of the sun, the Inca's primary deity, before a battle. The beakers he holds contain chicha.*

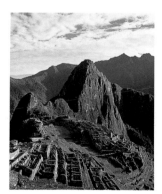

**9.35b**
*The Inca city of Machu Picchu, covering a ridge high above the Urubamba River in Peru, was probably a royal retreat.*

Gulf of Mexico

*Cultural Groups*
1  *Acoma*
2  *Casas Grandes*
3  *Cochiti*
4  *Hopi*
5  *Mimbres*
6  *Navajo*
7  *San Ildefonso*
8  *Western Apache*
9  *Zuni*

The more than 700 pieces in the MFAH's collection of Native American art come from two geographic areas. Approximately 200 archaeological items from the Eastern Woodlands area (primarily east of the Mississippi River) were the gift of Arthur T. McDannald in 1963, and the other 500 Native American works, most of which were donated to the museum in 1944 by Ima Hogg, are from the American Southwest. The Southwest component presents an unbroken visual history of the Pueblo peoples of northern Arizona and New Mexico from prehispanic times to the mid-20th century, and it also includes works from the last 125 years made by the Navajo, the Apache, and other seminomadic peoples. Ceramics, kachina dolls, opaque watercolors, textiles, baskets, stone and silver jewelry, and various kinds of wooden objects are represented. Highlights of the ceramics are a rare, unbroken Mimbres jar and a large, black-on-black jar made by the most famous of the modern Pueblo potters, Maria and Julian Martinez. Of special significance are the 130 kachina dolls made between 1900 and 1933 and 95 works from the school of Native American painters of the 1920s and 1930s.

**10.1** Mogollon
(Mimbres style),
Jar, 1025–1150
*The Mimbres people, who lived
along the Mogollon Mountains
in what is now New Mexico,
created the earliest-known
pottery in the American South-
west. By about* A.D. *200, they
were making coiled-clay vessels,
and in the 7th century they be-
gan painting such vessels with*

*dark-on-white decoration.
During its classic phase
(1025–1150), the Mimbres cul-
ture was creating sophisticated
pottery that featured complex
geometric designs and human
and animal figures. Most
existing vessels are shallow
bowls with painted interiors.
Unusual in size and shape, this
water jar exhibits a dynamic
design of stepped motifs.*

**10.2** Mogollon
(Mimbres style),
Bowl, 1025–1150
*The Mimbres people placed
inverted bowls over the heads
of the deceased during burial,
puncturing the bowls in the
center to release the spirit within.
While most bowls had geometric
decorations, some designs included
people and animals. This fine
example depicts two hooked fish.*

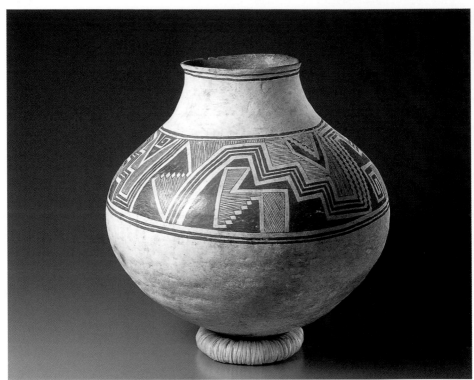

**10.1**

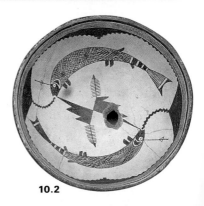

**10.2**

**10.3** Mogollon
(Casas Grandes style),
Macaw Bowl, 1300–1350
*In the 12th century, as the*
*Mimbres culture collapsed,*
*the town of Casas Grandes rose*
*to prominence. Located in the*
*present-day state of Chihuahua*
*in Mexico, Casas Grandes*
*became an important trading*
*center linking the indigenous*
*peoples of the American South-*
*west with Mesoamerican cultures*
*to the south. Coveted for their*
*colorful feathers, macaws were*
*among the Mesoamerican goods*
*that reached Native Americans*
*through Casas Grandes. This*
*earthenware bowl has been*
*transformed into a macaw*
*through the addition of an*
*expressive head and small tail.*
*Bold, geometric designs cleverly*
*convey a sense of the bird's wings.*
*The fine painting reveals*
*the ongoing influence of*
*Mimbres artists.*

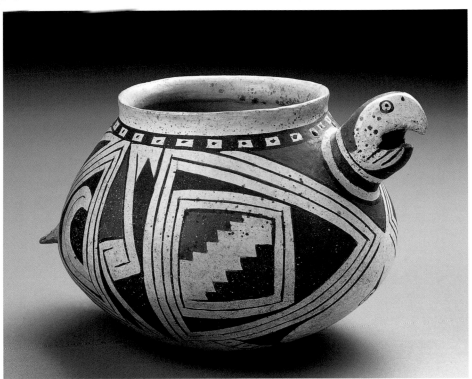

**10.3**

**10.4** Pueblo (Acoma),
Jar, c. 1890
*Descendants of the ancient
Anasazi culture, the native
peoples of northern Arizona and
New Mexico share a heritage
that is at least 2,000 years old.
Collectively called Pueblo, after
the word Spanish explorers used
for adobe villages, the groups are
also identified by the specific
pueblos in which they live.*

*Perched on top of a steep
sandstone mesa in central
New Mexico, Acoma Pueblo has
survived for a millennium and
is one of the oldest continuously
inhabited settlements in the
United States. Like other pueblos,
Acoma developed its own distinct
style of pottery. This magnificent
water jar is painted with fine
lines in a bold geometric design
that is typical of Acoma vessels.*

**10.5** Pueblo (Zuni),
Jar, 1880–85
*Situated near the western border
of New Mexico, Zuni Pueblo is
renowned for its extraordinary
pottery. In the late 19th century,
Zuni artists developed an
elaborate, curvilinear style of
vessel painting in which thin
lines divide the surfaces into
horizontal zones, and the
color red is used in addition to
black and white. Synthesizing
indigenous designs with foreign
motifs, the artist who made this
jar borrowed the large rosettes
from Spanish woodcarvings,
whereas the gracefully stylized
birds and the hooked feather
motifs that frame the deer are
Zuni designs. Although other-
wise rendered naturalistically,
the deer on the jar exhibit a red
"heart line." This device, which
symbolizes the life force of the
animal, probably came to the
Southwest with the Apache or
Navajo peoples.*

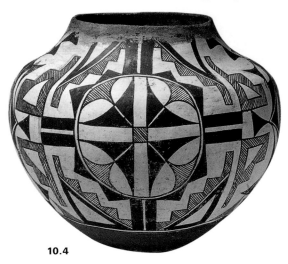

**10.4**

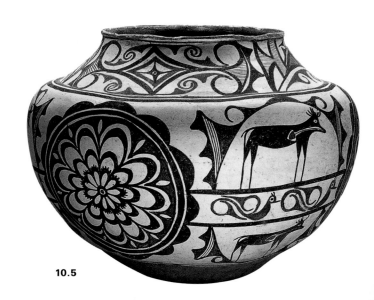

**10.5**

**10.6** Pueblo (Cochiti), Storage Jar, c. 1885

*Cochiti Pueblo lies on the Rio Grande, 23 miles southwest of Santa Fe in New Mexico. By about 1880, a distinctive new style of pottery painting had emerged at the village. Avoiding formal geometric designs, Cochiti artists decorated their vessels with lively motifs dispersed across light backgrounds.*

*These artists incorporated the sacred animal and plant designs usually reserved for ritual vessels into secular pottery as well. Birds, which are often associated with rain, appear frequently in Cochiti art. This earthenware storage jar derives considerable energy from the sprightly birds that encircle it. The placement of the birds in scalloped circles set within*

*squares is atypical of Cochiti painting, which usually avoided paneled designs.*

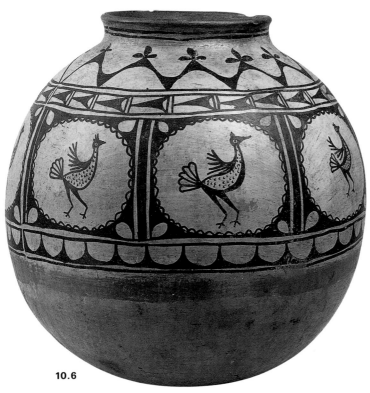

**10.6**

**10.7** Pueblo (Zuni),
Kiva Jar, c. 1900

*The Zuni consider corn to be
sacred, and they use it in
purifying rituals and as
spiritual food for kachina masks.
Kachinas are spirits that in-
habit the world of the Pueblo
people. During ceremonies
throughout part of the year,
kachina-masked impersonators
dance in elaborate costumes*

*representing these supernatural
beings. When not in use, the
kachina masks are kept in kivas,
semi-subterranean chambers
that serve ritual purposes. This
jar, like other vessels depicting
frogs and tadpoles —both
symbols of rain —may also have
been kept in a kiva and used
to store corn or cornmeal. The
symmetrical decoration includes
mosquitoes and hummingbirds.*

**10.8** Pueblo (Cochiti),
Ritual Bowl, c. 1890

*The designs on Pueblo pottery
often relate to rain, the lack
of which is a constant concern
for the people of the American
desert Southwest. This ritual
bowl is decorated on the inside
with a sun (10.8a) and on the
outside with birds, clouds,
lightning, and rain. Compared
with the painting on secular*

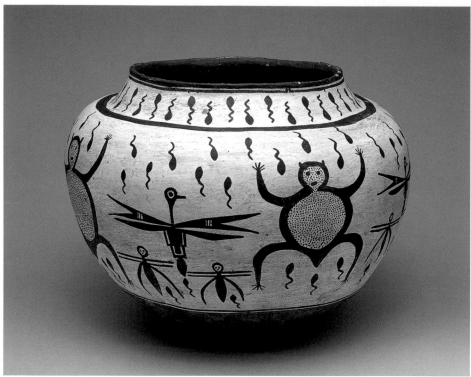

**10.7**

**10.8**

jars, the lines on this example are more delicate. Cochiti Pueblo was once a center for black-on-cream vessels of many shapes. However, demands from an eager market of tourists and collectors have spurred Cochiti potters to concentrate on animal-shaped vessels and figurines. Consequently, the production of more traditional bowls and jars has declined.

**10.9** Maria Martinez and Julian Martinez, Pueblo (San Ildefonso), Jar, 1934–43
Maria and Julian Martinez of San Ildefonso Pueblo in northern New Mexico created some of the finest Pueblo pottery of the 20th century. Inspired by black pottery shards excavated in 1908, the couple spent more than 10 years developing a technique

for making black-on-black ware in which shiny surfaces contrast with matte areas. On this large masterpiece, a repeated feather pattern adapted from Mimbres designs decorates the upper register, while the undulating form of an avanyu —a horned, feathered serpent associated with rain—winds its way around the widest part of the jar.

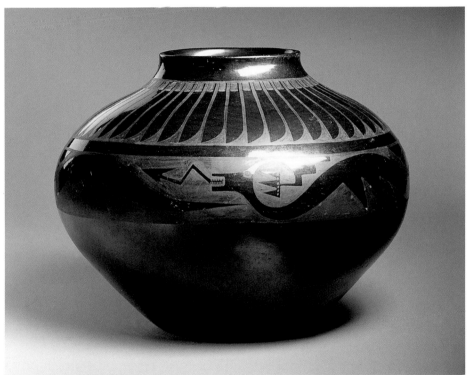

**10.9**

**10.8a**

**10.10** Fred Kabotie, Pueblo (Hopi), Hopi Corn Dance, c. 1925

For centuries, the Hopi people have built their pueblos in the rugged mesa terrain of northeastern Arizona. Inherent to this arid land is the continual struggle for survival that accompanies subsistence farming. The Hopi enlist the help of ancestral spirits called kachinas in a series of dances and ceremonies reflecting the agricultural cycle. At the annual Corn Dance, villagers participate in a ritual they believe will bring ample rain and good crops. Photographing such sacred ceremonies is forbidden, but by 1920 the emergence of a new artistic tradition provided a vivid glimpse inside this Hopi world. At the Santa Fe Indian School, where many Native American children were forcibly sent by the U.S. government to study, students were encouraged to chronicle aspects of cultural life in tempera (opaque watercolor) paintings. The Hopi artist Fred Kabotie first studied easel painting while a student at the school. In this rhythmic work, Kabotie re-creates the Hopi Corn Dance. The women wear

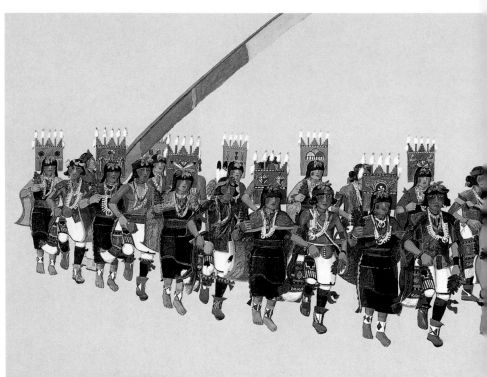

**10.10**

traditional black dresses and painted wooden headdresses; their bare feet denote their closeness to the earth. The men wear moccasins and kilts, and display feathers in their hair. All the dancers carry evergreen branches, symbolizing the beginning of life. Two clowns, whose antics afford comic relief, lead them, while a drummer and singers provide music.

**10.11** Pueblo (Hopi), Water-Drinking Maiden Doll, 1925–33

For the Hopi, as for the Zuni, kachinas are an integral part of life. More than 250 individual kachinas have been identified, each with its own distinctive personality and appearance. Because young girls are excluded from many rituals, Hopi men carve kachina dolls to teach the girls about the kachinas and their roles. Kachina maidens such as Palhik' Mana, the Water-Drinking Maiden, are thought to represent the wives and sisters of the kachinas. During ceremonies, these maidens are impersonated by male dancers, who wear painted wooden headdresses like the one on this doll.

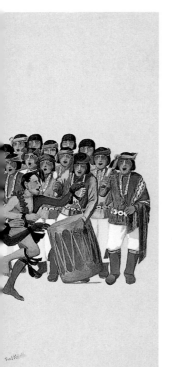

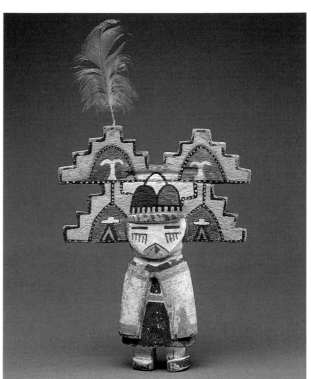

**10.11**

## Kiaklo and the Mud-Heads

An important Zuni legend tells of Kiaklo, Duck, Rainbow, and the Mud-Heads. According to the story, a man named Kiaklo became separated from his people. He wandered to an icy land, where his face turned white with the frost from his own breath. Lost and snow-blind, Kiaklo called to his people until his lips split. Tears carved tracks in his face. Duck heard Kiaklo's cries and guided him out of the cold. Rainbow then carried Kiaklo to a sacred lake, leaving a rainbow reflection on Kiaklo's face before withdrawing. Blind, lame, and alone again, Kiaklo was forlorn. Meanwhile, directed by Zuni deities who lived below the lake, Duck ordered the Mud-Heads, or clowns, to carry Kiaklo to the lakeshore. There, the deities restored Kiaklo's sight, entrusted him with the creation story, and gave him knowledge of the gods and sacred customs. When the Mud-Heads carried Kiaklo to the Zuni people, he recounted the deities' words to them before returning to his home in the west.

**10.12 Pueblo (Zuni), Doll of Mud-Head Carrying Kiaklo Kachina, 1910–25**

*Every four years, during the initiation ceremony for young boys, the Zuni reenact the story of Kiaklo. Chattering and cavorting, Mud-Head impersonators take turns carrying the Kiaklo character into town on their backs, just as the original ones did. Villagers eagerly await Kiaklo's arrival at each kiva, where he recites his messages from the deities. Like the ceremony itself, this doll re-creates Kiaklo's ride. White-faced, cracked-lipped, tear-scarred, and rainbow-stained, Kiaklo is carried on the back of a Mud-Head. Duck, Kiaklo's constant companion, is perched atop a baton in Kiaklo's hand.*

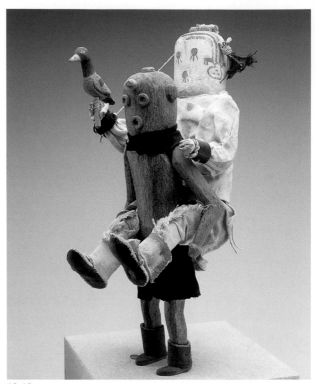

**10.12**

**10.13** Pueblo (Hopi), Crow Mother Kachina Doll, 1925–33

*The dramatic Crow Mother kachina has black crow wings attached to her helmet mask. Her Hopi name,* Angwusnasomtaqa, *means Man with Crow Wings Tied To. She is considered by some Hopis to be the mother of all kachinas. During the Bean Dance ceremony, a Crow Mother*

*impersonator supervises the initiation of boys and girls into the kachina cult. After being versed in tribal lore, the children are brought before her. She hands yucca-leaf whips to men dressed as Whipper kachinas, who ceremonially strike each child four times. Later, she leads other kachinas into the village, carrying a basket of corn kernels and bean sprouts to herald a new season.*

**10.14** Pueblo (Zuni), Buffalo Kachina Doll, c. 1915

*When ranchers all but eradicated large, wild animals from the area, the Zuni were left without a source of fur. Hoping to promote the return of the animals, they borrowed the Buffalo Dance from the Sioux. This kachina doll wears real horns and a cloak of real buffalo fur.*

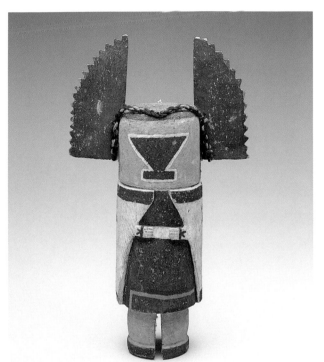

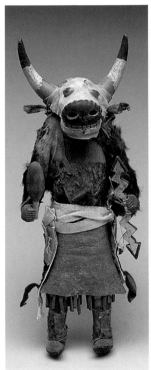

**10.13**

**10.14**

**10.15** Navajo, Phase III Chief Blanket, 1880-90
The Navajo arrived in the Southwest during the 14th and 15th centuries. Formerly a nomadic people, they soon adopted their Pueblo neighbors' more sedentary practices, like farming and weaving. Chief blankets were woven not for chiefs, but for wealthy men and for trade. *This blanket belongs to the last of three design phases, when simple stripes had given way to complex arrangements of stripes, diamonds, and triangles that only fully emerge when the blanket is worn, wrapped around the body. At the front, the middle triangles along the sides of the blanket meet to form a central diamond, echoing the one at the middle of the wearer's back.*

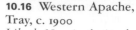

**10.16** Western Apache, Tray, c. 1900
*Like the Navajo, the Apache emigrated to the Southwest from northern Canada. The name "Apache" is from a Zuni word meaning enemy, and the Apache were feared for their frequent raids on neighboring settlements. Collectively, the various groups of Apache in the forested mountains of east central Arizona are called Western Apache. Lacking a pottery tradition, the Western Apache wove baskets for serving and storing their food. By the end of the 19th century, weavers were adapting their designs to suit the tastes of a rising commercial market. Traditional geometric*

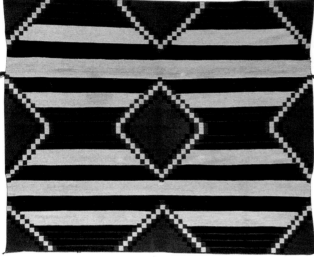

**10.15**

**10.16**

patterns gave way to more elaborate innovations. Made in a coiling technique with natural and dyed plant fibers, this tray features concentric rosettes and a broad, zigzag border of human figures and red crosses.

**10.17**  Navajo, Squash-Blossom Necklace, 1910-25
The Navajo learned the art of silversmithing in the mid-19th century through contact with Mexican craftsmen, who in turn had assimilated Spanish traditions. Perhaps the best-known form of Navajo jewelry is the squash-blossom necklace. So called because of the form of the necklace's silver beads, the beads in fact imitate similarly shaped pomegranates, not squashes. A favorite Spanish motif, small silver pomegranates were used as fastenings on the clothing of colonial Mexican men. The central, crescent-shaped pendant, another borrowed form, was first used by the Navajo as centerpieces in horses' bridles.

**10.17**

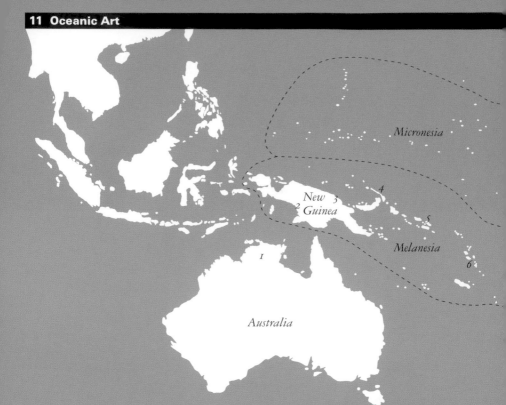

In the South Pacific Ocean, 25,000 islands lie between Asia and the Americas. Together with the continent of Australia, these islands make up Oceania, which conventionally is divided into four areas by culture: Australia, Melanesia, Micronesia, and Polynesia. The MFAH's collection of Oceanic art is small in number but comprises many exceptional pieces. Its primary strength is in Melanesian works, particularly from the Sepik River region of New Guinea, with a secondary strength in Australian bark paintings.

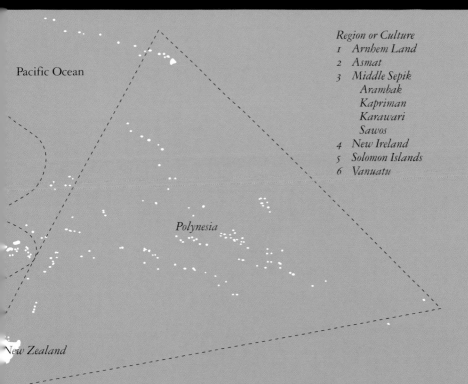

Pacific Ocean

Polynesia

New Zealand

Region or Culture
1  Arnhem Land
2  Asmat
3  Middle Sepik
   Arambak
   Kapriman
   Karawari
   Sawos
4  New Ireland
5  Solomon Islands
6  Vanuatu

The presence of the sea has shaped the cultures of Oceania, with the exception of inland peoples on the larger islands. While the ocean inspires the imagery of these cultures, it simultaneously restricts the availability of natural resources. In Melanesia, religion is based on the belief that the universe is governed by the invisible forces of nature. Ancestors are revered because their souls are thought to influence the living. Imbued with spiritual power, Melanesian religious objects, implements of war, and personal adornments are distinguished by visually potent designs.

**11.1** Karawari, Papua New Guinea, Middle Sepik, Crocodile, early 20th century

*An area of prolific art production, the Sepik River region of New Guinea is home to some 200 tribes. Central to their mythology is the crocodile, which is both feared and revered as the*

*creator and ancestor of life on earth. The Karawari people used large wooden crocodiles in initiation rites, during which boys received scarification marks mimicking crocodile tooth marks*

**11.1**

**11.2** Australia, Arnhem Land, Kangaroo Painting, mid-20th century

*For the aboriginal peoples of Australia, survival in the continent's harshest environments depended upon frequent migration, requiring the building of temporary shelters made of branches and bark, called humpys. Inside, the native peoples painted the bark with vibrant designs in ocher, clay, and charcoal. This kangaroo painting was probably intended to ensure a successful hunt. The classic "X-ray" style depicts the animal's internal organs, essential knowledge for people whose major food source was —and still is—the kangaroo.*

**11.2**

to indicate that the boys had been eaten symbolically by the animal and were now reborn as men. The wooden figures were also used prior to head-hunting raids. In these ceremonies, men danced with the crocodile figures, supporting them on poles put through holes in the crocodiles' sides. After the raids, the captured human heads were placed within the wooden jaws. This example is 23 feet long, a size attained by real crocodiles.

### 11.3 Asmat, Indonesia, Irian Jaya, War Shield, mid-20th century

The Asmat people had little contact with European civilization until the 1930s, and their rituals of head-hunting and cannibalism persisted into the 1960s. Obsessed with warfare, they focused much of their artistic energies on creating elaborate shields that they carved during special festivals. Believing that enemies caused all deaths, the Asmat named the war shields after deceased relatives. The Asmat then used the shields in head-hunting raids to avenge those deaths and appease the spirits of the dead. This enormous war shield (over 6 1/2 feet high) is richly decorated with stylized designs representing creatures native to the region: herons (the large, central images), and small mammals called cuscuses (the small, curling forms are cuscus tails).

**11.3**

**11.4a** *In Fanla village, Chief Tofor stands next to the slit-drum (11.4) before it was acquired by the MFAH.*

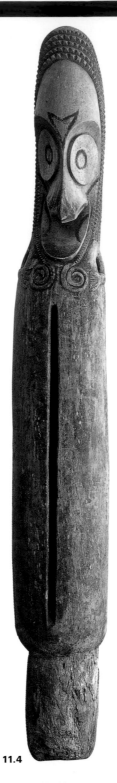

**11.4** Chief Tofor, Vanuatu, Ambrym Island, Slit-Drum, 1960–70
*In the central islands of Vanuatu, the center of village ritual life is the outdoor dancing ground. This area is dominated by sets of monumental slit-drums used in ceremonies commemorating advancement in the male age-grade system. Throughout their lives, men achieve progressively higher positions by accumulating wealth, commissioning drums and other paraphernalia, and generally buying their way. The few men who achieve the highest grades become community leaders. This particular drum was the major ceremonial drum for Fanla village and was carved by its powerful chief, Tofor. The shaft is surmounted by a large, concave head representing an ancestor whose voice is said to be the sound the drum makes.*

**11.4**

**11.5** Kapriman,
Papua New Guinea,
Middle Sepik,
Janus-Faced Post for a
Men's House, 1900–1950

*Spiritual life in the Sepik River
area of New Guinea centers
around men's ceremonial houses,
where initiates socialize, store
sacred objects, and prepare for
sacred rituals. Traditionally,
each village has at least one*

*of these imposing buildings.
Constructed of wood, bark,
and thatch, these houses can
reach 180 feet long and 60 feet
high. The roof beams, rafters,
and raised floors are supported
by large, carved posts. The upper
portion of a support post, this
sculpture probably represents
a clan ancestor, a spirit that
protects clan members from
hostile forces.*

**11.6** Probably Sawos,
Papua New Guinea,
Middle Sepik,
War Shield, before 1918

*Most of the art produced in
the Sepik River region of
New Guinea is used in reli-
gious rituals, in warfare, or
to decorate men's ceremonial
houses. Large faces representing
mythical ancestors are a common
image. Members of the Sawos
tribe believe that when placed
on shields, these faces provide
protective powers. The long
tongues, huge eyes, and bulging
pupils inspire awe — or even
terror — in the enemy. An
ancestral face fills the entire
height of this shield. High and
low reliefs create a striking
three-dimensional effect,
while the painted design of
concentric circles and curvilinear
lines gives the work a sense of
movement and vitality.*

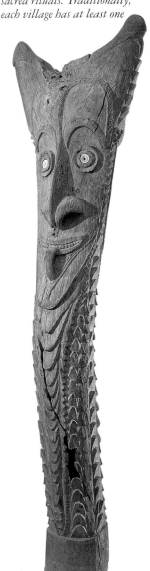

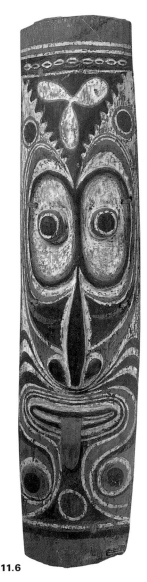

**11.5**

**11.6**

**11.7** Probably Arambak,
Papua New Guinea,
Middle Sepik,
Male Spirit Mask,
1900–1925
*While many Sepik River tribes
create basketry masks, Middle
Sepik examples are unusual
in having long, beak-like noses.
The masks represent male an-
cestral spirits who live in water
or hollow trees. Worn during
rites initiating boys into the
men's secret society, the masks
house the spirits temporarily.
This mask, nearly 4 feet high,
is one of the largest known.*

**11.8** Papua New Guinea,
New Ireland,
Helmet Mask,
late 19th century
*The island of New Ireland is
distinguished for its colorful
and flamboyant art, much of
which is made for the ancestor
rites that dominate the island's
social and religious life. The
most important ceremonies are
called* malanggan. *Held to
commemorate the deaths of
important people, these lengthy
festivities also provide an
opportunity to initiate and
circumcise young men.*

*In preparation for malanggan,
artists work under the direction
of clan elders to create large
wooden sculptures and several
types of masks. Distinctive
among these masks are those
called* tatanua, *which are worn
by men and represent the spirits
of specific ancestors. One side
of this fierce, asymmetrical
tatanua mask is decorated with
arcs of lime plaster, representing
the shaved and plastered head
of a man in mourning.*

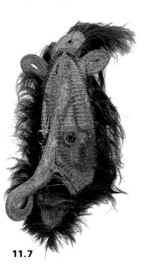

**11.7**

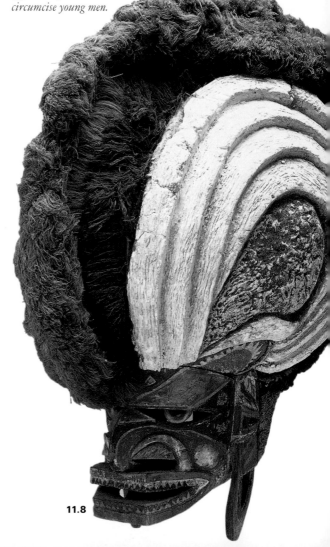

**11.8**

**11.9** Solomon Islands, Malaita Island, Forehead Ornament, before 1910

*Until the 20th century, headhunting was of great importance to the warlike tribes of the Solomon Islands. The captured heads were regarded not only as symbols of prestige but also as conduits for transferring powers from victim to captor. Successful headhunters and high-ranking men were entitled to wear a* kapkap, *or circular shell ornament, on the forehead or temple. Because most of the peoples of Oceania lacked precious and semiprecious stones, as well as metals, they often used shells to make their jewelry and to decorate their sculpture.*

**11.10** Santa Cruz Islands, Ndeni Island, Chest Ornament, before 1890

*The Santa Cruz Islands lie to the southeast of the Solomon Islands, and the art of the two archipelagoes is closely linked. In both places, the emblem of a high-ranking man and of an eminent warrior is a circular ornament made of* tridacna *shell with a turtle-shell overlay. In the Santa Cruz Islands, this ornament—called a* tema—*is worn on the chest rather than on the head, and the design is vertical rather than radial. The importance of fishing is evident in the stylized sharks, school of fish, and frigate bird on this example.*

**11.9**

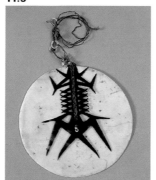

**11.10**

**11.9a** *A chief of Malaita Island wears a forehead ornament* (kapkap).

The story of modern art at the MFAH unfolds across two museum buildings. Early 20th-century art is on view in the Beck Building, beginning with the dramatic evolution of Impressionism into Post-Impressionism and Cubism. Illustrating this transition, Beck Collection (pp. 98–113) works by André Derain and Pierre Bonnard, for example, lead into Cubist works by Pablo Picasso and Fernand Léger. Early Modernism follows, with classical examples by artists such as Henri Matisse, Constantin Brancusi, and Piet Mondrian, while American works of the same period are housed in the museum's American galleries (pp. 172–209).

The story continues in the Law Building's monumental Upper Brown Pavilion, where art at mid-century is one of the MFAH's outstanding strengths. The Abstract Expressionist collection deserves particular recognition, as it contains key works by artists such as Jackson Pollock, Lee Krasner, and Franz Kline. The next generation is also well represented, with paintings by Helen Frankenthaler and Kenneth Noland, among others. Post-World War II sculpture includes examples by Picasso

and Alexander Calder, whereas the invention of Assemblage art can be studied through works by Niki de Saint Phalle and Jean Tinguely.

Artists reacting to the heroic grandeur of Abstract Expressionist painting gave rise first to Hard-Edge Abstraction and then to Pop Art. The museum's 20th-century collection includes signature abstract works by Ellsworth Kelly and Agnes Martin, and Pop examples by Claes Oldenburg, Andy Warhol, and James Rosenquist. The advent of Minimalism can be seen in works by Donald Judd and Jo Baer, while the subsequent flowering of imagist art includes important paintings by Philip Guston and Jasper Johns as well as selections by Susan Rothenberg, Georg Baselitz, and Anselm Kiefer. The MFAH has always collected works by Texas artists. Among the many 20th-century Texans represented are John Biggers, Dorothy Hood, and James Surls. The museum also maintains a commitment to promoting the next wave in contemporary art. By commissioning new work, the MFAH extends its mission from collecting and caring for art of the past to fostering art in the present.

As Gertrude Stein once said, "Paris was where the 20th century was." Indeed Paris is where modern art was born, attracting to its creative atmosphere artists from across Europe and America. In Paris between 1907 and 1914, Pablo Picasso and Georges Braque invented Cubism, a radical break with the way previous western European artists represented the natural world. Since the Italian Renaissance, painters had relied on conventions of perspective to create the illusion of three dimensions on the flat painting surface. Picasso and Braque rejected this tradition, instead exploring ideas about the geometric underpinnings of paintings first suggested by the Post-Impressionist painter Paul Cézanne. They recorded the surfaces of their subjects with more and more planar divisions, producing increasingly abstract works that respected the actual flatness of the painting. The two artists sought to liberate painting from its traditional role of imitating nature. Its new mission would be to record visual perceptions and conceptual truths.

**12.1 Pablo Picasso, The Rower, 1910**

Like Georges Braque's Fishing Boats *of 1909 (p. 113), this work by Pablo Picasso is a pivotal early Cubist painting. In it, Picasso analyzes a figure from many different points of view, breaking down the forms into abstracted geometric planes. The oval head, rectangular neck, and sharp angles of elbows are recognizable, even as the arrangement of shapes suggests abstract volumes in space. Painted in a Spanish fishing village, the work was first thought to depict a "rower," but it is more likely a study of a woman. For additional works by Picasso, see pp. 128, 317, and 334.*

**12.1**

*It is the social function of great poets and artists to continually renew the appearance nature has for the eyes of men. . . . Cubism differs from the old schools of painting in that it aims, not at an art of imitation, but at an art of conception, which tends to rise to the height of creation.*

Poet Guillaume Apollinaire, 1913

**12.2** Pablo Picasso,
Pipe and Sheet Music, 1914
*Since 1909, both Picasso and
Braque had been exploring
the paradoxical relationships
between illusion, art, and
reality. In 1912, while working
on still-life paintings, they
invented the collage, in which
an actual construction of cut-
and-pasted paper forms replaced
the painted illusion of such*
*forms. In this work Picasso
playfully combines drawn
objects (the pipe, sheet music,
and table top) with a trompe
l'oeil, or fool-the-eye, gilt frame
(actually printed wallpaper),
illusionistic cast shadows, and
a signed nameplate. "Ma Jolie,"
a popular song title inscribed
on the sheet music, was Picasso's
pet name for his mistress at the
time, Eva Gouel.*

**12.3  Fernand Léger, Man with a Cane, 1920**

Prior to fighting in World War I, Fernand Léger painted abstracted Cubist works in primary colors and in black and white. His experiences in combat awakened his sympathy for the working class, and after the war he sought to create art that would be accessible to people from all walks of life.

*It was in a regiment of the Engineer Corps during the War, among rough and worn human beings, that I discovered man. While I lived there, surrounded by machinery, I felt growing in me an appreciation for the mechanical and dynamic side of modern life. . . .*

Fernand Léger, 1935

*This painting shows Léger's new, more figurative Cubist style fused with his interest in machines. Using geometric shapes, recombined into a flat, tightly interlocked composition, he portrays a man in an interior. Bright colors animate the surface, echoing the syncopated rhythms of the jazz age. The image of a dapper man holding a ball-headed cane presents the artist's optimistic vision of humankind as firmly placed in a modern, mechanized, urban environment.*

**12.3**

**12.4** Pablo Picasso,
Two Women in Front
of a Window, 1927
*In this work from the late 1920s,
Picasso retained the geometric
rhythms of early Cubism as well
as a framing device similar to
those in many of his collages
(12.2). At the same time, the
freer drawing of the figure on
the right suggests an interest
in the subconscious sketching*
*techniques of the new Surrealist
movement. One can identify
the figure on the left as a hard,
angular woman, perhaps
Picasso's wife, Olga — her main
feminine feature being two
circles for breasts — and the one
on the right as a more sensuous
woman, Marie-Thérèse Walter,
his lover at the time.*

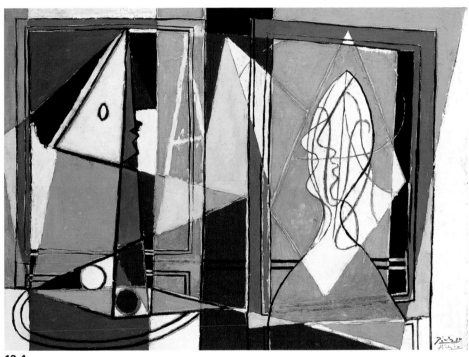

**12.4**

*Do you think it concerns me
that a particular picture of
mine represents two people? . . .
The "vision" of them gave me a
preliminary emotion; then little
by little their actual presences
became blurred; they developed
into a fiction and then dis-
appeared altogether, . . .*

*They are no longer two people,
you see, but forms and colors:
forms and colors that have
taken on, meanwhile, the idea
of two people and preserve the
vibration of their life.*

Pablo Picasso, 1933

**12.5** Piet Mondrian, Composition with Gray and Light Brown, 1918

*In 1917 Piet Mondrian helped to found the Dutch art group de Stijl (the Style), among the most idealistic and severe of the early abstract movements. Driven by more than aesthetics, de Stijl also had an almost religious mission: to unite the material and spiritual worlds through an art of pure geometry. For Mondrian, a grid-pattern composition of horizontal and vertical lines could represent the universal harmony of the world. An X-ray of this painting reveals that Mondrian had first sketched a uniform grid of rectangles based on the classical golden rectangle; each of the overlaying rectangles is made up of components from this grid.*

**12.6** Constantin Brancusi, A Muse, 1917

*Like Piet Mondrian, Constantin Brancusi also believed in basic forms as a path to truth. Arriving in Paris from Romania in 1904, Brancusi turned from an early interest in Auguste Rodin (pp. 424–25) to Cycladic sculptures (p. 38) and African art (p. 212–35). Brancusi's goal in sculpture was to reveal the essence of a subject rather than its exterior form. In A Muse, Brancusi explores the classical form of ideal female beauty (see also p. 257), rendered in the simplified shapes of Cycladic art. Originally carved in marble, this unique, polished-bronze version—made for the collector John Quinn—displays a hard, streamlined beauty forecasting the machine aesthetics of modern art.*

**12.5**

**12.6**

### 12.7 Henri Matisse, Olga Merson, 1911

*When Henri Matisse painted this picture of Olga Merson, a Russian artist studying with him, he was seeking what he called the "condensation of sensations which constitutes a picture." Not a conventional likeness ("Exactitude is not truth," he once said), its strong presence was created by balancing the simple shapes of the figure with the background, and especially by the two curving black lines that lock the figure into place. Matisse allowed the revisions he made to the face and arm to remain visible, another indication that for Matisse, overall harmony and balance were more important than traditional notions of a finished picture. See also p. 109.*

**12.7a** *Henri Matisse, 1932*

**12.7**

© Arnold Newman

**12.8a** *In 1949, photographer Arnold Newman captured Jackson Pollock painting Number 6.*

"On the floor I am more at ease…
I can walk around it [the painting],
work from the four sides and
literally be in the painting."

Jackson Pollock, "Problems of Contemporary Art," 1947–48

# Abstract Expressionism

During the 1940s, a number of young artists working in New York created powerful paintings charged by energetic new techniques. Learning from the Surrealists and other European artists who had come to the United States to escape World War II, and debating ideas about art at informal gatherings in such places as the Cedar Tavern in Greenwich Village, these young painters revolutionized modern painting, gradually shifting the center of the art world from Paris to New York. Known as Abstract Expressionists, or the New York School, the first ground-breaking generation included Jackson Pollock, Franz Kline, Lee Krasner, Robert Motherwell, and Mark Rothko.

Largely in response to the horrors of the war, these artists believed that all previous approaches to art were now invalid, and they searched for subjects and methods that would be truer to their experiences. They were therefore particularly responsive to the Surrealists, whose drawing techniques for liberating the unconscious gave rise to new ways of seeing. Surrealism also taught them an appreciation of the art of children and of so-called primitive cultures, whose ideographic and mythic art contained the authentic quality of expression they were seeking.

Championed by the art critics Harold Rosenberg and Clement Greenberg, the Abstract Expressionist movement took two main forms: action painting, a term coined by Rosenberg to describe gestural works by Pollock, Kline, and Willem de Kooning, in which the canvas was "an arena in which to act"; and Color Field painting, a term used to describe works by Rothko, Barnett Newman, and later painters who used large, unbroken areas of color to create evocative canvases devoid of any associative images.

**12.8 Jackson Pollock,
Number 6, 1949**

*A pioneer Abstract
Expressionist, Jackson
Pollock (pp. 132-33) was
the most influential artist
of the post-World War II
period, paving the way for
artistic breakthroughs by his
contemporaries and younger
artists alike. In the 1930s
and early 1940s, Pollock
absorbed ideas from
such diverse artists as the
regionalist painter Thomas
Hart Benton (p. 206);
David Alfaro Siqueiros; and
Surrealists André Breton,
Max Ernst, and Roberto
Sebastián Matta. Number 6
belongs to the first trium-
phant period of "drip"
paintings, when Pollock
began experimenting with
automatic techniques.
Working on canvas laid
on the floor, he poured,
dripped, and flung enamel
paint on the surface,
eliminating brushes and
literally drawing with
the liquid medium.
Revolutionary not only
for their technique, these
paintings redefined
representations of space
and the subject of art.
With no single focal point,
the energetic web of color
and gestural lines—the
concrete notation of the
act of painting—became
the artist's subject.*

**12.8**

**12.9**

**12.9 Jackson Pollock,
Untitled c. 1949**
*Jackson Pollock created
just 8 sculptures in the
round, and only 5 still exist.
The MFAH owns 2 of them,
including this wire-and-
plaster work. This small
piece (about 3 inches high)
is a model for an unrealized
work that Pollock planned
to be over 6 feet high.*

## 12.10 Franz Kline, Wotan, 1950

Franz Kline arrived at his mature style in 1950 with the powerful black-and-white abstractions for which he is now celebrated. Purging all color and representational subjects from his compositions, he focused on simple forms and the elemental contrast between black and white. Although the finished paintings appear to be spontaneous and expressive gestures, in fact—as the small study (12.11) for Wotan reveals—the final paintings are the result of careful experimentation. Wrestling with the balance of forms in sketches on pages of telephone books or newsprint, Kline created arrangements of black and white that are equal in force, forming an interdependent and dynamic tension. The title for this austere masterpiece refers to a central character in Richard Wagner's operas, Der Ring des Nibelungen, to which Kline often listened while painting.

**12.10**

## 12.11 Franz Kline, Untitled (Study for Wotan), 1950

**12.11**

**12.12 Lee Krasner, Blue and Black, 1951–53**

One of the few women among the first group of Abstract Expressionists, Lee Krasner was also the only native New Yorker. Academically trained, in 1937 she began studying with Hans Hofmann, the German émigré artist who influenced many American artists with his theories about color and shape in abstract painting. By the early 1940s she became associated with most of the early Abstract Expressionist artists, including Jackson Pollock (12.8–12.9), whom she married in 1945. Blue and Black shows Krasner's love for the work of Henri Matisse (pp. 109, 319); the curved filigree pattern on the left, repeated in an enlarged version on the right, echoes Matisse's Mediterranean paintings, in which French windows frame iron scroll-work balconies. Like the black and white in Kline's Wotan, the complex interplay of black and blue creates spatial tension and dramatic impact.

**12.12**

A case can be made for Wotan as Kline's master-piece: that extraordinarily forthright black rectangle with a stub of the top "girder" sticking out to the right, is an image whose Wagnerian power fits its title. Majestic and a little slangy at the same time, it is one of the most commanding American paintings.

Robert Hughes,
*Time Magazine*, 1986

**12.12a** *Lee Krasner, 1980*

*Nothing as drastic an innovation as abstract art could have come into existence, save as the consequence of a most profound, relentless, unquenchable need. The need is for felt experience—intense, immediate, direct, subtle, unified, warm, vivid, rhythmic.... Abstract art is an effort to close the void that modern men feel.*

Robert Motherwell, *Bulletin of The Museum of Modern Art* (New York), 1951

**12.13 Robert Motherwell, Black on White, 1961**
*Robert Motherwell, one of the youngest of the original Abstract Expressionists, was classically educated in philosophy, art history, and French literature. An intellectual and a writer on art, he was associated closely with the Surrealist artists in New York, and he adapted their automatic techniques to his own work.*

*In the monumental oil painting* Black on White, *Motherwell characteristically balances contradictory elements—intellect and emotion, shape and line, sweeping gesture and measured rhythms—in the pursuit of lyrical and poetic expression.*

### 12.14 Mark Rothko, Painting, 1961

*A Russian immigrant, Mark Rothko was raised in Oregon and moved to New York in the late 1920s to study art. His work of the early 1940s reflected Surrealist themes and techniques, but by 1949 he had arrived at his signature abstract style. Rothko used layers of thinned paint, soaked into the canvas, to create nuances of tone that gradually emerged as ethereal, floating rectangles of color. In contrast to the action painters, he worked to eliminate the gestural line, creating instead vast areas of color to envelop the viewer and promote feelings of the sublime.*

### 12.15 Helen Frankenthaler, Blue Rail, 1969

*A second generation Abstract Expressionist, Helen Frankenthaler arrived at her breakthrough style after seeing a 1951 show of black-and-white paintings by Jackson Pollock (12.8–12.9). She began pouring thinned paint from coffee cans onto unprimed canvas.*

12.14

12.15

Sometimes starting by drawing on the canvas in charcoal, Frankenthaler created an equilibrium between barely tinted soctions, denser patches, and bare areas of canvas. Gestural and controlled, flat yet evoking the natural landscape, this work exemplifies Frankenthaler's lyrical and sensual style.

## 12.16 Kenneth Noland, Half, 1959

Between 1956 and 1963 Kenneth Noland created approximately 200 circle paintings, exploring the tension between Abstract Expressionist gesture and geometric order. Influenced by Frankenthaler's staining techniques, and using an intuitive sense of color

relationships, he produced surprisingly wide variations within this narrowly defined project. Along with Ellsworth Kelly (12.25, 12.54) and Frank Stella (12.53), Noland rejected the subjective nature of Abstract Expressionism in favor of strictly pictorial works.

**12.16**

*I wanted color to be the origin of the painting.... I wanted to make color the generating force.*

Kenneth Noland, 1971

Even though Abstract Expressionism is also known as the New York School, some of the most vital practitioners of gesture and Color Field painting worked outside of New York, including three significant artists in Texas.

**12.17 Joseph Glasco, Untitled, 1995**

*This painting by Joseph Glasco demonstrates his skill with the vocabulary of post-World War II art, from the vigorous brushwork of the Abstract Expressionists to the push-pull color dynamics of Hans Hofmann. After service in World War II, Glasco studied art in Texas, California, and*

*Mexico before arriving in New York during the heyday of Abstract Expressionism. Although he continued to exhibit regularly in New York, he moved away in the mid-1950s, settling in Galveston in 1972 to pursue his own brand of painting: a synthesis of European and American forms of abstraction and Surrealism. Painted just a year before his death, this work presents vivid blue, white, and red rectangles united by an underlying grid structure. Filled with assurance and gusto, it is the work of an artist at the peak of his career.*

**12.18 Dorothy Antoinette (Toni) LaSelle, Puritan, 1947–50**

*After completing a master's degree at the University of Chicago, Toni LaSelle joined the faculty of Texas Woman's University in Denton in 1928, where she continued to teach for 44 years. In 1944, she began spending summers at Hans Hofmann's school in Provincetown, Massachusetts, an experience that proved to be a turning point in her art. LaSelle painted small-scale abstractions featuring colors and shapes that almost dance in a charged equilibrium.*

**12.17**

**12.18**

**12.19**  Dorothy Hood,
Haiti, 1969
*Dorothy Hood's abstract
canvases simultaneously evoke
interior, psychic spaces and
sweeping, natural landscapes.
Trained at the Rhode Island
School of Design, she moved to
Mexico City in 1941, where she
developed a lifelong interest in
Surrealism and Latin American
art. After moving to Houston in*
*1962, Hood continued to travel
frequently to Central America.
In Haiti, the swift-moving
washes of gold earth tones and
the blue and white of sky and
sea are united under the shadow
of an ominous black center. The
beautifully balanced abstraction
conjures the island of Haiti,
as the artist has stated, as a
"newly born wonder," lyrical
yet portentously tragic.*

**12.19**

**12.20** John Biggers,
Jubilee: Ghana Harvest
Festival, 1959–63

*During the 1940s, John Biggers
forged a new painting style
rooted in the Mexican mural
movement as well as in the 1930s
murals commissioned by the
U.S. government as part of its
Federal Arts Project. Born in
Gastonia, North Carolina,
and educated at the Hampton
Institute in Virginia and at
Pennsylvania State University,
Biggers arrived in Houston in*

*1949 to head the art department
at the newly opened Texas
Southern University. Embracing
mural painting as a means
of expressing his heritage, he
became the region's most eloquent
chronicler of the changing
identity of African-Americans.
In 1957 he was a pioneer in
traveling to Africa to learn more
about his cultural roots. Out
of his experiences he developed*

12.20

a unique synthesis of African,
European, and American art
that influenced numerous
younger artists. In this painting,
on view in the MFAH's galleries
of African art (pp. 212–35),
Biggers chronicles the annual
harvest festival in Ghana. The
cyclical passage of the seasons is
echoed in the swaying rhythms of
the singing and dancing women.

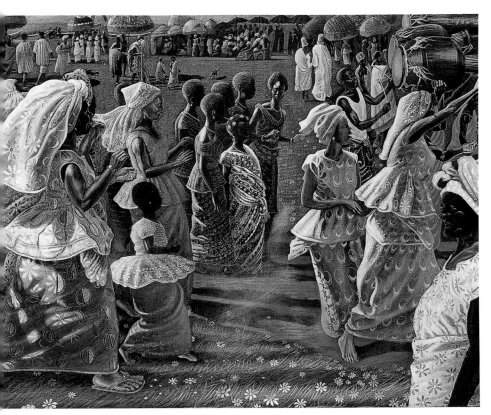

The role of art is to express the triumph of
the human spirit over the mundane and the
material. . . . My motivation is to portray
that very rare and unseen spirituality of
the Afro-American that is universal for
all mankind.

John Biggers, *Fresh Paint, The Houston School* (MFAH), 1985

**12.21** Pablo Picasso,
Woman with
Outstretched Arms, 1961

*As a child, Pablo Picasso (12.1) entertained his sister by cutting and folding paper figures. A love for the exuberance of children's art persisted throughout his career, as is clearly evident in this life-size sculpture, cut and bent from a single sheet of metal. The sureness of the lines and folds attests to the rapid execution of his small-scale original* *paper version, as does the playful shorthand of steel mesh and black paint he used to identify the features and gender of the figure. Having created a series of paper works in the 1940s, Picasso attempted his first steel version in 1953. This sculpture was made in 1961, the same year that the 80-year-old Picasso married Jacqueline Roque.*

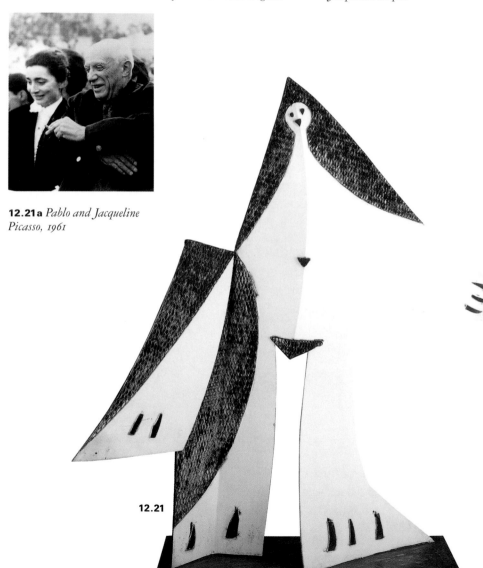

**12.21a** *Pablo and Jacqueline Picasso, 1961*

**12.21**

**12.22** Alexander Calder, The Crab, 1962

*The son and grandson of sculptors, Alexander Calder is best known for the colorful, hanging kinetic sculptures that he made while living in Paris in the early 1930s. These works, dubbed mobiles by the artist Marcel Duchamp, are carefully balanced arrangements of cut steel to which Calder brought his early training in engineering. Out of them grew another new form, one that Calder called stabiles—large-scale sculptures, generally without moving parts, that also incorporate engineering feats to balance seemingly delicate sheets of steel. The Crab, created with characteristic Calder inventiveness, is a stabile that portrays a bright red sea creature, depicted halfway in between abstraction and representation. Like Picasso, Calder is an artist whose attachment to childhood wonder inspired wit and fantasy in a unique vocabulary of forms.*

**12.22a** *The Crab has graced the grounds of the MFAH since the 1960s. In this 1970 newspaper cartoon, artist Bill Hinds spoofs the much-loved Houston landmark.*

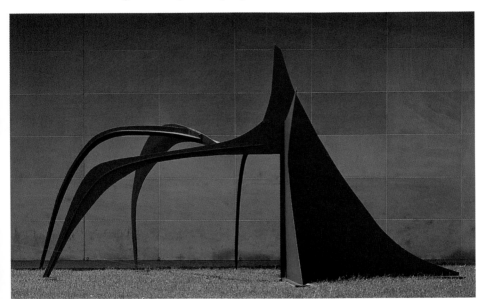

**12.22**

**12.22a**

**12.23** Lee Bontecou,
Untitled, 1962

*A student at the Art Students
League, New York, from 1952
to 1955, Lee Bontecou began
constructing abstract hybrids of
painting and sculpture in 1959.
She salvaged bits of canvas,
then sutured them with wire to
underlying structures of welded
metal. The resulting wall reliefs
grew progressively in size over
the next several years and
eventually came to include gas
masks, helmets, and bits of*

*ragged metal. In these eerie
topological abstractions,
seemingly ruptured surfaces
reveal mysterious inner spaces.
At once mechanistic and sexual,
abstract yet evocative of the
brutal forces of war, Bontecou's
works are both of their time
and distinctly her own. Along
with Louise Nevelson (12.24),
Bontecou was one of only a few
women sculptors who achieved
recognition in the 1960s.*

**12.23**

**12.24** Louise Nevelson, Mirror Image I, 1969

*Born in Russia and raised in Maine, Louise Nevelson studied art, theater, dance, and voice in Europe and New York before settling on sculpture in the 1930s. Over the next two decades her work evolved, incorporating aspects of Pre-Columbian, Native American, Surrealist, and Abstract Expressionist art. In 1957 she took the crates that she had previously used as pedestals for her work and turned them into containers for her carved wooden forms, unifying the parts with a coat of matte paint. This move quickly led to wall-sized assemblages in which the crates served as an infinitely expandable grid. Nevelson created the monumental sculpture* Mirror Image I *—over 18 feet wide and an example of her later, more streamlined style—for an exhibition of her work held at the MFAH in 1969.*

**12.24**

**12.25** Ellsworth Kelly, Green and Black, 1988

*While Ellsworth Kelly's paintings appear to be pure geometric abstractions, in fact they are rooted in nature and architecture. Having studied art in Paris in the late 1940s, Kelly began to paint segmented views from the world around him: the play of shadows on an irregular surface, or the shape of an arch beneath a bridge. By 1968 he abandoned the traditional square and*

*rectangular canvases in favor of shaped canvases. In such trapezoids, rhomboids, and triangles Kelly sought to distill the beauty of the natural world into simple, harmonious forms and colors. Often referred to as Hard-Edge Abstraction, Kelly's work relates to Minimalism (pp. 340–41) in its pure color and geometry; however, Kelly's passionately analytic vision is firmly grounded in his observations of nature. For a sculpture by Kelly, see 12.54.*

**12.25**

**12.26** Agnes Martin, Untitled #12, 1990

*Before settling permanently in New Mexico in 1967, Agnes Martin spent part of her time in New York, living and working in the late 1950s in the same studio building as Ellsworth Kelly. Like Kelly, she was interested in distilling essential forms out of nature, seeking in simple compositions a harmony to echo that found in the natural world. Attempting to balance an ideal of perfect form with the imperfect forms of the material world, Martin began hand-drawing delicate linear grids on canvas in 1960. In these quiet canvases the pure forms of geometry are mediated by the imprecise gestures of the human hand. For example, the drawn lines of this work stop just short of the canvas edge while bands of light gray paint continue past it, the difference reminding the viewer again of the human presence in this serenely abstract work.*

**12.26**

In the 1960s many artists reacted against what they considered to be emotional excesses of Abstract Expressionism. Using industrial materials and fabrication techniques, painters and sculptors created simple, primary shapes with no trace of the artist's hand. While this movement was popularly called Minimalism— initially with a negative connotation implying reductionism—the artists themselves preferred to think of their approach as paring art down to its bare essentials.

**12.27  Donald Judd, Untitled, 1975**
*Donald Judd, a leading Minimalist sculptor and an articulate champion of new art, considered painting and representational art outmoded. He believed instead that the art object itself—its shape, scale, and material—was the valid subject of art. In 1962 he began producing steel or aluminum cubes that others fabricated, thereby ensuring the absence of the artist's touch. As he did for this work, commissioned by the MFAH, Judd frequently chose a single form to combine structure, color, and material into a unified whole. The interior bottom of the box is painted a brilliant red, which reflects against the side panels to fuse surface and light.*

**12.27**

*It isn't necessary for a work to have a lot of things to look at, to compare, to analyze one by one, to contemplate. The thing as a whole, its quality as a whole, is what is interesting.... In the new work the shape, image, color, and surface are single and not partial and scattered.*

Donald Judd, from "Specific Objects," *Arts Yearbook 8*, 1965

**12.28** Jo Baer,
Untitled (Stations of
the Spectrum Triptych),
c. 1964–74
*Within Minimalism a split
occurred between artists like
Donald Judd, who believed that
only three-dimensional objects
existing in real space could be
successfully anti-illusionistic,
and artists who chose to pursue
the flatness of the picture plane*

*in painting. Jo Baer, who along
with Frank Stella (12.53) and
others was one of the radical
painters of the 1960s, was
committed to this latter path.
In this triptych, by care-
fully regulating the relative
dimensions of the black bands
surrounding the white centers,
Baer eliminates all sense of
foreground and background,
creating nonreferential, wholly*

*flat paintings. She links the
three canvases by subtly shifting
the tonal whites from warm to
cool. The thin lines of color call
additional attention to the
surface and physical presence
of the work.*

**12.28**

Assemblage—making art out of objects from daily life—gained currency in the wake of Abstract Expressionism. During the 1960s, Niki de Saint Phalle and Jean Tinguely were part of a group of French artists (the *Nouveau Réalistes*, or New Realists) who used Assemblage to reconnect art to the real world.

**12.29** Niki de Saint Phalle, Gorgo in New York, 1962
*Niki de Saint Phalle used empty bottles, toys, plastic flowers, and a papier-mâché monster, Gorgo, to make this view of an atomic-age New York. To intensify the violent subject, she shot a rifle at aerosol paint cans attached to the artwork, thereby peppering it with exploding paint and bullet holes.*

**12.30** Jean Tinguely, La Bascule VII, 1967
*When, in 1964, MFAH director James Johnson Sweeney cabled trustees John and Dominique de Menil about a wonderful exhibit of sculptures in France by Jean Tinguely, the de Menils cabled back, "Buy the show!" The inheritor of Alexander Calder's (12.22) playful, kinetic style, Tinguely also shared the*

**12.29**

**12.29a** *Niki de Saint Phalle with her husband, Jean Tinguely, 1960s*

sensibilities of the nonsensical 1920s Dada artists, who strove to undermine preconceived ideas about art. His clattering contraptions move with complexity and humor, producing a great deal of noise and frequently self-destructing in the process. The title of this sculpture means seesaw or rocker; when turned on, it evokes the image of a cannon rocking madly back and forth.

*Playing is art, so I am playing. . . .
All machines are art. I correct the vision
of reality that assaults me in everyday life.*

Jean Tinguely, 1959

**12.30**

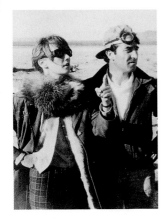

Pop Art in America began as a rebellion by young artists against the high-mindedness and success of Abstract Expressionism. Intentionally subversive, artists such as Roy Lichtenstein, Andy Warhol, and Claes Oldenburg turned their backs on abstraction and "fine" art by making paintings and sculptures based on the popular images of mass-produced commercial art. With works that were frequently humorous, easily accessible, and often brash and colorful, the Pop artists became, ironically, even more commercially successful than their predecessors. At the same time, their work challenged assumptions about the nature of art and provided incisive commentary on American life.

**12.31  Roy Lichtenstein, Still Life with Pitcher, 1975**
*Roy Lichtenstein began painting images based on comic strips and advertising in about 1960, producing works that wryly and succinctly confronted clichés in both art and society. In the 1970s he turned to still-life paintings, showing that vital examples of "high art" had become part of popular culture. Here, he rendered two common Cubist still-life elements—a newspaper and a pitcher—with the heavy black outlines and flat areas of subdued color characteristic of a 1920s offshoot of Cubism called Purism.*

**12.31**

**12.32** Claes Oldenburg, Giant Soft Fan (Ghost Version), 1967

*Claes Oldenburg was a pioneer of America's Pop Art movement, developing his style out of late-1950s Happenings (performances that were hybrids of theater and art) and specifically out of his 1961 installation* The Store, *a lower Manhattan storefront filled with plaster replicas of household goods. The work poked fun at America's consumer society, and in 1962 Oldenburg created a gallery installation based on the same theme. The scale of the gallery required larger works and led the artist to fabricate his first oversize soft sculptures. This work is one in a series of soft fans, in which he whimsically inverted the hard, metallic, functional properties of an actual fan, producing works whose essential humor built on contradictions of scale, materials, and representation.*

*I am for an art that takes its form from the lines of life itself, that twists and extends and accumulates and spits and drips, and is heavy and coarse and blunt and sweet and stupid as life itself.*

Claes Oldenburg, on the opening of *The Store*, 1961

**12.32**

**12.33** Andy Warhol, Self-Portrait, 1986

*The creator of Campbell's Soup Can paintings and Brillo Box sculptures, Andy Warhol took on the art establishment, challenged the value of originality in art, and eventually made celebrity the subject of his work. He rejected the idea that artworks are handmade objects for collectors, preferring to have*

*assistants fabricate multiple copies of his creations. Portraiture and self-portraiture are common subjects in Warhol's work, and his silkscreens from snapshots of Chairman Mao, Elizabeth Taylor, and Marilyn Monroe became iconic images. Ultimately, Warhol's greatest artwork was perhaps his own celebrity— he made his face as familiar as the idols of mass culture.*

**12.34** James Rosenquist, Evolutionary Balance, 1977

*Because he worked as a billboard painter early in his career, James Rosenquist was particularly intrigued with how information is transmitted. Using the abridged format and airbrush techniques of advertising, Rosenquist frequently painted billboard-*

**12.33**

**12.34**

**12.34a** *James Rosenquist, 1986*

Photo © Timothy Greenfield-Sanders

scale canvases, compressing
multiple images into one
tightly organized composition.
Evolutionary Balance *offers
an eloquent essay on the passage
of time. The left panel contains
an image of youth: the picture-
perfect features of a model
superimposed over a sunlit
interior. The center panel shows
memory and time passing: a clip-
board with an image of birthday*
candles and a drifting oar.
*The right panel depicts old
age and death: abstract brush
strokes conceal the silhouette of a
skull. The strip of bacon uniting
the three sections represents the
corporeal, mortal body.*

*[Painting is] . . . the ability to put layers of
feeling on a picture plane and then have those
feelings seep out as slowly as possible. . . .*

James Rosenquist

**12.35** Elmer Bischoff,
Interior with
Two Figures, 1968
*Elmer Bischoff was one of the chief innovators, along with Richard Diebenkorn (12.36) and David Park, of the Bay Area Figurative Painting School that emerged in the 1950s, just as Abstract Expressionists were emphatically championing gestural abstraction. Although many critics at the time considered the return to the figure and landscape reactionary, these artists shared with their East Coast counterparts an interest in gestural technique and abstract space. In the late 1960s, Bischoff created a series of urban interiors, including* Interior with Two Figures. *In a bleak room filling with shadows in the late-afternoon light, a somber man and woman are separated both physically and psychologically. Calling to mind the work of artist Edward Hopper, the painting's formal composition, subtle colors, and loose brushwork ally it with post-World War II abstract art.*

**12.35**

*Art ought to be a troublesome thing, and one of my reasons for painting representationally is that this makes for more troublesome pictures.*

Elmer Bischoff, *Contemporary Bay Area Figurative Painting*,
Oakland Art Museum, California, 1957

**12.36** Richard Diebenkorn, *Ocean Park #124*, 1980

*The youngest of the original Bay Area Figurative painters, Richard Diebenkorn turned from abstract to representational painting in 1955. Inspired by Paul Cézanne (pp. 80, 103) and Henri Matisse (12.7), he painted beautifully colored landscapes and figures, as intent on revealing underlying geometric structures as on capturing the brilliant California light. In 1966 he moved to Santa Monica and the following year returned to abstraction with the series of Ocean Park paintings that would occupy the rest of his career. Focusing on a strip of Pacific coastline, he transformed the scene into increasingly simplified planes and lines.*

*At once improvisational and highly disciplined, abstract yet rooted in nature, these subtly hued paintings are lyrical embodiments of space and light. For another work by Diebenkorn,* see p. 134.

**12.36**

> *When a picture is right and complete there is a cumulative excitement in the sequential encounters with the parts until the work is completely (or as completely as possible) experienced. The pitch of "right" response mounts, if the chain isn't broken, to an extreme and often physical sympathy with the presentation.*
>
> Richard Diebenkorn, *Studio International*, 1974

**12.37** Philip Guston, Legend, 1977

*In the last decade of his life, Philip Guston radically turned away from the shimmering paintings of his Abstract Expressionist years to make raw, figurative works filled with cartoon characters and haunted nightmare images. Depicting the terror and doubts of a life gone by, Guston mediates these intense, autobiographical paintings with a wild humor, borrowing from the graphic style of George Herriman's vintage "Krazy Kat" cartoons. In Legend, the artist portrays himself asleep; behind him are the hindquarters of a horse, a literal "night-mare." A paw holding a garbage-can lid shields the artist from the detritus of his studio—cigarettes, paint cans, and wooden stretched blocks; and random memories of violence—a cudgel, a flying brick, and a threatening fist. Initially greeted with sharp criticism, Guston's late paintings have come to be recognized as his greatest achievements.*

12.37

**12.38** Jasper Johns, Ventriloquist, 1983

*In this complex painting, Jasper Johns transforms the traditional subject of the artist's studio into a self-portrait. Filled with personal references, artworks, and other possessions, the painting is a somber reverie on the artist's physical and psychological environment. As the title indicates, the objects speak for Johns himself. They include a reference to his own artwork — the paired images of the American flag — together with an inverted image of a Barnett Newman print, ceramic pots by George Ohr, and a silver vase in Johns's collection. Behind the vertical lines on the left, he portrays an illustration by Barry Moser from a 1979 edition of* Moby-Dick *he had been reading. Inverted and hard to decipher, these images are uncanny surrogates for the intensely private and reserved Johns. For another work by Johns, see p. 135.*

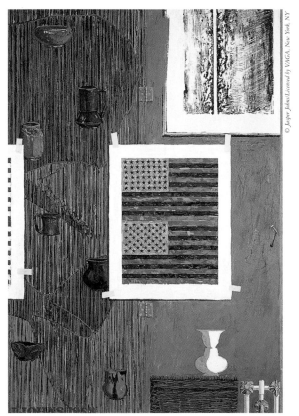

© Jasper Johns/Licensed by VAGA, New York, NY

**12.38a** *A humorous element in* Ventriloquist *is this portrayal of the British royal family's 1977 Silver Jubilee vase. Jasper Johns emphasizes the trophy's silhouette, created by the facing profiles of Queen Elizabeth II and Prince Philip.*

**12.38**

**12.39** Susan Rothenberg, Red Banner, 1979

*In the 1970s Susan Rothenberg was among the artists who turned their backs on the coolness and abstraction of Minimalism, preferring to make evocative works with recognizable, if cryptic, images. Around 1974 Rothenberg painted her first image of a horse, finding it to be "a way of not doing people,*

*yet it was a symbol of people, a self-portrait, really." Still committed to retaining the flatness of the picture plane, Rothenberg spent the next six years painting schematic horses, producing densely brushed, non-illusionistic canvases containing dark, emotive power.*

**12.40** Nancy Graves, Head on a Spear, 1969

*Nancy Graves stunned the art world when she first exhibited Camels, her sculptures of 1967-69. While studying in Florence, Graves had encountered life-size wax models by the 18th-century anatomist Susuni, who reconstructed animals from other materials. Emulating his example, Graves made her*

**12.39**

**12.40a** *Nancy Graves films camels in Morocco.*

**12.40**

Camels *look like taxidermy, but in fact she constructed them from materials such as steel, wax, marble dust, acrylic, sheepskin, and oil paint. Salvaging the head from a destroyed life-size camel sculpture, Graves created* Head on a Spear *as an independent work. Presented like a trophy, the sculpture escalates the issue of reality versus illusion.*

**12.41 Luis Cruz Azaceta, A Question of Color, 1989**
*Luis Cruz Azaceta moved to New York from his native Cuba in 1960. In the prevailing style of the time, his earliest works were geometric abstractions. Seeing paintings by Hieronymus Bosch and Francisco Goya during a trip to Europe in 1969 convinced Azaceta to paint "more from the guts, from feelings."*

*In* A Question of Color *Azaceta addresses the subject of racism using almost abstract means; the richly worked black-and-white composition is divided by the image of a chainlink fence. Combining abstract principles with social commentary, the painting eloquently conveys the blunt reality of color barriers.*

**12.41**

At the time I painted A Question of Color I *was exploring the idea of fences as boundaries, symbols of power, human confinements, territorial spaces, and psychological limitations. As you know, the painting deals with racism.*

Letter from Luis Cruz Azaceta to MFAH curator Alison de Lima Greene, 1990

In the 1960s the Frankfurt philosopher T. W. Adorno asserted that, after the horrors of Auschwitz in Nazi Germany, poetry (and by extension, all art) was no longer possible. German artists coming of age after World War II faced a consuming challenge: Was it possible to give expressive visual form to their country's tragic past?

**12.42 Georg Baselitz, The Lamentation, 1983**

*In 1969 Georg Baselitz began to make large, expressive paintings of upside-down figures. Their boldly brushed, lush colors, recalling Germany's great, pre-World War I Expressionist paintings, clashed with the bizarre images of the inverted figures. The works evoked a culture gone awry, struggling*

*for meaning and unity—a powerful metaphor for postwar Germany. The Lamentation is unique in that the upside-down figure also has narrative meaning. Its biblical subject is the Deposition, when the crucified Christ was taken down from the cross. The dramatic color and sweeping brush strokes enlarge the Christian theme into a universal tragedy.*

**12.42**

**12.43**

**12.43** Anselm Kiefer, Der Nibelungen Leid (The Sorrow of the Nibelungen), 1973 *This important early work, painted on burlap, depicts a wooden room with heavily grained bare boards and rafters, much like Anselm Kiefer's attic studio at the time. Taking as his inspiration the 13th-century German epic poem* Der Nibelungen Lied, *Kiefer records the names of the fallen rulers of the Nibelungen (the Burgundians) next to their own pools of blood. Because this poem was also the source for Richard Wagner's operas* Der Ring des Nibelungen, *which Adolf Hitler exploited to invoke the heroism of loyalty, the painting conflates Germany's mythical past with its more recent, tragic history. Kiefer created a searing pun in his title: by substituting* "**Lied**" *for* "**Leid**," "The **Song** *of the Nibelungen" became "The* **Sorrow** *of the Nibelungen."*

*Our moral behavior is still in the Stone Age. So I can't say I know the way. But I want to do something between man's aggression and the transforming energy. I want to be a catalyst, a small quantity that affects a larger thing—and that's all that an artist can hope to be.*

Anselm Kiefer,
*Art News*, 1987

The Texas landscape is vast and varied, extending from eastern swamps and pine forests to central rolling hills, and further to western plains, deserts, and dramatic mountains. Rich also in folklore and history, these vistas provide inspiration to numerous artists.

**12.44  Keith Carter, Fireflies, 1992**
*The quiet, rural landscape of Beaumont, Texas, plays a crucial role in Keith Carter's work. For Carter, living there means having access to the extraordinary culture of the Deep South. In the tradition of his favorite Southern authors — Flannery O'Connor, Reynolds Price, Eudora Welty—Carter*

**12.45  James Surls, I Am Building with the Axe, the Knife, and the Needle's Eye, 1982**
*For many years James Surls lived in the Piney Woods of East Texas, and a deep attachment to the land pervades his rough-hewn sculptures carved from local woods. Combining mythic figures, childhood memories, and invented creatures, his art*

**12.44**

*documents the lives of country people, finding magical overtones in daily acts. In Fireflies, two boys catching fireflies peer into their glowing jar, their elfin profiles silhouetted against shimmering water. Carter transforms this rite of child-hood into a mysterious ritual as the shadowy figures perform an indistinct activity in the eerie setting.*

**12.45**

describes a personal world filled with dreams, ritual, and humor. This work, over 13 feet tall, is of a giant shaman, a creator-destroyer who wields his powers with the weapons and tools in his multiple hands. Also a portrayal of the archetypal sculptor, who as a wood carver must destroy in order to create, the figure looms like an ancient Paul Bunyan emerging from a primeval forest.

**12.46  Kermit Oliver, K. J.'s Calf, 1975**
A sense of place is essential to this painting by Kermit Oliver, a visionary painter from the ranch lands of South Texas. Calling his works "notes from a child's odyssey," Oliver combines biblical imagery and autobiography to make paintings with layers of meaning. K. J.'s Calf recalls a memory of seeing a

friend's calf through the lunette window of the local church. The painting is a religious allegory of death and rebirth: the calf symbolizes a sacrificial animal; the pail represents sustenance; and the lily signifies the perennial passage from life to death to rebirth. Oliver later reinforced this interpretation of the painting by creating an altar-like gold frame.

**12.46**

**12.47** Christian Boltanski, Monuments (La Fête du Pourim), 1989

*The French artist Christian Boltanski investigates the subjects of childhood, memory, and loss. In 1984 he began a series of works in which cropped, blurry photographs of children are displayed in tin frames, the haunting faces illuminated solely by exposed light bulbs.*

*Originally nonspecific, the series calls to mind Christian icons, reliquaries, and memorial candles. Later, Boltanski's monuments began to focus on the lost children of the Holocaust. For this work, Boltanski used a 1939 photograph of Jewish children celebrating Purim as his source for the smiling faces. Purim, a joyous holiday commemorating the ancient*

*rescue of Persian Jews from mass destruction, provides an ironic contrast to the execution of European Jews in World War II. Although the actual fates of these children are not known, the work elicits a powerful emotional response and reminds the viewer that without memory, humanity will be lost.*

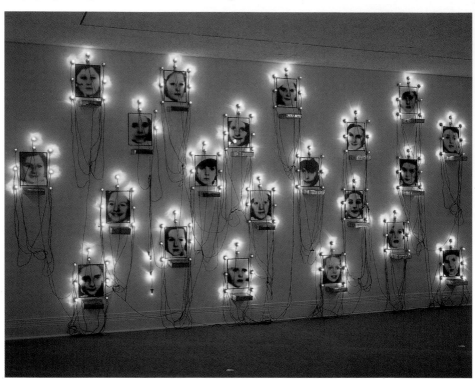

12.47

**12.48** Vicki Meek,
The Crying Room:
A Memorial to the
Ancestors, 1992
*Dallas artist Vicki Meek's
room-size installations chronicle
social injustices perpetrated
against African-Americans.
This work presents slave-trade
records along with ideographic
symbols of the ancestral realm
from Nigeria's Yoruba people,*
*invoking the continuity of
traditions from Africa to
America. The lava-rock walk-
way represents a purifying path
to eternity; shells indicate the
sea passage of Africans to
America; and an overturned
flowerpot symbolizes death as a
reversal of life. Comment cards
are provided so that viewers can
post their thoughts on a wall in
the installation.*

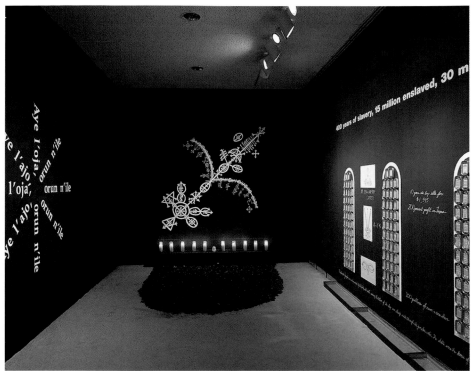

**12.48**

*Public memorials are important because they allow a society or a
community to reconcile its grief. The collective grief over the loss of
the millions of ancestors lost during the Middle Passage and through
the mass lynchings of the 20th century has never had an outlet. . . .
The Crying Room is meant to allow us to remember and grieve
for all those many ancestors whose lives were sacrificed. . . .*

Vicki Meek, 1992

**12.49** Richard Long, Ring of Flint, 1996 East West Circle, 1996

*Combining aspects of Conceptual and Minimal art, in 1967 the British artist Richard Long began making elegant installations based on a physical involvement with nature. While taking extended walks through uninhabited areas of the world, he constructs temporary arrange-* *ments of wood and stone along the way. As an extension of these activities, he uses natural materials in gallery installations, laying them on the floor in lines (to reflect the paths his walks take); and in circles or rings (to represent chosen sites). Ring of Flint is made from the type of stone first used by prehistoric peoples for cutting tools.* East West Circle *consists* *of black stones that the artist collected from a Japanese riverbed. Recalling the ancient struggle between tamed and untamed nature, Long's simple forms are timeless and accomplished examples of 20th-century abstraction.*

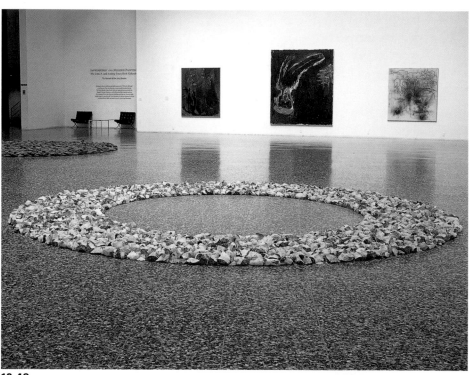

**12.49**

**12.49a** *Richard Long installs* East West Circle *in Japan, 1996.*

**12.50** Per Kirkeby, Inferno II, 1992

*Evoking the landscape with sumptuous colors, gestural brushwork, and organic forms, Per Kirkeby's paintings are inspired by his scientific study of the earth. As a student of geology at the University of Copenhagen in the late 1950s and early 1960s, he went on geological expeditions to Central America, the Arctic, Australia, and Greenland. Studying art at the same time, the multifaceted Kirkeby produced installation pieces and performance art before turning to painting, sculpture, film, and writing. His painting technique involves building up and scraping away multiple layers of oil paint, producing a rich, textured surface in a process he likens to sedimentation. For Kirkeby, that geological term is also a metaphor for the multiple layers of his life's experience. The dark and somber mood of* Inferno II, *which depicts a forest, recalls the opening lines of Dante's* Inferno.

**12.50**

*Midway on our life's journey, I found myself In dark woods, the right road lost.*

Dante Alighieri, *The Inferno*, 1321

# Museum Commissions

Ever since 1935, when the MFAH invited sculptor William McVey to create four panels for a limestone balustrade on the south lawn, the museum has asked artists to make works for the collection. By commissioning artwork, the museum engages contemporary artists directly with its collection, its campus, and its history. The resulting creations offer interpretations of art that enrich the museum in unique, unpredictable, and exciting ways. Every aspect of a commission—from the selection of the artist and his or her discussions with museum staff members, to the fabrication and installation of the artwork—sustains the museum's role in fostering the supportive and creative environment so vital to the flourishing of art.

**12.51 Ezra Stoller,**
**W. L. Moody Building, 1965**
*In 1962, the museum commissioned Ezra Stoller and Henri Cartier-Bresson to photograph the 19th-century buildings of Galveston, the once-great port city south of Houston. These images were published in a book titled* The Galveston That Was, *conceived by architect Howard Barnstone to document the monuments of the city's more prosperous times before the structures all but disappeared. The building pictured here once housed*

*. . . a museum's duty is to record, preserve, and set in proper relationship to the present the achievements of the past or of a passing age.*

MFAH director James Johnson Sweeney, *The Galveston That Was,* 1965

**12.52 Eduardo Chillida, Abesti Gogora V, 1966**

*In 1965, the Basque artist Eduardo Chillida expressed to the MFAH's director an ambition to create a monumental granite sculpture. The museum, which had purchased Chillida's oak sculpture* Abesti Gogora I *four years earlier, secured support to fund the new work and transport it to Houston.* Abesti Gogora (abesti gogora *means wonderful song in the Basque language) weighs approximately 45 tons and remains one of Chillida's largest sculptures.*

*We have had very good luck with the stone. She was very healthy but terribly strong for working—too much! Imagine, she gets so hot when worked, that you can light a cigarette on it!*

Letter from Eduardo Chillida to museum director James Johnson Sweeney, 1966

**12.52a**

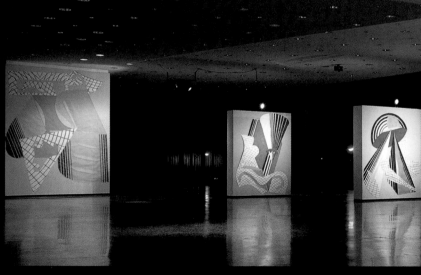

**12.53 Frank Stella, "Stella by Starlight" MFAH Ball Murals, 1982, reworked 1983**

Frank Stella first gained acclaim in the late 1950s for his starkly minimal, pinstripe paintings. By the late 1970s his art had exploded into a collage-like aesthetic of flamboyant shapes and colors. In 1982, the MFAH commissioned Stella to design the decorations for the museum's annual fund-raising gala. Guided by the artist's drawings for the project, artists from the Core Artist-in-Residency Program at the MFAH's Glassell School of Art spent 1,500 hours painting 13 murals directly onto the walls of Cullinan Hall and Brown Pavilion. Just days after the gala event, the museum's walls were repainted white. Stella's original drawings remain in the MFAH collection.

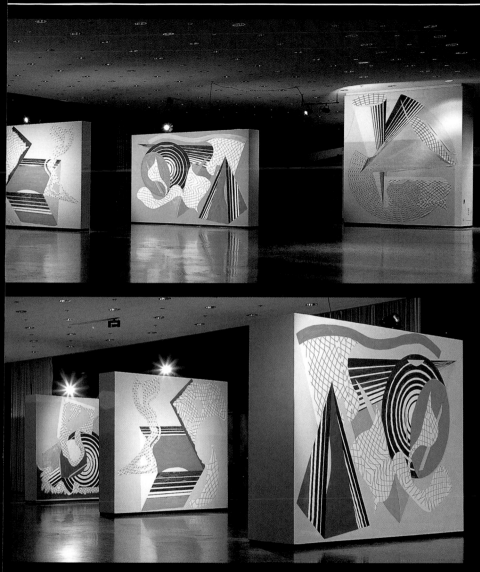

**12.53a** *Frank Stella directs two artists in Brown Pavilion, 1982.*

## 12.54 Ellsworth Kelly, Houston Triptych, 1986

The MFAH has commissioned a number of artists to make works for the Lillie and Hugh Roy Cullen Sculpture Garden. The first such commission was given to Ellsworth Kelly (12.25, 16.9), who began studying Isamu Noguchi's plans for the garden while construction was underway. Influenced by Noguchi's angular walls and by Henri Matisse's Backs (16.8), which the MFAH had just purchased, Kelly created a triptych, or three-part work. Three bronze shapes, variations on the basic geometric shapes of the arc and the triangle, reflect the artist's interest in forms found in both nature and architecture. Kelly designed Houston Triptych to hang on the garden's west wall, within view of Matisse's work.

12.54a Ellsworth Kelly (right of ladder) oversees installation of Houston Triptych, 1987.

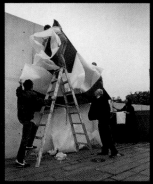

**12.54a**

## 12.55 Jim Love, Can Johnny Come Out and Play?, 1990–91

*In 1990 the museum invited Houston artist Jim Love to create a work for Cullen Sculpture Garden. At the time, Love had already completed several public projects in Houston. Although these earlier works often were whimsical assemblages constructed from industrial scraps, Love decided to fabricate a giant sphere for the garden, creating a work that is both playful and monumental. The artist made a full-scale model and rolled it around the garden to determine the best installation site. The actual sculpture, however, was cast in bronze and had to be hoisted over the garden wall with a crane.*

**12.55a** *After museum preparators install* **Can Johnny Come Out and Play?**, *Jim Love stands next to his sculpture, 1991.*

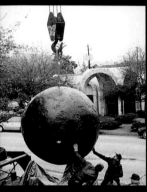
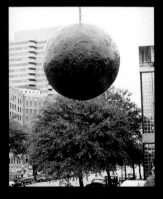
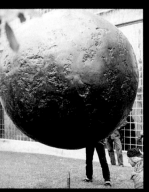

**12.55a**

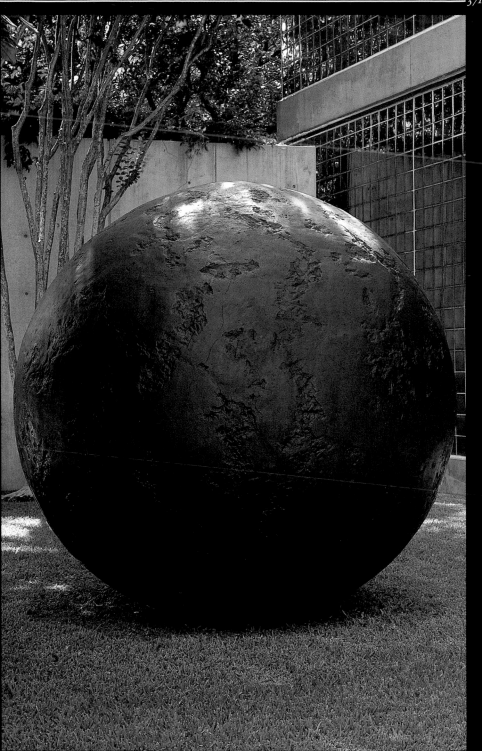

**12.56  Tony Cragg, New Forms, 1991–92**

In 199[ ] British artist Tony Cragg exhibited his work in a show at Houston's Contemporary Arts Museum. Positive response to the exhibition prompted the MFAH to commission Cragg to make a related work for Cullen Sculpture Garden. In New Forms, the artist takes the basic shapes of objects commonly found in a chemistry lab—an Erlenmeyer flask and a graduated cylinder—and distorts their forms. The practical function of these lab vessels (to facilitate chemical reactions) and their metamorphoses into new forms suggest issues of grow[ ] change, and union [ ] typical of Cragg [ ].

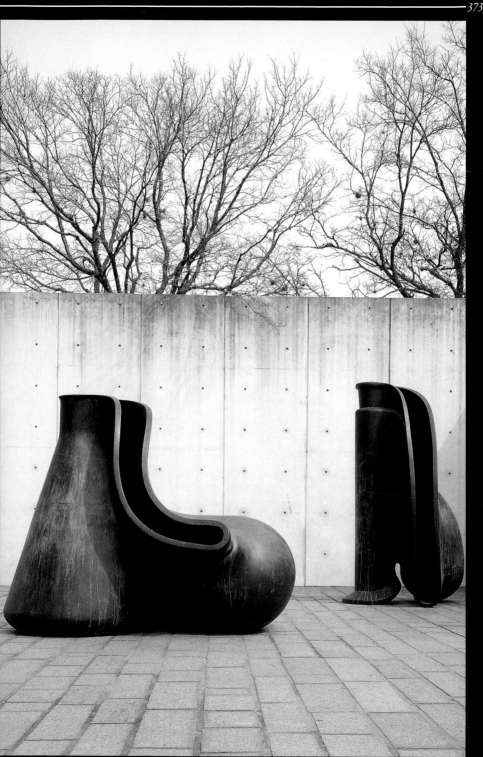

n 1987 the MFAH and
Parnassus Foundation
collaborated on a project
exploring the architecture
of North American banks.
Important to every com-
munity, banks historically
have had a significant
architectural presence in
towns and cities through-
out the United States and
Canada. By documenting
the changing nature of
bank architecture, from the
pillars and lavish interiors of
traditional buildings to the
massive scale of contempo-
rary skyscrapers, the project
provided fresh perspectives
on an enduring institution
and its evolving role in North
American society. Presented
as an exhibition and a book,
the project was called
*Money Matters: A Critical
Look at Bank Architecture.*
It included commissioned
works by 11 photographers
and interpretive texts by
4 contemporary writers.

**12.57  Serge Hambourg,
National Farmer's Bank,
Owatonna, Minnesota,
1987**

**12.58  Edward Burtynsky,
MBank, Momentum Place,
Dallas, 1988**

*Led on from page to page,
we wait for the pictured
walls to speak. For bending
forward and listening hard,
we hear, do we not, some-
thing more interesting to us
than the chink of coins, the
hushed rustle of dollar bills?*

Brendan Gill, *Money Matters:
A Critical Look at Bank
Architecture,* 1990

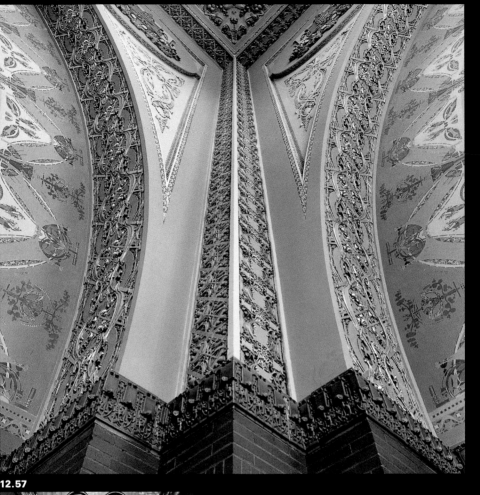

**12.57**

**12.59** Robert Moskowitz,
**Giacometti Piece IV,**
**Giacometti Piece II,**
**1997**
*In the early 1980s, the New*
*York artist Robert Moskowitz*
*began a series of works*
*based on sculptures by*
*Constantin Brancusi (12.6),*
*Alberto Giacometti (16.7),*
*and Auguste Rodin (16.11).*
*Redefining these sculptures*
*in flattened, intentionally*
*ambiguous drawings, he*
*created ghostly images of*
*the sculptures' silhouettes.*
*Because Moskowitz's*
*interpretation of an*
*elongated figure by*
*Giacometti resonates with*
*one of the MFAH's own*
*Giacometti sculptures*
*(12.59a), the museum*
*invited Moskowitz to create*
*this pair of large-scale*
*drawings specifically for*
*the permanent collection.*

**12.59a**
**Alberto Giacometti,**
**Tall Figure, 1948–49**

12.59a

### 12.60 Joseph Havel, Curtain, 1999

*Flanking the main doors to the Audrey Jones Beck Building are monumental bronze curtains by sculptor Joseph Havel (16.12). An artist who often uses everyday objects in his artwork, Havel decided to "make curtains for the building" as a framing device for the entrance. Like much of Havel's work,* Curtain *is both aesthetically formal and conceptually potent. Embodied within an abstract composition, the curtains evoke the ceremonial nature of entering a grand space even as they recall the intimacy of domestic drapery. By implying a sense of passage, the curtains prepare the viewer to enter a place of presentation while maintaining the modesty of objects found in the home.*

### 12.60a

*Workers installed* Curtain *in June 1999, soon after artist Joseph Havel (top left) completed the sculpture.*

**12.61  James Turrell,
The Light Inside, 1999**
During the construction of
the Audrey Jones Beck
Building, the MFAH had
the unique opportunity to
commission site-specific art
for the new space. Interested
in transforming the walk
between the Beck Building
and the Law Building into
an art experience, the
museum invited the artist
James Turrell to create
an installation for that
passageway. Turrell is
known for his inventive
light sculptures that
inspire a sense of wonder
at how light affects both
visual perception and
emotional responses to
the environment. For the
museum's new tunnel,
Turrell created a light
installation, illustrated here
by computer-generated
images (12.61a). The work
turns the walls of the tunnel
into vessels for conducting
light. The walk between the
Beck and Law buildings
becomes an exploration
of color and space.

*Light is a powerful
substance. We have a
primal connection to it.
But, for something so
powerful, situations for its
felt presence are fragile. . . .
I like to work with it so that
you feel it physically, so
you feel the presence of
light inhabiting a space.*

James Turrell, 1985

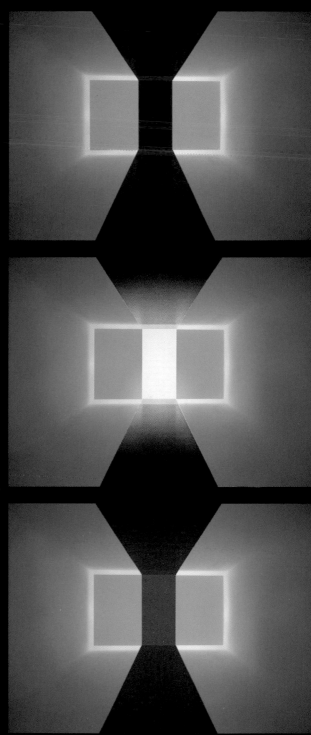

**12.61a**

Decorative arts *is an umbrella term that museums use to describe objects made for interior spaces—from furniture and metalwork to tableware and glass. When describing works made in the 20th century, the term also encompasses product design, lighting, and nontraditional objects. MFAH visitors can see works of decorative art at Bayou Bend, at Rienzi, and in the European and American galleries of the Beck Building. In addition, 20th-century European and post-1930s American works are on display in the Law Building. Periodically, independent installations present in-depth explorations of specific design movements.*

*Focusing on the major decorative arts movements of the 20th century and beyond, the MFAH acquires examples of exceptional design, craftsmanship, and originality. Both handcrafted and industrially produced objects demonstrate the wide range of creative designs at work during this time. The collection is particularly strong in furniture designed by architects and in objects made with innovative materials.*

The museum owns a number of prototypes (early, experimental examples) of furniture made by the original designers. In this age of mass production, the prototype (or, if not available, then the first issue of a production line) often best reveals the designer's creative process and intent. The museum also makes a special effort to collect 20th-century chairs. Because chairs must be both functional and aesthetically in keeping with changing lifestyles, they are considered one of the great tests of a designer's skills. Since 1995 the museum has collected designs of the late 20th century aggressively, thereby documenting important developments in the use of new materials and techniques. As it moves into the 21st century, the MFAH continues to collect and exhibit the latest in innovative decorative arts and design.

At the end of the 19th century, progressive designers in France and other European countries developed a new style that they considered appropriate for modern times. Using an original vocabulary of lavish forms inspired by nature and the abstract line, artists, designers, and architects produced everything from paintings and sculptures to vases, furniture, textiles, posters, and buildings in this new style. Termed *Art Nouveau* in France, the movement was also called *La Libre Esthétique* (Belgium), *Jugendstil* (Germany), *Sezessionstil* (Austria), *Stile Floreale* (Italy), and *Modernismo* (Spain).

**13.1** Emile Gallé, Vase, c. 1895–1900

*The leading maker of Art Nouveau glass in France was Emile Gallé, famous for his dramatic, sometimes disturbing, evocations of nature. An artist of remarkable technical skill and inventiveness, he inherited and expanded his father's ceramics and glass business.*

**13.1**

*Gallé explored widely ranging techniques, from historical methods such as acid etching, engraving, enameling, and mold blowing, to novel experiments with powdered colors, metallic foils, and marquetry, or inlay. This vase is based on an Asian form. An inner, pale green glass similar to celadon — the much admired Chinese ceramic glaze — is encased in red glass that is then carved away in a cameo technique to leave a pattern resembling water lilies.*

*My own work consists above all in the execution of personal dreams: to dress crystal in tender and terrible roles, to compose for it the thoughtful faces of pleasure or tragedy.*

Emile Gallé

**13.2**

**13.2** Vilmós Zsolnay, Bottle, 1890–1900

*Fine examples of Hungarian Art Nouveau objects were made at the Zsolnay ceramic factory in Pecs. Founded in 1853 by Miklos Zsolnay to produce vases, tiles, plates, and architectural ornaments, the factory later expanded into art pottery in the Art Nouveau style under the direction of Zsolnay's son, Vilmós.*

*In the 1890s Vilmós Zsolnay invented an intense, blood red glaze that, when combined with gilding—as in this example—produced a dazzling effect. This bottle typifies the Art Nouveau style with its plant forms and organic lines. The sinuously curving stems of the dark red flowers form the classic Art Nouveau pattern known as whiplash.*

**13.3** Louis Comfort Tiffany, Vase, c. 1892–93

*In 1892, Louis Comfort Tiffany, whose father founded Tiffany & Co., was already well-known for his work as an interior decorator and designer of stained-glass windows (pp. 198–99) and lamps. In that year, he developed a glass coloring technique that would seal his reputation as America's greatest Art Nouveau designer. Called Favrile and created by exposing molten glass to metallic vapors, this colored glass has a beautiful, iridescent quality. Among Tiffany's greatest creations were vases decorated with peacock feathers. These vases were difficult to make but visually compelling. The large size of this example (21 1/2 inches high), the subtle coloring, and the carefully controlled creation of the iridescent feather designs make it particularly fine. Tiffany considered it to be a major work.*

**13.3**

After World War II, the growing number of young and prosperous American families created a demand for well-designed, mass-produced, functional objects. The manufacturers Herman Miller and Knoll Associates engaged respected designers such as Charles Eames, Ludwig Mies van der Rohe, and Eero Saarinen to create furniture and related objects for the home and office. Partially in reaction to these factory products, a new generation of artisans working alone or in small studios began creating handmade objects in wood, clay, fiber, and glass. By the 1960s and 1970s the Studio Craft movement was formalized in design schools and university programs that emphasized handcrafted design.

**13.4 Magdalene Odundo, Vase, 1995**

*Born in Kenya and educated in England, Magdalene Odundo creates graceful vessel forms using the ancient technique of stacking coils of clay, one on the other. She then rubs the coils to a smooth finish and covers them with slip, a watery clay solution that produces a smooth coating.*

*Like African potters, Odundo fires the vessels in a kiln twice; the second firing produces a chemical change that turns the clay black. Echoing the female form and the traditional roles of tribal women, Odundo's simple and sensuous vessels at once express 20th-century artistic sensibilities and evoke age-old traditions.*

Neg. #224436

**13.4a** *Mangbetu women arrange a headdress, c. 1910.*

13.4

**13.5** Wendell Castle, Coat Rack with Trench Coat, 1978

*Originally trained as a sculptor at the University of Kansas, Wendell Castle emerged as a leader of American Studio Craft in the 1960s. In his upstate New York studio, he sculpted exquisitely crafted, wholly original, organic forms from large blocks of laminated hardwoods. In 1976 he began producing historically inspired furniture, playfully augmented with carved trompe l'oeil (fool-the-eye) objects. In this superb example, a supple, life-size trench coat — complete with buttonholes, a missing button, and a hem — appears to hang on a functional coat rack. Using mahogany to sculpt an object that is traditionally made of cloth, Castle plays with the definitions of art and reality, sculpture and functional object.*

**13.6** Barry R. Sautner, The Mended Web II, 1991

*Barry Sautner began carving glass in 1979, soon becoming a master of cameo glass and of diatreta, an ancient technique in which a solid piece of glass is carved to leave a latticework design. The Mended Web II, commissioned by the MFAH, presents a natural history of ladybugs, hummingbirds, and morning glories, highlighted by a double-layered spider web holding small insects and a spider.*

**13.6**

**13.5**

Exploring new materials and techniques appropriate to the architecture and lifestyles of a highly industrialized society, architects and designers have consistently pushed the boundaries of traditional forms to create innovative works. Nowhere is this experimentation better exemplified than in the chair, an essential form through which designers test their skills and imagination.

*A chair is a very difficult object. A skyscraper is almost easier. That is why Chippendale is famous.*

Ludwig Mies van der Rohe

**13.7** Jean Prouvé, Folding Chair, designed c. 1924–28, made 1929
*The French architect Jean Prouvé experimented in the 1920s with the use of industrial materials in both his architectural and furniture designs. In this example, he used tubular steel to produce a chair that looks machine-made. In fact, he created the chair by hand, hammering the steel to produce flattened contours. The design of this chair, one of a set of six that Prouvé created as a wedding gift for his sister, reflects a time in France when traditional woodworking methods were giving way to new materials and techniques.*

**13.8** Ludwig Mies van der Rohe, Barcelona Chair (Model MR 90), 1929–30
*Ludwig Mies van der Rohe designed the German pavilion and its interior furnishings for the Barcelona World Exposition of 1929. For the inaugural ceremony Mies designed two x-frame chairs, for use by the king and queen of Spain, and based on ancient Egyptian and Greek folding chairs—a design recognized as a symbol of power in those two cultures. The MFAH's rare, chrome-plated steel chair, made in the first year of manufacture, was assembled with hand-secured screws and expensive lap joints. Later versions were welded together.*

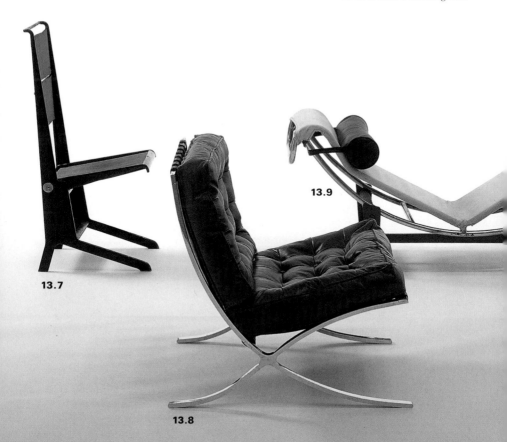

13.9

13.7

13.8

**13.9** Le Corbusier (born Charles-Edouard Jeanneret), Pierre Jeanneret, and Charlotte Perriand, Chaise Longue, Model 2072, designed 1928–29, made c. 1933–37
*In the 1920s, Le Corbusier, his brother Pierre Jeanneret, and fellow designer Charlotte Perriand used machine-age styling and industrial materials to reinterpret traditional chair designs for the modern age. This example is a successor to a 19th-century Viennese bentwood chaise longue. Revolutionary when it was made, this chair quickly became an icon of 20th-century design.*

**13.10** Frank O. Gehry in collaboration with Robert Irwin; made by Jack Brogan, Working Prototype for the Easy Edges Dining Chair, c. 1970–72
*Frank Gehry is well known as an architect and designer who tests the limits of modern design and materials. For this chair, he and his colleagues experimented with corrugated cardboard furniture, producing a design that typifies Gehry's playful, paradoxical style. Using a familiar material in unfamiliar ways, he created a durable form from a flimsy industrial material. This specific chair is a rare prototype used by the designers to explore possible shapes and colors for a line of furniture.*

**13.11** Gaetano Pesce, Prototype for the Pratt Chair Series, 1982
*The Italian architect and industrial designer Gaetano Pesce created a series of nine chairs while teaching at the Pratt Institute in Brooklyn. The series exemplifies his radical pursuit of new forms created by manipulating and developing industrial materials. Pesce made this early prototype at a time when he was still experimenting with the design and testing the formula for the polyurethane that would be used in the mold-cast version. Through these experiments, Pesce was able to determine the translucency and the rigidity of the final form.*

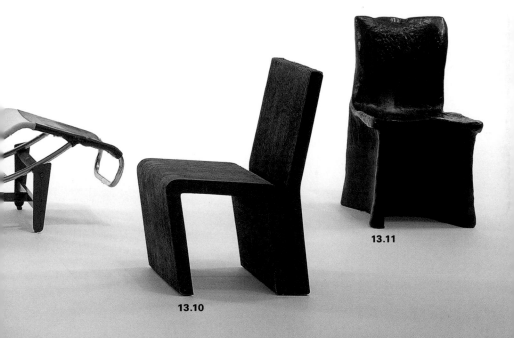

13.11

13.10

Kem Weber, 1934

Charles and Ray Eames, 1945–46

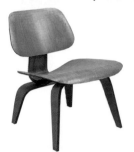

Jonathan De Pas, Donato D'Urbino, and Paolo Lomazzi, 1970

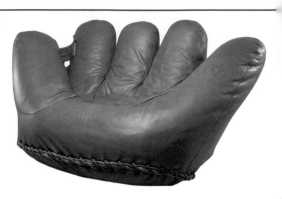

Lella and Massimo Vignelli with David Law, 1979

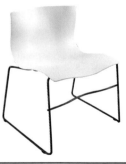

Venturi, Rauch, and Scott Brown, 1979–84

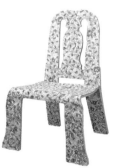

Ron Arad, 1992

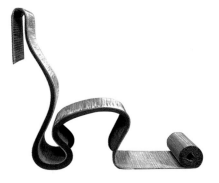

Charles and Ray Eames, 1950–53

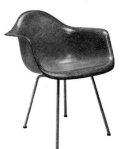

Harry Bertoia, 1952

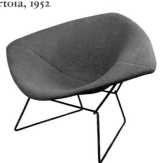

Studio 65, 1970

Frank Gehry, 1989–91

Philippe Starck, 1991

Bill Stumpf and Don Chadwick, 1994

Pol Quadens, 1995

*In 1939, the year that* Gone with the Wind *and* The Wizard of Oz *were released, the Museum of Fine Arts, Houston, began to exhibit and research film as a 20th-century art form. This rapidly changing medium added a new dimension to the museum experience. The active calendar of film-related events that evolved has turned the MFAH's Brown Auditorium into the premier alternative repertory cinema in Houston. Education and community outreach programs*

augment the film screenings and consistently attract new audiences to the museum.

The MFAH houses the Robert Frank Film and Video Archive, a collection that includes restored prints of the artist's first film, Pull My Daisy, and of his feature-length Me and My Brother. The museum also owns rare, early films by the artists Fernand Léger, Charles Sheeler, and Paul Strand.

14.1

© Robert Frank

The Swiss-born American artist Robert Frank first gained critical acclaim in 1958 with his book *The Americans*, for which he traveled the United States photographing people and landscapes (p. 157). In 1959 he turned to filmmaking as a method of capturing the narratives that he could not express in still images. Of this transition, Frank said, "I think I became more occupied with my own life, with my own situation, instead of traveling and looking at the cities and landscape. And I think that brought me to move away from the single image, and begin to film, where I had to tell a story." His first film, *Pull My Daisy* (codirected by Alfred Leslie), is cited as one of the most influential works of avant-garde independent film and as the beginning of the New American Cinema.

**14.1** Pull My Daisy

**14.2** Me and My Brother

**14.3** Energy and How to Get It

14.2

## Films by Robert Frank

*Pull My Daisy,* 1959
*The Sin of Jesus,* 1961
*O.K. End Here,* 1963
*Me and My Brother,* 1965–68
*Conversations in Vermont,* 1969
*Life-raft Earth,* 1969
*About Me: A Musical,* 1971
*Keep Busy,* 1975
*Life Dances On,* 1980
*Energy and How to Get It,* 1981
*This Song for Jack,* 1983
*Home Improvements,* 1985
*Hunter,* 1989
*C'est Vrai,* 1990
*Last Supper,* 1992
*The Present,* 1996
*Flamingo,* 1997
*I Remember,* 1998

In 1986 the MFAH, which owns more than 300 of Frank's photographs, became the archive and distributor for his films and videos. In addition to preserving and restoring these landmark works, the museum is dedicated to making them accessible to other institutions, offering 18 titles in a circulating collection. A study collection of Frank's films on videotape is also available for researchers and scholars to borrow.

© Robert Frank

14.3

The film exhibition program at the MFAH offers movie-goers a unique venue for appreciating both classic and contemporary films, including premieres of significant new independent productions. Films are often presented within an overall theme that focuses on a certain country or region, a specific actor or director, or a particular topic.

From Taiwanese Cinema, New Greek Cinema, and the National Film Registry Tour to retrospectives of films by Alan Clarke, Rainer Werner Fassbinder, Krzysztof Kieslowski,

Mohsen Makhmalbaf, Preston Sturges, François Truffaut, and Agnès Varda, these thematic series are groundbreaking and diverse. In conjunction with the film screenings, the museum presents appearances by media artists, critics, and scholars, whose perspectives add fresh insights.

MFAH Films
March/April 1998

Ticket Information

General admission tickets are $5 for one film only. Matinee and students with I.D. receive are $40 for nonmembers and $35 f

**March**

1 Sun 7:00 pm **Anthem**
*Special Presentation*

6 Fri 7:30 pm **1940s: The Pioneers**
*Essential Cinema*

7 Sat 7:30 pm **Damnation**
*Eastern Europe*

8 Sun 2:00 pm **Damnation**
*Eastern Europe*

13 Fri 7:30 pm **Early 1960s:**
**The New American Cinema**
*Essential Cinema*

15 Sun 6:00 pm **Mrs. Dalloway**
*Film Buffs/MFAH Members-Only Sneak Preview*

20 Fri 7:30 pm **Underg**
*Eastern Eu*

21 Sat 7:30 pm **Undergro**
*Eastern Europe*

22 Sun 2:00 pm **Undergroun**
*Eastern Europe*

27 Fri 7:30 pm **Mid-1960s:**
**The New Americ**
*Essential Cinema*

28 Sat 7:30 pm **Mother**

29 Sun 2:00

**Summer Cinémathèque: Truffaut/Hitchcock**

Welcome to the museum's fourth Cinémathèque, the annual series that re figures in world cinema. This sum    FAH focuses on the allian Truffaut (1932-1984) and                899-1980). Truffaut, helped to found th                          te 1950s and went directin                                suspense with
                                    t, who pa
                                      n wi

MFAH Films
January/February 1999

The MFAH offers an innovative educational program called Screening America to Houston-area middle schools and high schools. By engaging students with familiar forms of media, Screening America helps them relate to issues that might otherwise be intimidating. For example, Charlie Chaplin's film *The Immigrant* can lead to a guided discussion about the history of immigration in the United States and can inspire foreign-born students to examine their own experiences. The Henry Fonda movie *12 Angry Men* offers a context for studying the American jury system, and the "Job Switching" episode of *I Love Lucy* encourages students to talk about gender stereotypes. Developed by the American Museum of the Moving Image in Astoria, New York, Screening America is supplemented by teacher training and assigned readings.

Textiles and costumes have long and rich histories in all parts of the world. Traditionally used as items of trade and symbols of status, in addition to the practical purposes of furnishing homes and protecting people from the weather, textiles and costumes (the museum term for clothing) are intimately bound up with a culture's rites of passage, religious beliefs, power structures, and economic activities. They are also viewed as works of art and important forms of self-expression.

With the 19th-century development of mass-produced, machine-made textiles, new materials and styles appeared with increasing frequency, giving rise to the modern fashion system, an international network of cross-influences and shared commerce. Western European and American contributions to this relatively recent history of fashion are the primary focus of the MFAH's textiles and costume collection. The youngest area of the museum, this department was established in 1986 by the Costume Institute of the Museum of Fine Arts, Houston, a support organization founded to assist the museum in collecting and exhibiting textiles and costumes.

The collection focuses on women's garments and continues to build on its existing strengths in late 20th-century design. Collection items reflect the tastes of Houston's keenly fashionable women and include designers such as Geoffrey Beene, Bill Blass, and Oscar de la Renta. In addition, the museum's selection of English and haute-couture French fashions contains important examples from Liberty and Vivienne Westwood, Givenchy, Yves Saint Laurent, and Madame Grès. Future collecting will continue to concentrate on this period and on contemporary designs.

The textiles and costume department also oversees a large collection of historical American works (including quilts, needlework, and clothing) that are housed at the Bayou Bend Collection of American decorative arts (pp. 426–67). In addition, the museum owns superb examples of non-Western textiles and costumes, especially Indian and Indonesian works, displayed periodically with their respective areas of the collection. Because fabric is particularly vulnerable to light, the MFAH presents textiles and costumes only in short-term installations.

**15.1** Jean-Philippe Worth, Evening Dress, 1896

*This dress originally belonged to May Goelet, one of the young American heiresses who sparked the imaginations of novelists such as Henry James and Edith Wharton. In 1903 Goelet married into British aristocracy, becoming the 8th duchess of Roxborough. Before being presented to society, she traveled with her mother to Paris. There, like other social luminaries, the two shopped at Maison Worth, the leading French designer of the time. Worth gowns are distinctive for their opulent fabrics and elaborate ornamentation. The sumptuous silk of this gown is patterned with cascading feathers, a motif associated with Maison Worth for at least its first 50 years. With its rigidly shaped bodice, the gown still owes much to the corseted forms of the 19th century.*

*"In my youth," Miss Jackson rejoined, "it was considered vulgar to dress in the newest fashions; and Amy Sillerton has always told me that in Boston the rule was to put away one's Paris dresses for two years. Old Mrs. Baxter Pennilow, who did everything handsomely, used to import twelve a year ... before she died they found forty-eight Worth dresses that had never been taken out of tissue paper."*

Edith Wharton,
*The Age of Innocence,* 1920

**15.1**

## A Shopper's Guide

**Haute couture:** $ $ $ $ $
In French, haute couture means "high fashion." To buy an haute-couture outfit you must go directly to the fashion house (in New York, Paris, Milan, etc.), where you select from a designer's new lines. The dress or suit you pick is then made especially for you, fitted to your figure, adapted to your tastes, and sewn in a fabric of your choice.

**Couture:** $ $ $ $
Finer department stores have boutiques carrying fashions from the major designers. Store dressmakers alter the clothes to fit your figure.

**Off-the-rack:** $ $ $ - $ $
Many designers create clothing to be sold in department stores as is, with limited potential for custom-fitting.

**Dressmaking:** $ $
Less popular than it once was, this process involves going to an independent dressmaker with a concept selected from a pattern book or fashion magazine. You can order a "designer" outfit made out of a fabric you choose yourself.

**Home sewing:** $
You select a commercial pattern and fabric, then sew according to instructions.

**15.2** Jeanne Lanvin, Day Dress, 1909
*Jeanne Lanvin was one of the first designers to free women from the constraints of corsets. Her radical new approach to the female form may have had its roots in her early career, when she designed dresses for young girls. Part of a matching mother-daughter ensemble, this party dress was probably intended for a teenage girl. A version for a smaller girl was made as well. The dress demonstrates Lanvin's remarkable ability to create timeless designs inspired by historic costumes.*

**15.2a** *Young girl in Lanvin day dress, c. 1909*

**15.2**

**15.3** Natacha Rambova, Evening Coat, c. 1927–31

*Although she was a designer of considerable flair, Natacha Rambova is better known as the second wife of movie legend Rudolph Valentino. This woman with the international name and romantic history was, in fact, a native of Alabama —her name at birth was Winifred Kimball Shaughnessy. Having arrived in Hollywood as a dancer, Rambova soon established herself as a designer of costumes and scenery. After Valentino's death, she opened a boutique in New York that specialized in exotic clothing like this dramatic evening coat. The sleeves are adorned with abstract, avant-garde needlework, which may be the work of Russian or Polish designers working in exile in Paris.*

*I loathe fashion. I want to dress in a way that is becoming to me, whether it is the style of the hour or not. So it should be with all women, in my opinion.*

Natacha Rambova

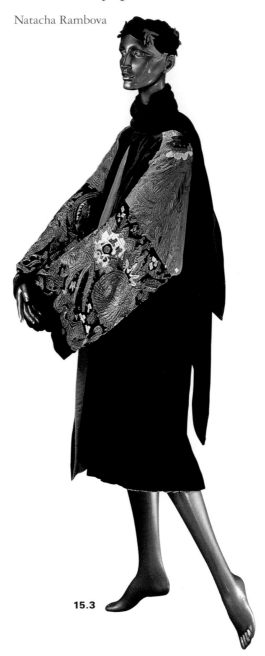

**15.3**

**15.4** Gilbert Adrian, Day Ensemble, c. 1946

*A designer of film and theater costumes, Gilbert Adrian helped to define Hollywood glamour. He introduced Joan Crawford's trademark padded shoulders to deflect attention from the actress's wide hips, thereby creating a fashion revolution. A dress Adrian designed for Crawford's character in the 1932 film* Letty Lynton *became an instant sensation, with Macy's department store alone selling nearly 500,000 copies of the garment. In 1942, as movie fans clamored to imitate their screen idols, Adrian established a string of boutiques that helped women dress for their new roles in the wartime workforce. The equestrian circus motif featured on this ensemble is typical of Adrian's designs, which are distinctive for their bold shapes and patterns. The slim silhouette was a wartime necessity, because the United States government limited the amount of fabric that could be used on civilian clothing. Three decades later, when women reentered the workforce in droves, Adrian's assertively padded shoulders once again dominated the fashion world.*

**15.4**

**15.5 Indian, Sari, c. 1900–1933**

*The patola technique, called ikat in southeast Asia, is an elaborate form of weaving in which yarns are tied in bundles in preset lengths before dyeing, creating color patterns in the untied strands that are then woven on a loom. This sari illustrates a double ikat method, meaning that the patterns have been dyed into both the vertical threads (called the warp) and the horizontal threads (called the weft). Important as export items from India to southeast Asia, skillfully made patolas and ikats are also considered sacred cloths by the cultures of both regions. In the western Indian region of Gujarat, the center of patola production, women wore these saris to their weddings, as well as to first-pregnancy ceremonies and special temple visits. Patola saris typically include symbols of fertility and good luck.*

# Precious Symbols, Precious Commodities: The Value of Textiles and Costume

Even before the time of Helen of Troy (c. 1250 B.C.), textiles and costumes had both real and symbolic value. Handmade, often with precious materials, they have been used by those in power to convey wealth and status, and to inspire awe. Textiles and costumes also have been used as diplomatic gifts, religious offerings, and required tribute payments. In many powerful empires, from China to Byzantium to Rome, textiles, especially silk, were highly coveted items for trade.

In most societies, textiles and costumes have played a vital role in the life-cycle ceremonies of birth, coming-of-age, marriage, and death. Used as gifts, symbols of rank, and heirlooms, these textiles and clothing typically display the finest artistry in weaving, handwork, or other decoration. In many European and Asian cultures, girls would spend years preparing their trousseaus—weaving, sewing, and embroidering clothes and home furnishings for their married lives. The marriage ceremony often included a ritual exchange of cloth, whereas the actual marriage clothes were set aside as quasi-sacred objects, worn again only for special festivals and sometimes as funeral shrouds.

**15.5**

*... Helen lingered beside the chests. And there they were, brocaded, beautiful robes her own hand had woven. Queenly Helen, radiance of women, lifted one from the lot, the largest, loveliest robe, and richly worked and like a star it glistened....*

Helen of Troy selecting a wedding robe to give to Telemachus, son of Odysseus.
Homer, *The Odyssey,* Book 15

**15.6 Indonesian, Ceremonial Shoulder Cloth, c. 1900**
*In Indonesia, weaving symbolizes the structure of the universe: the vertical warp represents the pre-determined aspects of life, while the weft, woven back and forth, represents the chance elements that shape a life. Together with gold jewelry (pp. 260-63), textiles are symbolically charged and highly valued objects in the island cultures of Indonesia. Woven by women during the times of year when they are not planting or harvesting crops, the fabrics can take years to complete, and are thus used only for ceremonial and religious purposes. This shoulder cloth was worn by a bride and symbolized her high status and the sacredness of the occasion.*

15.6

**5.7 Attributed to James Leman or Samuel Baudouin, Fabric, c. 1730**

During the 18th century London was a textile center, and Spitalfields, a newly developed part of town, became known for the woven silks produced here. Master designers like James Leman and Samuel Baudouin famous for their detailed renderings of nature on fabric drew complex designs on specially gridded paper which were then transferred to "drafts" for weavers to follow on their looms. Textiles with complex patterns like this example were expensive, due mostly to the high cost of silk and metallic gold thread but also because of the hand labor involved. To produce the 14 yards or so required for a dress would take a weaver and his assistants a week and a half. One way to cut costs was to produce brocaded fabric, in which the expensive threads were used only to make the pattern (the flowers in this example) rather than woven through the entire width of the cloth. This fabric probably was cut and sewn into clothing for reasonably affluent customers.

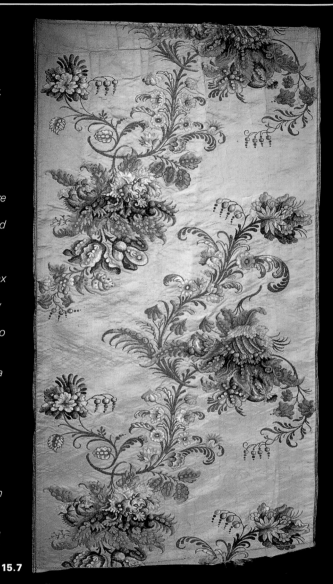

**15.7**

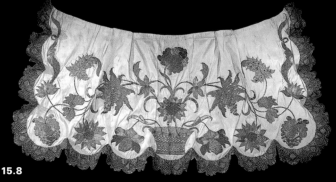

**15.8**

### 15.8 English, Apron, 1760

Although aprons were originally intended to protect a woman's dress, in the mid-18th century richly embroidered examples were more a sign of status than a functional accessory. This apron, embroidered and trimmed with gold thread, was worn by an upper-class English woman at formal occasions. She may have embroidered it herself or, more likely, had it custom-made. To conserve the expensive thread, the embroiderer "couched" it on the surface, meaning that the thread is attached only to the front of the cloth.

### 15.9 Greek (Attic), Bridal/Festive Ensemble, c. 1900

Since ancient times, Greek women have woven simple cottons, linens, and wools on hand looms and have embroidered the fabrics with locally produced silk thread. No item would be more important than one's wedding dress, and this example displays the elaborate handwork typical of the Attic region around Athens. Fashions combined the classical styles of ancient Greece with subsequent influences from numerous invading cultures. For example, the sleeveless undergarment of this ensemble derives from classical Greece, whereas the embroidery on its skirt is stitched over padding, a technique used in the Byzantine Empire to adorn priestly robes. The rich embroidery indicates the social status of the bride.

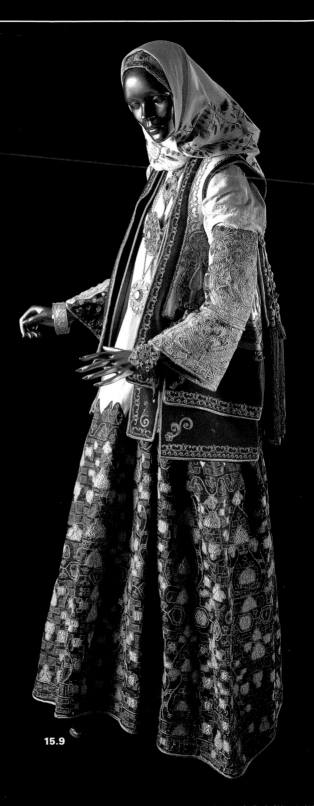

15.9

**15.10** Cristóbal Balenciaga, Evening Ensemble, 1954

*Cristóbal Balenciaga was one of the most innovative dress designers of the mid-20th century. He specialized in seemingly simple but superbly cut designs that flattered the figures of his clientele.*

*Balenciaga produced refined and uncluttered designs, preferring unpatterned fabrics that would highlight the shape, construction, and fit of his creations. Although reminiscent of the glamorous gowns of the 1930s, this exquisitely crafted dress also anticipates the more severe designs of the early 1960s.*

**15.11** Vivienne Westwood and Malcolm McLaren for Seditionaries— Clothes for Heroes, Punk Ensemble, 1977

*Vivienne Westwood's and Malcolm McLaren's subversive designs exploded onto the London scene in the early 1970s. Anarchic and irreverent, the clothes epitomized the nihilistic subculture that became known as the punk movement. With its aggressively spiked hairstyles, extravagantly pierced body parts, and intentionally abhorrent clothes, punk was an anti-fashion stance that became, ironically, a fashion statement. McLaren also helped to create and manage punk's premier band, the Sex Pistols.*

*God save the Queen, the fascist regime ... God save the Queen, she ain't no human bein'...
It don't matter what you want, don't matter what you need, there's no future, no future, no future for you.*

The Sex Pistols,
"God Save the Queen," 1977

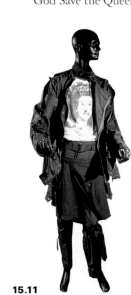

15.10

15.11

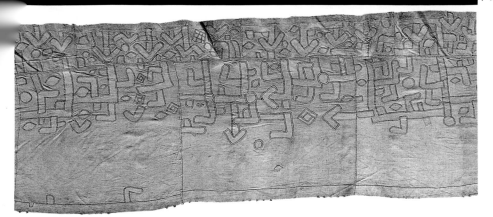

**15.12**

## Woman's Work?

Because of the common misconception that making textiles and costumes is exclusively "woman's work," the history of the subject has rarely been studied. In fact, in many cultures, men are the primary makers of fabric, and in others fabric is produced by both sexes. In parts of Africa, for example, men produce woven and dyed textiles as well as embroidery. For the woman's skirt illustrated above, men from the Kuba culture wove the textile out of raffia, a fiber from a type of palm tree. Women then dyed and decorated the skirt with appliquéd designs. In royal textile traditions throughout the world, men commonly wove the robes, rugs, and tapestries for the court. Conversely, in societies where women have been in charge of the production and distribution of textiles, as in Southeast Asia, women also have had greater power in social and political life.

**15.12** African, Kuba, Woman's Skirt with Appliquéd Designs, late 19th or early 20th century

**15.13** Bill Blass,
Pantsuit, 1983

*One of America's most recognized
designers, Bill Blass is famous
for his glamorous evening gowns
and elegant suits. As a designer
of American sportswear, he
characteristically softens the
lines of traditional menswear
garments with feminine curves.
Blass often forms close friendships
with the women he dresses,
incorporating what he learns
about their tastes and needs into
his designs. One such friend is
Houston socialite Lynn Wyatt,
the original owner of this
pantsuit. She was immediately
drawn to it by the witty use of
a watermelon slice as a lapel.*

*When I first saw this outfit in
a Bill Blass runway show I fell
in love. It has a sense of humor
about it as well as an elegance.
It's one of those outfits that
creates a buzz whenever worn
because of the seriousness of the
embroidery (by the famous
Frenchman Lesage) and the
throwaway-chic humor in which
Mr. Blass chose to design it.*

Lynn Wyatt

15.13

**15.14** Issey Miyake, "Flying Saucer" Gown, 1994

*Fascinated by the physical properties of fabric, Issey Miyake creates bold designs that sometimes push fashion in new directions. In this fanciful dress, the shape of the wearer's body is subordinate to the extreme geometry of the design. Miyake's clothes often span Eastern and Western influences, and this example is reminiscent of Japanese lanterns as well as the flying saucers of science-fiction films. As it moves with the wearer, the dress constantly changes in length and proportion.*

15.14

**5.15  Made in Italy for
. Miller, distributed by
. Magnin, Pair of Shoes,
c. 1920s**

*Made during the Roaring
20s and sold in the
exclusive San Francisco
department store I. Magnin,
these party shoes are
unusual in two respects.
First, the patterned fabric
was designed and woven
specifically for the configu-
ation of shoes, in contrast
o using preexisting cloth.
Second, the pattern is
Art Deco, a decorative style
hat reached its zenith in
France in 1925. Worn under
shorter hem lines, these
shoes, with their contem-
porary design and delicate
silk and metallic threads,
were the height of fashion.*

# Accessories for the "Fashionable Lady"

With its focus on women's fashion of late 20th-century
Western culture, the MFAH collection of textiles and
costume includes wonderful examples of the accessories
that are de rigueur for the beautifully dressed woman. Like
the garments themselves, these hats, shoes, pocketbooks,
and jewelry are subject to the dictates of fashion, their
makers designing new styles that seek a balance between
inherited tastes and venturesome departures.

*…ladies… always go into the
drawing room with their hats and
gloves on. They wear their fur neck
pieces and carry their muffs in their
hands, if they choose, or they leave
them in the hall or dressing room.
But fashionable ladies never take
off their hats.*

Emily Post, *Etiquette: In Society,
in Business, in Politics, and at Home,*
1922

**5.15**

**5.18a** *Jackie Kennedy
made Halston's pillbox
hat famous.*

**15.16**

**15.16 Jean Schlumberger, "Scarf" Necklace, 1948**
*This necklace typifies Jean Schlumberger's work in its playful yet elegant design. Using diamonds, emeralds, and sapphires, he simulates the intertwining of two neck scarves—one blue, the other green, both with white fringe.*

**15.17 French, Champagne Bucket Pocketbook, c. 1950s**
*In the 1950s, shoppers on the Rue de Rivoli in Paris could buy this witty "bucket bag" at Anne-Marie, a retail shop in the heart of the tourist district. A bow to Paris as the center of high fashion and an homage to France's superior champagne industry, this proto-Pop Art work was a perfect souvenir.*

**15.18 Halston (born Roy Halston Frowick), for Bergdorf-Goodman, Hat, c. 1959–67**
*Halston's most famous hat design may well be the pillbox hat, immortalized by Jackie Kennedy. This example, made of cock feathers that were dyed burgundy, demonstrates the sculptural skill he brought to his creations.*

**15.17**

**15.18**

*Occupying about one acre of land, the museum's Lillie and Hugh Roy Cullen Sculpture Garden links the two main MFAH buildings with the Glassell School of Art. In 1976, at the suggestion of Alice Pratt Brown, one of the museum's most distinguished trustees, the MFAH commissioned American sculptor Isamu Noguchi to create a garden setting for selected sculptures in the collection. Over the next few years, Noguchi worked with the museum staff and community representatives to create a unified yet flexible design that would produce a quiet oasis for art within an urban setting.*

*Shaping grass-covered lawns into mounds and slopes, Noguchi enclosed the space with walls of varying heights. The artist considered these walls, cast from 5,100 tons of concrete, as sculptures in their own right, as well as backdrops for the more than 20 late 19th- and 20th-century sculptures that would eventually fill the space.*

Some exterior walls rise high to block out the noise and activity of the streets beyond, while others remain low to provide an urban backdrop for viewing certain works. Interior walls intersect with the paving stones throughout the garden, forming intimate settings for contemplating artworks. Dozens of native Texas trees, including crape myrtles, magnolias, pines, sycamores, and water oaks, shade the seating areas that can accommodate more than 100 people.

Named after the great Houston philanthropists Lillie and Hugh Roy Cullen, and funded in large part by the Cullen Foundation, the sculpture garden opened to the public in 1986.

Walking through the garden, I think there is a kind of conversation going on, a very quiet conversation between walls and spaces, people and sculptures. The walls are sculptures as far as I am concerned. They form a geometry of playfulness in a sense. It is a very much alive place.

Isamu Noguchi, 1986

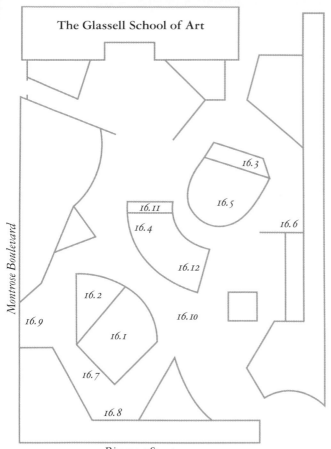

The Glassell School of Art

*Montrose Boulevard*

16.3
16.5
16.11
16.4
16.6
16.12
16.2
16.9
16.10
16.1
16.7
16.8

Bissonnet Street

## The Lillie and Hugh Roy Cullen Sculpture Garden

*Numbers indicate the location of the artists' works that are illustrated on pages 417-24.*

**16.1** Joel Shapiro, Untitled, 1990
*Joel Shapiro's assemblage of bronze blocks evokes a figure arrested in mid-motion. Seen from one side, the figure can appear to be running forward, full tilt; seen from another side, it can appear to be leaning back in a broad stride. The playful combination of minimal shapes with a recognizable form characterizes Shapiro's work.*

**16.2** Louise Bourgeois, Quarantania I, 1947–53
*Cast in bronze in 1981 with the artist's approval, this group of elongated, abstract figures was originally carved in wood by Louise Bourgeois some 30 years earlier. Inspired by totemic African forms and spindles related to her family's tapestry business, the figures symbolize people close to the artist.*

**16.3** DeWitt Godfrey, Untitled, 1989
*DeWitt Godfrey's sculpture is made from welded steel rebar, created through a labor-intensive process pioneered by the artist. As with most of Godfrey's work, Untitled marries plantlike forms with pure geometry. In profile, the work suggests a ripening seed pod, whereas it forms a perfect cone when viewed straight on.*

**16.4** Anthony Caro, Argentine, 1968
*A leading English sculptor since the 1960s, Anthony Caro made this MFAH work from steel boilerplates. After cutting the metal into simple geometric forms, he welded the pieces into a seamless composition and painted them a vibrant color. Placed on the ground, the sculpture directly interacts with the surrounding space.*

*(text continues on p. 425)*

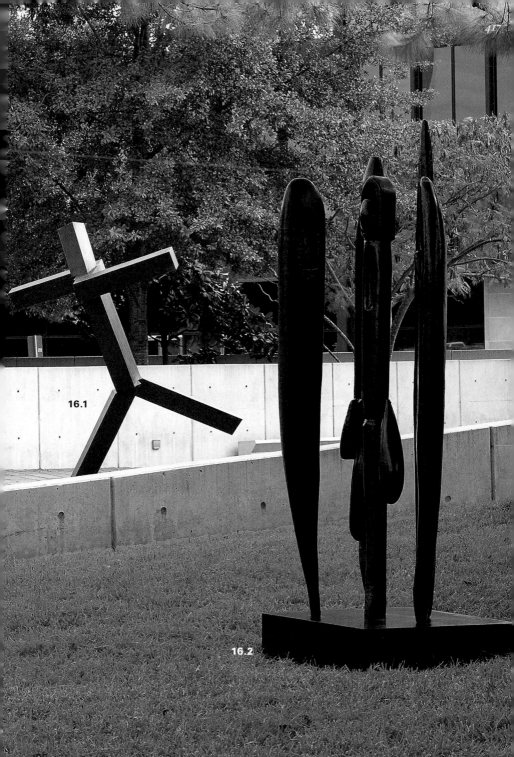

16.1

16.2

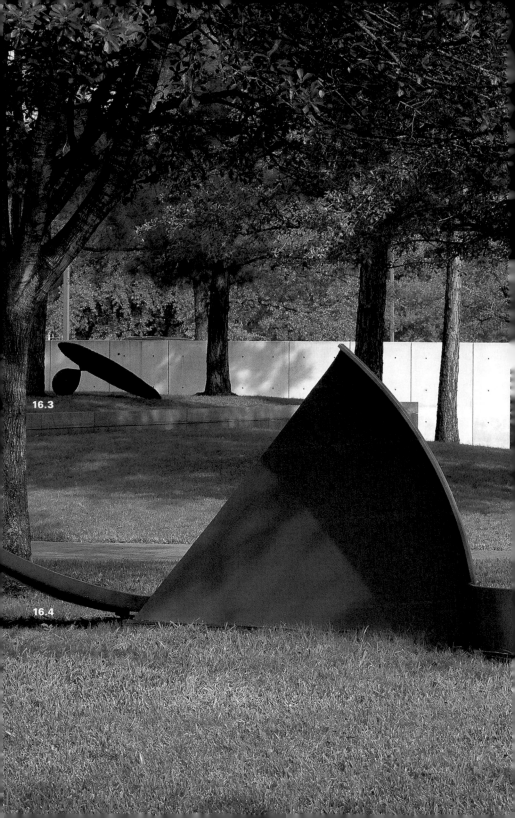

16.3

16.4

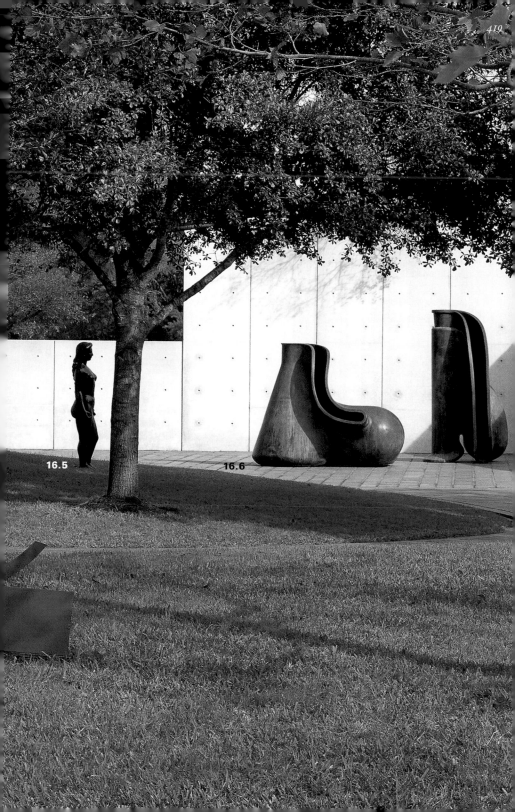

16.5

16.6

16.8

16.7

16.9

16.10

16.11

16.12

**16.5** Aristide Maillol,
Flora, Nude, 1910
*Aristide Maillol's nude
sculptures celebrate the female
body. Inspired by ancient
Greek and Roman figures,
they epitomize classical
restraint and idealized forms.
Representing Flora, the Roman
goddess of spring and flowers,
Flora, Nude personifies
fertility and abundance.*

**16.6** Tony Cragg,
New Forms, 1991–92
*Tony Cragg's early interest in
chemistry is evident in this
evocative work commissioned for
the Cullen Sculpture Garden
in 1991. Two enormous, bronze
vessels echo a laboratory flask
and cylinder. Despite their
weight and size, the swelling
forms suggest male and female
organisms, or the elemental
division of cells. (See also
pp. 372–73.)*

**16.7** Alberto Giacometti,
Large Standing Woman I
(detail), 1960
*From 1950 until his death in
1966, Alberto Giacometti made
sculptures of standing women,
walking men, and portrait
heads. Created as single units
and in groups, these images
fulfilled Giacometti's wish to
express "the totality of life."
This example, nearly 9 feet
high, captures the essence and
eloquence of the female form.
(See also p. 376.)*

**16.8** Henri Matisse,
Backs I–IV, 1909–c. 1930
*Known primarily as a great
painter, Henri Matisse was
also a brilliant sculptor.
The Backs are Matisse's
most radical works in bronze.
He executed the four panels over
a 20-year span, reworking each
successive image from a plaster
cast of the preceding one.
Although the figure becomes
progressively straightened
and simplified, it retains its
expressive human presence.
(See also pp. 109, 319.)*

**16.9** Ellsworth Kelly,
Houston Triptych, 1986
*Ellsworth Kelly created this
commission for the sculpture
garden using a vocabulary
of geometric shapes similar to
those in his signature paintings.
Mounted 12 inches from the
wall, the three monumental
bronzes appear to be floating,
having been scattered randomly
across its surface. In fact, this
playful effect derives from
Kelly's studied response to the
site. (See also pp. 368–69.)*

**16.10** David Smith,
Two Circle Sentinel, 1961
*The artist credited with
bringing international
acclaim to American
sculpture, David Smith was
a master of burnished steel,
a material he believed suited the
20th century. About the series
of sentinel figures, or watchers,
that he made toward the end
of his life, Smith commented,
"They have an odd atmosphere
of grandeur and, at the same
time, delight."*

**16.11** Auguste Rodin,
The Walking Man, 1905
*One of Auguste Rodin's
most important sculptures,
The Walking Man evolved
from an early torso study into
this larger-than-life figure.
By cropping away the head
and arms, Rodin evokes Greek
and Roman antiquities, even
as he focuses the viewer's
attention on the powerful legs
frozen in mid-stride.*

**16.12** Joseph Havel,
Exhaling Pearls, 1993
*Using cast bronze to unite
unlikely combinations of found
objects, Joseph Havel makes
witty sculptures that appear to
defy gravity. Here, two Japanese
paper lanterns and a cargo-ship
rope were directly cast into
bronze. The resulting hybrid
dances with buoyant energy.
For another work by Havel,
see pp. 378–79.*

Ground Floor

Second Floor

Ground Floor

1, 3 Terrace
2 Portico
4 Chillman Foyer
5 Chillman Parlor
6 Sam Houston Hall
7 Scullery
8 Webster Porch
9 Belter Parlor
10 Dining Room
11 Philadelphia Hall
12 Drawing Room
13 Pine Room
14 Folk Art Porch
15 Massachusetts Room
16 Murphy Room
17 Porch

Second Floor

18 Music Room
19 Washington Hall
20 McIntire Bedroom
21 Chippendale Bedroom
22 Maple Bedroom
23 Upper Philadelphia Hall
24 Memorial Room
25 Queen Anne Sitting Room
26 Queen Anne Bedroom
27 Ceramics Study Room
28 Pennsylvania German Hall
29 Federal Parlor
30 Texas Hall
31 Texas Room
32 Newport Room
33 Glazed Porch

*Bayou Bend Collection and Gardens is one of the world's great collections of American paintings, furniture, and other decorative arts. Located five miles from the central campus of the Museum of Fine Arts, Houston, and situated on 14 acres of formal and wooded gardens, the Bayou Bend Collection is housed in the historic residence of Texas philanthropist Ima Hogg (1882–1975).*

Ima Hogg, c. 1953

The only daughter of James Stephen Hogg, the first native-born governor of Texas, Miss Hogg believed that for many Texans, the settlement of Britain's 13 original colonies occurred at a time and place so remote as to seem mythical. Soon after she purchased her first example of early American furniture in 1920, Miss Hogg determined to form a collection of objects made and used by early settlers, thereby providing all Texans with firsthand exposure to their colonial heritage.

In 1927 and 1928, Miss Hogg and two of her brothers, William C. and Michael, both bachelors, oversaw the construction of a grand house to serve as a home for themselves and their growing art collections. This house would be known as Bayou Bend. In addition to collecting early American art, Miss Hogg collected Southwestern Native American works (pp. 290–301) and contemporary European works on paper.

Miss Hogg formed her magnificent collection and gardens over a 50-year period, working closely with curators, dealers, landscape architects, and fellow collectors. In 1957 she gave Bayou Bend to the MFAH. The home was converted into a house museum, and it opened to the public in 1966. Approximately 5,000 objects are installed in 28 room settings that reflect historic and stylistic periods from 1620 to 1870. The collection is especially strong in furniture made for urban homes from the early colonial period through the Civil War. It also features a remarkable survey of early American painting and silver as well as English ceramics appropriate for the early American settings.

Miss Hogg considered the objects she assembled as the foundation of a work in progress. Her wish that the collection would grow continues to be fulfilled, and since her death, Bayou Bend has acquired many significant works.

**Murphy Room**

The Murphy Room, named after Ima Hogg's close friend and fellow collector, Katharine Prentis Murphy, showcases extraordinary, early colonial furnishings that are more lavish than those typically found in the modest homes of Americans at that time. These settlers maintained strong ties with their native countries and sought to preserve Old World comforts and customs in their new surroundings. Through immigration and active trade, they kept up with the latest styles and fashions; as in their homelands, expensive furnishings were valued as signs of status and sophistication.

*Katharine Prentis Murphy (near right) and Ima Hogg (far right) attended the Murphy Room dedication in 1959.*

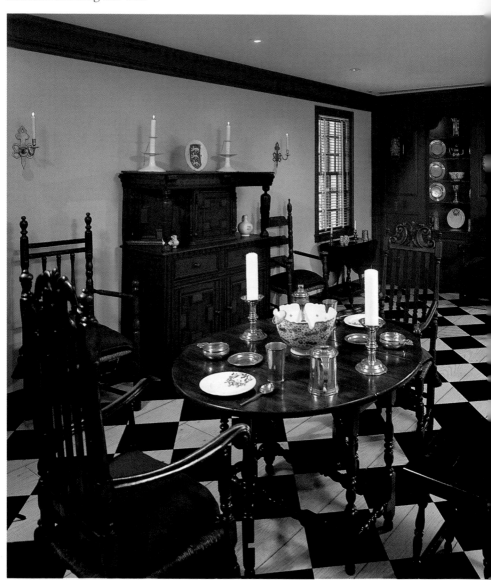

### 17.1 Essex County, Massachusetts, Great Chair, 1640–85

The great chair was the most prestigious type of seating in the 17th century. Owning such an impressive chair indicated high social status. Only the head of the household was privileged to sit in one; other family members were usually relegated to side chairs, benches, or small stools.

*Like most 17th-century furniture, this chair is made of oak, in keeping with the English fashion of the time. The craftsman who made the chair was probably an English immigrant who based its design on patterns he had produced in his homeland.*

**17.1**

**17.2** Boston area, Cupboard, 1670–1700

*Originally, a cupboard was simply what its name implied: a board or tabletop on which cups were kept. The form evolved to include multiple shelves and, sometimes, enclosed storage compartments. Eventually, the term cupboard described a form of furniture with doors and shelves. Its function was not only to store dishes, pots, and table linens, but also to display valuable ceramics, silver, pewter, and glass on its top and exposed shelves. Many colonial American households contained simple chests for storage, but only the very wealthy could boast a cupboard.*

**17.2**

**17.3** Southwark, Montague Close, or Pickleherring Pottery, London, England, Posset Pot, 1628–51

*A favorite beverage in England and America, posset consisted of hot milk curdled with wine, beer, or ale. Pots like this one were produced in England and Holland during the 17th and 18th centuries to hold posset and other frothy drinks. The long spout allowed the user to drink from the bottom of the pot, thus avoiding the foam at the top. The distinctive blue-and-white pottery, extremely popular in the American colonies, responds to the European rage for Chinese porcelain, a material not produced in Europe until 1708. The decoration on this posset pot is borrowed from a Ming dynasty design.*

**A Sack Posset Without Eggs**

*Take a Quart of Cream or new Milk, and grate three Naples-biskets in it, and let them boil in the Cream; grate some Nutmeg in it, and sweeten it to your Taste; let it stand a little to cool, and then put half a Pint of Sack [a type of wine], a little warm in your Bason, and pour your Cream to it, holding it up high in the pouring; let it stand a little, and serve it.*

E. Smith,
*The Compleat Housewife,*
Williamsburg, 1742

**17.4** Shop of John Hull and Robert Sanderson, Sr., Boston, Dram Cup, 1655–64

*The word "dram" derives from the ancient Greek drachma, a coin weighing one-eighth of an ounce. In England, the term described a small draft of liquor. "To dram" meant to drink distilled spirits. While the practice of dramming also existed in America, today only about a dozen American dram cups are known. This diminutive dram cup, only about 1 inch high, was made by the immigrant English silversmiths John Hull and Robert Sanderson, who produced the earliest surviving examples of colonial silver.*

*Collins wish'd to be employ'd in some Counting House; but whether they discover'd his Dramming by his Breath, or by his Behaviour, tho' he had some Recommendations, he met with no Success. . . .*

Benjamin Franklin, *The Autobiography*, c. 1790

**17.4**

**17.3**

## Newport Room

As prosperity in the colonies grew, so did a desire for luxury objects. Silversmiths were at work in America by the early 17th century. The objects they created were the most sophisticated of any produced by colonial American artists or artisans. Using silver provided by the clients, they made small items such as spoons, buckles, and buttons; more significant objects typically had to be specially ordered. At Bayou Bend, colonial American silver is on view in the Newport Room; late 18th- and 19th-century examples are exhibited in the Dining Room, Chillman Foyer, Chillman Parlor, Belter Parlor, and Washington Hall.

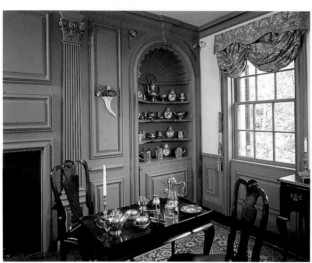

**17.5**

**17.5** Shop of John Coney, Boston, Tankard, 1695–1711

One of America's great silversmiths, John Coney was also an expert engraver. This tankard bears the coat of arms of the Foster family of Boston. Engraved on the bottom are names and dates that chronicle the tankard's ownership through seven generations and more than two centuries. Tankards were commonly used to hold beer, ale, cider, or punch. Alcohol was believed to be good for one's health and was, in fact, free from cholera and other deadly germs that often infected water supplies. Drinking alcohol was an important social activity —primarily for men—and tankards were frequently passed from one person to the next.

Most tankards were made of wood or pewter and were therefore more affordable than this superb, silver example.

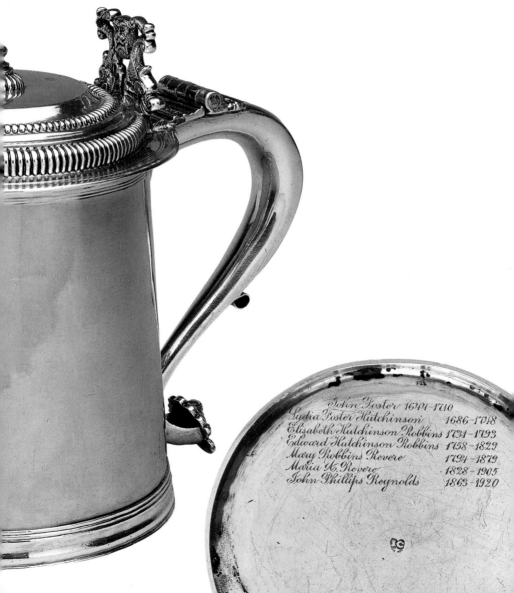

John Foster 1640-1710
Lydia Foster Hutchinson 1686-1748
Elizabeth Hutchinson Robbins 1734-1793
Edward Hutchinson Robbins 1758-1829
Mary Robbins Revere 1794-1879
Maria K. Revere 1828-1905
John Phillips Reynolds 1863-1920

**17.6** Shop of
Paul Revere, Jr.,
Boston, Slop Bowl, 1797
*This slop bowl bears the silver-*
*smith's mark of Paul Revere,*
*certainly the most famous of all*
*American silversmiths. It was*
*used to hold the dregs and cold*
*tea from a teapot or cup before*
*fresh tea was brewed or poured.*
*Tea drinking (p. 455) had been*
*an important social ritual in*
*18th-century America until*

*1767, when many Americans*
*abandoned the beverage to*
*protest England's heavy tax*
*on tea consumption. After the*
*American Revolution, Britain's*
*monopoly on the American*
*tea trade came to an abrupt end,*
*and tea drinking regained its*
*popularity. The accoutrements*
*for serving tea were an important*
*part of Revere's production.*

**17.7** Shop of
Paul Revere, Jr.,
Boston, Teaspoon, one
of a pair, c. 1796–c. 1806
*Spoons are among the few forms*
*in American silver that have*
*been produced continuously*
*since the 17th century. They*
*are also the objects most often*
*made by colonial silversmiths.*
*Over the centuries, spoons*
*evolved considerably in form*
*and design. Paul Revere is the*
*only American silversmith to*
*fashion teaspoons with fluted*
*bowls. He copied the design from*
*an English import, perhaps to*
*complement tea vessels with*
*fluted sides. The handle of this*
*spoon incorporates the initials*
*of its original owners.*

**17.6**

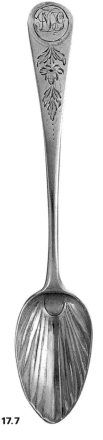

**17.7**

*Being call'd one Morning to Breakfast, I found it in a China Bowl*
*with a Spoon of Silver. They had been bought for me without my*
*Knowledge by my Wife, and had cost her the enormous Sum of*
*three and twenty Shillings, for which she had no other Excuse,*
*or Apology to make, but that she thought **her** Husband deserv'd*
*a Silver Spoon & China Bowl as well as any of his Neighbours.*

Benjamin Franklin, *The Autobiography*, c. 1790

**17.8** Charles Balthazar-Julien Févret de Saint-Mémin, Philadelphia, *Portrait of Paul Revere, Jr.*, 1800

**17.9** Paul Revere, Jr., Boston, *The Bloody Massacre*, 1770

*In addition to being a master silversmith, Paul Revere was an accomplished printmaker. The most famous of all colonial American prints, this engraving records an infamous moment in history. On March 5, 1770, an angry Boston mob, resentful over new taxes, provoked a group of English soldiers. Five people were killed in the ensuing skirmish. Revere's version of the event depicts a firing squad of British redcoats brutally gunning down helpless Bostonians. Historically biased, Revere's print became a powerful propaganda tool.*

**17.8**

**17.9**

**17.10** Manufactory of
Thomas Fletcher
and Sidney Gardiner,
Boston and Philadelphia,
Pitcher, 1815

*With its paw feet, acanthus
leaves, eagle-headed handle, and
dolphin finial, this silver pitcher
epitomizes the Grecian taste
popular in America in the first
decades of the 19th century.
Lady Ann Moodie Houstoun
commissioned the pitcher from
the Philadelphia firm Fletcher
and Gardiner, perhaps the finest
silversmiths at work in the
young nation, as a gift to her
attorney and son-in-law,
Colonel James Johnston.*

**17.10a** *Original bill of sale for
Fletcher and Gardiner pitcher*

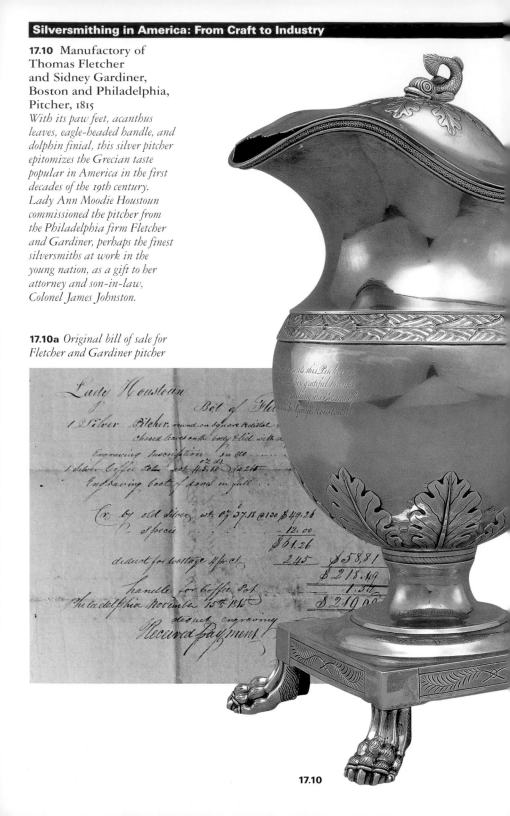

**17.10**

**17.11** Gorham
Manufacturing Company,
Providence, Rhode Island,
Soup Tureen, c. 1858
*This superbly crafted tureen
embodies the stylish design and
technical expertise that characterize
Gorham's best work. Using a
technique called repoussé, silver-
smiths hammered out the lush
floral designs from inside the
vessel. Frances S. Newman of*

*New Orleans received the custom-
made tureen as a gift, probably
on the occasion of her marriage
to Arthur B. Griswold. In the
1860s, Griswold operated a
jewelry store at the corner of
Canal and Royal Streets, where
he became the New Orleans agent
for Gorham.*

**17.11a** *Griswold showroom
in New Orleans*

**17.11**

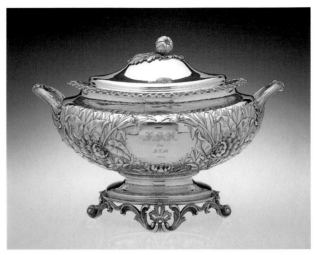

**17.11a**

At the end of the 17th century, the high chest emerged as a new furniture form, soon replacing the cupboard as a status symbol in affluent colonial households. Throughout this period the bedroom was a more public space than it is today, and high chests were placed there to be seen at social gatherings. Clothing, linen, and other valuables were stored in the drawers, and prized objects were prominently displayed on the chests' flat tops.

A finished high chest could require the work of several craftsmen: cabinetmakers and joiners assembled the basic chest; carvers contributed the legs, finials, and decorative details; other artisans applied gold leaf and painted decorations. The evolution of the high chest over the course of the 18th century reflects growing prosperity, an increasingly refined life in the colonies, and the emergence of a uniquely American interpretation of an English furniture form.

**17.12  Boston, High Chest, 1700–1725**
*By around 1690, the Early Baroque style (also known as the William and Mary style) heralded a new era in craftsmanship, an era later recognized as the beginning of modern cabinetmaking tradition. Furniture became taller, lighter, and vertical in emphasis. Walnut, with its richly patterned grain, replaced oak as the wood of choice. Veneers of prized burled walnut, cut from the knots of tree trunks, give this high chest its luxurious surface, and the elaborately turned legs are typical of Early Baroque design.*

**17.12**

**17.13**  Boston,
High Chest, 1730–60

An obsession with the S-curve
dominated American design by
around 1725. With outwardly
curved knees and inwardly
turned ankles, graceful
legs (called cabriole legs)
became the hallmark of
Late Baroque, or Queen Anne,
furniture. Meanwhile, cabinet-
makers grew increasingly

inventive and ambitious in their
designs. This high chest is made
mostly of pine rather than of a
more expensive wood because it
was intended to be japanned.
An application of paint, gesso
(a mixture of plaster and glue),
and gold leaf, japanning is
a decorative technique used
to imitate Asian lacquer,
a coveted but prohibitively
expensive luxury.

**17.14**  Philadelphia,
High Chest, 1760–1800

In the mid-18th century,
American and English cabinet-
makers drew inspiration from
Thomas Chippendale's land-
mark 1754 pattern book, The
Gentleman and Cabinet-
Maker's Director. An English-
man, Chippendale was a master
of Rococo design, an exuberant,
French-inspired style that in
19th-century England and
America became synonymous
with his own name. This exam-
ple contains details typical of
Philadelphia high chests, from
the ball-and-claw feet on the
legs, to the carved shell on the
bottom center drawer, to the
scrolled pediment on the top.

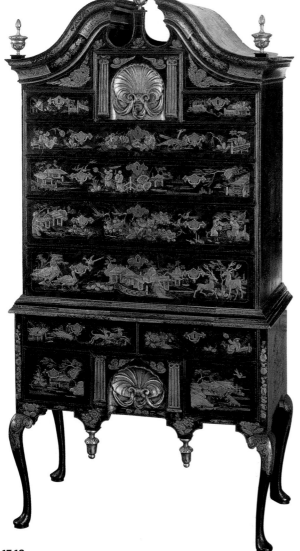

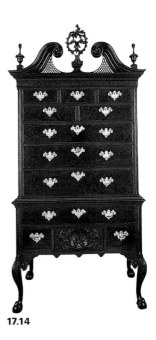

**17.14**

**17.13**

With its large collection of paintings, furniture, and related decorative arts, Bayou Bend provides a rich picture of family life in the 18th and 19th centuries, especially the under-documented experiences of women and children in early America.

**17.15** Joseph Badger, Boston, Portrait of John Gerry, 1745
*The Gerry family lived in a grand house in Marblehead, Massachusetts. John was the fifth of 16 children, but few of his siblings survived beyond childhood. By grim luck, he became the oldest living son and thus the family heir. He would later serve as a naval officer in the American Revolution. Not yet 4 years old at the time of this portrait, John wears the clothes of an adult, in keeping with customs of the time. The artist probably copied the extravagant pose and setting from engraved portraits of English aristocrats.*

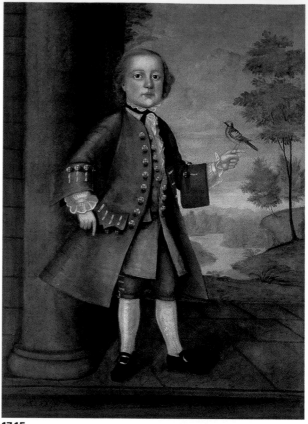

**17.15**

**17.16** Shop of Thauvet Besley, New York City, Whistle, Bells, and Coral, 1727–57
*This 18th-century version of a rattle has a whistle and bells to amuse a child, and coral at one end for teething. Coral was believed to possess special powers — to protect children from illness and evil, and to help harden a child's emerging teeth. Made of silver, this whistle, bells, and coral was an extravagant indulgence. Three sets of engraved initials confirm that the toy served several generations. A similar example is included in a portrait in the MFAH's American collection (p. 189).*

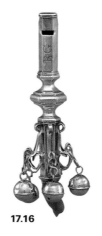

**17.16**

**17.15a** John Gerry's Coat, c. 1745

**17.17** Eastern Massachusetts, Easy Chair, 1750–1800

*The Irish stitch needlework that covers this chair represents months or even years of work, probably by the woman whose family owned the chair. The woman's husband may have commissioned a chair maker to construct the Rococo-style frame and an upholsterer to assemble the cushion and cover. In early America, upholsterers were second only to silversmiths in prestige and prosperity. In addition to their upholstery work, these craftsmen frequently helped coordinate the fabrics for the rest of the room, if not the entire home, functioning much like today's interior designers.*

**17.18** Attributed to the shop of John and Thomas Seymour or to Thomas Seymour's Boston Furniture Warehouse, Tambour Desk, 1794–1810

*In the 18th century, half of the women in America were illiterate. Girls received no formal schooling and most were taught little more than sewing and household skills. The post-revolutionary period ushered in a more enlightened attitude toward women. Increased leisure time and educational opportunities allowed women to pursue more genteel interests. This type of writing desk served the needs of the new American woman. With its classically inspired inlaid columns and ·floral swags, this desk is a superb example of Neoclassical design. The tambour, or sliding doors, are made of narrow strips of wood applied to canvas, allowing the doors to slide back horizontally from the center.*

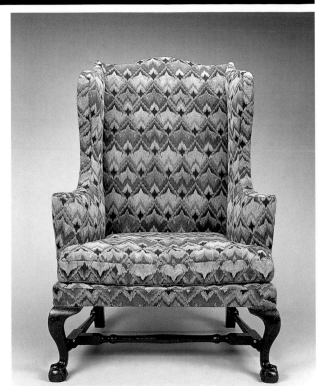

**17.17**

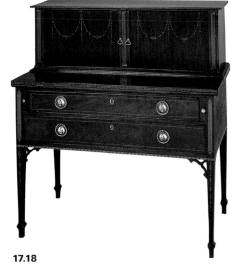

**17.18**

**17.19** Attributed to Almira Earle, Milton, Massachusetts, Memorial Embroidered Picture, c. 1815–20
*Learning to embroider was an essential part of a woman's education well into the 19th century. As a means of developing or practicing their needle skills, young women often made family memorial pictures*

*that commemorated deceased relatives. This example is especially poignant, as it depicts four members of the Earle family mourning the loss of loved ones: 33-year-old Winthrop Earle and two of his children, 22-month-old Horace and 4-year-old Eliza.*

**17.20** Manufactory of Samuel Kirk & Son, Baltimore, Medal, c. 1850
*The son of free African-American parents, Dr. Daniel Alexander Payne promoted education within the African-American community. In 1849, as minister of the Bethel African Methodist Episcopal Church in Baltimore, Payne organized the inaugural*

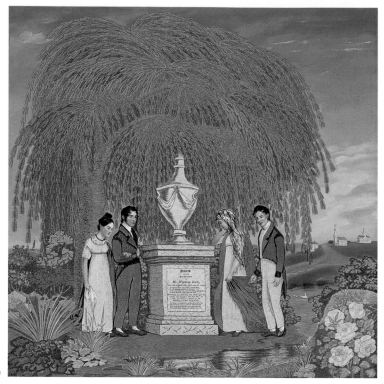

**17.19**

**17.20**

"Literary and Artistic Demonstration for the Encouragement of Literature and the Fine Arts among the Colored Population." The following year he awarded this silver medal to Jane Jones for the "2d best piece of Embroidery" in the exhibition. Payne later served as president of Wilberforce University in Ohio and was a compelling antislavery advocate.

**17.21 Mary Ann McCue, Philadelphia, Odd Fellows Appliqué Album Quilt, c. 1850**

The tradition of quilt making was born out of necessity. During colonial times, most cloth was imported and thus very expensive. With quilting, bedcovers could be created out of fabric remnants and scraps of old clothing. Largely the domain of women, quilting evolved into a sophisticated art form. Appliqué quilts are made by sewing cutout shapes onto solid-colored fabric. In this example, the second square from the left in the top row includes symbols of the Independent Organization of Odd Fellows, an English benevolent group brought to America in 1819.

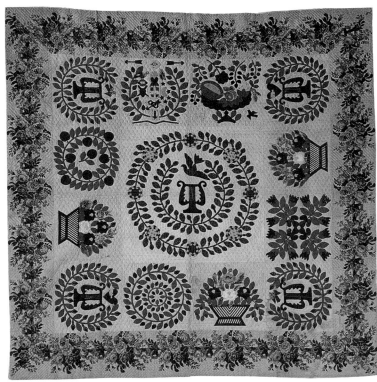

**17.21**

You remark upon the deficiency of Education in your Countrymen. . . . If you complain of neglect of Education in sons, What shall I say with regard to daughters, who every day experience the want of it. With regard to the Education of my own children, I find myself soon out of my debth, and destitute and deficient in every part of Education.

Letter from Abigail Adams to her husband, John, 1776

**17.22** Peter Pelham, Boston, Mather Byles, 1732-39

A *nephew of the witch-hunting minister Cotton Mather, Mather Byles was a renowned wit and the most popular preacher of his time. The artist Peter Pelham made this engraved portrait from his own painting of Byles, thus allowing the image to be reproduced in large quantity. With the invention of the camera still a century away, engraved portraits allowed Americans to become familiar with the faces of the famous. Byles was the father of Elizabeth Byles (Mrs. Gawen) Brown, a portrait of whom appears at right (17.23).*

**17.23** John Singleton Copley, Boston, Portrait of Mrs. Gawen Brown, 1763

*Although largely self-taught, John Singleton Copley is generally considered the greatest American painter of the 18th century. The son of poor Irish immigrants, he achieved fame and fortune by painting portraits of the social and political elite of Boston,*

*including Samuel Adams, John Hancock, and Paul Revere. Like most early American artists, Copley learned the traditions of European art from prints, including those collected by his stepfather, Peter Pelham (17.22). For this pastel portrait, Copley borrowed the pose and props from an engraving of an English countess (17.23a).*

**17.22**

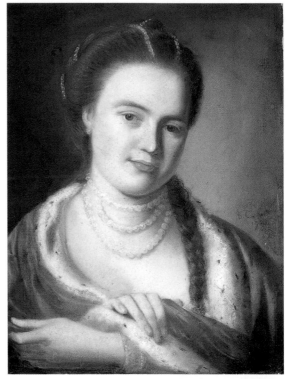

**17.23**

**17.23a** Thomas Frye, London, Maria, Countess of Coventry, 1761
*(Collection of Colonial Williamsburg Foundation)*

**17.24** Gilbert Stuart, Philadelphia, Portrait of John Vaughan, c. 1795
*Born in Rhode Island, Gilbert Stuart became a successful portraitist in Britain before returning to America. He is best known for his iconic images of George Washington, one of which is still reproduced on the U.S. $1 bill (17.24a). A patron of the arts and sciences, John Vaughan*

*once commissioned Stuart to make a portrait of the nation's first president. At the same time that the artist fulfilled that commission, he created this engaging portrait of Vaughan. The intense characterization, luminous flesh tones, and spontaneous brushwork are typical of Stuart's best portraits. His work had a profound effect on the next generation of artists.*

**17.25** John Smibert, Boston, Portrait of Samuel Pemberton, 1734
*The son of a wealthy Boston merchant, Samuel Pemberton was just 11 years old when he sat for this portrait. His confident pose, elegant costume, and elaborate wig indicate his high social status. The portrait was painted by John Smibert, the Scottish-born artist who is generally considered America's first important painter. Smibert arrived in Boston in 1730 and became an instant sensation, eventually producing portraits of more than 200 prominent New Englanders. His studio and print shop became a mecca for aspiring artists — including John Singleton Copley (17.23, 17.26) — who learned their profession from Smibert's own work and from the English engravings that he imported and sold.*

**17.24**

**17.25**

**17.24a**

**17.26** John Singleton Copley, Boston, Portrait of a Boy, c. 1758–60

*The identity of the dapper boy in this full-length portrait is unknown, but he was most likely the son and heir of a very wealthy Massachusetts family. John Singleton Copley (17.23) surrounded his subject with a profusion of props—costly toys, a hat, architectural stonework, and various landscape elements—that were borrowed from 18th-century English portraits. Together with the boy's nonchalant pose, these objects lend aristocratic status to the subject and indicate his privileged lifestyle.*

## We are the lavishest and showiest and most luxury-loving people on earth.

Mark Twain, "Diplomatic Pay and Clothes," 1899

**17.27** Attributed to the shop of John Townsend, Newport, Rhode Island, Bureau Table, 1785–1800

*A masterpiece of American design, this superb bureau table represents the height of style, prestige, and craftsmanship in the bustling town of Newport. Fashioned from expensive, imported mahogany, the bureau table originally stored jewelry,*

*brushes, combs, and other items essential to a well-dressed gentleman. Functioning as a dressing table, it belonged in a bedroom, which in early America was a more public space and therefore suitable for the display of wealth.*

**17.26**

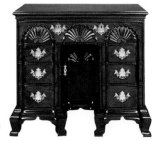

**17.27**

**17.28** Shop of John Henry Belter, New York City, Étagère, 1855
*More ornate and flamboyant than the 18th-century Rococo style that inspired it, the Rococo Revival style dominated fashionable parlors of the mid-19th century. The German immigrant John Henry Belter became one of America's leading exponents of the new style. His technique for laminating rosewood enabled the creation of curving, lavishly carved and pierced forms. A new form of furniture, the étagère was intended to display a family's prized possessions. As such, it served a purpose similar to that of the cupboard in the 17th century and the sideboard in the late 18th and 19th centuries.*

**17.29** Movement by Peter Stretch, Philadelphia, Tall Clock, 1725–46
*Rare and costly, a clock was a luxury only the wealthiest colonial households could afford. Early clocks kept time by the swinging of a pendulum: the longer the pendulum, the more accurate the time. In the 17th century, clocks were introduced with tall cases to accommodate longer pendulums. Not until sometime during the 19th century did these tall clocks become popularly known as "grandfather" clocks. The walnut case for this Late Baroque example was made by a Philadelphia cabinetmaker.*

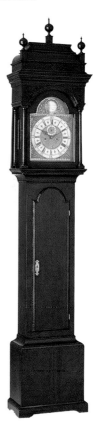

**17.29**

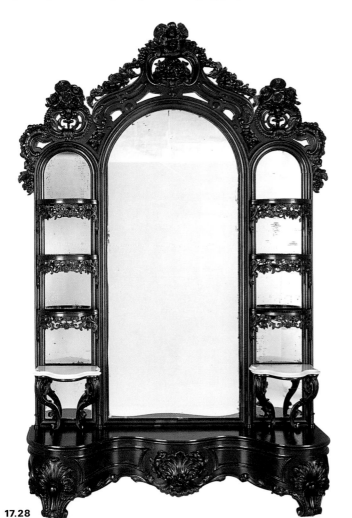

**17.28**

The Bayou Bend Collection features objects representing seven major stylistic periods. Different types of objects within each period reflect a continuity of style. For example, the contour of the leg on a Rococo chest corresponds to the related components on a Rococo chair. Works in other media, such as silver teapots, contain similar contours. Details—ornamental shells, scrolls, flowers, ball-and-claw feet—further define each style. Incorporated into each period's furniture, silver, other decorative arts, and even paintings and architecture, these stylistic features create a unified decor.

**Mannerist,**
c. 1640–95
(also called Jacobean)

1642–60
*The English Civil War is fought.*
1656
*La Salle claims the Louisiana territory for France.*
1664
*England seizes Dutch New Amsterdam and renames it New York.*

**Early Baroque,**
c. 1695–1725
(also called William and Mary)

1689–1702
*William and Mary reign in England.*
1700
*Population of the American colonies is approximately 275,000.*
1718
*France founds the city of New Orleans.*

**Late Baroque,**
c. 1725–60
(also called Queen Anne)

1730
*Construction begins on Independence Hall in Philadelphia.*
1748
*Excavations begin at Pompeii.*
1752
*Benjamin Franklin proves that lightning is electricity.*

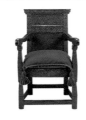 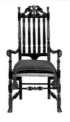 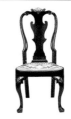

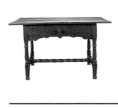 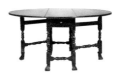 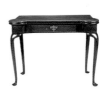

 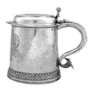 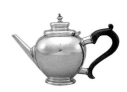

| Rococo, c. 1760–90 (also called Chippendale) | Neoclassical, c. 1790–1810 (also called Federal) | Grecian, c. 1810–45 (also called Empire) | Rococo Revival, c. 1845–70 (also called Early Victorian) |
|---|---|---|---|
| 1764 *Bostonians denounce British "taxation without representation."* 1776–83 *The American Revolution is fought.* 1789 *The French Revolution begins.* | 1791 *Pierre-Charles L'Enfant designs Washington, D.C.* 1793 *Eli Whitney invents the cotton gin.* 1803 *United States purchases Louisiana from France.* | 1814 *Francis Scott Key writes "The Star-Spangled Banner."* 1825 *The Erie Canal is completed.* 1836 *The Republic of Texas is established.* | 1845 *The first California Gold Rush begins.* 1847 *Frederick Douglass starts an abolitionist newspaper.* 1861–65 *The American Civil War is fought.* |

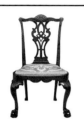
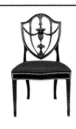
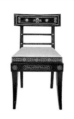
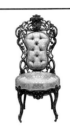

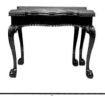
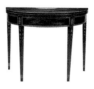

**17.30** Edward Hicks,
Bucks County,
Pennsylvania,
Penn's Treaty with
the Indians, c. 1830–40
*According to legend, in 1682 the
Quaker reformer William Penn
met with Native Americans
at Shackamaxon in Delaware
to exchange gifts for land.
Although history shows that
Penn did meet with the Lenape*

*Indians, no actual treaty exists.
For the Quakers, however, the
meeting fulfilled the biblical
prophecy of a peaceable kingdom
on earth. The theme inspired
more than a hundred paintings
by the Quaker preacher Edward
Hicks, who also worked as a
sign and coach painter. Using a
seemingly unsophisticated style,
Hicks concentrated on images
that conveyed his Quaker beliefs.*

**17.31** French, decoration
possibly New York,
Presentation Pitcher,
c. 1848–50
*Embellished with a portrait of
General Zachary Taylor on one
side and a landscape with a battle
formation on the other, this pitcher
commemorates Taylor's triumph
in the 1847 Battle of Buena Vista
during the Mexican War.*

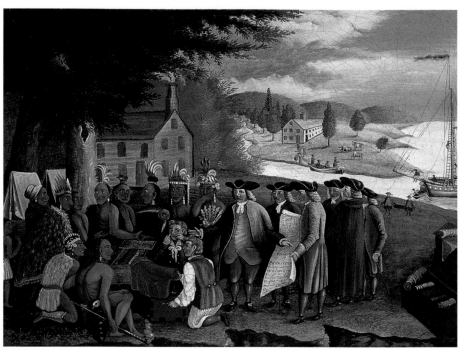

**17.30**

**17.31**

**17.32** John Bower, Philadelphia, A View of the Bombardment of Fort McHenry, c. 1815
*The successful defense of Baltimore in September 1814 was a turning point leading to American victory in the War of 1812. Strategically located at the harbor of this major seaport, Fort McHenry endured two days and nights of shelling by* the British fleet. *The inscription on this hand-colored print reads, in part, "taken from the Observatory . . . on the morning of the 13th of Sep[tembe]r 1814," suggesting that the view is a firsthand account. Another eyewitness to this historic event was Francis Scott Key, who observed the bombardment while in prison behind enemy lines. Key commemorated the battle* in his poem "The Star-Spangled Banner," *which was adopted as the national anthem in 1931. An American flag flies over the fort in the center.*

*Our country! In her intercourse with foreign nations, may she always be in the right; but our country, right or wrong.*

Stephen Decatur, 1816

A VIEW of the BOMBARDMENT of Fort McHenry, near Baltimore, by the British fleet, taken from the Observatory under the Command of Admirals Cochrane & Cockburn, on the morning of the 13th of Sep.r 1814 which lasted 24 hours, & thrown from 1500 to 1800 shells, in the Night attempted to land by forcing a passage up the ferry branch but were repulsed with great loss.

**17.32**

**17.33** Manufactory of Andrew Ellicott Warner, Baltimore, Soup Tureen, 1817
*After the War of 1812, patriotic Americans commissioned gifts of silver for the heroes of the young nation. The daring naval commander Stephen Decatur had served his country with distinction during the war, and in 1817 the grateful citizens of Baltimore presented him with a lavish silver service.*

**17.33**

Long before the American Revolution, colonists were interested in furnishing their homes with sophisticated goods and furniture on a par, as much as possible, with their Old World counterparts. Thus when Chinese design became the rage in Europe, early American settlers followed suit and incorporated Asian styles into their home furnishings. Later in the 18th century, after the discovery of the ruins of the ancient Roman city of Pompeii prompted a renewed love of everything classical, fashionable Americans decorated their homes in the latest Neoclassical styles.

**17.34** American China Manufactory, Philadelphia, Sauceboat, 1770–72

*To promote their own industries, the English discouraged the production of most luxury goods in the colonies. The establishment of the American China Manufactory in 1769 represented an attempt by colonists to free themselves from dependence on England. Because the firm* employed skilled immigrant craftsmen, its wares were comparable in quality and style to those of its English competitors but proved more costly to produce. Unable to compete, the American China Manufactory closed in 1772. Fewer than 20 pieces produced by the factory survive, including this exquisite porcelain sauceboat with its Chinese-inspired decoration.

**17.34**

**17.35**

**17.35** Shop of Bartholomew Schaats, New York City, Teapot, 1728–48

*Americans were brewing tea from China as early as the mid-17th century. Exotic and expensive, the beverage was valued initially for its supposed medicinal qualities. Tea drinking soon became an elaborate social ritual,* *necessitating the introduction of a new furniture form— the tea table—and an array of specialized tea-serving equipment. This silver teapot, with its spherical shape, was patterned after Chinese wine pots; the simplicity corresponds with Late Baroque taste. Just 6 1/2 inches high, the teapot's small scale reflects the high price of tea at that time.*

*If we consult history, we shall find, that in most nations foreign trade has preceded any refinement in home manufactures, and given birth to domestic luxury.... It rouses men from their indolence; and, presenting the gayer and more opulent part of the nation with objects of luxury which they never before dreamed of, raises in them a desire of a more splendid way of life than what their ancestors enjoyed.*

David Hume, "Essay of Commerce," 1752

**17.36** Asher Brown Durand, after a painting by John Vanderlyn, New York, Ariadne, 1835

*In Greek mythology, the beautiful princess Ariadne fell in love with Theseus, the hero who was imprisoned by her father, King Minos. Ariadne helped Theseus escape, but he later deserted her. She is seen here asleep, at the moment of her abandonment.*

*John Vanderlyn was the first American artist to master the French style of Neoclassical painting. Although this painting had been exhibited in Paris to great acclaim, it was condemned in America for Ariadne's nakedness. Unable to find a buyer, Vanderlyn eventually sold* Ariadne *to another artist, Asher Brown Durand. A masterful engraver, Durand*

*copied the painting and sold it as a print. The nudity continued to deter buyers, however, and Durand's engraving also failed to achieve success. For another painting of Ariadne, see p. 73.*

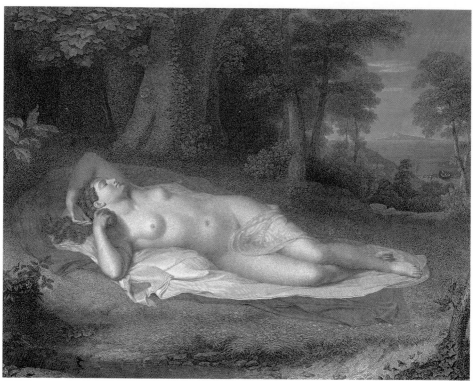

**17.36**

*Thy Naiad airs have brought me home
To the glory that was Greece
And the grandeur that was Rome.*

Edgar Allan Poe, "To Helen," 1831

**17.37** Benjamin H. Latrobe, Philadelphia or possibly Baltimore, Side Chair, one of a pair, c. 1808

*The Grecian style captured the American imagination in the first decade of the 19th century. Like their European counterparts, American furniture makers copied designs found on ancient bas-relief sculptures and vase paintings, giving the style an archaeological accuracy. This elegant chair is among the first and finest manifestations of Grecian style in America. It was part of a suite of furniture made for William Waln, a prominent Philadelphia businessman. The following year, Benjamin H. Latrobe designed similarly styled furniture for the White House.*

**17.38** Shop of Aaron Willard, Sr., or Aaron Willard, Jr., Boston, Wall Clock, 1802–30

*In keeping with the new taste for the antique, the bottom glass panel on this wall clock was painted with a scene from classical mythology. Aurora, the Roman goddess of dawn, is spirited away in her chariot by two winged horses as the sun rises behind her, thus drama- tizing the passage of time. This type of clock, today popularly known as a banjo clock, was invented by Simon Willard in 1802 as a substitute for the tall clock (17.29).*

**17.38**

**17.37**

A painter, politician, patriot, inventor, upholsterer, saddler, watchmaker, silversmith, and naturalist, Charles Willson Peale was also the founder of America's most remarkable artistic dynasty. Eight of his 17 children (all of whom were named after great artists), became noteworthy painters in their own right.

**17.39 Charles Willson Peale, Philadelphia, Self-Portrait with Angelica and Portrait of Rachel, c. 1782–85**
*Based in Philadelphia, Charles Willson Peale was among America's most fashionable portrait painters. In 1782 he opened the first art gallery in the colonies, where he exhibited his own paintings.*

*The gallery grew to encompass a vast collection of natural history specimens, including the first mastodon skeleton unearthed in America. In this complex self-portrait, Peale in turn paints a portrait of his wife, Rachel. Their daughter Angelica, serving as an allegorical muse of painting, guides her father's brush with one hand, while her other hand points heavenward.*

**17.39**

**17.40** Charles Willson Peale, Philadelphia, Landscape Looking Toward Sellers Hall from Mill Bank, c. 1818

*In 1810, Charles Willson Peale retired to his rural home outside of Philadelphia and began experimenting with landscape painting. He was most concerned with the creation of harmonious, balanced compositions, and in fact used a painter's quadrant to help order the landscape elements. This oil on canvas was painted for his favorite son-in-law, Coleman Sellers.*

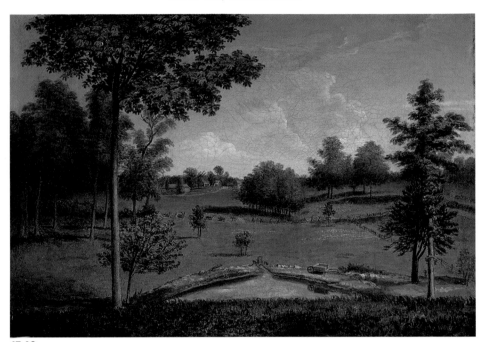

**17.40**

*I have gone over the Lan[d]scapes
I painted for Coleman, and they are so much improved,
by the use of the tints you gave me that
I expect the family will be delighted when they see them.*

Letter from Charles Willson Peale to his son Rembrandt, 1818

**17.41** James Peale, Bloomsbury, New Jersey, Pleasure Party by a Mill, late 1780s
*James Peale studied art by working as an assistant to Charles Willson Peale, his older brother (pp. 458–59). In this early, autonomous work, James combined the picturesque elements of European landscape painting with the topography of a particular American site.*

*Set at Musconetcong Creek ironworks and gristmill in Bloomsbury, the painting marks the beginning of a growing interest in America's scenic attractions. One of the earliest major American landscapes, the work anticipates the great tradition of Romantic landscape painting that would culminate in the 19th century with the artists of the Hudson River School (pp. 174–79).*

**17.42** Rembrandt Peale, Philadelphia or Baltimore, Portrait of Henry Robinson, c. 1816–20
*With diverse interests in art, business, and science, Rembrandt Peale shared the eclectic energies of his father, Charles Willson Peale (pp. 458–59). Rembrandt's striking portrait of his close friend Henry Robinson shows the artist at his best. Rembrandt painted this portrait as a gift to his friend.*

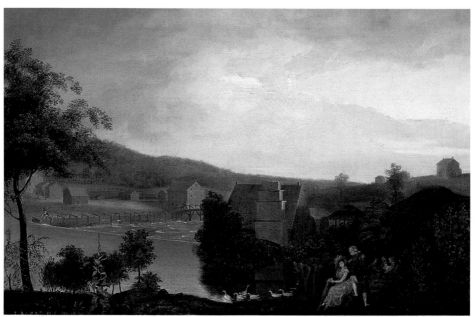

**17.41**

**17.42**

**17.43** James Peale, Philadelphia, Still Life with Vegetables, 1826
*James Peale and his nephew Raphaelle became pioneers of America's still life tradition. For this painting, James selected fruits and vegetables with strong shapes, vibrant colors, and varied textures. The 76-year-old artist may have intended the wilting leaves as an allusion to the transience of life.*

**17.44** Probably French or German, painted decoration probably American, Presentation Cup and Saucer, c. 1850
*This unique cup and saucer was hand painted as a gift. It depicts a street corner in Baltimore, including the building that housed Rembrandt Peale's (17.42) Baltimore Museum and Gallery of Fine Arts.*

**17.43**

**17.44**

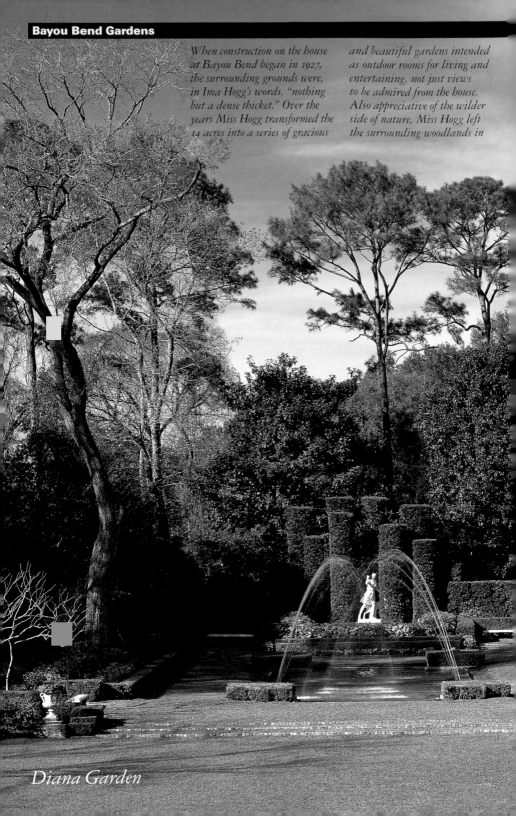

When construction on the house at Bayou Bend began in 1927, the surrounding grounds were, in Ima Hogg's words, "nothing but a dense thicket." Over the years Miss Hogg transformed the 14 acres into a series of gracious and beautiful gardens intended as outdoor rooms for living and entertaining, not just views to be admired from the house. Also appreciative of the wilder side of nature, Miss Hogg left the surrounding woodlands in

*Diana Garden*

their natural state. *The Diana Garden, the White Garden, and the Butterfly Garden are just three of the many formal and informal settings that make Bayou Bend one of the most scenic spots in Houston.*

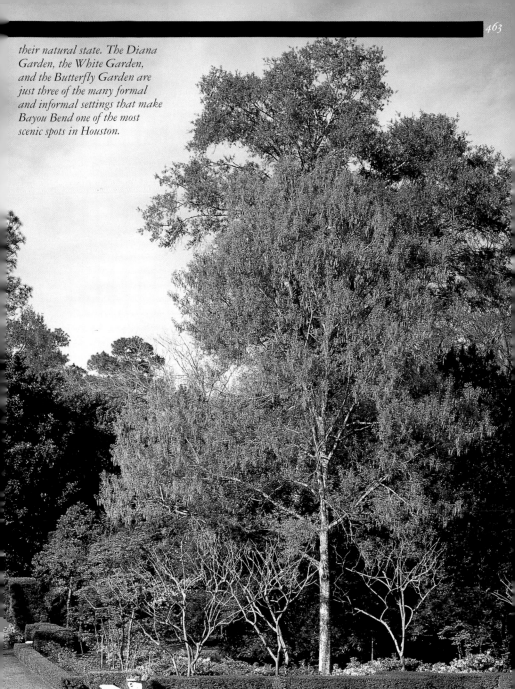

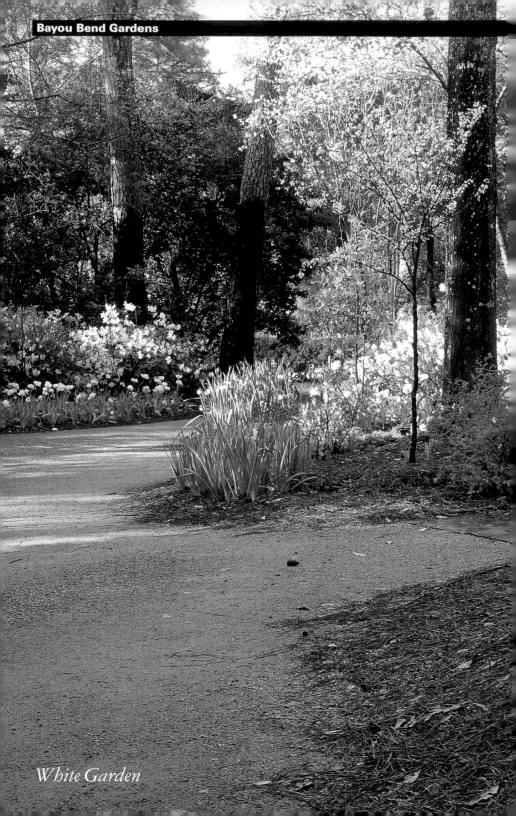

*White Garden*

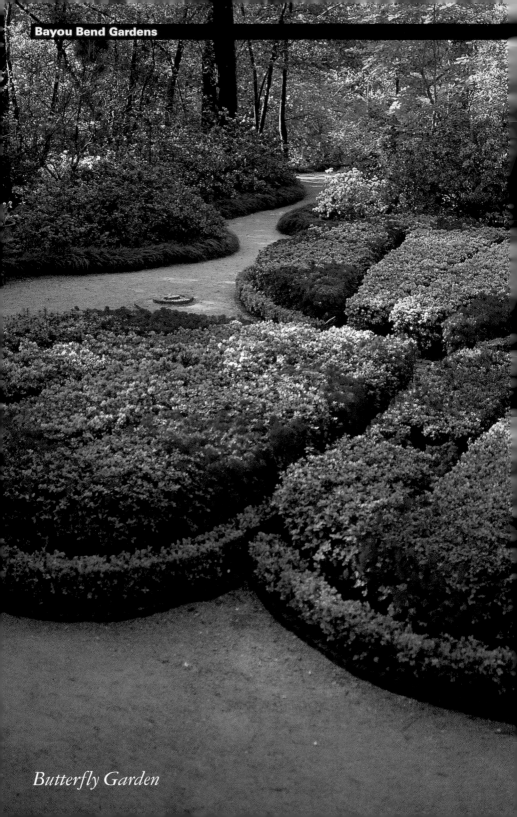

*Butterfly Garden*

*The plan and interiors you have outlined are extremely attractive,
and the desired combination of Palladian with contemporary offers
an interesting challenge.*

Letter from Rienzi architect John F. Staub to
Harris Masterson III, 1952

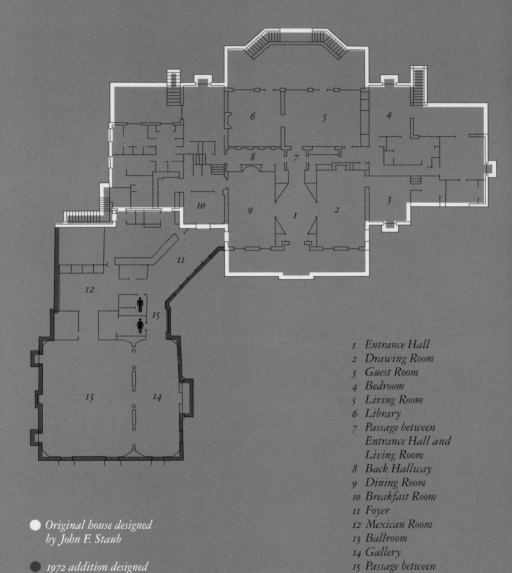

1   Entrance Hall
2   Drawing Room
3   Guest Room
4   Bedroom
5   Living Room
6   Library
7   Passage between
    Entrance Hall and
    Living Room
8   Back Hallway
9   Dining Room
10  Breakfast Room
11  Foyer
12  Mexican Room
13  Ballroom
14  Gallery
15  Passage between
    Gallery and Foyer

● Original house designed
  by John F. Staub

● 1972 addition designed
  by Hugo V. Neuhaus

*Opened to the public in 1999, Rienzi is the center for European decorative arts at the Museum of Fine Arts, Houston. Comprising a remarkable art collection, a house, and gardens, Rienzi was given to the museum by arts patrons Harris Masterson III and his wife, Carroll Sterling Masterson. Named for Rienzi Johnston, Mr. Masterson's grandfather, this handsome residence is situated on 4.4 acres in Homewood Addition, surrounded by Houston's River Oaks neighborhood. The structure was designed in 1952 by John F. Staub, the same architect who designed Bayou Bend, the house that now contains the museum's collection of early American decorative arts (pp. 426–67). Rienzi served as both a family home and a center for Houston civic and philanthropic activity from its completion in 1954, through Mrs. Masterson's death in 1994, and until Mr. Masterson's death in 1997.*

*The dramatic natural setting, between two ravines that lead into Buffalo Bayou, inspired a house with a one-story, symmetrical facade, a balustrade, and a parapet. The formal*

entrance to Rienzi evokes both early 18th-century English Georgian architecture and the designs of the great Italian architect Andrea Palladio (1508–1580). Conforming to the landscape of the two ravines, the back side of the house has a lower second story and three terraces, each with an exterior staircase and a view of the gardens. With these grand facades, the Mastersons and the architect realized their dream of creating a contemporary Palladian residence—a Texas villa overlooking a dramatic pool and landscape. Ralph Ellis Gunn designed the surrounding lush gardens.

In 1972 the Mastersons' neighbor, architect Hugo V. Neuhaus, completed a ballroom for the residence. This addition allowed the owners to expand their social activities and gave Harris Masterson more room for his growing art collection. Carroll Masterson encouraged her

husband's collecting while continuing to direct her considerable energy toward her children, grandchildren, and civic work. Harris Masterson was a born collector with a keen interest in European art, especially British painting and decorative arts, which he began to acquire while in England during World War II. His collecting interests were diverse, ranging from 18th-century English ceramics, furniture, and portraiture, to small, precious objects by jewelers such as Jean Schlumberger and David Webb.

Through the generosity of the Mastersons, Rienzi has opened new doors to collecting in Houston, while capturing a significant period in the city's cultural and philanthropic life.

*Mr. and Mrs. Harris Masterson III, mid-1980s*

Since 1972 the Ballroom, seen here from the Gallery, has been the grandest room at Rienzi. The Mastersons used the Ballroom for a wide range of functions, from intimate gatherings of family and friends to large, elaborate parties. Five 18th-century English portraits encircle the room, including Francis Cotes's *Dr. Connell* (c. 1765), which hangs over the mantel. A French Aubusson carpet, bearing the coat of arms of the duke of Buckingham and Chandos, is in the center of the room, surrounded by furniture made largely in mid-18th-century England. Small gold objects, by the American jeweler David Webb, sit on the tables in the seating area. Cabinets in each corner of the Ballroom and of the adjacent Gallery are filled with 18th-century Worcester porcelain made in England.

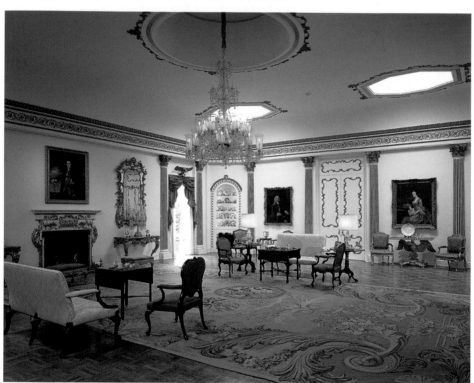

**18.1** Attributed to
William Hallett, Sr.,
Settee, c. 1735
*In the 18th century, the word
"settee" described a seat with
a carved or upholstered back.
Fine upholstered settees were a
prerogative of the very rich, as
textile coverings were extremely
expensive. This elegant example
is dominated by scrolling lines
and serpentine legs.*

**18.2** Attributed to
John Vardy,
Stool, one of a pair,
c. 1759
*This gilded stool was part of
a suite made specifically for
the spectacular Palm room at .
Spencer House, the London
home of the Spencers, the family
of Diana, princess of Wales. An
unusual and important design,
the stool features stylized, highly*

*carved palm motifs that reflect
the decoration featured in the
Palm room's interior. John
Vardy, one of the leading
architects of his time, not only
designed much of Spencer House's
furnishings and the ground-floor
interiors, he also designed the
Palladian house itself.*

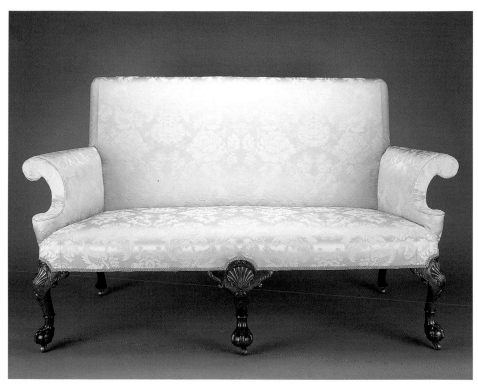

**18.1**

**18.2**

In 1952, while the Mastersons and architect John F. Staub were beginning to design Rienzi, Harris Masterson sketched a possible floor plan for the new home. In it he drew what he referred to as a "picture hall" with a "skylight ceiling." Although Staub did not incorporate this room in the plan, the Mastersons fulfilled their dream of a picture hall—with skylights—in Rienzi's 1972 addition. Called the Gallery, it runs the length of the Ballroom and is parallel to it. In addition to the cabinets filled with early Worcester porcelain in each corner of the room, life-size paintings, including a full-length portrait of a man named Robert Denison of Ossington, attributed to George Romney (18.7), hang on the walls. An early 19th-century, white marble sculpture of the Roman goddess Venus (18.3) commands one end of the Gallery. Attributed to Giovanni Pisani and Brothers, the work was modeled after a celebrated Antonio Canova sculpture, itself an interpretation of an ancient Roman carving of Venus. Pisani requested Canova's permission to copy the work in 1814. By 1817 the Pisani example was in Ripley Castle, the Yorkshire, England, home of its first owner.

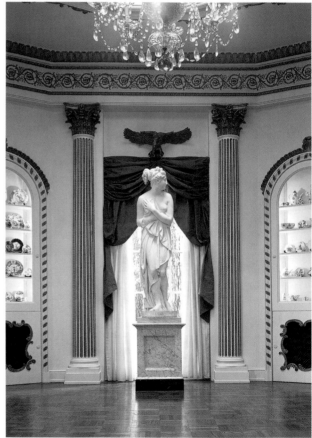

18.3

The Library is on the garden side of Rienzi. It opens onto the center terrace, and its picture windows offer views of the reflecting pool, the surrounding lawns and gardens, and a venerable magnolia tree. The Mastersons purchased *Saint Joseph and the Christ Child* (18.4) by Guido Reni (p. 65) to hang above the mantel in Rienzi's Library. One of Reni's best late works, this intimate painting is the serene focal point of the room. A portrait of an unidentified man, attributed to the highly regarded English artist Sir Peter Lely, hangs on the opposite wall. Its frame is just one of several distinguished period frames in Rienzi's collection. The Library contains English furniture made principally in the early decades of the 18th century.

**18.4**

The Dining Room is to the left of Rienzi's Entrance Hall. Flanking the Dining Room doors are two gilded, dolphin-base consoles made in London about 1805 by the firm of Marsh & Tatham for the first duke of Sutherland. Above the consoles are three-quarter-length portraits of Harris Masterson III and Carroll Sterling Masterson by Jan Boleslav Czedekowski. Twelve mid-18th-century side chairs surround a later dining table.

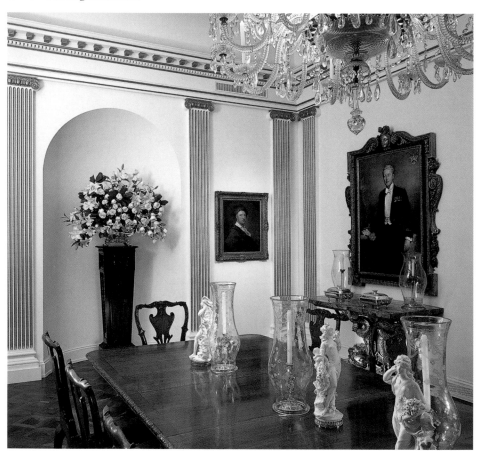

**18.5** Side Chair, one of a set of 12, c. 1740
*This walnut dining chair was made in England during the reign of George II. The chair's cabriole (S-curved) legs, curved rails, carved splats, and ball-and-claw feet are consistent with English mid-18th-century design and only slightly precede Thomas Chippendale's influential pattern book published in 1754 (p. 441). Viscount Clifden of Royston, England, commissioned the set of chairs; they remained in his family for two centuries. The leather upholstery, valued for its ease of cleaning, is typical of 18th-century dining furniture.*

**18.6** Attributed to Marsh & Tatham, Console Table, one of a pair, c. 1805
*More flamboyant than functional, console tables usually were made in pairs to anchor grand rooms. This gilded example is attributed to the firm of William Marsh and Thomas Tatham, who produced furniture for an illustrious clientele that included the prince of Wales. The dolphins that form the tripartite base were borrowed from antiquity. The design is credited to Tatham's brother, C. H. Tatham, who probably made the consoles for the Roman-style gallery in Cleveland House, the London residence of Earl Gower, first duke of Sutherland.*

**18.6**

**18.5**

The Drawing Room was the original formal entertaining room at Rienzi. Eventually, the room contained a select collection of 18th-century English Neoclassical paintings and furniture. *Latona and the Lycian Peasants* (18.9), a narrative painting by Joshua Cristall, dominates the far wall and sets the tone for the room. On the opposite wall, George Romney's portrait of Lady Blount (18.7) hangs over the seating group. Corner cabinets by the London firm of Mayhew and Ince sit on either side of the fireplace; two gilded armchairs, one attributed to John Linnell and the other inspired by the designs of architect Robert Adam, are nearby.

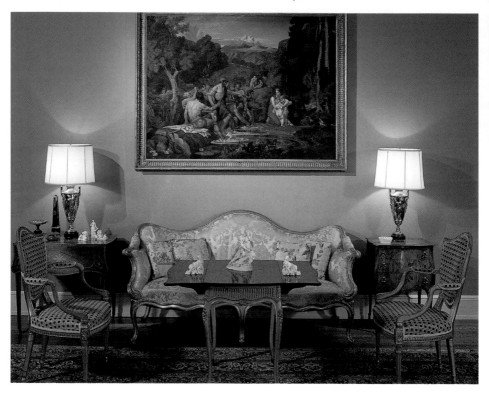

**18.7** George Romney, Lady Blount, 1760s

Along with Thomas Gainsborough (p. 93) and Sir Joshua Reynolds (p. 92), George Romney was one of the most successful portrait painters of the late 18th century. Perhaps best known for his dozens of portraits of Lady Emma Hamilton, Romney also painted many of England's social and cultural elite. This

three-quarter-length portrait is thought to represent Elizabeth Peers, who married Sir Charles William Blount in 1764. She wears a simple but sumptuous white gown, a preference of Romney's that many of his sitters were happy to indulge. Her pale skin, long neck, and sloping shoulders exemplify 18th-century ideals of beauty (see also pp. 257, 318).

**18.8** Attributed to Pierre Langlois, Commode, c. 1770

This tiny commode (chest of drawers) is a virtuoso example of the cabinetmaker's art. It is attributed to Pierre Langlois, a Frenchman who became one of London's leading furniture makers. The undulating front and sides, oval inlay panels, and slender cabriole legs are borrowed from French designs.

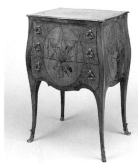

18.7

18.8

*He could impart to the eye a language almost as impressive as that of the tongue, and . . . represent with exact discrimination the shades by which kindred affections differ from each other. . . .*

John Romney writing about his father, George Romney, 1830

**18.9** Joshua Cristall, Latona and the Lycian Peasants, c. 1817

*Joshua Cristall was one of the few English artists of the late 18th and early 19th centuries who painted classical as well as contemporary scenes. This painting portrays a story from Ovid's* Metamorphoses. *The Roman goddess Latona, mother of the twins Apollo and Diana, attempts to quench her thirst at a lake in the province of Lycia. Despite Latona's pleas, the local peasants refuse to allow her to drink. Cristall depicts the moment when the churlish peasants thwart Latona by stomping the lake into mud. Later, the vengeful goddess transforms the Lycian peasants into frogs, condemning them to live forever in the lake's oozy waters.*

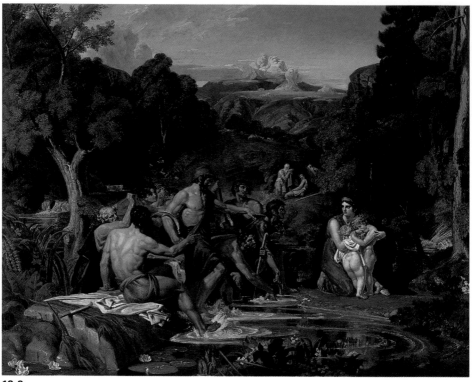

18.9

*Who — hearing words so sweet — would not be moved?*
*But they, despite her prayers, still refused;*
*And then they added threats, and insults, too.*
*And as if that were not enough, they soiled*
*The water with their feet and hands, and jumped —*
*Maliciously — to stir the bottom mud.*

Ovid, *Metamorphoses*, c. A.D. 8

**18.10** Matthew Boulton, Candelabrum, c. 1772

The egg-shaped form at the heart of this candelabrum is fashioned from bluejohn, an exceedingly rare mineral that exists only in England's Treak Cliff caverns in Derbyshire. Discovered by the Romans 2,000 years ago, the purple-and-yellow translucent stone has been found in vases excavated at Pompeii. Appropriately, when Matthew Boulton and other designers rediscovered the stone in the 1760s, they used it in forms that echoed those of ancient Rome. Here, the classically inspired winged female figures, scrolling candle arms, and pineapple finial (top ornament), are cast in metal finished to resemble gold. When used on such objects as candelabra and furniture, this type of metal is called ormolu.

**18.11** Pier Table, one of a pair, c. 1770

In the 1760s, leading English architects, designers, and craftsmen moved away from the exuberance of Rococo designs toward the Neoclassical, spurred on by the efforts of the eminent Scottish architect Robert Adam (p. 478), whose name was closely associated with the style. This gilded table was designed to be placed under a large mirror, or "pier glass." The work of a skilled and sophisticated craftsman, the table's slender legs are ornamented with a complex pattern of twisting ribs, each swirl mirroring the next. The swags under the skirt are carved to imitate drapery and bows, while the top contains a wooden inlay pattern of swags, bows, and a central shell design.

**18.11**

**18.10**

**18.12** Meissen
Porcelain Factory,
Modeled by Johann
Joachim Kändler and
Johann Friedrich Eberlein,
Plate from the Swan
Service, c. 1737–41

*In 1710, Augustus the Strong, elector of Saxony and king of Poland, established a porcelain factory after two of his workers discovered the formula for hard-paste porcelain—a coveted secret previously known only in Asia. Located at Meissen (in what is now Germany), the factory was placed under supervision of the prime minister, Heinrich, Count von Brühl, in 1733. He soon arranged for the production of a magnificent dinner service that would bear his coat of arms. Four years in the making, this famous set— known as the Swan Service— originally contained more than 2,200 pieces.*

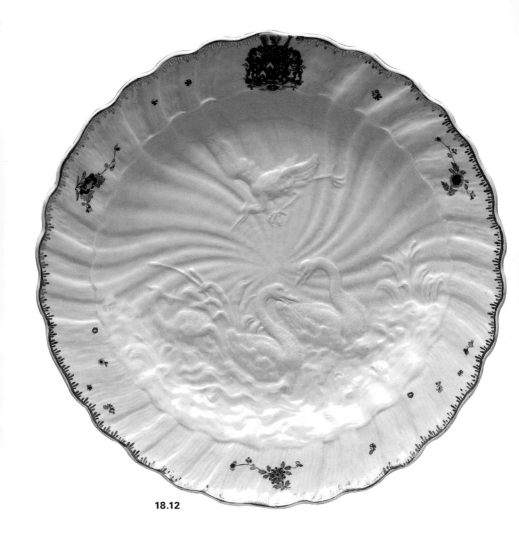

18.12

**18.13** Worcester
Porcelain Manufactory,
Wine Funnel, 1753–55
*Established in 1751, Worcester
was one of a growing number
of English porcelain companies
in the 18th century. English
porcelain wine funnels are quite
rare, as they are vulnerable
to breakage both during the
manufacturing process and
while in use. Worcester examples
were thrown on a potter's wheel,
making each one subtly different
in size and shape. The decoration
on this wine funnel was rendered
in a palette of "famille rose,"
a term used to describe the
rose-pink enamel originally
found on Chinese porcelains.*

**18.14** Worcester
Porcelain Manufactory,
Cream Boat, c. 1755–58
*This cream boat is one of a
group in the style and shape
called Wigornia, the Roman
name for the city of Worcester.
All Wigornia cream boats are
similar to an example bearing*

*that name in the Dyson Perrins
Museum in Worcester. This
cream boat's shape is based on
that of English silver vessels,
and its decoration is inspired by
a Chinese landscape, in keeping
with the mid-18th-century
vogue for all things Chinese
and Japanese.*

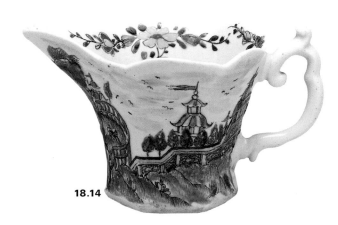

**18.14**

**18.13**

**18.15** Worcester Porcelain Manufactory, Teapot and Stand, c. 1770

By 1770, the Worcester factory was moving away from Chinese and Japanese influences in its designs, turning instead to European ceramic houses for inspiration. The decorative scheme on this teapot and stand is indebted to French porcelain. The colorful bird depicted in a landscape, the sumptuous borders, and the rich gilding are reminiscent of works produced at Sèvres, the royal porcelain manufactory of France.

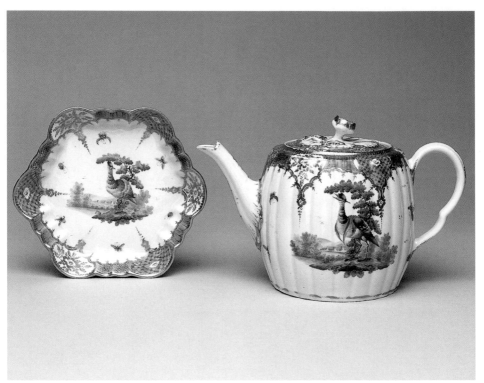

18.15

*The china was beautiful, but Dr. Johnson justly observed it was too dear; for that he could have vessels of silver, of the same size, as cheap as what were here made of porcelain.*

James Boswell, *Life of Johnson*, 1791

**18.16** Worcester
Porcelain Manufactory,
Figure of a Sportsman,
c. 1770

**18.17** Worcester
Porcelain Manufactory,
Sportsman's Companion,
c. 1770

*Molded figures provided an
enchanting alternative to
centerpieces on fashionable 18th-
century tables. The Worcester
company, unlike many of its
English competitors, made very
few figures, instead preferring
to concentrate on tea wares.
The Masterson collection con-
tains seven of the eight figures*

*firmly attributed to Worcester,
including this upper-class couple
dressed for sport. The sportsman,
holding a gun, is left white,
whereas his well-dressed com-
panion, holding a powder flask
and a bird, is enameled in color.
Clusters of flowers at their legs
disguise the supports for these
three-dimensional figures.*

**18.16**            **18.17**

**18.18** Flight Barr & Barr (Worcester Porcelain), Plate from the Stowe Service, c. 1813

*This marvelous, Regency-era plate is from the Stowe Service, one of the most lavish dinner services ever made by the factory Flight Barr & Barr. Each component is superbly painted with glorious Neoclassical scrollwork and the complex coat of arms of Richard Temple-Nugent-Brydges-Chandos-Grenville, second marquess of Buckingham,*

*England, and his wife, Lady Anna Eliza, Baroness Kinloss. Flight Barr & Barr produced the service in 1813, when the marquess inherited the great estate of Stowe in Buckinghamshire. Despite his enormous wealth, the marquess was extravagant beyond his means, and the service was sold at a bankruptcy sale in 1848.*

**18.18**

**18.19**

**18.19** Royal Porcelain Factory (KPM), Tazza, c. 1840

*Although the ruler of Saxony staunchly guarded the Meissen Porcelain Factory's recipe for hard-paste porcelain (18.12),*

*by the mid-18th century other European royalty obtained the formula. Some of these rulers hired former Meissen workers and established their own porcelain factories, seeking to produce wares that rivaled*

*Meissen's in terms of beauty, quality, and skill. By the 19th century, one such factory, the Royal Porcelain Manufactory (KPM) in Berlin, was decorating its wares with finely painted images of astonishing complexity. This monumental tazza, or footed dish, is a magnificent example of the factory's skills. Bands of gilded gadrooning (inverted fluting) highlight a frieze illustrating various aspects of German folk life.*

Dimensions are given in inches, height preceding width and depth. Centimeters follow in parentheses.

The number at the end of each entry is the artwork's accession number. In most entries, the first two digits indicate the year in which the work entered the MFAH collection.

**Behind the Scenes**

**1** see 1.16

**2** Claude Monet, French, 1840–1926
**The Windmill, Amsterdam,** 1871
Oil on canvas
21 1/4 x 25 1/2 (54 x 64.1)
Gift of Audrey Jones Beck
98.293

**3** Italian (Central),
third quarter of the 16th century
**Portrait of a Boy Holding a Book,**
1560s
Oil on wood
27 1/4 x 22 (69.2 x 55.9)
The Samuel H. Kress Collection
61.58

**4** see 8.12

**5** Probably New England
**Eagle,** 1850–1900
Unidentified wood and gilding
33 x 60 x 34 (83.8 x 152.4 x 86.4)
The Bayou Bend Collection,
gift of Miss Ima Hogg
B.55.6

**6** Philadelphia
**Armchair,** 1763–71
Mahogany and secondary wood
40 3/4 x 28 3/8 x 28 1/2
(103.5 x 72.1 x 72.4)
The Bayou Bend Collection,
gift of Miss Ima Hogg
B.60.30

Sébastien Bourdon, French,
1616–1671
**Laban Searching the
Belongings of Jacob,** c. 1634–37
Oil on canvas
19 1/4 x 26 1/4 (48.9 x 66.7)
Gift of the Armand Hammer
Foundation, the Occidental
Petroleum Company, and
museum purchase
80.16

**1 Ancient and European Art**

**1.1** Cycladic
**Female Figurine,**
Early Cycladic II, 2800–2300 B.C.
Marble
9 5/8 x 2 7/16 x 1 (24.4 x 6.2 x 2.5)
Gift of Miss Annette Finnigan
37.26

**1.2** Greek
**Horse Figurine,**
Late Geometric, 750–725 B.C.
Bronze
2 7/8 x 3 1/4 x 1 3/8 (7.3 x 8.3 x 3.5)
Gift of Miss Annette Finnigan
37.22

**1.3** Assyrian
**Eagle-Headed Winged Figure,**
Neo-Assyrian period, 875–860 B.C.
Gypsum
42 1/8 x 26 x 1 1/2 (107 x 66 x 3.81)
Museum purchase with funds
provided by the Agnes Cullen
Arnold Endowment Fund
80.53

**1.4** Painter of the Yale Oinochoe,
Greek (Attic)
**Hydria,**
Early Classical period, 470–460 B.C.
Ceramic
13 3/4 x 13 1/4 x 12 (34.9 x 33.7 x 30.5)
Museum purchase with funds
provided by General and Mrs.
Maurice Hirsch
80.95

**1.5** Greek
**Myrtle Wreath,** 330–250 B.C.
Gold
10 3/8 x 12 x 1 3/8 (26.3 x 30.5 x 3.5)
Gift of Miss Annette Finnigan
37.5

**1.6** Greek (Attic)
**Fragment of a Grave Stela,**
375–370 B.C.
Marble
20 x 17 1/2 x 3 3/4 (50.8 x 44.5 x 9.5)
Gift of Miss Annette Finnigan
37.25

**1.7** Roman
**Portrait Head of Plautilla,**
Severan period, 203–205
Marble
14 1/4 x 8 x 8 7/8 (36.2 x 20.3 x 22.5)
Museum purchase with funds
provided by the Laurence H. Favrot
Bequest
70.39

**1.8** Roman
**Portrait of a Ruler,**
Severan period, 200–225
Bronze
82 x 49 3/4 x 17 1/2
(208.3 x 126.4 x 44.5)
Gift of D. and J. de Menil in
memory of Conrad Schlumberger
62.19

**1.9** Byzantine
**Plaque with the Koimesis,**
mid-10th century
Ivory
4 3/16 x 3 7/16 x 1/2 (10.6 x 8.7 x 1.3)
Museum purchase with funds
provided by the Laurence H. Favrot
Bequest
71.6

**1.10** French
**Crozier Head, "Saint Michael
Trampling the Serpent,"**
c. 1225–50
Gilt copper, champlevé enamel
10 3/4 x 2 7/8 x 5 1/2 (27.3 x 7.3 x 14)
Museum purchase with funds
provided by the Laurence H. Favrot
Bequest
70.38

**1.11** French (Thérouanne)
**Head of an Apostle,** c. 1235
Limestone
17 1/2 x 12 1/4 x 12 1/2
(44.4 x 31.1 x 31.7)
Museum purchase with funds
provided by
Harry W. McCormick in honor
of Ursula DeGeorge McCormick
80.148

**1.12** Franco-Netherlandish
**God the Father,**
early 15th century
Ivory
9 3/4 x 5 1/8 x 3 (24.8 x 13 x 7.6)
The Edith A. and Percy S. Straus
Collection
44.581

**1.13** Norman
**Virgin and Child,**
early 14th century
Limestone with remains of
original polychromy
40 3/8 x 13 1/2 x 10 1/4
(102.6 x 34.3 x 26)
Museum purchase with funds
provided by the Laurence H. Favrot
Bequest
71.15

**1.14** Workshop of
Niclaus Weckman the Elder,
German, 1450/55–after 1526
**Virgin and Child,** c. 1500–1510
Lime wood, painted and gilded
63 x 24 x 15 (160 x 61 x 38.1)
Museum purchase with funds
provided by the Agnes Cullen
Arnold Endowment Fund
98.81

**1.15** Master of the Straus Madonna,
Italian (Florentine), active late 14th
and early 15th century
**Virgin and Child,** c. 1395–1400
Tempera and gold leaf on wood
35 1/2 x 19 (90.1 x 48.2)
The Edith A. and Percy S. Straus
Collection
44.565

**1.16** Italian (Ferrarese),
third quarter of the 15th century
**The Meeting of Solomon and
the Queen of Sheba,** c. 1470–73
Tempera and gold leaf on wood
36 3/8 diameter (92.3)
The Edith A. and Percy S. Straus
Collection
44.574

**1.17** Fra Angelico, Italian
(Florentine), c. 1395–1455
**Saint Anthony Abbot Shunning
the Mass of Gold,** 1430s
Tempera and gold leaf on wood
7 3/4 x 11 1/16 (19.7 x 28)
The Edith A. and Percy S. Straus
Collection
44.550

**1.18** Giovanni di Paolo, Italian
(Sienese), c. 1399–c. 1482
**Saint Clare Rescuing a Child
Mauled by a Wolf,** c. 1455–60
Tempera and gold leaf on wood
8 1/8 x 11 1/2 (20.6 x 28.1)
The Edith A. and Percy S. Straus
Collection
44.571

**1.19** Sebastiano del Piombo, Italian
(Venetian), 1485/6–1547
**Anton Francesco degli Albizzi,**
1525
Oil on canvas
53 x 38 7/8 (134.6 x 98.7)
The Samuel H. Kress Collection
61.79

**1.20** Bartolomeo Veneto, Italian
(Venetian), active 1502–31
**Portrait of a Man,** possibly 1512
Oil on wood
27 7/8 x 20 1/2 (70.8 x 52.1)
The Edith A. and Percy S. Straus
Collection
44.573

**1.21** Follower of Botticelli,
Italian (Florentine), 1444/5–1510
**Bust of a Young Woman,**
c. 1485–90
Tempera on wood
15 1/4 x 9 3/4 (38.7 x 24.8)
The Edith A. and Percy S. Straus
Collection
44.554

**1.22** Antonio Susini, Italian,
active 1580–1624
**Madonna and Child,** c. 1600
Bronze
15 3/16 height (38.6)
The Edith A. and Percy S. Straus
Collection
44.586

**1.23** Antico, Italian, c. 1460–1528
**Hercules Resting after Slaying
the Nemean Lion,** c. 1500
Bronze inlaid with silver
11 x 5 13/16 x 3/4 (27.9 x 14.8 x 1.9)
The Edith A. and Percy S. Straus
Collection
44.582

**1.24** Scarsellino (Ippolito Scarsella),
Italian (Ferrarese), c. 1550–1620
**Virgin and Child with Saints
Mary Magdalene, Peter, Clare,
Francis, and an Abbess,** c. 1600
Oil on canvas
110 7/8 x 63 5/8 (281.5 x 161.7)
Museum purchase with funds
provided by the Agnes Cullen
Arnold Endowment Fund
97.118

**1.25** Rogier van der Weyden,
Netherlandish, c. 1399–1464
**Virgin and Child,** after 1454
Oil on wood
12 9/16 x 9 (31.9 x 22.9)
The Edith A. and Percy S. Straus
Collection
44.535

**1.26** Hans Memling,
Netherlandish, 1430/40–1494
**Portrait of an Old Woman,**
1468–70
Oil on wood
10 1/8 x 6 15/16 (25.6 x 17.7)
The Edith A. and Percy S. Straus
Collection
44.530

**1.27** Corneille de Lyon, French,
1500/10–1575
**René de Batarnay,
Comte du Bouchage,** c. 1535–40
Oil on wood
6 9/16 x 5 7/16 (16.7 x 3.8)
The Edith A. and Percy S. Straus
Collection
44.539

**1.28** Frans Hals, Dutch,
1582/3–1666
**Portrait of an Elderly Woman,**
1650
Oil on canvas
33 5/16 x 27 3/16 (84.6 x 69.2)
The Robert Lee Blaffer
Memorial Collection, gift of
Sarah Campbell Blaffer
51.3

**1.29** Willem Claesz. Heda,
Dutch, 1594–1680
**Banquet Piece with Ham,** 1656
Oil on canvas
44 x 60 (111.7 x 152.3)
Gift of Mr. and Mrs.
Raymond H. Goodrich
57.56

**1.30** Ferdinand Bol, Dutch,
1616–1680
**Woman at Her Dressing Table,**
c. 1645
Oil on canvas
50 3/4 x 36 1/8 (128.4 x 91.7)
Gift of Mrs. Harry C. Hanszen
69.4

**1.31** Jan van Huysum, Dutch,
1682–1749
**Still Life of Flowers and Fruit,**
c. 1710–15
Oil on wood
31 1/4 x 23 3/4 (79.4 x 60.3)
Museum purchase with funds
provided by the Alice Pratt Brown
Museum Fund and the
Brown Foundation Accessions
Endowment Fund
98.80

**1.32** Carlo Dolci, Italian
(Florentine), 1616–1687
**Virgin and Child with the Infant
Saint John the Baptist**, c. 1635
Oil on wood
31 1/8 diameter (79.1)
Gift of Herbert Godwin
46.28

**1.33** Bernardo Strozzi, Italian
(Genoese), 1581/2–1644
**The Guardian Angel**, c. 1630
Oil on canvas
83 7/8 x 50 3/4 (213 x 129)
Anonymous gift in honor of
Mrs. William Stamps Farish
(née Libbie Randon Rice),
Benefactress and Lifetime Trustee of
the Museum of Fine Arts, Houston
76.256

**1.34** Orazio Gentileschi, Italian
(Florentine), 1563–1639
**Portrait of a Young Woman
as a Sibyl**, c. 1620
Oil on canvas
32 1/8 x 28 3/4 (82.5 x 73)
The Samuel H. Kress Collection
61.74

**1.35** Guido Reni, Italian
(Bolognese), 1575–1642
**Saint Joseph and the
Christ Child**, 1638–40
Oil on canvas
35 x 28 1/2 (88.9 x 72.4)
The Rienzi Collection, gift of
Mr. and Mrs. Harris Masterson III
96.1565

**1.36** Philippe de Champaigne,
French, 1602–1674
**The Repentant Magdalen**, 1648
Oil on canvas
45 5/8 x 35 (115.9 x 88.9)
Museum purchase with funds
provided by the Agnes Cullen
Arnold Endowment Fund
70.26

**1.37** Mattia Preti, Italian
(Neapolitan), 1613–1699
**The Martyrdom of Saint Paul**,
c. 1656–59
Oil on canvas
70 11/16 x 73 3/4 (179.6 x 187.3)
Museum purchase with funds
provided by the Laurence H. Favrot
Bequest
69.17

**1.38** Luca Giordano, Italian
(Neapolitan), 1634–1705
**Allegory of Prudence**, 1682
Oil on canvas
36 9/16 x 36 9/16 (92.9 x 92.9)
Museum purchase with funds
provided by the Agnes Cullen
Arnold Endowment Fund
75.33

**1.39** Jean-Baptiste Pater, French,
1695–1736
**A Pastoral Concert**, c. 1725
Oil on wood
11 11/16 x 8 7/16 (29.6 x 21.4)
The Edith A. and Percy S. Straus
Collection
44.544

**1.40** Charles-Joseph Natoire,
French, 1700–1777
**Bacchanal**, 1749
Oil on canvas
31 7/8 x 39 7/8 (81 x 101.2)
Museum purchase
84.200

**1.41** Jean-Siméon Chardin,
French, 1699–1779
**The Good Education**, c. 1753
Oil on canvas
16 5/16 x 18 5/8 (41.5 x 47.3)
Gift in memory of George R. Brown
by his wife and children
85.18

**1.42** Anton Raphael Mengs,
German, 1728–1779
**Truth**, 1756
Pastel
24 x 19 1/2 (60.9 x 49.5)
Museum purchase with funds
provided by "One Great Night
in November, 1998"
98.590

**1.43** Canaletto, Italian (Venetian),
1697–1768
**The Entrance to the
Grand Canal, Venice**, c. 1730
Oil on canvas
19 1/2 x 29 (49.6 x 73.6)
The Robert Lee Blaffer
Memorial Collection, gift of
Sarah Campbell Blaffer
56.2

**1.44** Angelica Kauffman, Swiss,
1741–1807
**Ariadne Abandoned by
Theseus on Naxos**, 1774
Oil on canvas
25 1/8 x 35 13/16 (63.8 x 91)
Gift of Mr. and Mrs. Harris
Masterson III in memory of
Neill Turner Masterson, Jr.
69.23

**1.45** Pompeo Batoni, Italian
(Roman), 1708–1787
**William Fermor**, 1758
Oil on canvas
39 1/8 x 28 15/16 (99.4 x 73.1)
The Samuel H. Kress Collection
61.76

**1.46** Jacob Bodendieck, English,
born Germany, active 1664–80
**Covered Ginger Jar**, 1677
Sterling silver
16 1/2 height (41.9)
Gift of George S. Heyer, Jr.,
in honor of his wife,
Hallie Dewar Heyer
90.488.A,.B

**1.47** Edward Wakelin, English,
active 1730–84
**Candlestick**, one of a pair, 1755–56
11 1/8 x 7 1/4 diameter (28.3 x 18.4)
Sterling silver
Gift of George S. Heyer, Jr.,
in honor of
Isabel B. and Wallace S. Wilson
91.1427.A,.B

**1.48** Paul de Lamerie, English,
1688–1751
**Ewer**, c. 1735
Sterling silver
14 15/16 x 13 (38 x 33.1)
Anonymous loan
TR:682-74

**1.49** Francisco de Goya, Spanish,
1746–1828
**Still Life with Golden Bream**,
1808–12
Oil on canvas
17 5/8 x 24 5/8 (44.8 x 62.5)
Museum purchase with funds
provided by the Alice Pratt Brown
Museum Fund and the
Brown Foundation Accessions
Endowment Fund
94.245

**1.50** Jean-Léon Gérôme, French, 1824–1904
**Tiger on the Watch,** c. 1888
Oil on canvas
25 x 35 5/8 (63.5 x 90.5)
Gift of the Houston Art League, the George M. Dickson Bequest
AL.21

**1.51** William Adolphe Bouguereau, French, 1825–1905
**The Elder Sister,** 1869
Oil on canvas
51 1/4 x 38 1/4 (130.2 x 97.2)
Gift of an Anonymous Lady in memory of her father
92.163

**1.52** Camille Corot, French, 1796–1875
**Orpheus Leading Eurydice from the Underworld,** 1861
Oil on canvas
44 1/4 x 54 (112.3 x 137.1)
Museum purchase with funds provided by the Agnes Cullen Arnold Endowment Fund
87.190

**1.53** Théodore Rousseau, French, 1812–1867
**The Great Oaks of Old Bas-Breau,** 1864
Oil on canvas
35 1/2 x 46 (90.2 x 116.8)
Museum purchase with funds provided by the Agnes Cullen Arnold Endowment Fund
72.87

**1.54** Auguste Renoir, French, 1841–1919
**Still Life with Bouquet,** 1871
Oil on canvas
28 13/16 x 23 3/16 (73.3 x 58.9)
The Robert Lee Blaffer Memorial Collection, gift of Sarah Campbell Blaffer
51.7

**1.55** Paul Cézanne, French, 1839–1906
**Madame Cézanne in Blue,** 1888–90
Oil on canvas
29 3/16 x 24 (74.1 x 61)
The Robert Lee Blaffer Memorial Collection, gift of Sarah Campbell Blaffer
47.29

**1.56** Claude Monet, French, 1840–1926
**Water Lilies,** 1907
Oil on canvas
36 1/4 x 31 15/16 (92.1 x 81.2)
Gift of Mrs. Harry C. Hanszen
68.31

**1.57** Paul Sérusier, French, 1864–1927
**Landscape at Le Pouldu,** 1890
Oil on canvas
29 1/4 x 36 1/4 (74.3 x 92.1)
Gift of Alice C. Simkins in memory of Alice Nicholson Hanszen
79.255

**1.58** Édouard Vuillard, French, 1868–1940
**The Promenade,** 1894
Distemper on canvas
84 3/8 x 38 9/16 (214.3 x 97.9)
The Robert Lee Blaffer Memorial Collection, gift of Mr. and Mrs. Kenneth Dale Owen
53.9
© 1999 Artists Rights Society (ARS), New York/ADAGP, Paris

**1.59** Edgar Degas, French, 1834–1917
**Woman Drying Herself,** c. 1905
Charcoal and pastel on tracing paper, mounted by the artist on wove paper
31 x 31 (78.7 x 78.7)
The Robert Lee Blaffer Memorial Collection, gift of Sarah Campbell Blaffer
56.21

2  The Collection of the Sarah Campbell Blaffer Foundation

**2.1** Lucas Cranach the Elder, German, 1472–1553
**The Suicide of Lucretia,** 1529
Oil on panel
29 1/2 x 21 1/4 (74.9 x 54)
The Sarah Campbell Blaffer Foundation
1971.4

**2.2** Jan van Goyen, Dutch, 1596–1656
**View of Dordrecht from the Northeast,** 1647
Oil on canvas
37 1/4 x 57 1/2 (94.6 x 146.1)
The Sarah Campbell Blaffer Foundation
1979.7

**2.3** Adriaen van Ostade, Dutch, 1610–1685
**Interior with Drinking Figures and Crying Children,** 1634
Oil on panel
12 1/4 x 16 7/8 (31.1 x 42.9)
The Sarah Campbell Blaffer Foundation
1979.4

**2.4** Sir Anthony van Dyck, Flemish, 1599–1641
**Portrait of Antoine Triest, Bishop of Ghent,** c. 1627
Oil on canvas
31 1/2 x 25 1/8 (80 x 63.8)
The Sarah Campbell Blaffer Foundation
1977.2

**2.5** Sandro Botticelli, Italian, 1444/5–1510
**The Adoration of the Christ Child,** c. 1500
Oil on panel
47 1/2 diameter (120.7)
The Sarah Campbell Blaffer Foundation
1974.2

**2.6** Bartolomeo Bettera, Italian, 1639–c. 1699
**Still Life with Musical Instruments,** c. 1680s
Oil on canvas
42 x 58 1/2 (106.7 x 148.6)
The Sarah Campbell Blaffer Foundation
1971.4

**2.7** Pietro Longhi, Italian,
1702–1785
The Display of the Elephant, 1774
Oil on canvas
19 x 23 3/4 (48.3 x 60.3)
The Sarah Campbell Blaffer
Foundation
1980.3

**2.8** Sir Joshua Reynolds, British,
1723–1792
Portrait of Mrs. Jelf Powis and
Her Daughter, 1777
Oil on canvas
93 x 57 (236.2 x 144.8)
The Sarah Campbell Blaffer
Foundation
1985.7

**2.9** Thomas Gainsborough,
English, 1727–1788
Coastal Scene with
Shipping and Cattle, c. 1781–82
Oil on canvas
30 x 25 (76.2 x 63.5)
The Sarah Campbell Blaffer
Foundation
1985.17

**2.10** George Stubbs, British,
1724–1806
Truss, A Hunter, c. 1802
Oil on canvas
20 3/8 x 24 1/8 (51.8 x 61.3)
The Sarah Campbell Blaffer
Foundation
1985.11

**2.11** Jean-Siméon Chardin,
French, 1699–1779
Still Life with Joint of Lamb, 1730
Oil on canvas
15 3/4 x 12 13/16 (40 x 32.5)
The Sarah Campbell Blaffer
Foundation
1992.4

**2.12** Nicolas de Largillière,
French, 1656–1746
Portrait of Pierre Cadeau
de Mongazon, c. 1720
Oil on canvas
32 x 25 1/2 (81.3 x 64.8)
The Sarah Campbell Blaffer
Foundation
1988.1

**2.13** Jean-Baptiste Oudry, French,
1686–1755
Allegory of Europe, 1722
Oil on canvas
63 3/4 x 59 3/4 (161.9 x 151.8)
The Sarah Campbell Blaffer
Foundation
1987.2

**2.14** Albrecht Dürer, German,
1471–1528
Six Soldiers, c. 1495–96
Engraving
5 1/4 x 5 3/4 (13.4 x 14.6)
The Sarah Campbell Blaffer
Foundation
1998.8

**2.15** William Hogarth, British,
1697–1764
Beer Street, 1750–51
Etching and engraving
14 1/8 x 11 11/16 (35.9 x 29.7)
The Sarah Campbell Blaffer
Foundation
1983.5.67

**2.16** Thomas Girtin, British,
1775–1802
A Windmill, c. 1800
Watercolor over pencil
12 1/2 x 9 7/8 (31.8 x 25.1)
The Sarah Campbell Blaffer
Foundation
1986.8

**3** The Collection of John A. and
Audrey Jones Beck

**3.1** Édouard Manet, French,
1832–1883
The Toilers of the Sea, 1873
Oil on canvas
25 x 31 1/4 (63 x 79.3)
Gift of Audrey Jones Beck
92.171

**3.2** Honoré Daumier, French,
1808–1879
Lawyers' Meeting, c. 1860
Oil on wood
7 5/16 x 9 3/8 (18.4 x 23.8)
Gift of Audrey Jones Beck
74.137

**3.3** Gustave Caillebotte, French,
1848–1894
The Orange Trees (The Artist's
Brother in His Garden), 1878
Oil on canvas
61 x 46 (154.9 x 116.8)
Gift of Audrey Jones Beck
98.273

**3.4** Vincent van Gogh, Dutch,
1853–1890
The Rocks, 1888
Oil on canvas
21 5/8 x 25 7/8 (54.9 x 65.7)
Gift of Audrey Jones Beck
74.139

**3.5** Paul Cézanne, French,
1839–1906
Bottom of the Ravine, c. 1879
Oil on canvas
28 3/4 x 21 1/4 (73 x 54)
Gift of Audrey Jones Beck
98.274

**3.6** Mary Cassatt, American
(active in France), 1844–1926
Susan Comforting the Baby, c. 1881
Oil on canvas
25 5/8 x 39 3/8 (65.1 x 100)
Gift of Audrey Jones Beck
74.136

**3.7** Edgar Degas, French,
1834–1917
Russian Dancers, c. 1899
Pastel on tracing paper, mounted
on cardboard
24 1/2 x 24 3/4 (62.2 x 62.9)
Gift of Audrey Jones Beck
98.278

**3.8** Camille Pissarro, French,
1830–1903
**The Goose Girl at Montfoucault
(White Frost),** 1875
Oil on canvas
22 3/4 x 28 3/4 (57.8 x 73)
Gift of Audrey Jones Beck
98.295

**3.9** Kees van Dongen, Dutch,
1877–1968
**The Corn Poppy,** c. 1919
Oil on canvas
21 1/2 x 18 (54.6 x 45.7)
Gift of Audrey Jones Beck
98.279
© 1999 Artists Rights Society
(ARS), New York/ADAGP, Paris

**3.10** Amedeo Modigliani, Italian,
1884–1920
**Léopold Zborowski,** c. 1916
Oil on canvas
45 3/4 x 28 3/4 (116.2 x 73)
Gift of Audrey Jones Beck
98.292

**3.11** František Kupka,
Czechoslovakian, 1871–1957
**The Yellow Scale,** c. 1907
Oil on canvas
31 x 29 1/4 (78.7 x 74.3)
Gift of Audrey Jones Beck
94.247
© 1999 Artists Rights Society
(ARS), New York/ADAGP, Paris

**3.12** André Derain, French,
1880–1954
**The Turning Road, L'Estaque,**
1906
Oil on canvas
51 x 76 3/4 (129.5 x 194.9)
Gift of Audrey Jones Beck
74.138
© 1999 Artists Rights Society
(ARS), New York/ADAGP, Paris

**3.13** Alexei Jawlensky, Russian,
1864–1941
**Portrait of a Woman,** 1910
Oil on board
20 7/8 x 19 1/2 (53 x 49.5)
Gift of Audrey Jones Beck
98.284
© 1999 Artists Rights Society
(ARS), New York/VG Bild-Kunst,
Bonn

**3.14** Henri Matisse, French,
1869–1954
**Woman in a Purple Coat,** 1937
Oil on canvas
31 7/8 x 25 11/16 (81 x 65.2)
Gift of Audrey Jones Beck
74.141
© 1999 Succession H. Matisse,
Paris/Artists Rights Society (ARS),
New York

**3.15** Paul Signac, French, 1863–1935
**The Bonaventure Pine,** 1893
Oil on canvas
25 7/8 x 31 7/8 (65.7 x 81)
Gift of Audrey Jones Beck
74.142
© 1999 Artists Rights Society
(ARS), New York/ADAGP, Paris

**3.16** Georges Seurat, French,
1859–1891
**Young Woman Powdering
Herself,** 1889
Oil on wood
9 3/4 x 6 5/16 (24.8 x 16)
Gift of Audrey Jones Beck
98.301

**3.17** Pierre Bonnard, French,
1867–1947
**Dressing Table and Mirror,**
c. 1913
Oil on canvas
48 7/8 x 45 15/16 (123.8 x 116.7)
Gift of Audrey Jones Beck
74.134

**3.18** Vassily Kandinsky, Russian,
1866–1944
**Sketch 160A,** 1912
Oil on canvas
37 3/8 x 42 1/2 (94.9 x 107.9)
Gift of Audrey Jones Beck
74.140

**3.19** Georges Braque, French,
1882–1963
**Fishing Boats,** 1909
Oil on canvas
36 1/4 x 28 7/8 (92.1 x 73.3)
Gift of Audrey Jones Beck
74.135
© 1999 Artists Rights Society
(ARS), New York/ADAGP, Paris

**4 Prints and Drawings**

**4.1** Albrecht Dürer, German,
1471–1528
**Virgin and Child with
the Monkey,** 1498
Engraving
Plate/sheet / /16 x 4 3/4 (18.9 x 12.1)
Museum purchase with funds
provided by Marjorie G. Horning,
the Marjorie G. and Evan C. Horning
Print Fund, the Director's Accessions
Fund, and the Evan C. Horning
Memorial Fund in memory of
Dr. Evan C. Horning
93.309

**4.2** Rembrandt van Rijn, Dutch,
1606–1669
**An Old Man with a Beard, Fur
Cap, and Velvet Cloak,** c. 1632
Etching
Plate 5 13/16 x 5 1/8 (14.8 x 13)
Sheet 8 7/16 x 7 3/8 (21.5 x 18.7)
Museum purchase with funds
provided by the Alvin S. Romansky
Prints and Drawings Accession
Endowment Fund
94.727

**4.3** Attributed to Jan or Lucas van
Duetecum, of Hieronymous Cock's,
An Quatre Vents studio
After Pieter Bruegel the Elder,
Dutch, c. 1525–1569
**The Fair on Saint George's Day,**
c. 1559–60
Etching and engraving, first of
two states
Plate/sheet 13 1/4 x 20 5/8 (33.6 x 52.4)
Museum purchase with funds
provided by The Brown
Foundation, Inc.
97.309

**4.4** Jacques Bellange, French,
active 1600–1617
**The Adoration of the Magi,**
c. 1614–17
Etching with engraving
Plate/sheet 23 1/4 x 16 3/4 (59 x 42.5)
Museum purchase with funds
provided by The Brown
Foundation, Inc.
93.400

**4.5** Canaletto, Italian, 1697–1768
**Imaginary View of Padua,**
c. 1741–44
Etching, first of three states
Plate 11 5/8 x 16 7/8 (29.5 x 42.8)
Sheet 15 x 21 (38.1 x 53.3)
Museum purchase with funds
provided by the Alice Pratt Brown
Museum Fund and The Brown
Foundation, Inc.
95.323

**4.6** Camille Corot, French,
1796–1875
**Young Man in front of a
Great Oak,** c. 1840
Graphite on tan paper
11 3/4 x 16 1/4 (29.8 x 41.3)
Museum purchase with funds
provided by the Houston Alumnae
Chapter of Delta Delta Delta
Sorority in honor of
Laura Lee Blanton
97.209

**4.7** Édouard Manet, French,
1832–1883
**The Execution of Maximilian,**
c. 1867–68
Lithograph on chine collé
Image/sheet 13 1/4 x 17 1/4
(33.7 x 43.8)
Museum purchase with funds
provided by Mr. Louis K. Adler,
Mr. Allen H. Carruth, Mr. Morton
A. Cohn, Mr. Peter R. Coneway,
Mr. Robert J. Cruikshank,
Mr. Alfred C. Glassell, Jr.,
Mr. Meredith J. Long, Mr. Patrick
R. Rutherford, Mr. Fayez Sarofim,
and Mr. Gene M. Woodfin at "One
Great Night in November, 1991"
91.1567

**4.8** Édouard Manet, French,
1832–1883
**The Races,** 1864/65–72
Lithograph on chine collé
Image/sheet 15 1/8 x 20 1/16 (38.4 x 51)
Museum purchase with funds
provided by the Alice Pratt Brown
Museum Fund
91.1922

**4.9** Henri de Toulouse-Lautrec,
French, 1864–1901
**The Jockey,** 1899
Lithograph in colors
Image/sheet 20 3/8 x 14 1/4
(51.8 x 36.2)
Museum purchase with funds
provided by "One Great Night
in November, 1992"
92.456

**4.10** Camille Pissarro, French,
1830–1903
**The Vegetable Market
at Pontoise,** 1891
Etching and aquatint, first state
Plate 9 15/16 x 7 7/8 (25.2 x 20)
Sheet 11 13/16 x 10 1/16 (30 x 25.6)
Museum purchase with funds
provided by the 1991 Prints and
Drawings Benefit
92.39

**4.11** Emil Nolde, German,
1867–1956
**Prophet,** 1912
Woodcut
Block 12 1/2 x 8 13/16 (31.8 x 22.4)
Sheet 14 15/16 x 12 (37.9 x 30.5)
Museum purchase with funds
provided by the Alvin S. Romansky
Prints and Drawings Accession
Endowment Fund
93.324

**4.12** Edvard Munch, Norwegian,
1863–1944
**Self-Portrait,** 1895
Lithograph
Image 17 7/8 x 12 9/16 (45.4 x 31.9)
Sheet 21 7/8 x 15 11/16 (55.6 x 39.8)
Museum purchase with funds
provided by Isabel B. Wilson and
The Brown Foundation, Inc.
97.23

**4.13** Odilon Redon, French,
1840–1916
**The Trees,** 1890s
Charcoal on paper
19 3/4 x 14 3/4 (50.2 x 37.5)
Gift of Mrs. Harry C. Hanszen
72.29

**4.14** Max Klinger, German,
1857–1920
**Shame,** 1903
Etching, engraving, and aquatint
Plate 18 1/2 x 12 1/2 (47 x 31.7)
Image 16 1/2 x 10 1/2 (41.9 x 26.7)
Sheet 24 x 17 1/2 (61 x 44.5)
Museum purchase with funds
provided by the Alvin S. Romansky
Prints and Drawings Accession
Endowment Fund, Ralph S.
O'Connor, Mr. and Mrs. Benjamin
Danziger in honor of Barry Walker,
an anonymous lady in honor of
Mrs. Isabell Smith Herzstein, the
Estate of Alvin S. Romansky, the
Rowan Foundation for Prints and
Drawings, Edward Oppenheimer,
Jr., in honor of Mrs. Wynne Phelan,
and Mr. and Mrs. Robert H. Allen
95.52.9

**4.15** Adolphe Menzel, German,
1815–1905
**Study of a Man with a Beard,
His Hand in His Pocket,** 1885
Graphite on paper
8 15/16 x 5 13/16 (22.7 x 14.8)
Museum purchase with funds
provided by the Houston Alumnae
Chapter of Delta Delta Delta Sorority
96.697

**4.16** Pablo Picasso, Spanish,
1881–1973
**Portrait of Françoise in a Suit,**
c. 1946
Drypoint
Plate 27 1/8 x 19 7/16 (68.8 x 49.4)
Sheet 28 13/16 x 22 3/8 (73.2 x 56.8)
Museum purchase with funds
provided by the Museum Collectors
96.853
© 1999 Estate of Pablo Picasso/
Artists Rights Society (ARS),
New York

**4.17** Pablo Picasso, Spanish,
1881–1973
**Three Women at the Fountain,**
1921
Pastel on paper
25 5/8 x 19 1/2 (65.1 x 49.5)
Gift of Miss Ima Hogg and Other
Trustees of the Varner-Bayou Bend
Heritage Fund
69.2
© 1999 Estate of Pablo Picasso/
Artists Rights Society (ARS),
New York

**4.18** Amedeo Modigliani, Italian, 1884–1920
**Caryatid,** c. 1914
Gouache on paper
55 3/8 x 26 3/16 (140.7 x 66.5)
Gift of Oveta Culp Hobby
84.412

**4.19** Aristide Maillol, French, 1861–1944
**Standing Nude, Marie,** c. 1931
Pastel on brown wrapping paper
47 1/4 x 26 (120 x 66.1)
Museum purchase, given in honor of Isabel B. Wilson
97.203
© 1999 Artists Rights Society (ARS), New York/ADAGP, Paris

**4.20** Arshile Gorky, American, born Armenia, 1904–1948
**Virginia—Summer,** 1946
Pencil and crayon on paper
18 15/16 x 24 3/8 (48.1 x 61.9)
Museum purchase with funds provided by Oveta Culp Hobby
92.424
© 1999 Estate of Arshile Gorky/ Artists Rights Society (ARS), New York

**4.21** Joan Miró, Spanish, 1893–1983
**Composition,** 1930
Charcoal on paper
24 13/16 x 18 3/8 (63 x 46.7)
Museum purchase with funds provided by Oveta Culp Hobby
92.119
© 1999 Artists Rights Society (ARS), New York/ADAGP, Paris

**4.22** Eva Hesse, American, born Germany, 1936–1970
**Untitled,** 1964
Gouache on paper
19 1/2 x 25 1/2 (49.5 x 64.8)
Museum purchase with funds provided by the Caroline Wiess Law Accessions Endowment Fund
98.529
© The Estate of Eva Hesse

**4.23** Jackson Pollock, American, 1912–1956
**Untitled,** c. 1947
Ink wash and encaustic
25 7/8 x 20 3/4 (65.7 x 52.5)
Museum purchase with funds provided by Louisa Stude Sarofim in memory of Alice Pratt Brown
96.1754
© 1999 Pollock-Krasner Foundation/Artists Rights Society (ARS), New York

**4.24** Jackson Pollock, American, 1912–1956
**Untitled,** c. 1946–47
Brown ink and india ink on paper
8 7/8 x 11 7/8 (22.5 x 30.2)
Museum purchase with funds provided by Caroline Wiess Law
96.1752.2
© 1999 Pollock-Krasner Foundation/Artists Rights Society (ARS), New York

**4.25** Jackson Pollock, American, 1912–1956
**Untitled,** c. 1946–47
Brown ink on paper
8 7/8 x 11 7/8 (22.5 x 30.2)
Museum purchase with funds provided by Caroline Wiess Law
96.1752.1
© 1999 Pollock-Krasner Foundation/Artists Rights Society (ARS), New York

**4.26** Jackson Pollock, American, 1912–1956
**Untitled,** c. 1946–47
Brown ink on paper
11 7/8 x 8 7/8 (30.2 x 22.5)
Museum purchase with funds provided by Caroline Wiess Law
96.1752.5
© 1999 Pollock-Krasner Foundation/Artists Rights Society (ARS), New York

**4.27** Richard Diebenkorn, American, 1922–1993
**Untitled,** 1972
Mixed media, including acrylic, gouache, charcoal, and pasted paper
Each image/sheet 25 x 18 (63.5 x 45.7)
Museum purchase with funds provided by the Caroline Wiess Law Accessions Endowment Fund and gift of an anonymous donor
94.109.A–.C

**4.27a** Leo Holub, American, born 1916
**Richard Diebenkorn, Santa Monica,** 1984
Gelatin silver photograph
9 3/4 x 11 3/4 (24.8 x 29.8)
Gift of the artist
99.119

**4.28** Jasper Johns, American, born 1930
**Untitled,** 1991
Etching and aquatint with scraping and burnishing
Each plate approximately 33 13/16 x 24 (85.9 x 61)
Overall image 33 13/16 x 71 3/4 (85.9 x 182.2)
Sheet 41 1/4 x 77 1/2 (104.4 x 196.9)
Museum purchase with funds provided by Caroline Wiess Law in memory of Genevieve Favrot Peterkin
94.726
© Jasper Johns/Licensed by VAGA, New York, NY

**4.29** Eric Fischl, American, born 1948
**Year of the Drowned Dog,** 1983
Aquatint, soft-ground etching, drypoint, and scraping, on six sheets
Overall 25 x 70 (63.5 x 177.8)
From the Peter Blum Edition Archive
Museum purchase with funds provided by the Alice Pratt Brown Museum Fund
96.20.1–.6

**5  Photography**

**5.1**  Meade Brothers (Charles Richard Meade, American, 1826–1858, and Henry William Matthew Meade, American, 1823–1865)
**Samuel Houston,** 1851
Daguerreotype, full-plate in presentation glass mat and frame
Image 8 x 5 3/16 (20.3 x 13.2)
Museum purchase with funds provided by Vinson & Elkins L.L.P. in honor of the Firm's 75th anniversary
92.444

**5.2**  Edward Steichen, American, born Luxembourg, 1879–1973
**Trees, Long Island,** 1905
Gelatin carbon photograph
14 3/8 x 13 9/16 (36.5 x 34.4)
Museum purchase with funds provided by the Long Endowment for American Art and the Sarah Campbell Blaffer Foundation
86.1
© Courtesy Joanna T. Steichen

**5.3**  Gordon Matta-Clark, American, 1945–1978
**Caribbean Orange,** 1978
Silver dye bleach photograph
13 3/16 x 19 3/8 (33.5 x 49.2)
The Allan Chasanoff Photographic Collection
91.886
© Courtesy the Estate of Gordon Matta-Clark and David Zwirner, New York

**5.4**  Alvin Langdon Coburn, American, 1882–1966
**Vortograph,** 1917
Gelatin silver photograph
10 5/8 x 8 1/16 (27 x 20.5)
Museum purchase with funds provided by Alexandra Marshall, the S. I. Morris Photography Endowment Fund, Louisa Stude Sarofim, The Brown Foundation, Inc., courtesy of Mr. and Mrs. M. S. Stude, the Director's Accessions Fund, and the 16th Anniversary of the Photography Department
93.266

**5.5**  Christian Schad, German, 1894–1982
**Schadograph No.** 10, 1919
Printing-out-paper photogram
3 1/8 x 2 3/8 (8 x 6)
Museum purchase with funds provided by Max and Isabell Smith Herzstein
88.15

**5.6**  Man Ray, American, 1890–1976
**Rayograph,** 1923
Gelatin silver photogram
9 7/16 x 7 1/16 (24 x 17.9)
Museum purchase with funds provided by the Brown Foundation Accessions Endowment Fund and Max and Isabell Smith Herzstein
86.502
© 1999 Man Ray Trust/Artists Rights Society, NY/ADAGP, Paris

**5.7**  László Moholy-Nagy, American, born Austria-Hungary, 1895–1946
**Untitled,** 1925
Gelatin silver photogram
9 x 7 (22.9 x 17.8)
Museum purchase with funds provided by the Prospero Foundation
84.232
© Courtesy Hattula Moholy-Nagy

**5.8**  Paul Outerbridge, Jr., American, 1886–1958
**Advertisement for George P. Ide Company,** 1922
Platinum photograph
4 3/4 x 3 5/8 (12.1 x 9.2)
The Target Collection of American Photography, museum purchase with funds provided by Target Stores
76.296
© Courtesy G. Ray Hawkins Gallery, Santa Monica

**5.9**  Edward Weston, American, 1886–1958
**Tina Modotti,** 1924
Platinum photograph
9 5/8 x 7 1/2 (24.4 x 19.1)
The Target Collection of American Photography, museum purchase with funds provided by Target Stores
78.61
© 1981 Center for Creative Photography, Arizona Board of Regents Collection, Center for Creative Photography, the University of Arizona

**5.10**  Paul Strand, American, 1890–1976
**Ceramic and Fruit,** 1916
Platinum photograph
9 5/8 x 12 11/16 (24.4 x 32.2)
Museum purchase with funds provided by the Brown Foundation Accessions Endowment Fund
94.62
© 1990, Aperture Foundation, Inc., Paul Strand Archive

**5.11**  Charles Sheeler, American, 1883–1965
**New York,** 1920
Gelatin silver photograph
9 11/16 x 7 3/4 (24.6 x 19.7)
Museum purchase
79.6

**5.12**  Morton Schamberg, American, 1881–1918
**God,** 1917
Gelatin silver photograph, toned
9 1/4 x 7 3/8 (23.5 x 18.7)
Museum purchase with funds provided by the Brown Foundation Accessions Endowment Fund
89.31

**5.13**  Brassaï, French, born Hungary, 1899–1984
**Watchmaker, Dauphine Alley, Paris,** c. 1932–33
Gelatin silver photograph
9 1/4 x 7 (23.5 x 17.8)
Gift of an anonymous donor in honor of Susan Bielstein
97.705
© Gilberte Brassaï

**5.14**  André Kertész, American, born Hungary, 1894–1985
**Chairs, the Medici Fountain,** 1926
Gelatin silver photograph
6 3/8 x 7 1/4 (16.2 x 18.4)
Museum purchase with funds provided by the Sarah Campbell Blaffer Foundation
87.194
© Estate of André Kertész

**5.15**  Eugene Atget, French, 1857–1927
**Pont Marie,** 1926
Albumen printing-out-paper photograph
7 1/16 x 8 15/16 (17.9 x 22.7)
Museum purchase with funds provided by Lucile Bowden Johnson in honor of Frances G. McLanahan and Alexander K. McLanahan
81.52

**5.16** Henri Cartier-Bresson,
French, born 1908
**Seville, Spain,** 1933
Gelatin silver photograph,
printed later
9 9/16 x 14 5/16 (24.3 x 36.4)
The Allan Chasanoff
Photographic Collection
91.4//
© Henri Cartier-Bresson

**5.17** Bill Brandt, British,
born Germany, 1904–1983
**Maid Preparing the
Evening Bath,** 1932
Gelatin silver photograph
9 5/8 x 7 9/16 (24.4 x 19.2)
Museum purchase with funds
provided by The Mundy Companies
85.109

**5.18** John Heartfield, German,
1891–1968
**The Thousand Year Reich,** from
Arbeiter Illustrierte Zeitung XIII:38,
1934
Rotogravure on newsprint from
original photomontage
15 1/8 x 11 1/8 (38.2 x 28)
Museum purchase
with funds provided by
Max and Isabell Smith Herzstein
82.59.10.20
© 1999 Artists Rights Society
(ARS), New York/VG Bild-Kunst,
Bonn

**5.19** August Sander, German,
1876–1964
**The Intellectual,** 1914
Gelatin silver photograph
9 7/8 x 6 11/16 (25.1 x 19.9)
Museum purchase with
funds provided by Mr. and
Mrs. Harry B. Gordon
80.21
© Die Photographische
Sammlung/SK Stiftung Kultur –
August Sander Archiv, Köln; ARS,
New York 1999

**5.20** Hannah Höch, German,
1889–1979
**Broken,** 1925
Collage, rotogravure on Japan paper
6 x 4 1/4 (15.2 x 11.4)
Museum purchase with funds
provided by the Brown Foundation
Accessions Endowment Fund
89.377
© 1999 Artists Rights Society
(ARS), New York/VG Bild–Kunst,
Bonn

**5.21** László Moholy-Nagy,
American, born Austria-Hungary,
1895–1946
**At Coffee,** c. 1926
Gelatin silver photograph
11 1/8 x 8 1/8 (28.3 x 20.6)
Museum purchase
with funds provided by
Max and Isabell Smith Herzstein
84.231
© Courtesy Hattula Moholy-Nagy

**5.22** Charlotte (Lotte) Stam Beese,
German, born 1903
**Bauhaus Weavers,** 1928
Gelatin silver photograph
3 5/16 diameter (8.4)
Museum purchase
with funds provided by
Mr. and Mrs. S. I. Morris
83.150

**5.23** František Drtikol,
Czechoslovakian, 1883–1961
**Portrait of Errina Kupferova,**
c. 1925
Gelatin silver and pigment
photograph
11 7/16 x 8 7/8 (29.1 x 22.5)
Museum purchase
with funds provided by
Max and Isabell Smith Herzstein
86.155

**5.24** Josef Sudek,
Czechoslovakian, 1896–1976
**Untitled,** 1954
Carbro photograph
6 9/16 x 8 5/8 (16.7 x 21.9)
Museum purchase with funds
provided by the Alice Pratt Brown
Museum Fund
89.162

**5.25** Jaromír Funke,
Czechoslovakian, 1896–1945
**Composition,** 1923
Gelatin silver photograph
8 5/8 x 11 9/16 (21.9 x 29.4)
Museum purchase
with funds provided by
the Prospero Foundation
84.95

**5.26** Max Alpert, Russian,
1899–1980
**Kirghiz Horsewoman,** 1936
Gelatin silver photograph
14 7/16 x 9 13/16 (36.7 x 25)
Museum purchase with funds
provided by The Brown Foundation,
Inc., courtesy of Mr. and Mrs. M. S.
Stude, Joan and Stanford Alexander,
Mr. and Mrs. Jack Blanton, Jr.,
Anne Bushman, Mrs. Clare A.
Glassell, Mr. and Mrs. Alexander K.
McLanahan, James Edward Maloney
and Beverly Ann Young, Joan
Morgenstern, Mr. and Mrs. Joe S.
Mundy, Mary Lawrence Porter,
Harry and Macey Reasoner, and
Isabel B. and Wallace S. Wilson
97.62

**5.27** Issue edited by Alexander
Rodchenko, Russian, 1891–1956
**USSR in Construction,**
vol. 6, no. 12, 1935
Hirsch Library, the
Museum or Fine Arts, Houston

**5.28** Alexander Rodchenko,
Russian, 1891–1956
**Portrait of V. V. Mayakovsky,** 1924
Gelatin silver photograph
8 1/2 x 5 7/8 (21.6 x 14.9)
Museum purchase with funds
provided by the Brown Foundation
Accessions Endowment Fund
95.329
© Estate of Alexander Rodchenko/
Licensed by VAGA, New York, NY

**5.29** El Lissitzky, Russian,
1890–1941
**Sculpture at Pressa, Cologne,** 1928
Gelatin silver photograph
4 3/8 x 3 1/8 (11.1 x 7.9)
Museum purchase with funds
provided by the Alice Pratt Brown
Museum Fund
91.240
© 1999 Artists Rights Society
(ARS), New York/VG Bild-Kunst,
Bonn

**5.30** Ansel Adams, American, 1902–1984
**Untitled (#2)** from Surf Sequence, 1940
Gelatin silver photograph, printed before mid-1960s
10 1/2 x 13 1/8 (26.7 x 33.3)
The Allan Chasanoff Photographic Collection
91.340
© 1999 by the Trustees of the Ansel Adams Publishing Rights Trust. All Rights Reserved.

**5.31** Frederick Sommer, American, born Italy, 1905–1999
**Arizona Landscape,** 1945
Gelatin silver photograph
7 5/8 x 9 1/2 (19.4 x 24.1)
The Target Collection of American Photography, museum purchase with funds provided by Target Stores
76.253

**5.32** Robert Adams, American, born 1937
**Near Willard, Utah,** from the series The Missouri West, 1978
Gelatin silver photograph
8 15/16 x 11 1/16 (22.7 x 28.1)
Gift of American Telephone and Telegraph Company
82.173
© Robert Adams, courtesy Fraenkel Gallery

**5.33** Lewis W. Hine, American, 1874–1940
**Riveters,** 1932
Gelatin silver photograph
13 9/16 x 10 9/16 (34.4 x 26.8)
Museum purchase with funds provided by The Mundy Companies
84.98

**5.34** Berenice Abbott, American, 1898–1991
**Exchange Place,** c. 1934
Gelatin silver photograph, printed later
19 15/16 x 5 6/16 (50.6 x 13.8)
Gift of Mr. Ronald A. Kurtz
87.357
© Berenice Abbott/Commerce Graphics, Ltd.

**5.35** W. Eugene Smith, American, 1918–1978
**Untitled,** from the series Country Doctor, 1948
Gelatin silver photograph
13 7/16 x 10 5/16 (34.1 x 26.2)
Museum purchase with funds provided by Mr. and Mrs. B. W. Crain in honor of E. L. Crain, M.D.
85.94
© The Heirs of W. Eugene Smith 1948

**5.36** Robert Frank, American, born Switzerland, 1924
**U.S. 285, New Mexico,** from the series The Americans, 1955
Gelatin silver photograph, printed 1977
13 1/4 x 8 7/8 (33.7 x 22.5)
Museum purchase with funds provided by Jerry E. and Nanette Finger
83.89
© Robert Frank, courtesy of PaceWildenstein MacGill

**5.37** Roy DeCarava, American, born 1919
**Graduation, New York,** 1949
Gelatin silver photograph, printed 1982
8 13/16 x 13 (22.4 x 33)
Museum purchase with funds provided by Photo Forum 1994
94.746
© Roy DeCarava, 1996

**5.38** Earlie Hudnall, Jr., American, born 1946
**Hip Hop,** 1993
Gelatin silver photograph
18 13/16 x 15 (47.8 x 38.1)
Museum purchase with funds provided by Alfred C. Glassell, Jr., in honor of Clare A. Glassell
98.331

**5.39** James VanDerZee, American, 1886–1983
**Daddy Grace, NYC,** 1938
Gelatin silver photograph, printed 1970
9 1/2 x 7 9/16 (24.2 x 19.3)
Museum purchase with funds provided by Mrs. Clare A. Glassell
95.1

**5.40** D. Michael Cheers, American, born 1953
**Doctors Karen Ambrose, Paula A. McKenzy, and Deborah Arrindell,** 1990
Gelatin silver photograph
19 9/16 x 23 1/4 (51.6 x 60.9)
The *Songs of My People* Collection, gift of New African Visions, Time Warner Inc., and Warner Cable, Houston
94.544

**5.41** Manuel Alvarez Bravo, Mexican, born 1902
**Frida Kahlo in Manuel Alvarez Bravo's Studio,** 1930s
Gelatin silver photograph, printed later
9 5/8 x 7 1/4 (24.4 x 18.4)
Museum purchase with funds provided by the Lynn and Peter Coneway Foundation
89.305

**5.42** Flor Garduño, Mexican, born 1957
**Basket of Light,** 1989
Gelatin silver photograph
12 x 9 1/16 (30.5 x 23)
Museum purchase with funds provided by Mary L. Porter in memory of Harriet Van Schoonhoven Roy
92.332

**5.43** Graciela Iturbide, Mexican, born 1942
**Angel Woman,** 1979
Gelatin silver photograph
6 7/8 x 10 3/16 (17.5 x 25.9)
Museum purchase with funds provided by Isabel B. and Wallace S. Wilson
85.131

**5.44** Gerardo Suter, Mexican, born 1957
**Tlapoyahua,** 1991
Gelatin silver photograph
13 7/8 x 14 (35.2 x 35.6)
Museum purchase with funds provided by Joan Morgenstern
93.292

**5.45** Richard Avedon, American, born 1923
**The Duke and Duchess of Windsor,** 1957
Gelatin silver photograph
7 x 6 15/16 (17.8 x 17.6)
The Sonia and Kaye Marvins Portrait Collection, museum purchase with funds provided by Sonia and Kaye Marvins
85.216
© Richard Avedon

**5.46** Edward Steichen, American, born Luxembourg, 1879–1973
**Greta Garbo,** 1928
Gelatin silver photograph
13 13/16 x 10 3/4 (13.8 x 27.3)
Bequest of Edward Steichen by direction of Joanna T. Steichen and George Eastman House
82.87
© Courtesy Joanna T. Steichen

**5.47** Irving Penn, American, born 1917
**Barnett Newman,** 1966
Platinum photograph, printed 1980
15 1/2 x 15 1/2 (39.4 x 39.4)
Museum purchase with funds provided by the Museum Collectors
93.205
© Condé Nast Publications Inc.

**5.48** Annie Leibovitz, American, born 1949
**Steve Martin, Beverly Hills,** 1981
Silver dye bleach photograph
14 1/2 x 14 1/2 (36.8 x 36.8)
The Allan Chasanoff Photographic Collection
91.832
© 1998 Annie Leibovitz

**5.49** Ray K. Metzker, American, born 1931
**Frankfurt, Germany,** from the series Europe, 1961
Gelatin silver photograph
6 x 8 3/4 (15.2 x 22.2)
Museum purchase with funds provided by Arthur Andersen and Company
84.315

**5.50** George Krause, American, born 1937
**Swish,** from the series I Nudi, 1979
Gelatin silver photograph, toned, printed 1980
17 3/16 x 13 5/8 (43.7 x 34.6)
Gift of Mr. and Mrs. Harrison Itz
87.334

**5.51** Harry Callahan, American, 1912–1999
**Multiple Trees,** 1949
Gelatin silver photograph
9 1/2 x 9 7/16 (24.1 x 24)
Museum purchase with funds provided by the Museum Collectors
87.168
© Harry Callahan, courtesy PaceWildensteinMacGill

**5.52** Robert Heinecken, American, born 1931
**Space/Time Metamorphosis #1,** 1975
Photographic emulsion and charcoal on canvas
42 x 62 (106.7 x 157.5)
The Target Collection of American Photography, museum purchase with funds provided by Target Stores and the National Endowment for the Arts
76.274

**5.53** Robert Cumming, American, born 1943
**Watermelon/Bread,** 1970
Gelatin silver photograph, contact print
7 1/2 x 9 9/16 (19.1 x 24.3)
Museum purchase with funds provided by Louisa Stude Sarofim
83.319

**5.54** Esther Parada, American, born 1938
**Past Recovery,** 1979
Gelatin silver photographs
96 x 144 (243.8 x 365.8)
The Target Collection of American Photography, museum purchase with funds provided by Target Stores
82.74.1–.100

**5.55** John Baldessari, American, born 1931
**Two Cages (Similar) with Another Person Choosing,** 1991
Gelatin silver photographs, oil tint, and acrylic paint
81 x 110 1/2 (205.7 x 280.7)
Gift of Michael A. Caddell and Cynthia Chapman
98.226.A–.C

**5.56** Cindy Sherman, American, born 1954
**Untitled,** 1982
Chromogenic photograph
15 1/2 x 9 1/8 (39.3 x 23.2)
Museum purchase with partial funds provided by the Charles Engelhard Foundation, Stephen D. and Karen Susman, and Max and Isabell Smith Herzstein
97.161
© Courtesy Cindy Sherman and Metro Pictures

**5.57** Bernd and Hilla Becher, German, born 1931 and 1934, respectively
**Water Towers,** 1980
Gelatin silver photographs
61 1/4 x 49 1/4 (155.6 x 125.1)
Museum purchase with funds provided by Louisa Stude Sarofim
82.575.1–.9

**5.58** Lee Friedlander, American, born 1934, and Jim Dine, American, born 1935
**Untitled,** from Work from the Same House, 1969
Gelatin silver photographs and etchings on paper
Sheet (approximately) 17 1/2 x 30 (44.4 x 76.2)
Museum purchase with funds provided by Harry K. Smith in honor of Isabell Smith Herzstein
86.297.19

**5.59** Lorna Simpson, American, born 1960
**2 Frames,** 1990
Gelatin silver photographs and plastic plaque
35 x 72 (88.9 x 182.9)
Museum purchase with partial funds provided by the Charles Engelhard Foundation, Stephen D. and Karen Susman, and Max and Isabell Smith Herzstein
97.153.A,.B
© Courtesy Sean Kelly Gallery, New York

**5.60** Hiroshi Sugimoto, Japanese, born 1948
**Bass Strait, Table Cape,** 1997
Gelatin silver photograph
16 3/4 x 21 3/8 (42.5 x 54.3)
Museum purchase with funds provided by Mr. and Mrs. Alexander K. McLanahan and the Louisa Stude Sarofim Charitable Trust, courtesy of Mary Lawrence Porter
98.549

**6 American Painting, Sculpture, and Decorative Arts**

**6.1** Thomas Cole, American, 1801–1848
**Indian Pass,** 1847
Oil on canvas
40 1/16 x 29 3/4 (101.8 x 75.6)
Museum purchase with funds provided by the Agnes Cullen Arnold Endowment Fund
95.138

**6.2** John Frederick Kensett, American, 1816–1872
**A View of Mansfield Mountain,** 1849
Oil on canvas
48 x 39 5/8 (121.9 x 100.6)
Museum purchase with funds provided by the Hogg Brothers Collection, gift of Miss Ima Hogg, by exchange; the Houston Friends of Art and Mrs. William Stamps Farish, by exchange; and the General Accessions Fund
76.200

**6.3** Frederic Edwin Church, American, 1826–1900
**Cotopaxi,** 1855
Oil on canvas
30 x 46 7/8 (76.2 x 119.1)
Museum purchase with funds provided by the Hogg Brothers Collection, gift of Miss Ima Hogg, by exchange
74.58

**6.4** Severin Roesen, American, born Germany, c. 1815–1872
**Victorian Bouquet,** c. 1850–55
Oil on canvas
36 1/8 x 29 (91.8 x 73.7)
Museum purchase with funds provided by the Agnes Cullen Arnold Endowment Fund
71.21

**6.5** Manufactory of Edward C. Moore, American, 1827–1891
Retailed by Tiffany & Co., American, established 1837
New York
**Coffee and Tea Service,** 1856–59
Silver
11 x 8.5 x 6 (27.9 x 21.6 x 15.2)
The Bayou Bend Collection, museum purchase with funds provided by Mr. and Mrs. Robert F. Strange, Sr.
B.91.37.1–.4

**6.6** Possibly New York
**Sideboard,** c. 1855
American tulipwood, white pine, black walnut, and marble
106 x 69 x 28 (269.2 x 175.3 x 71.1)
Museum purchase with funds provided by Anaruth and Aron S. Gordon
83.46.1–.16

**6.7** Frederic Remington, American, 1861–1909
**Aiding a Comrade,** 1889–90
Oil on canvas
34 x 48 1/8 (86.4 x 122.2)
The Hogg Brothers Collection, gift of Miss Ima Hogg
43.23

**6.8** Frederic Remington, American, 1861–1909
**Fight for the Water Hole,** 1903
Oil on canvas
27 1/8 x 40 1/8 (68.9 x 101.9)
The Hogg Brothers Collection, gift of Miss Ima Hogg
43.25

**6.9** Attributed to Pottier and Stymus, American, active 1858/59–after 1900
New York
Joseph Cremer, French, 1811–1878
**Parlor Cabinet,** c. 1862
Rosewood, burled ash, maple, eastern white pine, other woods, gilt, and bronze
55 x 54 x 22 7/8 (139.7 x 137.2 x 58.1)
Museum purchase with funds provided by the Agnes Cullen Arnold Endowment Fund
91.1306.A,.B

**6.10** Herter Brothers, American, active after 1865–c. 1906
New York
**Desk,** 1869–71
Maple, bird's eye maple, rosewood, possibly mahogany, possibly burled walnut; marquetry of various woods; white oak, butternut, cherry, maple, possibly walnut; brass; textile not original
54 5/8 x 31 1/4 x 20 1/8 (138.7 x 79.4 x 51.1)
Museum purchase
77.373

**6.11** Gorham Manufacturing Company, American, established 1831
Providence, Rhode Island
Compote, c. 1863–68
Sterling silver
10 x 17 x 8 3/4 (25.4 x 43.2 x 22.2)
Museum purchase with funds provided by the Sinclair Foundation
81.128

**6.12** John Singer Sargent, American, 1856–1925
**Mrs. Joshua Montgomery Sears,** 1899
Oil on canvas
58 1/8 x 38 1/8 (147.6 x 96.8)
Museum purchase with funds provided by George R. Brown in honor of his wife, Alice Pratt Brown
80.144

**6.13** Thomas Eakins, American, 1844–1916
**Portrait of John B. Gest,** 1905
Oil on canvas
40 x 30 (101.6 x 76.2)
Museum purchase with funds provided by the Agnes Cullen Arnold Endowment Fund
91.62

**6.14** Willard Leroy Metcalf, American, 1858–1925
**Sunlight and Shadow,** 1888
Oil on panel
12 3/4 x 16 1/8 (32.4 x 41.0)
Gift of Miss Ima Hogg
41.28

**6.15** William Merritt Chase, American, 1849–1916
**Sunlight and Shadow, Shinnecock Hills,** c. 1895
Oil on canvas
35 x 40 (88.9 x 101.6)
Partial gift of
Mrs. James W. Glanville
98.247

**6.16** Henry Ossawa Tanner, American, 1859–1937
**Flight into Egypt,** 1921
Oil on board
20 x 24 (50.8 x 61)
Gift of Mrs. Evan W. Burris
50.10

**6.17** Childe Hassam, American, 1859–1935
**Evening in New York,** 1890s
Oil on canvas
21 1/4 x 18 1/4 (54.0 x 46.4)
Gift of Mrs. Langdon Dearborn
91.1862

**6.18** Frederick Carl Frieseke, American, 1874–1939
**Girl Reading,** c. 1900
Oil on canvas
32 x 25 3/4 (81.3 x 65.4)
Wintermann Collection of American Art, gift of Mr. and Mrs. David R. Wintermann
85.168

**6.19** William Merritt Chase, American, 1849–1916
**Mother and Child (The First Portrait),** c. 1888
Oil on canvas
70 1/8 x 40 1/8 (178.1 x 101.9)
Gift of Ehrich Newhouse Gallery, New York
34.81

**6.20** Herter Brothers, American, 1865–c. 1906
New York
**Side Chair,** c. 1876–79
Cherry, other woods, gilt, and upholstery
37 3/8 x 17 x 18 1/4 (94.9 x 43.2 x 46.4)
Museum purchase with funds provided by the Stella H. and Arch S. Rowan Foundation
93.15

**6.21** Tiffany & Co., American, established 1837
New York
**Napkin Clips,** 1879
Silver, gilt, and enamel
each 3/4 x 2 7/16 x 3 3/8 (1.9 x 6.2 x 8.6)
Museum purchase with funds provided by the Alice Pratt Brown Museum Fund
91.1328.1–.8

**6.22** Tiffany & Co., American, established 1837
New York
**Punch Bowl,** 1884
Sterling silver and gilt
8 1/8 x 15 5/8 diameter (20.6 x 39.7)
Museum purchase with funds provided by the Museum Collectors
84.90

**6.23** Robert Henri, American, 1865–1929
**Antonio Baños,** 1908
Oil on canvas
31 3/4 x 26 1/16 (80.6 x 66.2)
Gift of Ernest M. Closuit through Meredith J. Long
57.18

**6.24** George Bellows, American, 1882–1925
**Portrait of Florence Pierce,** 1914
Oil on panel
38 x 30 (96.5 x 76.2)
Gift of Mr. and Mrs. Meredith J. Long in memory of Mrs. Agnes Cullen Arnold
74.255

**6.25** George Bellows, American, 1882–1925
**A Stag at Sharkey's,** 1917
Lithograph on paper
Image 18 9/16 x 23 13/16 (47.1 x 60.5)
Sheet 20 1/4 x 25 3/4 (51.4 x 65.4)
Museum purchase with funds provided by "One Great Night in November, 1989"
89.252

**6.26** George Bellows, American, 1882–1925
**Dempsey and Firpo,** 1923–24
Lithograph on paper
Image 18 1/4 x 22 3/8 (46.4 x 56.8)
Sheet 22 7/8 x 26 (58.1 x 66)
Museum purchase with funds provided by "One Great Night in November, 1988"
88.340

**6.27** Augustus Welby Northmore Pugin, English, 1769–1832
Made by John Webb
**Chair,** c. 1847
Oak, leather, and brass
39 1/2 x 18 x 18 (100.3 x 45.7 x 45.7)
Museum purchase with funds provided by the Stella H. and Arch S. Rowan Foundation
96.608

**6.28** Charles Rohlfs, American, 1853–1936
Buffalo, New York
**Desk,** c. 1899
Oak, iron, and burlap
Open 54 13/16 x 25 3/8 x 36
(139.2 x 64.5 x 91.4)
Closed 54 13/16 x 25 3/8 x 26
(139.2 x 64.5 x 66)
Museum purchase with funds
provided by the Alice Pratt Brown
Museum Fund
90.252

**6.29** Benn Pitman, attributed
cabinet designer, British, 1822–1910
Mary Madeline Nourse, attributed
carver, American, 1870–1959
Artus Van Briggle, attributed
ceramist, American, 1869–1904
Cincinnati, Ohio
**Wall Cabinet,** 1887–93
Black walnut and glazed clay
40 1/4 x 42 x 10 (102.2 x 106.7 x 25.4)
Gift of Marian Thompson Deininger
97.194.A–.E

**6.30** Roycroft Shop, active
1895–1938
East Aurora, New York
**Side Chair,** c. 1905–12
Oak
46 1/2 x 18 1/2 x 18 3/4
(118.1 x 47 x 47.6)
Museum purchase with funds
provided by the Alice Pratt Brown
Museum Fund
91.1926

**6.31** John Scott Bradstreet,
American, 1845–1914
John Bradstreet & Co., American,
active 1873–1914
Minneapolis, Minnesota
**Table,** c. 1905
Cypress
27 x 29 5/8 diameter (68.6 x 75.2)
Museum purchase with funds
provided by Helena Woolworth
McCann and the Winfield
Foundation, by exchange
96.801

**6.32** Artus Van Briggle, American,
1869–1904
Made at Rookwood Pottery,
American, active 1880–1967
Cincinnati, Ohio
**Vase,** 1896
Sage green clay
12 x 7 diameter (30.5 x 17.8)
Gift of Marian Thompson Deininger
97.193

**6.33** Louis Comfort Tiffany,
American, 1848–1933
Tiffany Studios, New York,
established 1900
**A Wooded Landscape
in Three Panels,** c. 1905
Glass, copper-foil, and lead
86 1/2 x 131 9/16 x 1 3/4
(219.7 x 334.2 x 4.4)
Museum purchase with funds
provided by the Brown Foundation
Accessions Endowment Fund
96.765.A–.C

**6.34** Morgan Russell, American,
1886–1953
**Synchromy,** c. 1914
Oil on composition board
13 x 13 3/4 (33 x 34.9)
Museum purchase
78.149

**6.35** Marsden Hartley, American,
1877–1943
**Abstraction,** c. 1914
Oil on paper board,
mounted on panel
24 1/4 x 20 (61.6 x 50.8)
Gift of Mr. and Mrs. Ralph
O'Connor in honor of Mr. and
Mrs. George R. Brown
80.82

**6.36** Stanton Macdonald-Wright,
American, 1890–1973
**Arm Organization,** 1914
Oil on canvas
36 x 30 3/16 (91.4 x 76.7)
Museum purchase
80.33

**6.37** Ernest Martin Hennings,
American, 1886–1956
**Passing By,** c. 1924
Oil on canvas
44 x 49 (111.8 x 124.5)
Gift of the Ranger Fund,
National Academy of Design
26.11

**6.38** Georgia O'Keeffe, American,
1887–1986
**Red Hills with White Shell,** 1938
Oil on canvas
30 x 36 1/2 (76.2 x 92.7)
Gift of Isabel B. Wilson in memory
of her mother, Alice Pratt Brown
91.2027

**6.39** Alfred Stieglitz, American,
1864–1946
**Portrait of Georgia O'Keeffe,** 1933
Gelatin silver photograph
8 3/4 x 7 1/2 (22.2 x 19.1)
The Target Collection of American
Photography, museum purchase
with funds provided by Target Stores
78.63

**6.40** Winslow Homer, American,
1836–1910
**Eight Bells,** 1887
Etching
Plate 18 7/8 x 24 3/8 (47.9 x 61.9)
Sheet 24 7/8 x 31 7/8 (63.1 x 80.9)
Museum purchase with funds
provided by Frank J. Hevrdejs
and Mike Willis in honor of
Peter R. Coneway at "One Great
Night in November, 1996"
96.1706

**6.41** John Marin, American,
1870–1953
**The Little Sailboat,** 1924
Watercolor and charcoal on
wove paper
17 x 21 (43.2 x 53.3)
Museum purchase with funds
provided by The Brown Foundation,
Inc., and by bequest of Ida R.
Nussbaum, by exchange
75.4

**6.42** Stuart Davis, American,
1894–1964
**Gloucester Harbor,** 1938
Oil on canvas, mounted on panel
23 1/16 x 30 1/8 (58.6 x 76.5)
Museum purchase with funds
provided by the Agnes Cullen
Arnold Endowment Fund
77.330
© Estate of Stuart Davis/Licensed
by VAGA, New York, NY

**6.43** Thomas Hart Benton,
American, 1889–1975
**Haystack,** 1938
Tempera with oil glaze on linen,
on wood panel
24 x 30 (61 x 76.2)
Gift of Mr. Frank J. Hevrdejs
92.273
© T. H. Benton and R.P. Benton
Testamentary Trusts/Licensed by
VAGA, New York, NY

**6.44** Russell Lee, American,
1903–1986
**Mailbox,** 1930s
Gelatin silver photograph
7 1/4 x 9 5/8 (18.4 x 24.4)
Gift of Howard Greenberg
87.276

**6.45** Walker Evans, American,
1903–1975
**6th Avenue at 42nd Street,
New York City,** 1929
Gelatin silver photograph
8 1/4 x 12 3/16 (21 x 31)
Museum purchase with funds
provided by the Lynch Foundation
89.35
© Walker Evans Archive,
The Metropolitan Museum of Art

**6.46** Robert Spencer, American,
1879–1931
**The Exodus,** 1928
Oil on canvas
30 x 36 (76.2 x 91.4)
Museum purchase with funds
provided by the Houston
Friends of Art
30.2

**6.47** Paul Manship, American,
1885–1966
**Hercules Upholding
the Heavens,** 1918
Bronze
128 x 84 x 45 (325.1 x 213.4 x 114.3)
Gift of Mrs. Mellie Esperson
39.148

**6.48** Elie Nadelman, American,
born Poland, 1882–1946
**Tango,** c. 1918–24
Cherry-wood and gesso
Male figure 33 1/2 x 17 1/2 x 13 1/4
(85.1 x 44.5 x 33.7)
Female figure 34 3/4 x 17 1/2 x 11 3/4
(88.3 x 44.5 x 29.8)
Gift of
Meredith J. and Cornelia Long
96.1751.A,.B

7 **African Art**

**7.1** Baule
**Fly Whisk,** 19th–20th century
Wood, gold leaf, and animal hair
26 x 3 1/2 (66 x 8.9)
The Glassell Collection of African
Gold, gift of Alfred C. Glassell, Jr.
97.859

**7.2** Akan
**Linguist Staff with Elephant
Finial,** 19th–20th century
Wood and gold leaf
Finial 7 3/8 x 2 7/8 x 7 3/8
(18.7 x 7.3 x 18.7)
Overall 53 1/2 x 2 1/4 (135.9 x 5.7)
The Glassell Collection of African
Gold, gift of Alfred C. Glassell, Jr.
97.1291.A–.C

**7.3** Akan
**Drum Figure,** 19th–20th century
Wood, gold leaf, and paint
17 5/8 x 6 x 4 (44.8 x 15.2 x 10.2)
The Glassell Collection of African
Gold, gift of Alfred C. Glassell, Jr.
97.805

**7.4** Asante
**Chief Swordbearer's Headdress,**
19th–20th century
Sheet gold, sheet metal, cloth,
feathers, leather, wood, and
metal staples
21 1/2 x 19 3/4 x 14 (54.6 x 50.2 x 35.6)
The Glassell Collection of African
Gold, gift of Alfred C. Glassell, Jr.
97.908

**7.5** Akan
**Sword with Sheath,**
19th–20th century
Gold leaf, wood, iron,
and animal skin
26 x 2 1/2 x 3 (66 x 6.4 x 7.6)
The Glassell Collection of African
Gold, gift of Alfred C. Glassell, Jr.
97.1367.A,.B

**Sword Ornament of a Monkey
with a Cricket,** 19th–20th century
Cast gold
7 1/2 height (19.1)
The Glassell Collection of African
Gold, gift of Alfred C. Glassell, Jr.
97.1402

**7.6** Akan
**Pectoral with Sun and Crocodile,**
19th–20th century
Cast gold
7 1/4 diameter (18.4)
The Glassell Collection of African
Gold, gift of Alfred C. Glassell, Jr.
97 1326

**7.7** Akan
**Necklace,** 19th–20th century
Gold
18 1/2 x 6 x 1 3/8 (47 x 15.2 x 3.5)
The Glassell Collection of African
Gold, gift of Alfred C. Glassell, Jr.
97.995

**7.8** Akan
**Ram's Head Pendant,**
19th–20th century
Cast gold
4 3/4 (12.1)
The Glassell Collection of African
Gold, gift of Alfred C. Glassell, Jr.
97.880

**7.9** Baule
**Comb,** 19th–20th century
Wood and gold leaf
5 7/8 x 2 3/8 x 1 (14.9 x 6 x 2.5)
The Glassell Collection of African
Gold, gift of Alfred C. Glassell, Jr.
97.782

**7.10** Baule
**Comb,** 19th–20th century
Wood and gold leaf
4 1/2 x 3 1/4 (11.4 x 8.3)
The Glassell Collection of African
Gold, gift of Alfred C. Glassell, Jr.
97.783

**7.11** Akan
**Crown,** 19th–20th century
Repoussé sheet gold
6 3/4 x 7 diameter (17.1 x 17.8)
The Glassell Collection of African
Gold, gift of Alfred C. Glassell, Jr.
97.788

**7.12** Akan
**Ring with Cocoon,**
19th–20th century
Gold
2 1/4 x 2 (5.7 x 5.1)
The Glassell Collection of African
Gold, gift of Alfred C. Glassell, Jr.
97.1240

**7.13** Akan
**Ring with Mudfish,**
19th–20th century
Gold
2 3/4 x 1 7/8 x 1 3/4 (7 x 4.8 x 4.4)
The Glassell Collection of African
Gold, gift of Alfred C. Glassell, Jr.
97.1161

**7.14** Nok
Nigeria, Jos Plateau region
**Head and Torso of a Female
Figure,** 500 B.C.–A.D. 200
Earthenware
22 1/2 x 11 1/4 x 8 (57.2 x 28.6 x 20.3)
Museum purchase with funds
provided by the Brown Foundation
Accessions Endowment Fund
96.946

**7.15** Possibly Agbonbiofe, died 1945,
Adeshina School, Yoruba
(Ekiti subgroup)
Nigeria, Efon-Alaye town
**Helmet Mask with Equestrian
Figure (*Epa* masquerade),**
1900–1950
Wood and paint
49 5/8 x 12 x 13 1/2 (126 x 30.5 x 34.3)
Museum purchase with funds
provided by the African American
Art Advisory Association
95.142

**7.16** Edo
Nigeria, Benin City
**Plaque with Court Retainer,**
1550–1680
Brass
18 11/16 x 12 3/8 (47.5 x 31.4)
Museum purchase with funds
provided by the Agnes Cullen
Arnold Endowment Fund
73.78

**7.17** Yoruba (Ekiti subgroup)
Nigeria
**Mother and Child Figure,**
late 19th century
Wood and traces of indigo
17 1/2 x 5 x 8 (44.5 x 12.7 x 20.3 )
Museum purchase with funds
provided by the Alice Pratt Brown
Museum Fund
91.238

**7.18** Yoruba (Igbomina subgroup)
Nigeria, Ila-Orangun town
**Female Twin Figure (*ere ibeji*),**
late 19th–early 20th century
Wood, glass beads, and traces
of tukula
11 x 3 3/4 x 2 7/8 (27.9 x 9.5 x 7.3)
The Dr. Gus K. Nicholson
Collection
91.1449

**7.19** Asante (Ashanti)
Ghana
**Fertility Figure (*akua-ba*),**
early 20th century
Wood
13 1/4 x 5 1/4 x 1 3/4 (33.7 x 13.3 x 4.4)
The Dr. Gus K. Nicholson
Collection
91.1441

**7.20** Ibo (Igbo)
Nigeria
**Helmet Mask of a Maiden Spirit**
(Mmwo society),
late 19th–early 20th century
Wood, kaolin, paint, wire,
cotton string, and trade cloth
26 x 7 3/4 x 14 (66 x 19.7 x 35.5)
Museum purchase with funds
provided by the Museum Collectors
90.401

**7.21** Bamileke
Cameroon, Grasslands
**Elephant Mask (Kuosi society),**
1900–1950
Cotton cloth, flannel, glass beads,
raffia cloth, indigo dye,
and possibly cane
55 1/2 x 24 7/8 x 7 3/4
(141 x 63.2 x 19.7)
Museum purchase with funds
provided by The Brown Foundation,
Inc., and the Brown Foundation
Accessions Endowment Fund
97.341

**7.22** Sala Mpasu
Congo (Kinshasa),
Kwilu-Kasai region
**Male Helmet Mask**
(Idangani society), 1925–50
Raffia, cane, other plant fibers,
feathers, paint, and twine
47 x 19 x 19 (119.4 x 48.3 x 48.3)
Museum purchase with funds
provided by the Alice Pratt Brown
Museum Fund
91.1923

**7.23** Bobo
Burkina Faso, Bobo Diulasso region
**Helmet Mask with
Buffalo Horns** (Do society),
early 20th century
Wood and paint
65 1/2 x 14 x 13 1/2 (166.4 x 35.6 x 34.3)
Gift of D. and J. de Menil in
memory of Dr. Jermayne MacAgy
64.13

**7.24** Chamba
Nigeria
**Helmet Mask of a Bush Cow**
(Vara society), late 19th century
Wood, sacrificial matter, metal,
nails, and animal hide
31 1/2 x 12 3/4 x 10 3/4
(80 x 32.4 x 27.3)
Museum purchase with funds
provided by Mr. and Mrs.
Thomas H. Friedkin
89.261

**7.25** Dogon
Mali, Bandiagara region
**Ceremonial Trough with
Horse's Head and Tail,**
18th–early 19th century
Wood
18 x 76 3/4 x 19 1/2 (45.7 x 195 x 49.5)
Gift of D. and J. de Menil
64.11

**7.26** Ekpeye
Nigeria
**Pangolin Headdress**
(Egbukere society), 1925–50
Wood, paint, metal, cloth, rope,
and nail
9 x 41 1/2 x 13 (22.9 x 105.4 x 33)
Museum purchase with funds
provided by Baroid Corporation
in honor of their loyal Nigerian
employees at "One Great Night
in November, 1990"
90.499

**7.27** Senufo
Côte d'Ivoire
**Anthropomorphic Hornbill**
(Poro society), early 20th century
Wood
48 3/4 x 20 1/2 x 15 1/2
(123.8 x 52.1 x 39.4)
Gift of D. and J. de Menil
63.12

**7.28** Senufo
Côte d'Ivoire, Korhogo region
**Champion Cultivator Staff**
*(tefalipitya)*,
late 19th–early 20th century
Wood, cowry shells, plant fiber,
horn, and iron
40 1/2 x 3 5/8 x 3 3/8 (102.9 x 9.2 x 8.6)
The Dr. Gus K. Nicholson
Collection
91.1437

**7.29** Dan
Liberia or Côte d'Ivoire
**Spoon** *(wunkirmian)*,
late 19th–early 20th century
Wood and plant fiber
18 1/2 x 3 3/4 x 2 (47 x 9.5 x 5.1)
Museum purchase with funds
provided by The Brown
Foundation, Inc.
93.330

**7.30** Baule
Côte d'Ivoire
**Nature Spirit** *(asie usu)*,
late 19th century
Wood, sacrificial matter, cotton
cloth, string, and glass beads
16 1/2 x 3 3/4 x 3 3/4 (41.9 x 9.5 x 9.5)
Museum purchase with funds
provided by the Alice Pratt Brown
Museum Fund
91.237

**7.31** Lega
Congo (Kinshasa)
**Hat with Elephant Tail**
(Bwami society), 1925–50
Plant fiber, cowry shells, and
elephant tail
22 1/2 x 13 1/2 x 5 5/8 (57.2 x 34.3 x 14.3)
Museum purchase with funds
provided by Louis K. Adler,
John A. Brent, John T. Cater,
Morton A. Cohn, Peter R. Coneway,
Robert Cruikshank, Louis B. Cush-
man, James J. Elacqua, Paul M.
Janicke, C. Berdon Lawrence,
John F. Lynch, Michael Padon,
R. A. Seale, Jr., E. Ashley Smith,
and Gene M. Woodfin in honor
of Alfred C. Glassell, Jr., at "One
Great Night in November, 1990"
90.502

**7.32** Lega
Congo (Kinshasa)
**Hat with Hornbill Skull**
(Bwami society), 1925–50
Plant fiber, plastic discs (zigidas),
mussel shells, cowry shells, hornbill
skull, and cotton cloth
22 1/2 x 7 x 6 1/4 (57.2 x 17.8 x 15.9)
Museum purchase with funds
provided by Louis K. Adler,
John A. Brent, John T. Cater,
Morton A. Cohn, Peter R. Coneway,
Robert Cruikshank, Louis B. Cush-
man, James J. Elacqua, Paul M.
Janicke, C. Berdon Lawrence,
John F. Lynch, Michael Padon,
R. A. Seale, Jr., E. Ashley Smith,
and Gene M. Woodfin in honor
of Alfred C. Glassell, Jr., at "One
Great Night in November, 1990"
90.501

**7.33** Lega
Congo (Kinshasa)
**Hat with Pangolin Skin**
(Bwami society), 1925–50
Plant fiber, pangolin skin, snake
skin, elephant hair, glass buttons,
glass beads, and feathers
20 7/8 x 12 x 6 3/4 (53 x 30.5 x 17.1)
Museum purchase with funds
provided by Louis K. Adler,
John A. Brent, John T. Cater,
Morton A. Cohn, Peter R. Coneway,
Robert Cruikshank, Louis B. Cush-
man, James J. Elacqua, Paul M.
Janicke, C. Berdon Lawrence,
John F. Lynch, Michael Padon,
R. A. Seale, Jr., E. Ashley Smith,
and Gene M. Woodfin in honor
of Alfred C. Glassell, Jr., at "One
Great Night in November, 1990"
90.500

**7.34** Yoruba (Owo subgroup)
Nigeria, Kingdom of Owo
**Ceremonial Knife with Scabbard**
*(udamalore)*,
late 19th–early 20th century
Ivory, iron, glass beads, brass bells,
cotton cloth, wood, and cane
Knife 17 1/4 x 2 3/8 x 2 (43.8 x 6 x 5.1)
Holder with base 17 x 14 5/8 x 4
(43.2 x 37.1 x 10.2)
Museum purchase with funds
provided by Dr. Jules Bohnn,
Mr. Louis Tenenbaum, Mr. H. Brock
Hudson, Mr. Matthew R. Simmons,
and Dr. Byron Bohnn in honor of
the founder of "One Great Night
in November," William J. Hill, at
"One Great Night in November,
1991"
91.1551

**7.35** Ndebele
South Africa, Transvaal
**New Bride's Ceremonial Apron**
*(jocolo)*, 1900–1950
Leather, glass beads, and brass rings
24 1/4 x 20 3/8 (61.6 x 51.7 )
Museum purchase with funds
provided by William James Hill
86.304

## 8 Asian Art

**8.1** Chinese
Gansu Province, Banshan
**Funerary Jar,** Neolithic period,
c. 2400 B.C.
Earthenware with
black and red pigment
16 x 17 1/4 x 17 1/4 (40.6 x 43.8 x 39.4)
Museum purchase with funds
provided by Mr. and Mrs. Jack
Wexler, Mr. and Mrs. Arthur
B. Rothwell, Dr. Linus Long,
the Estate of Ann Eden Woodward,
Mr. and Mrs. Joe Stanley, Jr.,
and Mrs. Gertrude Cummings,
by exchange
91.312

**8.2** Chinese
**Ritual Vessel *(ding),*** Eastern Zhou
dynasty, early 5th century B.C.
Bronze
15 3/4 x 21 7/8 x 18 (40 x 55.6 x 45.7)
Museum purchase with funds
provided by the Alice Pratt Brown
Museum Fund
94.2.A,.B

**8.3** Chinese
**Tomb Brick,** Western Han,
206 B.C.–A.D. 9
Earthenware with
red and white pigment
24 3/4 x 47 1/2 (62.9 x 120.7)
Gift of Carol and Robert Straus
69.25

**8.4** Chinese
**Guardian Figure *(lokapala),***
Tang dynasty, 618–906
Earthenware with three-color glaze
42 1/4 x 16 1/2 x 9 1/2
(107.3 x 41.9 x 24.1)
Museum purchase with funds
provided by the Brown Foundation
Accessions Endowment Fund
98.256

**8.5** Chinese
**Vase,** Qianlong period, 1736–96
Jade (nephrite)
6 3/4 x 6 1/2 (17.1 x 16.5)
Anonymous gift
76.204

**8.6** Bian Shoumin, Chinese,
1683–1752
**Geese Descending on a
Sandbank,** Qing dynasty, 1730
Ink and slight color on paper
52 x 28 (132.2 x 71.2)
Museum purchase with funds
provided by the Alice Pratt Brown
Museum Fund
90.513

**8.7** Indian
**Images of the Buddha** (detail),
Kushan dynasty, 50–320
Gray schist
8 7/8 x 34 x 3 (22.5 x 86.4 x 7.6)
Museum purchase with funds
provided by the Museum Collectors
85.115

**8.8** Japanese
**Bosatsu,** Heian period,
mid-12th century
Cypress wood
39 3/8 height (100)
Museum purchase
68.50

**8.9** Indian
**Maitreya,** Kushan dynasty,
c. 2nd century
Pink sandstone and gray schist
15 7/8 x 13 3/4 x 3 (40.3 x 34.9 x 7.62)
Museum purchase with funds
provided by Mr. and
Mrs. James Vaughn
90.439

**8.10** Chinese
**Guardian with Attendants,**
Ming dynasty, 14th century
Ink and color on silk
50 5/8 x 25 3/4 (128.6 x 65.4)
Gift of Mrs. Henrietta Schwartz
86.302

**8.11** Japanese
**Guardian Lion *(shishi),***
Kamakura period, 14th century
Wood and lacquer
23 x 9 3/8 x 25 3/8 (58.4 x 23.8 x 64.4)
Museum purchase with funds
provided by the Mitsubishi
International Corporation
94.131

**8.12** Koei (Unkei IX), Japanese,
active 15th century
**Amida,** Muromachi period, 1472
Wood with traces of polychrome
21 x 17 3/4 x 16 1/8 (53.3 x 45.1 x 41)
Museum purchase with funds
provided by the Brown Foundation
Accessions Endowment Fund
92.193

**8.13** Korean
**Ritual Sprinkler *(kundika),***
Koryo dynasty, 12th–13th century
Bronze
16 x 5 5/8 (40.6 x 14.3)
Gift of Dr. Mabelle E. Adams-Mayne
95.50

**8.14** Indonesian
Java
**Head of a Deity,** 9th century
Andesite (volcanic stone)
13 3/4 x 6 1/8 x 7 1/2 (34.9 x 15.6 x 19.1)
Museum purchase with funds
provided by Terry Huffington and
Ralph Ernest Dittman
91.333

**8.15** Japanese
**Pot with Whorl Design,**
c. 10,500–300 B.C.
Earthenware
14 3/4 x 13 (37.5 x 33.1)
Museum purchase with funds
provided by the Museum Collectors
82.66

**8.16** Japanese
**Haniwa Warrior,**
Kofun period, late 6th century
Red earthenware
27 x 14 1/2 x 13 1/2 (68.6 x 36.8 x 34.2)
Museum purchase with funds
provided by the Agnes Cullen
Arnold Endowment Fund and
the McAshan Educational and
Charitable Trust
88.58

**8.17**  Tosa School, Japanese
**The Tale of Genji,** Edo period,
late 17th–early 18th century
Ink with red pigment, gold, and
mica on paper
Each screen 137 1/2 x 66 1/2
(349.2 x 168.9)
Museum purchase with funds
provided by Mr. and Mrs. Harris
Masterson III, Mr. and Mrs. John R.
Moran, Mr. Carl Detering, Mr. and
Mrs. Gary Levering, Mr. and Mrs.
M. S. Stude, Continental Oil
Company, Mary Alice Wilson,
Mr. and Mrs. William Coates, Jr.,
Texas Pipe and Supply Company,
Mrs. Barbara K. Sandy, Mr. and
Mrs. Lee Bartleby Stone, Mr. and
Mrs. J. R. Thomas
80.149.1,.2

**8.18**  Aigai, Japanese, 1791–1843
**Tiger and Bamboo,**
Edo period, early 19th century
Ink on silk
38 5/8 x 12 5/8 (98.1 x 32.1)
Museum purchase with funds
provided by The Mitsubishi
Bank, Ltd.
91.60

**8.19**  Miyashita Zenji, Japanese,
born 1939
**Domed Vase,** 1994
Stoneware
18 3/4 x 23 1/2 x 8 9/16
(47.6 x 59.7 x 21.7)
Museum purchase with funds
provided by Nippon Steel USA,
Inc., the Japan Business Association
of Houston, and the Director's
Unrestricted Accessions Fund
95.265

**8.20**  Indian
Madhya Pradesh
**Vishnu and His Avatars,**
Medieval period, c. 10th century
Red sandstone
54 1/2 x 31 1/2 (138.4 x 80)
Museum purchase with funds
provided by the Agnes Cullen
Arnold Endowment Fund
71.1

**8.21**  Indian
**Nagini,** Medieval period,
9th century
Buff sandstone
35 x 11 5/8 x 6 3/4 (89 x 29.5 x 17.2)
Museum purchase with funds
provided by "One Great Night
in November, 1990"
90.510

**8.21a**  William Henry Rinehart,
American, 1825–1874
**Thetis,** c. 1861
Marble
45 3/4 x 17 x 12 1/2 (116.2 x 43.2 x 31.8)
Museum purchase with funds
provided by "One Great Night
in November, 1996"
96.1702

**8.22**  Indian
**Shiva Nataraja,**
Chola dynasty, 13th century
Bronze
29 1/2 height (74.9)
Gift of Carol and Robert Straus
73.77

**8.23**  Indian
Rajasthan, Udaipur
**Maharana Jägat Singh II and
Nobles Watching the Raslila
Dance Dramas,** c. 1736–40
Opaque watercolor and
gold on paper
26 1/16 x 19 3/4 (66.1 x 50.2)
Museum purchase with funds
provided by Mr. A. Soudavar
and the Agnes Cullen Arnold
Endowment Fund
89.334

**8.24**  Indonesian
Java
**Funerary Mask**
Sheet gold
7 7/16 x 5 5/16 x 1 (18.9 x 13.5 x 2.5)
The Glassell Collection
TR:356–98

**8.25**  Indonesian
Bali, Singaraja Court
**King's Necklace**
Repoussé gold, rubies, sapphires,
and diamonds
12 1/2 x 9 15/16 x 1 1/2 (31.8 x 25.2 x 3.8)
The Glassell Collection
TR:286–97

**8.26**  Indonesian
Nias
**Man's Crown** *(saembu ana'a)*
Gold
19 x 11 diameter (48.3 x 27.9)
The Glassell Collection
TR:529–94

**8.27**  Indonesian
Moluccas, Luang Island
**Ancestral Crown and Mask**
Hammered and repoussé gold
and gold wire
The Glassell Collection
TR:610–96

**8.28**  Indonesian
Flores, Nage region
**Man's Headpiece** *(lado)*
**with Seven Birds**
Gold
15 x 10 x 1/4 (38.1 x 25.4 x .7)
The Glassell Collection
TR:72.15–94

## 9 Pre-Columbian Art

**9.1** Olmec
Mexico, state of Mexico, Tlapacoya
Seated Figure,
Early Pre-Classic, 1200–900 B.C.
Earthenware with black pitch
(*chapopote*) and bichrome
slip painting
12 x 9 1/4 x 7 1/4 (30.5 x 23.5 x 18.4)
Gift of Mrs. Ralph S. O'Connor in
honor of her cousins, Louisa Stude
Sarofim and Mike Stude
86.409

**9.2** Colima
Mexico, Colima
Seated Musician,
Proto-Classic, 200 B.C.–A.D. 250
Earthenware with bichrome
slip painting
15 9/16 x 14 1/2 x 9 (39.5 x 36.8 x 22.9)
Museum purchase with funds
provided by the Junior League
of Houston
93.210

**9.3** Colima
Mexico, Colima
Half-Seated Dog,
Proto-Classic, 200 B.C.–A.D. 250
Earthenware
11 1/4 x 10 1/2 x 8 1/4 (28.6 x 26.7 x 21)
Museum purchase with funds
provided by Meredith J. Long
in honor of Fayez Sarofim and
Alfred C. Glassell, Jr., at "One
Great Night in November, 1994"
94.440

**9.4** Jalisco (Ameca Gray style)
Mexico, Jalisco
Kneeling Woman Nursing a Baby,
Proto-Classic, 200 B.C.–A.D. 250
Earthenware with polychrome
slip painting
13 x 8 1/4 x 5 1/4 (33 x 21 x 13.3)
Gift of Mrs. Harry C. Hanszen
65.105

**9.5** Nayarit
Mexico, Nayarit
Emaciated Seated Man,
Proto-Classic, 200 B.C.–A.D. 250
Earthenware with polychrome
slip painting
11 1/2 x 5 1/4 x 6 (29.2 x 13.3 x 15.2)
Gift of D. and J. de Menil
50.26

**9.6** Maya (Jaina style)
Mexico, Campeche
Seated Woman,
Late Classic, 550–800
Earthenware with traces of paint
8 x 4 1/2 x 3 5/16 (20.3 x 11.4 x 8.4)
Anonymous gift
70.22

**9.7** Maya
Guatemala, Petén
Covered Bowl with
Bird-Head Handle,
Early Classic, 250–550
Earthenware
10 3/8 x 9 3/4 diameter (26.4 x 24.8)
Gift of
Mr. and Mrs. George R. Brown
77.49.A,.B

**9.8** Maya
Guatemala, Petén
Covered Bowl with
Human-Head Handle,
Early Classic, 250–550
Earthenware with polychrome
slip painting
10 1/2 x 12 7/8 diameter (26.7 x 32.7)
Museum purchase with funds
provided by The Brown Foundation,
Inc., and Oveta Culp Hobby
76.426.A,.B

**9.9** Maya
Probably Guatemala, Petén
Vase with Two Blowgunners
and Waterbirds,
Late Classic, 550–800
Earthenware with polychrome
slip painting
5 3/8 x 6 1/8 diameter (13.7 x 15.6)
Museum purchase with funds
provided by "One Great Night
in November, 1989"
89.264

**9.10** Maya
Guatemala, Petén
Bowl with Birds in Cartouches,
one of a pair,
Middle Classic, 500–700
Earthenware with painted stucco
5 3/4 x 5 3/4 diameter (14.6 x 14.6)
Museum purchase with funds
provided by The Brown Foundation,
Inc., in honor of Frances Marzio's
10th anniversary with the
Museum of Fine Arts, Houston
92.201

**9.11** Maya
Guatemala, Petén
Bowl with Water Scene,
Middle Classic, 500–700
Earthenware with painted stucco
5 5/8 x 7 1/16 diameter (14.3 x 17.9)
Museum purchase with funds
provided by the Alice Pratt Brown
Museum Fund
92.112

**9.12** Teotihuacán
Mexico, Central Highlands
Tripod Vase with Two
Blowgunners and Quetzal Birds
in Cacao Trees,
Late Xolalpan, 550–650
Earthenware with painted stucco
6 1/8 x 6 7/16 diameter (15.6 x 16.4)
Gift of Mrs. Harry C. Hanszen
65.70

**9.13** Maya
Mexico, Chiapas, probably Palenque
Seated Male from a Relief Panel,
Late Classic, 702–64
Limestone with traces of paint
39 1/8 x 26 1/2 x 1 3/4
(99.4 x 67.3 x 4.4)
Museum purchase
62.42

**9.14** Maya
Guatemala, probably Petén
Ceremonial Flint with
God K and Two Lords
in a Monster-Headed Canoe,
Late Classic, 550–800
Flint
5 1/2 x 12 5/8 x 5/8 (14 x 32.1 x 1.6)
Museum purchase with funds
provided by the Alice Pratt Brown
Museum Fund
91.332

**9.15** Maya
Mexico or Guatemala
Headdress Ornament with the
Head of the Jester God,
Late Classic, 550–800
Jadeite
2 13/16 x 2 3/16 x 1/4 (7.1 x 5.6 x .6)
Museum purchase with funds
provided by the Museum Collectors
and Mrs. Robert E. Hansen in
memory of Dr. Robert E. Hansen
88.108

**9.16** Teotihuacán
Mexico, Central Highlands
**Incense Burner Lid,**
Tlamimilolpa-Xolalpan, 200–650
Earthenware with polychrome
painting
20 x 17 1/8 x 10 1/4 (50.8 x 43.5 x 26)
Museum purchase with funds
provided by the Brown Foundation
Accessions Endowment Fund
97.113.A,.B

**9.17** Maya
Guatemala, Quiché
**Funerary Urn with Feline Lid,**
Late-Terminal Classic, 550–950
Earthenware with polychrome
slip painting
35 1/8 x 25 1/2 x 21 1/2
(89.2 x 64.8 x 54.6)
Museum purchase with funds
provided by "One Great Night
in November, 1993"
93.389.A,.B

**9.18** Zapotec
Mexico, Oaxaca
**Funerary Urn with a Seated God,**
Monte Albán II, 200 B.C.–A.D. 200
Earthenware
10 1/2 x 7 1/2 x 5 1/2 (26.7 x 19.1 x 14)
Gift of Mrs. Harry C. Hanszen
65.146

**9.19** Classic Central Veracruz
Mexico, Veracruz
**Palma with a Waterbird,**
Early Post-Classic, 900–1200
Volcanic stone
32 1/4 x 9 x 5 7/8 (81.9 x 22.9 x 14.9)
Museum purchase with funds
provided by the Brown Foundation
Accessions Endowment Fund
96.800

**9.20** Ulúa
Honduras, Ulúa Valley
**Tripod Vase with Bird Handles,**
Terminal Classic, 800–1000
Marble
5 3/4 x 13 x 10 (14.6 x 33 x 25.4)
Museum purchase with funds
provided by the Alice Pratt Brown
Museum Fund
87.189

**9.21** Aztec
Mexico, Central Highlands
**Standard-Bearer,** 1425–1521
Volcanic stone
47 7/16 x 16 x 13 1/4
(120.5 x 40.6 x 33.7)
Gift of D. and J. de Menil
66.8

**9.22** Guanacaste-Nicoya
Costa Rica
**Ceremonial Grinding Stone
(metate) with Jaguar Head,**
Late Period IV–early Period V,
300–700
Volcanic stone
16 1/2 x 14 1/2 x 37 (41.9 x 36.8 x 94.0)
Museum purchase with funds
provided by the Director's
Accessions Fund, the Friends of
Pre-Columbian Art, and J. Landis
Martin in honor of Bill Walker and
Matthew R. Simmons at "One
Great Night in November, 1990"
90.424

**9.23** Guanacaste-Nicoya
Costa Rica
**Jaguar Vessel,**
Late Period VI, 1200–1400
Earthenware with polychrome
slip painting
12 3/4 x 11 3/4 x 11 3/4
(32.39 x 29.85 x 29.85)
Museum purchase with funds
provided by Mr. Robert C. McNair,
Mr. John S. Arnoldy, Mr. Jack Bace,
Mr. Dunbar N. Chambers, Jr.,
Mr. H. Fred Levine, Mr. R. Cary
McNair, Jr., Mr. Charles L. Sowell,
and Mr. Bruce W. Wilkinson at
"One Great Night in
November, 1991"
91.1550

**9.24** Atlantic Watershed
Costa Rica
**Standing Warrior with
Trophy Head,**
Late Period V–early Period VI,
700–1100
Volcanic stone
26 x 17 1/2 x 7 3/4 (66 x 44.5 x 19.7)
Museum purchase with funds
provided by Mr. Allen H. Carruth
and Alfred C. Glassell, Jr., in honor
of Meredith J. Long at "One Great
Night in November, 1992"
92.454

**9.25** Paracas
Peru, South Coast, Ica Valley
**Falcon Vessel,**
Late Paracas, 300–200 B.C.
Earthenware with resin paint
6 1/2 x 6 3/8 diameter (16.51 x 15.9)
Museum purchase with funds
provided by the Agnes Cullen
Arnold Endowment Fund
89.66

**9.26** Nazca
Peru, South Coast
**Killer-Whale Vessel,**
Early Nazca, 100 B.C.–A.D. 100
Earthenware with polychrome
slip painting
7 1/4 x 9 x 3 1/2 (18.4 x 22.8 x 8.9)
Museum purchase with funds
provided by Shell Oil Company
Foundation at "One Great Night
in November, 1997"
97.469

**9.27** Nazca
Peru, South Coast
**Vessel with a Caped Woman,**
Late Nazca, 300–600
Earthenware with polychrome
slip painting
8 1/2 x 7 1/4 diameter (21.6 x 18.4)
Museum purchase with funds
provided by Isabel B. and
Wallace S. Wilson
91.311

**9.28** Chavín (Tembladera style)
Peru, North Coast,
Jequetepeque Valley
**Fish Vessel,**
Phase III (Late Chavín),
450–200 B.C.
Incised earthenware
7 5/8 x 5 3/16 x 8 3/8 (19.4 x 13.2 x 21.3)
Museum purchase with funds
provided by the Alice Pratt Brown
Museum Fund
88.2

**9.29** Moche
Peru, North Coast
**Portrait-Head Vessel,**
Moche IV, 400–600
Earthenware with bichrome
slip painting
12 13/16 x 8 1/4 x 7 (32.5 x 21 x 17.8)
Museum purchase with funds
provided by the Museum Collectors
89.107

**9.30** Moche
Peru, North Coast
**Stirrup Jar with Owl-Warriors,**
Moche IV, 400–600
Earthenware with bichrome
slip painting
8 3/4 x 8 x 5 1/2 (22.2 x 20.3 x 14)
Gift of Marjorie G. and
Evan C. Horning
79.261

**9.31** Huari
Peru, South Coast
**Pair of Earplugs with
Human Heads,**
Middle Horizon, 600–1000
Wood with stone and shell inlays
1 3/4 x 1 5/16 x 2 3/4 (4.4 x 3.3 x 7)
Museum purchase with funds
provided by the Alice Pratt Brown
Museum Fund
90.258.1,.2

**9.32** Moche
Peru, North Coast
**Ritual Spatula with a
Clenched Fist,** 1–700
Bone with turquoise, shell,
and stone inlays
5 5/8 x 1 1/8 diameter (14.3 x 2.9)
Museum purchase with funds
provided by the Alice Pratt Brown
Museum Fund
86.391

**9.33** Atacameño
Northern Chile
**Snuff Tablet with a Condor,**
900–1100
Wood with green stone inlays
5 5/8 x 2 1/8 x 1 1/2 (14.2 x 5.3 x 3.7)
William J. Hill Land and
Cattle Company Collection
TR:352.1-90

**9.34** Sicán
Peru, North Coast,
Lambayeque Valley, Batán Grande
**Janus-Faced Beaker,**
Middle Sicán, 850–1050
Gold
5 5/16 x 4 11/16 diameter (13.5 x 11.9)
Gift in memory of Alice Pratt
Brown from her children
86.320

**9.35** Inca
Peru, South Coast
**Stepped Beaker (aquilla),**
Late Horizon, 1470–1532
Silver
6 13/16 x 4 5/8 diameter (17.3 x 11.7)
Museum purchase with funds
provided by the Alice Pratt Brown
Museum Fund
90.376

**9.36** Colonial Inca
Peru, South Highlands
**Ceremonial Pouring Vessel
(paccha),** 1675–1725
Chonta wood, resin paint, and nails
7 15/16 x 24 1/16 x 7 (20.2 x 61.1 x 17.8)
Museum purchase with funds
provided by "One Great Night
in November, 1991"
91.1552

10 **Native American Art**

**10.1** Mogollon (Mimbres style)
United States, New Mexico
**Jar (olla) with Geometric
Designs,** Style III, 1025–1150
Earthenware with bichrome
slip painting
16 1/2 x 17 1/4 diameter (41.9 x 43.8)
Museum purchase with funds
provided by Meredith J. Long in
honor of Fayez Sarofim at "One
Great Night in November, 1992"
92.455

**10.2** Mogollon (Mimbres style)
United States, New Mexico
**Bowl with Two Hooked Fish,**
Style III, 1025–1150
Earthenware with bichrome
slip painting
3 15/16 x 9 1/8 diameter (10.6 x 23.2)
Museum purchase with funds
provided by Mrs. Robert E. Hansen
in memory of Gene G. Gables
89.207

**10.3** Mogollon (Casas Grandes style)
Mexico, Chihuahua
**Macaw Bowl,**
Tardío period, 1300–1350
Earthenware with polychrome
slip painting
5 1/4 x 8 x 6 1/4 (13.3 x 20.3 x 15.9)
Gift of Miss Ima Hogg
44.107

**10.4** Pueblo (Acoma)
United States, New Mexico
**Jar (olla) with Abstract Designs,**
c. 1890
Earthenware with polychrome
slip painting
11 1/4 x 14 1/2 diameter (28.6 x 36.8)
Gift of Miss Ima Hogg
44.17

**10.5** Pueblo (Zuni)
United States, New Mexico
**Jar (olla) with Deer, Birds,
and Rosettes,** 1880–85
Earthenware with polychrome
slip painting
9 5/16 x 13 diameter (23.7 x 33)
Gift of Miss Ima Hogg
44.96

**10.6**  Pueblo (Cochiti)
United States, New Mexico
Storage Jar *(olla)* with
Birds in Frames, c. 1885
Earthenware with polychrome
slip painting
21 1/2 x 20 1/16 diameter (54.6 x 51.1)
Gift of Miss Ima Hogg
44.38

**10.7**  Pueblo (Zuni)
United States, New Mexico
Kiva Jar with Frogs, Tadpoles,
Hummingbirds, and Insects,
c. 1900
Earthenware with polychrome
slip painting
10 x 12 1/2 diameter (25.4 x 31.8)
Gift of Miss Ima Hogg
44.170

**10.8**  Pueblo (Cochiti)
United States, New Mexico
Ritual Bowl with Sun (inside)
and Birds, Clouds, Lightning,
and Rain (outside), c. 1890
Earthenware with polychrome
slip painting and rawhide
9 1/2 x 16 1/8 diameter (24.1 x 41)
Gift of Miss Ima Hogg
46.14

**10.9**  Maria Martinez, 1887–1980,
and Julian Martinez, 1885–1943,
Pueblo (San Ildefonso)
United States, New Mexico
Jar *(olla)* with Feathers and
an Avanyu, 1934–43
Matte black-on-black earthenware
14 1/4 x 18 5/8 diameter (36.2 x 47.3)
Gift of Miss Ima Hogg
44.171

**10.10**  Fred Kabotie (Nakayoma),
1900-1986, Pueblo (Hopi)
United States, Arizona,
Shungopovi village
Hopi Corn Dance, c. 1925
Tempera on paper
18 15/16 x 24 7/8 (48.1 x 63.2)
Gift of Miss Ima Hogg
44.291

**10.11**  Pueblo (Hopi)
United States, Arizona
Water-Drinking Maiden
*(Palhik' Mana)* Doll, 1925–33
Wood, paint, and feather
10 1/2 x 7 1/2 x 3 (26.7 x 19.1 x 7.6)
Gift of Miss Ima Hogg
44.414

**10.12**  Pueblo (Zuni)
United States, New Mexico
Doll of Mud-Head or Clown
*(Koyemsi)* Carrying Kiaklo
Kachina, 1910–25
Wood, paint, wool and cotton cloth,
leather, wool yarn, gut, nails, wire,
and string
19 x 7 1/2 x 8 (48.3 x 19.1 x 20.3)
Gift of Miss Ima Hogg
44.427

**10.13**  Pueblo (Hopi)
United States, Arizona
Crow Mother
*(Angwusnasomtaqa)*
Kachina Doll, 1925–33
Wood, paint, wool yarn, and string
15 x 8 1/2 x 4 1/8 (38.1 x 21.6 x 10.6)
Gift of Miss Ima Hogg
44.370

**10.14**  Pueblo (Zuni)
United States, New Mexico
Buffalo *(Siwolo)* Kachina Doll,
c. 1915
Wood, paint, feathers, horns,
leather, buffalo fur, rawhide,
cotton cloth, satin ribbon, tin,
nails, and string
17 x 6 x 5 1/4 (43.2 x 15.2 x 13.3)
Gift of Miss Ima Hogg
44.438

**10.15**  Navajo
United States, Arizona or
New Mexico
Phase III Chief Blanket, 1880–90
Wool
65 x 78 1/2 (165.1 x 199.4)
The McDannald Collection,
gift of Arthur T. McDannald
63.197

**10.16**  Western Apache
United States, Arizona
Tray with Rosettes, Humans,
and Crosses, c. 1900
Willow, devil's claw, and yucca root
3 5/8 x 16 3/8 diameter (9.2 x 41.6)
Museum purchase with funds
provided by Fayez Sarofim & Co.
in honor of Meredith J. Long and
Morton A. Cohn at "One Great
Night in November, 1993"
93.382

**10.17**  Navajo
United States, Arizona or
New Mexico
Squash-Blossom Necklace,
1910–25
Silver, turquoise, and string
Length 21 1/2 (54.6)
Pendant 3 1/4 x 2 5/8 (8.3 x 6.7)
Gift of Mrs. O. S. Simpson, Jr.
70.67

11 Oceanic Art

**11.1** Karawari
Papua New Guinea, Middle Sepik,
Manjamai village
**Crocodile,** early 20th century
Wood and paint
15 1/2 x 275 x 14 (39.4 x 698.5 x 35.6)
Gift of Houston Endowment, Inc.
61.46

**11.2** Australia,
Western Arnhem Land
**Kangaroo Painting from a
Bush Shelter,** mid-20th century
Eucalyptus bark and paint
55 1/2 x 34 (141 x 86.4)
Museum purchase
64.19

**11.3** Asmat
Indonesia, Irian Jaya
**War Shield (jamasj),**
mid-20th century
Wood and paint
79 3/4 x 23 1/4 x 3 1/2
(202.6 x 59.1 x 8.9)
Museum purchase with funds
provided by the Alice Pratt Brown
Museum Fund
91.1924

**11.4** Chief Tofor
Vanuatu, Ambrym Island,
Fanla village
**Slit-Drum (tamtam),** 1960–70
Wood and paint
144 x 22 x 22 (365.8 x 55.9 x 55.9)
Museum purchase with funds
provided by the Alice Pratt Brown
Museum Fund
91.48

**11.5** Kapriman
Papua New Guinea, Middle Sepik,
Tunggambit village
**Janus-Faced Post for a
Men's House,** 1900–1950
Wood, conus shell, and paint
102 3/4 x 28 1/2 x 17 1/2
(261 x 72.4 x 44.5)
Museum purchase with funds
provided by the Director's Fund
61.56

**11.6** Probably Sawos
Papua New Guinea, Middle Sepik
**War Shield,** before 1918
Wood, paint, branch, rattan,
and bark
53 x 12 x 6 (134.7 x 30.5 x 15.2)
Museum purchase with funds
provided by Mr. Robert Cruikshank
in honor of Mr. and Mrs. Meredith
J. Long at "One Great Night in
November, 1989"
89.259

**11.7** Probably Arambak
Papua New Guinea, Middle Sepik
**Male Spirit Mask,** 1900–1925
Cane, other plant fibers, cassowary
feathers, mud, and paint
47 x 23 1/2 x 28 (119.4 x 59.7 x 71.1)
Museum purchase with funds
provided by Lester Smith in honor
of Harry H. Cullen at "One Great
Night in November, 1993"
93.390

**11.8** Papua New Guinea,
New Ireland
**Helmet Mask (tatanua),**
late 19th century
Wood, paint, opercula shells, lime
plaster, plant fiber, bark, bark cloth,
rattan, and cord
15 1/4 x 9 1/2 x 12 (38.7 x 24.1 x 30.5)
Museum purchase with funds
provided by an anonymous donor
90.256

**11.9** Solomon Islands,
Malaita Island
**Forehead Ornament (kapkap),**
before 1910
Tridacna shell, turtle shell, stone
and shell beads, and plant fiber
5 1/4 diameter x 5/8 (13.3 x 1.6)
Museum purchase with funds
provided by the Alice Pratt Brown
Museum Fund
86.412

**11.10** Santa Cruz Islands,
Ndeni Island
**Chest Ornament (tema),**
before 1890
Tridacna shell, turtle shell,
stone, animal teeth, glass button,
glass beads, and hibiscus fiber
6 1/2 diameter x 3/8 (16.5 x 1)
Museum purchase with funds
provided by the Brown Foundation
Accessions Endowment Fund
88.1

12 20th-Century Art

**12.1** Pablo Picasso, Spanish,
1881–1973
**The Rower,** 1910
Oil on canvas
28 3/8 x 23 1/2 (72.1 x 59.7)
Museum purchase with funds
provided by Oveta Culp Hobby,
Isaac and Agnes Cullen Arnold,
Charles E. Marsh, Mrs. William
Stamps Farish, the Robert Lee
Blaffer Memorial Collection, gift
of Sarah Campbell Blaffer, by
exchange, and the Brown Foundation
Accessions Endowment Fund
81.29
© 1999 Estate of Pablo Picasso/
Artists Rights Society (ARS),
New York

**12.2** Pablo Picasso, Spanish,
1881–1973
**Pipe and Sheet Music,** 1914
Gouache and graphite on
pasted papers
20 1/2 x 26 1/2 (52.1 x 67.3)
Gift of Mr. and
Mrs. Maurice McAshan
69.11
© 1999 Estate of Pablo Picasso/
Artists Rights Society (ARS),
New York

**12.3** Fernand Léger, French,
1881–1955
**Man with a Cane,** 1920
Oil on canvas
36 1/4 x 25 1/2 (92.1 x 64.8)
Gift of Mrs. Charles W. Engelhard
84.197
© 1999 Artists Rights Society
(ARS), New York/ADAGP, Paris

**12.4** Pablo Picasso, Spanish,
1881–1973
**Two Women in Front of a
Window,** 1927
Oil on canvas
38 1/2 x 51 1/2 (97.8 x 130.8)
Gift of Mr. and
Mrs. Theodore N. Law
64.17
© 1999 Estate of Pablo Picasso/
Artists Rights Society (ARS),
New York

**12.5** Piet Mondrian, Dutch, 1872–1944
**Composition with Gray and Light Brown,** 1918
Oil on canvas
31 9/16 x 19 5/8 (80.2 x 49.8)
Gift of Mr. and Mrs.
Pierre Schlumberger
63.16

**12.6** Constantin Brancusi, Romanian, 1876–1957
**A Muse,** 1917
Polished bronze and limestone
19 5/8 x 11 11/16 x 9 5/8
(49.8 x 29.7 x 24.4)
Museum purchase with funds provided by Mrs. Herman Brown and Mrs. William Stamps Farish
62.1
© 1999 Artists Rights Society (ARS), New York/ADAGP, Paris

**12.7** Henri Matisse, French, 1869–1954
**Olga Merson,** 1911
Oil on canvas
39 1/4 x 31 3/4 (99.7 x 80.6)
Museum purchase with funds provided by the Agnes Cullen Arnold Endowment Fund
78.125
© 1999 Succession H. Matisse, Paris/Artists Rights Society (ARS), New York

**12.8a** Arnold Newman, American, born 1918
**Jackson Pollock, Springs, 1949,** 1949
Gelatin silver photograph
12 1/8 x 10 1/4 (30.8 x 26)
TR:445-99
© Arnold Newman

**12.8** Jackson Pollock, American, 1912–1956
**Number 6,** 1949
Duco and aluminum paint on canvas
44 3/16 x 54 (112.2 x 137.2)
Gift of D. and J. de Menil
64.36
© 1999 Pollock-Krasner Foundation/Artists Rights Society (ARS), New York

**12.9** Jackson Pollock, American, 1912–1956
**Untitled,** c. 1949
Wire dipped in plaster and spattered with paint
2 3/4 x 3 11/16 x 3 1/16 (7 x 9.4 x 7.7)
Museum purchase with funds provided by Louisa Stude Sarofim in memory of Alice Pratt Brown
96.1758
© 1999 Pollock-Krasner Foundation/Artists Rights Society (ARS), New York

**12.10** Franz Kline, American, 1910–1962
**Wotan,** 1950
Oil on canvas, mounted on Masonite
55 x 79 5/16 (139.7 x 201.5)
Museum purchase, by exchange
80.120

**12.11** Franz Kline, American, 1910–1962
**Untitled (Study for Wotan),** 1950
Watercolor and gouache on paper
5 7/16 x 8 9/16 (13.8 x 21.7)
Museum purchase with funds provided by the Caroline Wiess Law Accessions Endowment Fund
96.848

**12.12** Lee Krasner, American, 1908–1984
**Blue and Black,** 1951–53
Oil on canvas
57 3/4 x 82 1/2 (146.7 x 209.6)
Museum purchase with funds provided by the Sarah Campbell Blaffer Foundation
80.42
© 1999 Pollock-Krasner Foundation/Artists Rights Society (ARS), New York

**12.13** Robert Motherwell, American, 1915–1991
**Black on White,** 1961
Oil on canvas
78 x 163 3/16 (198.1 x 414.5)
Museum purchase
62.7
© Dedalus Foundation/Licensed by VAGA, New York, NY

**12.14** Mark Rothko, American, 1903–1970
**Painting,** 1961
Oil on canvas
92 7/8 x 80 (235.9 x 203.2)
Museum purchase
67.19
© 1999 Kate Rothko Prizel & Christopher Rothko/Artists Rights Society (ARS), New York

**12.15** Helen Frankenthaler, American, born 1928
**Blue Rail,** 1969
Acrylic on canvas
106 15/16 x 93 3/4 (271.6 x 238.1)
Museum purchase with funds provided by the National Endowment for the Arts and the Friends of Modern Art
73.82

**12.16** Kenneth Noland, American, born 1924
**Half,** 1959
Acrylic on canvas
68 5/8 x 68 5/8 (174.3 x 174.3)
Museum purchase
74.260
© Kenneth Noland/Licensed by VAGA, New York, NY

**12.17** Joseph Glasco, American, 1925–1996
**Untitled,** 1995
Acrylic on canvas
81 3/16 x 61 3/16 x 1 3/8 (206.2 x 155.4 x 3.5)
Museum purchase with funds provided by the Caroline Wiess Law Accessions Endowment Fund
96.856
© Estate of Joseph Glasco

**12.18** Dorothy Antoinette (Toni) LaSelle, American, born 1901
**Puritan,** 1947–50
Oil on canvas
25 x 30 (63.5 x 76.2)
Museum purchase with funds provided by the Frank Freed Memorial Painting Fund
95.45
© Dorothy LaSelle

**12.19** Dorothy Hood, American, born 1919
**Haiti**, 1969
Oil on canvas
120 x 96 (304.8 x 243.8)
Gift of Mr. and Mrs.
Meredith J. Long
70.68

**12.20** John Biggers, American, born 1924
**Jubilee: Ghana Harvest Festival,** 1959–63
Tempera and acrylic on canvas
38 3/8 x 98 (97.5 x 248.9)
Museum purchase with funds provided by Duke Energy
85.3

**12.21** Pablo Picasso, Spanish, 1881–1973
**Woman with Outstretched Arms,** 1961
Painted iron and metal sheeting
70 5/16 x 61 9/16 x 28 9/16 (178.6 x 156.4 x 72.5)
Gift of the Esther Florence Whinery Goodrich Foundation
66.15
© 1999 Estate of Pablo Picasso/ Artists Rights Society (ARS), New York

**12.22** Alexander Calder, American, 1898–1976
**The Crab,** 1962
Painted steel
120 x 240 x 120 (304.8 x 609.6 x 304.8)
Museum purchase
62.11
© 1999 Estate of Alexander Calder/ Artists Rights Society (ARS), New York

**12.23** Lee Bontecou, American, born 1931
**Untitled,** 1962
Welded metals and canvas
68 x 72 x 30 (172.7 x 182.9 x 76.2)
Gift of D. and J. de Menil
62.45

**12.24** Louise Nevelson, American, born Russia, 1900–1988
**Mirror Image I,** 1969
Painted wood
12 x 220 1/2 x 26 (30.5 x 560.1 x 66)
Gift of The Brown Foundation, Inc.
69.10.1–.20
© Courtesy of Louise Nevelson and PaceWildenstein

**12.25** Ellsworth Kelly, American, born 1923
**Green and Black,** 1988
Oil on canvas
Overall irregular shape 96 x 132 (243.8 x 335.3)
Museum purchase with funds provided by the Brown Foundation Accessions Endowment Fund
89.11.A,.B

**12.26** Agnes Martin, American, born 1912
**Untitled #12,** 1990
Acrylic and graphite on canvas
72 x 72 (182.9 x 182.9)
Museum purchase with funds provided by the Caroline Wiess Law Accessions Endowment Fund
98.119
© Courtesy of Agnes Martin and PaceWildenstein

**12.27** Donald Judd, American, 1928–1994
**Untitled,** 1975
Brass and painted aluminum
36 1/8 x 60 x 60 diameter (91.8 x 152.4 x 152.4)
Museum purchase with funds provided by the National Endowment for the Arts and The Brown Foundation, Inc.
75.370.A–.E
© Estate of Donald Judd/Licensed by VAGA, New York, NY

**12.28** Jo Baer, American, born 1929
**Untitled (Stations of the Spectrum Triptych),** c. 1964–74
Oil on canvas
Three panels, each 72 x 72 (182.9 x 182.9)
Museum purchase with funds provided by the National Endowment for the Arts and Joan H. Fleming, Mrs. Colletta Lake Ray, Mrs. Oscar Wyatt, and an anonymous donor
77.6.1–.3

**12.29** Niki de Saint Phalle, French, born 1930
**Gorgo in New York,** 1962
Mixed media
95 3/4 x 193 x 19 1/2 (243.2 x 490.2 x 49.5)
Gift of D. and J. de Menil
62.47.1–.4
© Niki de Saint Phalle

**12.30** Jean Tinguely, Swiss, 1925–1991
**La Bascule VII,** 1967
Iron rocker bars, wood flywheel, steel tube, rubber V-belt, and electric motor
48 1/4 x 32 1/4 x 80 1/2 (122.6 x 81.9 x 204.5)
Gift of the artist
68.44
© Niki de Saint Phalle

**12.31** Roy Lichtenstein, American, 1923–1997
**Still Life with Pitcher,** 1975
Oil and magna on canvas
60 x 40 (152.4 x 101.6)
Museum purchase with funds provided by Mrs. George R. Brown
84.154
© Estate of Roy Lichtenstein

**12.32** Claes Oldenburg, American, born 1929
**Giant Soft Fan (Ghost Version),** 1967
Canvas, wood, and foam rubber
120 x 59 x 64 (304.8 x 149.9 x 162.6)
Gift of D. and J. de Menil
67.18.A,.B
© Courtesy of Claes Oldenburg and PaceWildenstein

**12.33** Andy Warhol, American, 1930–1987
**Self-Portrait,** 1986
Acrylic screenprint on canvas
80 x 80 (203.2 x 203.2)
Museum purchase with funds provided by the Charles Engelhard Foundation in honor of Linda L. Cathcart, director of the Contemporary Arts Museum from 1979 to 1987
88.34
© 1999 Andy Warhol Foundation for the Visual Arts/ARS, New York

**12.34** James Rosenquist, American, born 1933
**Evolutionary Balance,** 1977
Oil on canvas, mounted on panel
80 3/4 x 183 x 2 3/4 (205 x 465 x 7)
Museum purchase with funds provided by the Charles Engelhard Foundation
81.60
© James Rosenquist/Licensed by VAGA, New York, NY

**12.35** Elmer Bischoff, American,
1916–1991
**Interior with Two Figures,** 1968
Oil on canvas
79 3/4 x 79 5/8 (202.57 x 202.25)
Museum purchase with funds
provided by the Alice Pratt Brown
Museum Fund
92.113
© Courtesy of the Estate of Elmer
Bischoff and John Berggruen
Gallery, San Francisco

**12.36** Richard Diebenkorn,
American, 1922–1993
**Ocean Park #124,** 1980
Oil on canvas
93 1/8 x 81 1/8 (236.5 x 206.1)
Museum purchase with funds
provided by George R. Brown in
honor of his wife, Alice Pratt Brown
80.145

**12.37** Philip Guston, American,
1913–1980
**Legend,** 1977
Oil on canvas
69 x 78 1/2 (175.3 x 199.4)
Museum purchase with funds
provided by the Alice Pratt Brown
Museum Fund
88.35

**12.38** Jasper Johns, American,
born 1930
**Ventriloquist,** 1983
Encaustic on canvas
75 x 50 (190.5 x 127)
Museum purchase with funds
provided by the Agnes Cullen
Arnold Endowment Fund
84.87
© Jasper Johns/Licensed by
VAGA, New York, NY

**12.39** Susan Rothenberg,
American, born 1945
**Red Banner,** 1979
Acrylic on canvas
90 x 123 7/8 (228.6 x 314.6)
Museum purchase with funds
provided by the National
Endowment for the Arts and
Mrs. Theodore N. Law
79.263

**12.40** Nancy Graves, American,
1940–1995
**Head on a Spear,** 1969
Steel, wax, marble dust, acrylic,
animal skin, and oil paint
87 x 21 1/2 x 13 diameter
(221 x 54.6 x 33)
Museum purchase with funds
provided by the Alice Pratt Brown
Museum Fund
90.422
© Nancy Graves Foundation/
Licensed by VAGA, New York, NY

**12.41** Luis Cruz Azaceta,
American, born Cuba, 1942
**A Question of Color,** 1989
Acrylic on unstretched canvas
120 x 144 (304.8 x 365.8)
Museum purchase with funds
provided by the National
Endowment for the Arts and the
Prospero Foundation in honor
of Dr. Peter C. Marzio and the
exhibition *Hispanic Art in the United
States: Thirty Contemporary Painters
and Sculptors* (1987)
89.320

**12.42** Georg Baselitz, German,
born 1938
**The Lamentation,** 1983
Oil on canvas
118 1/4 x 98 1/2 (300.4 x 250.2)
Museum purchase with funds
provided by the Charles Engelhard
Foundation, the Vaughn Foundation
Fund, and Isabel B. and
Wallace S. Wilson
86.26
© Courtesy of Georg Baselitz and
PaceWildenstein

**12.43** Anselm Kiefer, German,
born 1945
**Der Nibelungen Leid (The
Sorrow of the Nibelungen),** 1973
Oil and charcoal on burlap
118 1/8 x 173 1/4 (300 x 440.1)
Museum purchase with funds
provided by the Caroline Wiess Law
Accessions Endowment Fund
98.52

**12.44** Keith Carter, American,
born 1948
**Fireflies,** 1992
Gelatin silver photograph
15 1/4 x 15 3/16 (38.7 x 38.6)
Gift of Joan Morgenstern
in honor of Sam Lasseter
93.370

**12.45** James Surls, American,
born 1943
**I Am Building with the Axe, the
Knife, and the Needle's Eye,** 1982
Hickory, oak, pine, padouk, and
mahogany
160 height (406.7)
Museum purchase with funds
provided by Duke Energy
82.489.1–.4

**12.46** Kermit Oliver, American,
born 1943
**K. J.'s Calf,** 1975
Acrylic on Masonite
24 3/8 x 48 (61.9 x 121.9)
Museum purchase with funds
provided by an anonymous donor
at "One Great Night in November,
1991"
91.1560

**12.47** Christian Boltanski, French,
born 1944
**Monuments (La Fête du Pourim),**
1989
21 gelatin silver photographs
covered with glass and sealed
with black adhesive tape, 21 metal
biscuit boxes, 168 light fixtures
with bulbs, and black electric wire
and connectors
Each image/sheet 15 3/4 x 11 7/8
(40 x 30.2)
Each biscuit box 2 3/8 x 9 1/8 x 8 1/2
(6 x 23.2 x 21.6)
Museum purchase with funds
provided by the Brown Foundation
Accessions Endowment Fund
89.284.1A–.2U
© Courtesy Marian Goodman
Gallery, New York

**12.48** Vicki Meek, American,
born 1950
**The Crying Room: A Memorial
to the Ancestors,** 1992
Mixed-media installation
Dimensions variable
Museum purchase with funds
provided by A.T.&T.
New Art/New Visions
and the Wilder Foundation
93.255.A–.Z

**12.49** Richard Long, English, born 1945
**Ring of Flint**, 1996
English flint
240 diameter (610)
Museum purchase with funds provided by
The Brown Foundation, Inc.
97.167.1

**East West Circle**, 1996
Black river stones
196 diameter (490)
Museum purchase with funds provided by Max and Isabell Smith Herzstein, Jeanne and Mickey Klein, and members of the Twentieth-Century Art Subcommittee
97.168.1

**12.50** Per Kirkeby, Danish, born 1938
**Inferno II**, 1992
Oil on canvas
78 3/4 x 67 (200 x 170.2)
Museum purchase with funds provided by Caroline Wiess Law Accessions Endowment Fund
97.110

**12.51** Ezra Stoller, American, born 1915
**W. L. Moody Building**, 1965
Gelatin silver photograph
13 5/16 x 10 5/8 (33.8 x 16 1/8)
Museum purchase
65.287
Ezra Stoller © Esto

**12.52** Eduardo Chillida, Spanish, born 1924
**Abesti Gogora V**, 1966
Granite
179 1/2 x 221 x 168 1/2
(455.9 x 561.3 x 428)
Gift of Houston Endowment, Inc., in memory of Mr. and Mrs. Jesse H. Jones
66.16

**12.53** Frank Stella, American, born 1936
**"Stella by Starlight" MFAH Ball Murals**, 1982, reworked 1983
Watercolor, graphite, and printed grids on collaged paper, mounted on board
Museum purchase with funds provided by Mr. and Mrs. S. M. McAshan, Jr.
82.474.1–.15

**12.54** Ellsworth Kelly, American, born 1923
**Houston Triptych**, 1986
Bronze
146 x 96 3/8 x 7/8
(370.8 x 244.8 x 2.22)
108 1/4 x 120 x 7/8 (275 x 304.8 x 2.22)
126 x 138 1/8 x 7/8 (320 x 350.8 x 2.22)
Museum purchase with funds provided by The Brown Foundation, Inc., and Mr. and Mrs. M. S. Stude in honor of Mr. and Mrs. George R. Brown
86.487.1–.3

**12.55** Jim Love, American, born 1927
**Can Johnny Come Out and Play?**, 1990–91
Bronze
107 diameter (271.8)
Gift of Caroline Wiess Law in memory of Theodore N. Law
90.419

**12.56** Tony Cragg, English, born 1949
**New Forms**, 1991–92
Bronze
80 x 97 x 74 1/2 (203.2 x 246.4 x 189.2)
101 x 57 1/2 x 60 1/2 (256.5 x 146.1 x 153)
Museum purchase with funds provided by The Schissler Foundation
92.170.1,.2
© Courtesy Marian Goodman Gallery, New York

**12.57** Serge Hambourg, French, born 1936
**National Farmer's Bank, Owatonna, Minnesota**, 1987
Chromogenic photograph
15 1/2 x 15 3/8 (39.4 x 39.1)
Commissioned and acquired in conjunction with Parnassus Foundation
90.66

**12.58** Edward Burtynsky, Canadian, born 1955
**MBank, Momentum Place, Dallas**, 1988
Color coupler photograph
8 1/2 x 14 5/8 (21.6 x 37.1)
Commissioned and acquired in conjunction with Parnassus Foundation
90.242

**12.59** Robert Moskowitz, American, born 1935
**Giacometti Piece IV**, 1997
Pastel on paper
108 x 41 1/2 (274.3 x 105.4)
Museum purchase with funds provided by Mr. and Mrs. Wallace D. Wilson
98.75
© Courtesy Lawrence Markey Gallery, New York

**Giacometti Piece II**, 1997
Pastel on paper
108 x 41 1/2 (274.3 x 105.4)
Museum purchase with funds provided by Mr. and Mrs. Wallace D. Wilson
98.76
© Courtesy Lawrence Markey Gallery, New York

**12.59a** Alberto Giacometti, Swiss, 1901–1966
**Tall Figure**, 1948–49
Bronze
65 x 6 1/2 x 13 1/2 (165.1 x 16.5 x 34.3)
Gift of Robert Sarnoff
76.369
© 1999 Artists Rights Society (ARS), New York/ADAGP, Paris

**12.60** Joseph Havel, American, born 1954
**Curtain**, 1999
Cast silicon bronze on a stainless steel frame
Two panels, each 114 x 117
(289.6 x 297.2)
Museum commission with funds provided in memory of Allen H. Carruth by Mrs. Allen H. Carruth

**12.61** James Turrell, American, born 1943
**The Light Inside** (not illustrated), 1999
Neon light, projected light, gypsum board, plaster, glass, and oak
132 x 246 x 1416 (335.3 x 624.8 x 3596.6)
Museum commission with funds provided by Isabel B. and Wallace S. Wilson

13 20th-Century Decorative Arts

**13.1** Emile Gallé, French,
1846–1904
**Vase,** c. 1895–1900
Glass
10 1/2 x 5 9/16 diameter (26.7 x 14.1)
Gift of J. Brian and Varina Eby
73.141

**13.2** Vilmós Zsolnay, Hungarian,
1828–1900
Manufactured by Zsolnay,
Hungarian, established 1862
**Bottle,** 1890–1900
Porcelain-faience
9 1/2 x 7 3/16 x 3 3/16 (24.1 x 18.3 x 8.1)
Gift of Mr. and Mrs.
John W. Mecom, Jr.
80.182

**13.3** Louis Comfort Tiffany,
American, 1848–1933
**Vase,** c. 1892–93
Glass
21 1/2 x 8 3/8 (54.6 x 21.3)
Museum purchase with funds
provided by J. Brian and Varina Eby,
by exchange
90.378

**13.4** Magdalene Odundo, Kenyan,
born 1950
**Vase,** 1995
Red clay
16 3/4 x 13 x 12 1/2 (42.6 x 33 x 31.7)
Museum purchase with funds
provided by Helena Woolworth
McCann and the Winfield
Foundation, by exchange
96.803

**13.5** Wendell Castle, American,
born 1932
**Coat Rack with Trench Coat,** 1978
Mahogany
75 x 22 7/8 x 21 1/2 (190.5 x 58.1 x 54.6)
Museum purchase with funds
provided by Roy M. Huffington,
Inc., and anonymous donors
84.299

**13.6** Barry R. Sautner, American,
born 1952
**The Mended Web II,** 1991
Glass
14 x 5 3/16 x 5 3/16 (35.6 x 13.2 x 13.2)
Museum purchase with funds
provided by J. Brian and Varina Eby,
by exchange
91.63

**13.7** Jean Prouvé, French,
1901–1984
Made by Les Ateliers Jean Prouvé
**Folding Chair,**
designed c. 1924–28, made 1929
Steel and linen canvas
40 1/4 x 17 1/2 x 18 5/8
(102.9 x 44.4 x 47.3)
Museum purchase with funds
provided by J. Brian and Varina Eby,
by exchange
97.192
© 1999 Artists Rights Society (ARS),
New York/ADAGP, Paris

**13.8** Ludwig Mies van der Rohe,
German, 1886–1969
Manufactured by Berliner
Metallgewerbe Josef Müller,
German
**Barcelona Chair (Model MR 90),**
1929–30
Chromed steel and leather
28 3/4 x 29 1/8 x 30 (73 x 74 x 76)
Museum purchase with funds
provided by J. Brian and Varina Eby,
by exchange
97.354
© 1999 Artists Rights Society
(ARS), New York/VG Bild-Kunst,
Bonn

**13.9** Le Corbusier (born Charles-
Edouard Jeanneret), Swiss,
1887–1965, Pierre Jeanneret, Swiss,
1896–1967, and Charlotte Perriand,
French, born 1903
Manufactured by Embru-Werke AG,
Swiss, established 1904
**Chaise Longue, Model 2072,**
designed 1928–29, made c. 1933–37
Chromed steel, iron, leather, canvas,
and rubber
26 x 21 1/4 x 63 (66 x 54 x 160)
Museum purchase with funds
provided by The Brown Foundation,
Inc., in memory of Sally Walsh
92.190.A–.C
© 1999 Artists Rights Society (ARS),
New York/ADAGP, Paris/FLC

**13.10** Frank O. Gehry, American,
born 1929, in collaboration with
Robert Irwin, American, born 1928
Made by Jack Brogan, American
**Working Prototype for the Easy
Edges Dining Chair,** c. 1970–72
Corrugated box material, pressed
fiber, and Masonite
32 1/2 x 20 x 16 3/16 (82.6 x 50.8 x 41.1)
Museum purchase with funds
provided by Mrs. David M.
Carmichael, Michael W. Dale,
Susan Garwood, Mrs. Jack Lapin,
Mrs. Rodney H. Margolis, Katsy
Mullendore Mecom, Sue Rowan
Pittman, Mrs. Melvyn Wolff,
Mr. and Mrs. Jimmy Younger, and
Nina and Michael Zilkha
96.609

**13.11** Gaetano Pesce, Italian,
born 1939
**Prototype for the Pratt Chair
Series,** 1982
Polyurethane
34 5/8 x 18 1/4 x 20 1/4
(87.9 x 46.4 x 51.4)
Museum purchase
with funds provided by
Nina and Michael Zilkha
98.41
© PESCE Limited

20th-Century Chairs

Karl Emanuel Martin (Kem) Weber,
American, 1889–1963
Manufactured by Airline Chair Co.,
American
**Airline Chair,** 1934
Maple and oil cloth
31 x 34 x 24 7/8 (78.7 x 86.4 x 63.2)
Museum purchase with funds
provided by J. Brian and Varina Eby,
by exchange
98.40

Charles Eames, American,
1907–1978, and Ray Kaiser Eames,
American, 1912–1988
Manufactured by Evans Products
Company, Molded Plywood
Division, American, established 1919
Retailed by Herman Miller
Furniture Company, American,
established 1923
**Lounge Chair, Model LCW,**
designed 1945–46, made 1946–49
Birch-faced plywood and rubber
26 11/16 x 24 x 22 (67.8 x 61 x 55.9)
Gift of Mr. William J. Hill
95.200

20th-Century Chairs (continued)

Charles Eames, American,
1906–1978 and Ray Kaiser Eames,
American, 1912–1988
Manufactured by Zenith Plastics,
American
Retailed by Herman Miller
Furniture Company, American,
established 1923
**Armchair, Model SAX,** 1950–53
Fiberglass, metal, and rubber
29 3/8 x 24 7/8 x 24 1/2
(74.6 x 63.2 x 62.2)
Gift of Mr. and Mrs.
Garrett R. Tucker, Jr.
98.74.2

Harry Bertoia, American, born Italy,
1915–1978
Manufactured by Knoll Associates,
American, established 1938
**Large Diamond Chair, Model 422,**
1952
Welded steel, paint, upholstery,
and rubber
27 1/2 x 44 3/4 x 31
(69.8 x 113.7 x 78.7)
Museum purchase with funds
provided by Mr. Herbert Wells
and Mrs. Miranda Leonard
96.857

Jonathan De Pas, Italian, 1932–1991,
Donato D'Urbino, Italian, born
1930, and Paolo Lomazzi, Italian,
born 1936
Manufactured by Poltronova,
Italian, established 1965
**Joe Sofa,** designed 1970,
made before 1981
Leather, polyurethane, and metal
32 1/8 x 67 1/4 x 40 1/8
(81.6 x 170.8 x 101.9)
Gift of the Houston Astros Baseball
Club and Drayton McLane
94.106.A,.B
© Poltronova

Studio 65, Italian, established 1965
Manufactured by Gufran, Italian
**Bocca (Lips),** designed 1970,
made after 1972
Polyurethane, metal, and upholstery
33 x 82 3/4 x 32 (83.8 x 210.2 x 81.3)
Museum purchase with funds
provided by friends of Susan Lapin
96.1749

Lella Vignelli, Italian, born 1930s,
and Massimo Vignelli, Italian,
born 1931, with David Law,
American, born 1937
Manufactured by Knoll
International, American,
established 1938
**Handkerchief Chair,**
designed 1979, made 1985
Plastic and steel
29 1/8 x 22 3/4 x 21 1/2 (74 x 57.8 x 54.6)
Gift of Lella and Massimo Vignelli
98.637

Venturi, Rauch, and Scott Brown,
American, established 1958
Manufactured by Knoll
International, American,
established 1938
**"Queen Anne" Side Chair,**
designed 1979–84,
manufactured 1984
Plywood and plastic laminate
39 x 26 1/2 x 23 1/2 (99.1 x 67.3 x 59.1)
Gift of Knoll International
through Gerry Fehn,
Houston Regional Manager
90.486
© Venturi, Scott Brown and
Associates, Inc.

Frank Gehry, American,
born Canada, 1929
Manufactured by Knoll Studio,
American, established 1938
**Hat Trick Side Chair,**
designed 1989–91, made 1994
Maple
33 1/2 x 18 3/4 x 21 (85.1 x 47.6 x 53.3)
Gift of Dr. and Mrs. Peter C. Marzio
97.213.1

Philippe Starck, French, born 1950
Manufactured by Vitra, German,
established 1957
**W. W. Stool,**
designed 1991, made 1996
Aluminum and paint
38 1/16 x 22 (96.7 x 55.9)
Museum purchase with
funds provided by
Mr. B. N. Woodson in honor of
Grace, Olivia, and Cate at "One
Great Night in November, 1996"
96.1711

Ron Arad, Israeli, born 1951
Manufactured by Ron Arad Studio,
Italian, established 1994
**Narrow Paparadelle Chair,**
designed 1992, made 1998
Stainless steel and steel
Fully unrolled 42 x 16 x 118 1/8
(106.7 x 40.6 x 300)
Museum purchase with funds
provided by the Sealy Family Trust,
by exchange
98.525

Bill Stumpf, American, and
Don Chadwick, American
Manufactured by Herman Miller
Furniture Company, American,
established 1923
**Aeron Chair,**
designed 1994, made 1997
36 1/8 x 27 x 24 (91.8 x 68.6 x 61)
Pellicle, leather, steel, and plastic
The Twentieth-Century Collection
of the Texas Gulf Coast Chapter of
the American Society of Interior
Designers, gift of Herman Miller
97.227

Pol Quadens, Belgian, born 1960
Manufactured by Pol International
Design Co., Belgian, established 1993
**Chair, Model C06,**
designed 1995, made 1997
Carbon, Kevlar, glass fiber,
and epoxy
32 1/4 x 16 1/8 x 23 (16.1 x 41.0 x 58.4)
Museum purchase with funds
provided by Michael Dale and by
Sue Rowan Pittman in honor of
Michael Dale
97.226

15  Textiles and Costume

**15.1** Jean-Philippe Worth, French, 1856–1926
**Evening Dress,** 1896
Patterned satin, sequins, seed beads, cordonnet, frisé, and cotton lace
Museum purchase with departmental funds and funds provided by Ellen English
93.404.A,.B

**15.2** Jeanne Lanvin, French, 1867–1946
**Day Dress,** 1909
Mousseline de soie and gold soutache braid
Museum purchase with funds provided by the Moselle B. Pollack Fund in honor of her 80th birthday and donations by Mrs. Pollack's grandchildren: Karen and Roy Brooks, Susan and Forrest Bruch, Nancy and Robbie Risman, Debbie and Ricky Kaplan, Melanie and Larry Margolis, Jill and Jeff Levenson, Elizabeth Asch, Marcy and Bill Gabella, Debbie Singer, and Hal Stein, with additional funding provided by Milton and Moselle Pollack and the Textiles and Costume Institute
96.947

**15.3** Natacha Rambova, American, 1897–1969
**Evening Coat,** c. 1927–31
Silk velvets and metallic and silk threads
Museum purchase with funds provided by the Textiles and Costume Institute
92.107

**15.4** Gilbert Adrian, American, 1903–1959
**Day Ensemble,** c. 1946
Printed silk crepe with circus motif
Museum purchase with funds provided by the Textiles and Costume Institute
92.108.A–.C

**15.5** Indian
Gujarat
**Patola Sari,** c. 1900–1933
Silk, double ikat
178 x 48 (452.1 x 121.9)
Gift of Miss Annette Finnigan
33.52

**15.6** Indonesian
Sumatra, Minangkabau, Solok village
**Ceremonial Shoulder Cloth** *(salendang),* c. 1900
Silk with gold-and-silver-wrapped threads and gold
9 x 75 (22.9 x 190.5)
Museum purchase in honor of Mr. Alfred C. Glassell, Jr., with funds provided by Mr. Peter C. Knudtzon, by exchange
97.129

**15.7** Attributed to James Leman, English, c. 1688–1745, or Samuel Baudouin, English
**Fabric,** c. 1730
Brocaded silk
21 x 40 (53.3 x 101.6)
Museum purchase with departmental funds
93.403

**15.8** English
**Apron,** c. 1760
Silk taffeta, metallic embroidery, and lace
40 1/2 x 20 3/4 (102.9 x 52.7)
Museum purchase with funds provided by the Textiles and Costume Institute
91.1355

**15.9** Greek (Attic)
**Bridal/Festive Ensemble,** c. 1900
Cottons and wools, embroidered with polychrome silk and metallic thread
Gift of Miss Annette Finnigan
35.9.A–.M

**15.10** Cristóbal Balenciaga, Spanish, 1875–1972
**Evening Ensemble,** 1954
Cream silk satin
Museum purchase with funds provided by the Textiles and Costume Institute
91.1344.A,.B

**15.11** Vivienne Westwood, English, born 1941, and Malcolm McLaren, English, born 1946, for Seditionaries—Clothes for Heroes
**Punk Ensemble,** 1977
Cottons, wool, and chrome trimmings
Museum purchase with funds provided by the Costume Institute Founders' Fund
86.700.1–.3

**15.12** African
Kuba (Bushong subgroup)
Congo (Kinshasa)
**Woman's Skirt with Appliquéd Designs,**
late 19th or early 20th century
Raffia
32 1/8 x 208 (81.6 x 528.3)
Museum purchase with funds provided by the Museum Collectors
91.310

**15.13** Bill Blass, American, born 1922
**Pantsuit,** 1983
Wool, silk ribbon, sequins, bugle beads, and paillettes
Gift of Lynn Wyatt
96.704

**15.14** Issey Miyake, Japanese, born 1938
**"Flying Saucer" Gown,** 1994
Pleated polyester
Gift of the Miyake Design Studio
94.1224

**15.15** Made in Italy for I. Miller
Distributed by I. Magnin, American, established 1876
**Pair of Shoes,** c. 1920s
Woven Art Deco patterned silk and silver kid
Museum purchase with funds provided by the Textiles and Costume Institute
91.1354.A,.B

**15.16** Jean Schlumberger, French, 1907–1987 (active in the United States 1945–87)
**"Scarf" Necklace,** 1948
Platinum and 18-karat yellow gold with 174 round sapphires, 198 round emeralds, 356 round diamonds, and 35 marquise diamonds
Gift of Oveta Culp Hobby
91.1842

**15.17** French
Retailed by Anne-Marie
**Champagne Bucket Pocketbook,**
c. 1950s
Leather and Lucite
9 3/4 x 7 1/2 x 3 7/8 (24.8 x 19.1 x 9.9)
Museum purchase with
departmental funds and funds
provided by Jas A. Gundry
94.603

**15.18** Halston (born Roy Halston
Frowick), American, 1932–1990,
for Bergdorf-Goodman, American,
established 1903
**Hat,** c. 1959–67
Dyed cock feathers
Gift of Mr. and Mrs.
Harris Masterson III
94.684

16  The Lillie and Hugh Roy
Cullen Sculpture Garden

**16.1** Joel Shapiro, American,
born 1941
**Untitled,** 1990
Bronze, edition 4/4
89 x 76 1/2 x 27 (226.1 x 194.3 x 68.6)
Museum purchase with funds
provided by Isabell and
Max Herzstein in memory of
Benjamin K. Smith
90.487
© Courtesy of Joel Shapiro and
PaceWildenstein

**16.2** Louise Bourgeois, American,
born France, 1911
**Quarantania I,** 1947–53
Bronze, edition 4/6
79 3/4 x 27 x 29 1/4
(202.6 x 68.6 x 74.3)
Museum purchase
85.214

**16.3** DeWitt Godfrey, American,
born 1960
**Untitled,** 1989
Welded steel
33 x 69 x 65 (83.8 x 175.3 x 165.1)
Museum purchase with funds
provided by Duke Energy
91.1341

**16.4** Anthony Caro, English,
born 1924
**Argentine,** 1968
Painted steel
50 x 140 x 124 (127 x 355.6 x 315)
Museum purchase with funds
provided by the Brown Foundation
Accessions Endowment Fund
87.290
© Anthony Caro, courtesy
Marlborough Gallery, New York

**16.5** Aristide Maillol, French,
1861–1944
**Flora, Nude,** 1910
Bronze
65 x 19 1/2 x 14 3/8 (165.1 x 49.5 x 36.5)
Museum purchase with funds
provided by Isaac Arnold, Jr.,
in honor of his wife,
Antonette Tilly Arnold
81.40
© 1999 Artists Rights Society (ARS),
New York/ADAGP, Paris

**16.6** Tony Cragg, English,
born 1949
**New Forms,** 1991–92
Bronze
80 x 97 x 74 1/2 (203.2 x 246.4 x 189.2)
101 x 57 1/2 x 60 1/2
(256.5 x 146.1 x 153.7)
Museum purchase with funds
provided by The Schissler
Foundation
92.170.1,.2

**16.7** Alberto Giacometti, Swiss,
1901–1966
**Large Standing Woman I,** 1960
Bronze
105 1/2 x 12 7/8 x 19 3/4
(268 x 32.7 x 50.2)
Museum purchase with funds
provided by the Brown Foundation
Accessions Endowment Fund
86.397
© 1999 Artists Rights Society (ARS),
New York/ADAGP, Paris

**16.8** Henri Matisse, French,
1869–1954
**Back I,** 1909
Bronze, edition 9/10
73 5/8 x 45 5/8 x 7 3/8
(18.7 x 115.9 x 18.7)
Gift of Mr. and Mrs. Theodore N.
Law in memory of Mr. and
Mrs. Harry C. Wiess
80.68
© 1999 Succession H. Matisse,
Paris/Artists Rights Society (ARS),
New York

**Back II,** 1913
Bronze, edition 9/10
74 5/8 x 47 3/4 x 7 3/8
(189.5 x 121.3 x 18.7)
Gift of Mr. and Mrs. Gus Wortham
80.69
© 1999 Succession H. Matisse,
Paris/Artists Rights Society (ARS),
New York

**Back III,** 1916–17
Bronze, edition 9/10
73 7/8 x 44 7/8 x 7 (187.6 x 114 x 17.8)
Gift of the Cullen Foundation
in memory of Hugh Roy and
Lillie Cullen
80.70
© 1999 Succession H. Matisse,
Paris/Artists Rights Society (ARS),
New York

**Back IV, c.** 1930
Bronze, edition 9/10
74 1/2 x 44 1/2 x 7 (189.2 x 113 x 17.8)
Gift of The Brown Foundation, Inc.,
in memory of Mr. and Mrs.
Herman Brown
80.71
© 1999 Succession H. Matisse,
Paris/Artists Rights Society (ARS),
New York

**16.9** Ellsworth Kelly, American,
born 1923
**Houston Triptych,** 1986
Bronze
146 x 96 3/8 x 7/8 (370.8 x 244.8 x 2.22)
108 1/4 x 120 x 7/8 (275 x 304.8 x 2.22)
126 x 138 1/8 x 7/8 (320 x 350.8 x 2.22)
Museum purchase with funds
provided by The Brown Foundation,
Inc., and Mr. and Mrs. M. S. Stude
in honor of Mr. and Mrs.
George R. Brown
86.487.1–.3

**16.10** David Smith, American,
1906–1965
**Two Circle Sentinel,** 1961
Stainless steel
86 x 37 1/4 x 15 3/4 (218.4 x 94.6 x 40)
Museum purchase with funds
provided by the Brown Foundation
Accessions Endowment Fund in
memory of Alice Pratt Brown
84.202
© Estate of David Smith/Licensed
by VAGA, New York, NY

**16.11** Auguste Rodin, French,
1840–1917
**The Walking Man,** 1905
Bronze
83 x 61 x 28 (210.8 x 154.9 x 71.1)
Gift of Margarett Root Brown in
honor of Louisa Stude Sarofim
64.24

**16.12** Joseph Havel, American,
born 1954
**Exhaling Pearls,** 1993
Patinated bronze
130 x 55 x 33 (330.2 x 139.7 x 83.8)
Museum purchase with funds
provided by the Caroline Wiess Law
Accessions Fund, Isabell and Max
Herzstein, Isabel B. Wilson,
Nona and Richard Barrett, and
friends of the artist
94.115

**17 Bayou Bend Collection
and Gardens**

**17.1** Essex County, Massachusetts
**Great Chair,** 1640–85
White oak
37 5/8 x 23 1/2 x 20 3/4
(95.6 x 59.7 x 52.7)
The Bayou Bend Collection,
museum purchase with funds
provided by Miss Ima Hogg,
by exchange
B.94.11

**17.2** Boston area
**Cupboard,** 1670–1700
Red oak, red maple; white pine
60 x 49 3/4 x 23 1/4
(152.4 x 126.4 x 59.1)
The Bayou Bend Collection,
museum purchase with funds
provided by the Theta Charity
Antiques Show
B.93.11

**17.3** Southwark, Montague Close,
or Pickleherring Pottery,
London, England
**Posset Pot,** 1628–51
Tin-glazed earthenware
8 x 9 5/8 x 7 1/2 (20.3 x 24 .4 x 19.1)
The Bayou Bend Collection,
gift of Katharine Prentis Murphy
B.59.128.A,.B

**17.4** Shop of John Hull, American,
1624–1683, and Robert Sanderson,
Sr., American, 1608–1693
Boston
**Dram Cup,** 1655–64
Silver
1 x 3 5/8 x 2 1/4 (2.5 x 9.2 x 5.7)
The Bayou Bend Collection,
museum purchase with funds
provided by the Theta Charity
Antiques Show
B.96.8

**17.5** Shop of John Coney,
American, 1655/56–1722
Boston
**Tankard,** 1695–1711
Silver
6 15/16 x 5 1/16 x 8 (17.6 x 12.9 x 20.3)
The Bayou Bend Collection,
gift of Miss Ima Hogg
B.74.19

**17.6** Shop of Paul Revere, Jr.,
American, 1734–1818
Boston
**Slop Bowl,** 1797
Silver
4 7/16 x 5 1/2 (11.3 x 14)
The Bayou Bend Collection,
gift of Miss Ima Hogg
B.69.98

**17.7** Shop of Paul Revere, Jr.,
American, 1734–1818
Boston
**Teaspoon,** one of a pair,
c. 1796–c. 1806
Silver
5 1/4 x 5/8 (13.3 x 1.6)
The Bayou Bend Collection,
museum purchase with funds
provided by family and friends in
memory of Aurelia Kurth Jameson
B.87.10.1

**17.8** Charles Balthazar-Julien Févret
de Saint-Mémin, French, 1770–1852
Philadelphia
**Portrait of Paul Revere, Jr.,** 1800
Mezzotint on laid paper
Image 2 3/16 diameter (5.6)
Sheet 3 3/8 x 3 (8.6 x 7.6)
The Bayou Bend Collection,
museum purchase with funds
provided by Alice C. Simkins
B.84.1

**17.9** Paul Revere, Jr., American,
1734–1818
Boston
**The Bloody Massacre,** 1770
Hand-colored line engraving and
etching on laid paper
Image 7 7/8 x 8 5/8 (20 x 21.9)
Sheet 10 3/8 x 9 1/4 (26.4 x 23.5)
The Bayou Bend Collection,
museum purchase with funds
provided by the Sarah Campbell
Blaffer Foundation
B.84.9

**17.10** Manufactury of Thomas
Fletcher, American, 1787–1866,
and Sidney Gardiner, American,
1785–1827
Boston and Philadelphia
**Pitcher,** 1815
Silver
13 1/2 x 6 1/2 x 10 1/8 (34.3 x 16.5 x 25.7)
The Bayou Bend Collection, gift of
Mrs. James P. Houstoun, Jr.,
in memory of
Mr. James P. Houstoun, Jr.
B.77.16

**17.11** Gorham Manufacturing
Company, American,
established 1831
Providence, Rhode Island
**Soup Tureen,** c. 1858
Silver
11 3/4 x 16 1/8 x 10 1/4 (29.8 x 41 x 26)
The Bayou Bend Collection,
museum purchase with funds
provided by the Houston Junior
Woman's Club
B.95.1.A,.B

**17.12** Boston
**High Chest of Drawers,**
1700–1725
Black walnut and burled walnut
veneers, soft maple, aspen; eastern
white pine, hemlock, and birch
68 1/4 x 40 1/4 x 22 1/4
(173.4 x 102.2 x 56.5)
The Bayou Bend Collection,
gift of Miss Ima Hogg
B.69.43

**17.13** Boston
**High Chest of Drawers,** 1730–60
Soft maple, eastern white pine
87 x 41 1/2 x 23 (221 x 105.4 x 58.4)
The Bayou Bend Collection,
gift of Miss Ima Hogg
B.69.348

**17.14** Philadelphia
**High Chest of Drawers,**
1760–1800
Mahogany, mahogany veneer;
Atlantic white cedar, southern
yellow pine, yellow poplar
94 3/8 x 46 1/2 x 30 5/8
(239.7 x 118.1 x 77.8)
The Bayou Bend Collection,
gift of Miss Ima Hogg
B.69.75

**17.15** Joseph Badger, American,
1708–1765
Boston
**Portrait of John Gerry,** 1745
Oil on canvas
50 1/8 x 36 5/16 (127.3 x 92.2)
The Bayou Bend Collection,
gift of Miss Ima Hogg
B.53.13

**17.15a** Probably Massachusetts
**John Gerry's Coat,** c. 1745
Wool, linen, and silk
22 1/2 x 23 (57.2 x 58.4)
The Bayou Bend Collection,
gift of Miss Ima Hogg
B.69.245

**17.16** Shop of Thauvet Besley,
American, died 1757
New York City
**Whistle, Bells, and Coral,** 1727–57
Silver
5 1/2 x 2 1/4 diameter (14 x 5.7)
The Bayou Bend Collection,
museum purchase with funds
provided by William J. Hill
B.87.11

**17.17** Eastern Massachusetts
**Easy Chair,** 1750–1800
Mahogany; with maple, white pine,
and original wool needlework
on linen canvas
45 1/2 x 32 3/4 x 31 3/4
(115.6 x 83.2 x 80.6)
The Bayou Bend Collection,
gift of Miss Ima Hogg
B.60.89

**17.18** Attributed to the shop
of John Seymour, American,
c. 1738–1818, and Thomas Seymour,
American, 1771–1848, or to
Thomas Seymour's Boston
Furniture Warehouse
Boston
**Tambour Desk,** 1794–1810
Mahogany, unidentified inlays;
eastern white pine, red oak
41 3/8 x 37 1/2 x 19 1/2
(105.1 x 95.3 x 49.5)
The Bayou Bend Collection,
gift of Miss Ima Hogg
B.65.12

**17.19** Attributed to Almira Earle,
American, 1800–1831
Milton, Massachusetts
**Memorial Embroidered Picture,**
c. 1815–20
Silk taffeta, silk threads, chenille,
and watercolors
26 x 26 (66 x 66)
The Bayou Bend Collection,
gift of Miss Ima Hogg
B.70.52

**17.20** Manufactory of
Samuel Kirk & Son, American,
active 1846–61 and 1868–96
Baltimore
**Medal,** c. 1850
Silver
2 3/8 diameter x 3/16 (6 x .5)
The Bayou Bend Collection,
museum purchase with funds
provided by the Bayou Bend
Docent Organization
B.88.22

**17.21** Mary Ann McCue
Philadelphia
**Odd Fellows Appliqué
Album Quilt,** c. 1850
Cotton and silk
91 1/4 x 90 (231.8 x 228.6)
The Bayou Bend Collection,
gift of the estate of Miss Ima Hogg
B.76.62

**17.22** Peter Pelham, American,
c. 1697–1751
Boston
**Mather Byles,** 1732–39
Mezzotint engraving on laid paper
Plate 6 3/16 x 4 1/2 (15.7 x 11.4)
Sheet 7 1/8 x 5 (18.1 x 12.7)
The Bayou Bend Collection,
gift of Miss Ima Hogg
B.61.69

**17.23** John Singleton Copley,
American, 1738–1815
Boston
**Portrait of Mrs. Gawen Brown,**
1763
Pastel on laid paper, mounted on
bleached plain-weave linen
17 1/2 x 14 1/2 (44.5 x 36.8)
The Bayou Bend Collection,
gift of Miss Ima Hogg
B.54.21

**17.24** Gilbert Stuart, American,
1755–1828
Philadelphia
**Portrait of John Vaughan,** c. 1795
Oil on canvas
30 1/8 x 25 1/4 (76.5 x 64.1)
The Bayou Bend Collection,
gift of Miss Ima Hogg
B.61.55

**17.25** John Smibert, American,
1688–1751
Boston
**Portrait of Samuel Pemberton,**
1734
Oil on canvas
30 1/8 x 25 1/2 (76.5 x 64.8)
The Bayou Bend Collection,
museum purchase with funds
provided by Miss Ima Hogg
B.72.7

**17.26** John Singleton Copley,
American, 1738—1815
Boston
**Portrait of a Boy,** c. 1758—60
Oil on canvas
48 5/8 x 36 1/4 (123.5 x 92.1)
The Bayou Bend Collection,
gift of Miss Ima Hogg
B.54.31

**17.27** Attributed to the shop
of John Townsend, American,
1732/33—1809, active c. 1754—1809
Newport, Rhode Island
**Bureau Table,** 1785—1800
Mahogany; chestnut, yellow-poplar
34 1/2 x 39 1/4 x 22  (87.6 x 99.7 x 55.9)
The Bayou Bend Collection,
gift of Miss Ima Hogg
B.69.91

**17.28** Shop of John Henry Belter,
American, 1804—1865
New York City
**Étagère,** 1855
Rosewood and rosewood veneer;
black walnut, mahogany, eastern
white pine, yellow poplar,
undetermined exotic wood
100 1/4 x 65 1/2 x 16 5/8
(254.6 x 166.4 x 42.2)
The Bayou Bend Collection,
gift of the estate of Miss Ima Hogg
B.81.9.10

**17.29** Movement by Peter Stretch,
American, 1670—1746
Philadelphia
**Tall Clock,** 1725—46
Black walnut; southern yellow pine,
eastern white pine,
Atlantic white cedar
103 x 20 3/8 x 10 5/8 (261.6 x 51.8 x 27)
The Bayou Bend Collection,
museum purchase with funds
provided by the Theta Charity
Antiques Show in memory of
Betty Black Hatchett
B.86.4

**The Evolution of Style**

Essex County, Massachusetts
**Great Chair,** 1640—85
White oak
37 5/8 x 23 1/2 x 20 3/4
(95.6 x 59.7 x 52.7)
The Bayou Bend Collection,
museum purchase with funds
provided by Miss Ima Hogg,
by exchange
B.94.11

New York or New Jersey
**Table with Drawer,** 1695—1725
White oak; soft maple,
southern yellow pine, white oak
27 1/2 x 46 5/8 x 27
(69.9 x 118.4 x 68.6)
The Bayou Bend Collection,
gift of Miss Ima Hogg
B.22.18

Massachusetts, Hatfield area
**Chest with Drawers,** 1670—1710
White oak; southern yellow pine,
red oak
38 3/4 x 48 1/8 x 17 3/4
(98.4 x 122.2 x 45.1)
The Bayou Bend Collection,
gift of Miss Ima Hogg
B.69.356

Shop of Cornelius Kierstede,
American, 1674/5—1757
New York City; Albany, New York;
and New Haven, Connecticut
**Two-Handled Bowl,** 1696—1731
Silver
2 3/16 x 6 5/16 x 4 3/8  (5.6 x 16 x 11.1)
The Bayou Bend Collection,
gift of Miss Ima Hogg
B.63.3

Eastern Massachusetts
**Armchair,** 1700—1725
Soft maple; with hard maple,
birch, ash, poplar, aspen poplar
or cottonwood
49 x 25 x 22 3/4  (124.5 x 63.5 x 57.8)
The Bayou Bend Collection,
gift of Miss Ima Hogg
B.69.44

Boston
**Table,** 1700—1730
Black walnut; soft maple,
chestnut, eastern white pine
Open: 27 5/8 x 56 1/2 x 48 1/2
(70.2 x 143.5 x 123.2)
Closed: 27 5/8 x 17 x 48 1/2
(70.2 x 43.2 x 123.2)
The Bayou Bend Collection,
gift of Miss Ima Hogg
B.59.71

Boston
**High Chest of Drawers,** 1700—1725
Black walnut and burled walnut
veneers, soft maple, aspen;
eastern white pine, hemlock, birch
68 1/4 x 40 1/4 x 22 1/4
(173.4 x 102.2 x 56.5)
The Bayou Bend Collection,
gift of Miss Ima Hogg
B.69.43

Peter Van Dyck, American,
1684—1751
New York
**Tankard,** c. 1710
Silver
7 7/8 x 6 1/4 x 9 7/16  (20 x 15.9 x 24)
The Bayou Bend Collection,
gift of Miss Ima Hogg
B.69.118

Philadelphia
**Side Chair,** 1745—95
Black walnut; southern yellow pine
41 7/8 x 19 3/4 x 19 1/4
(106.4 x 50.2 x 48.9)
The Bayou Bend Collection,
gift of Miss Ima Hogg
B.69.65

Boston
**Card Table,** 1730—60
Mahogany, inlay; mahogany,
cherry, eastern white pine
Open: 26 3/4 x 37 x 32 1/8
(67.9 x 94.0 x 81.6)
Closed: 27 1/4 x 36 1/4 x 18
(69.2 x 92.1 x 48.3)
The Bayou Bend Collection,
gift of Miss Ima Hogg
B.69.406

Hartford, Wethersfield, or
Glastonbury, Connecticut
**High Chest of Drawers,** 1750—82
Cherry; eastern white pine,
southern yellow pine
83 1/2 x 39 7/8 x 20 (212.1 x 101.3 x 50.8)
The Bayou Bend Collection,
gift of Miss Ima Hogg
B.28.1

Shop of Bartholomew Schaats,
American, 1670–1758
New York
Teapot, 1728–48
Silver
6 1/2 x 4 3/4 x 9 13/16
(16.5 x 12.1 x 24.9)
The Bayou Bend Collection,
gift of Miss Ima Hogg
B.69.111

New York
Side Chair, 1750–95
Mahogany; yellow poplar, red oak
39 3/8 x 23 1/4 x 22 1/2
(100 x 59.1 x 57.2)
The Bayou Bend Collection,
gift of Miss Ima Hogg
B.69.34

Attributed to the shop of Marinus
Willett, American, 1740–1830,
and Jonathon Pearsee, American,
active c. 1763–75
New York
Card Table, c. 1763–75
Mahogany; eastern white pine,
red gum, white oak
Open: 26 3/4 x 34 3/4 x 33 3/4
(67.9 x 88.3 x 85.7)
Closed: 27 5/8 x 34 3/4 x 17 1/2
(70.2 x 88.3 x 44.5)
The Bayou Bend Collection,
gift of Miss Ima Hogg
B.69.24

Philadelphia
Chest-on-Chest, 1760–1800
Mahogany; mahogany, Atlantic
white cedar, yellow poplar,
white oak, southern yellow pine
92 1/2 x 47 1/8 x 23 3/4
(235 x 119.7 x 60.3)
The Bayou Bend Collection,
gift of Miss Ima Hogg
B.69.74

Shop of Joseph Richardson, Sr.,
American, 1711–1784
Teapot, 1745–75
Silver
6 1/4 x 4 5/8 x 8 9/16 (15.9 x 11.7 x 21.7)
The Bayou Bend Collection,
gift of Miss Ima Hogg
B.60.29

Boston area or Salem, Massachusetts
Side Chair, one of a pair, 1785–99
Mahogany, ebony; eastern white
pine, ash, soft maple
38 x 21 3/4 x 20 5/8 (96.5 x 55.2 x 52.4)
The Bayou Bend Collection,
gift of Miss Ima Hogg
B.61.92.1

Baltimore
Card Table, 1785–1820
Mahogany, satinwood, unidentified
inlay; yellow poplar, white oak,
hickory
Open: 28 5/8 x 37 1/8 x 36 1/2
(72.7 x 94.3 x 92.7)
Closed: 29 1/2 x 37 1/8 x 18 1/4
(74.9 x 94.3 x 46.4)
The Bayou Bend Collection,
gift of Miss Ima Hogg
B.69.129

Portsmouth, New Hampshire
Bureau, 1805–20
Mahogany, birch; eastern white pine
37 x 40 1/8 x 21 1/4 (94 x 101.9 x 54)
The Bayou Bend Collection,
gift of Miss Ima Hogg
B.69.379

Shop of Standish Barry, American,
1763–1844
Baltimore
Teapot, part of tea set, 1784–1815
Silver
12 x 5 1/4 x 10 1/2 (30.5 x 13.3 x 26.7)
The Bayou Bend Collection,
gift of Tiffany and Co.
B.67.5.1.A.,B

Philadelphia
Side Chair, one of a pair, 1810-25
Mahogany, ebony, rosewood, brass
inlay; ash, eastern white pine
31 3/4 x 19 x 22 1/4 (80.6 x 48.3 x 56.5)
The Bayou Bend Collection,
gift of Miss Ima Hogg
B.69.72.1

New York
Card Table, 1820–30
Grained, painted, and gilded
mahogany, birch, black walnut;
eastern white pine, ash, cherry
Open: 30 1/8 x 36 3/4 x 36 3/4
(76.5 x 93.3 x 93.3)
Closed: 30 7/8 x 36 3/4 x 18 3/8
(78.4 x 93.3 x 46.7)
The Bayou Bend Collection,
gift of Miss Ima Hogg
B.68.31

New York
Writing Table and Bookcase,
1825–35
Mahogany; eastern white pine,
yellow poplar
77 3/4 x 47 3/4 x 21 3/4
(197.5 x 121.3 x 55.2)
The Bayou Bend Collection,
museum purchase with funds
provided by Mrs. Fred T. Couper,
Jr., in loving memory of her mother,
Mrs. William Victor Bowles
B.82.4

Manufactory of Samuel Kirk,
1793–1872
Baltimore
Coffee or Hot Water Pot, part of
tea and coffee service, 1824–29
Silver
12 3/4 x 6 3/4 x 12 3/4
(32.4 x 17.1 x 32.4)
The Bayou Bend Collection,
museum purchase with funds
provided by Miss Ima Hogg and
the Friends of Bayou Bend
B.71.89.1

New York
Side Chair, one of a pair, 1850–60
Rosewood; mahogany, ash
43 x 18 3/4 x 24 3/4
(109.2 x 47.6 x 62.9)
The Bayou Bend Collection,
gift of Miss Ima Hogg
B.71.36.1

Shop of Charles A. Baudouine,
American, 1808–1895, active 1829–55
New York
Card Table, one of a pair, 1853–55
Mahogany; yellow poplar,
black walnut, ash, primavera
Open: 28 1/2 x 45 1/4 x 30 1/2
(72.4 x 114.9 x 77.5)
Closed: 29 1/2 x 45 1/4 x 15 1/4
(74.9 x 114.9 x 38.7)
The Bayou Bend Collection, gift of
Mr. and Mrs. Robert F. Strange, Sr.
B.74.4.1

Probably New York
Dressing Table with
Looking Glass, 1850–60
Mahogany; marble; eastern white
pine, eastern red cedar, cherry
67 7/8 x 45 x 24 5/8
(172.4 x 114.3 x 62.5)
The Bayou Bend Collection,
gift of Miss Ima Hogg
B.57.5

Manufactory of Edward C. Moore,
American, 1827–1891
Retailed by Tiffany & Co.,
American, established 1837
New York
**Teapot,** part of coffee and
tea service, 1856–59
Silver
9 3/4 x 8 3/4 x 6 (24.8 x 22.2 x 15.2)
The Bayou Bend Collection,
museum purchase with
funds provided by Mr. and
Mrs. Robert F. Strange, Sr.
B.91.37.2

**17.30** Edward Hicks, American,
1780–1849
Bucks County, Pennsylvania
**Penn's Treaty with the Indians,**
c. 1830–40
Oil on canvas
17 5/8 x 23 5/8 (44.8 x 60)
The Bayou Bend Collection,
gift of Alice C. Simkins in memory
of Alice Nicholson Hanszen
B.77.46

**17.31** French, decoration possibly
New York
**Presentation Pitcher,** c. 1848–50
Porcelain with polychrome
and gilding
9 5/8 x 6 1/4 x 9 (24.4 x 15.9 x 22.9)
The Bayou Bend Collection,
gift of Miss Ima Hogg
B.54.16

**17.32** John Bower, American,
active 1809–19
Philadelphia
**A View of the Bombardment
of Fort McHenry,** c. 1815
Hand-colored aquatint on
wove paper
Image 10 3/4 x 17 (27.3 x 43.2)
Sheet 12 5/8 x 17 5/8 (32.1 x 44.8)
The Bayou Bend Collection,
museum purchase with funds
provided by "One Great Night
in November, 1988"
B.90.14

**17.33** Manufactory of Andrew
Ellicott Warner, American,
1786–1870
Baltimore
**Soup Tureen,** 1817
Silver
12 1/2 x 14 3/4 x 9 1/2 (31.8 x 37.5 x 24.1)
The Bayou Bend Collection,
museum purchase with funds
provided by the Theta Charity
Antiques Show in honor of
Betty Black Hatchett
B.80.6.A,.B

**17.34** American China
Manufactory (Gousse Bonnin and
George Anthony Morris), American,
active 1769–72
Philadelphia
**Sauceboat,** 1770–72
Soft-paste porcelain
2 1/4 x 2 5/8 x 4 7/8 (5.7 x 6.7 x 12.4)
The Bayou Bend Collection,
museum purchase with funds
provided by the Friends of
Bayou Bend
B.83.4

**17.35** Shop of Bartholomew
Schaats, American, 1670–1758
New York City
**Teapot,** 1728–48
Silver
6 1/2 x 4 3/4 x 9 13/16 (16.5 x 12.1 x 24.9)
The Bayou Bend Collection,
gift of Miss Ima Hogg
B.69.111

**17.36** Asher Brown Durand,
American, 1796–1886, after a
painting by John Vanderlyn,
American, 1775–1852
New York City
**Ariadne,** 1835
Line engraving on China wove
paper, seventh state
Image 14 3/8 x 17 15/16 (36.5 x 45.6)
Sheet 17 x 20 1/2 (43.2 x 51.4)
The Bayou Bend Collection,
museum purchase with funds
provided by the Bayou Bend
Docent Organization
B.95.2

**17.37** Benjamin H. Latrobe,
American, 1764–1820
Possibly made by Thomas Wetherill,
American, died 1824
Painted decoration attributed to
George Bridport, American, born
England before 1794, died 1819
Philadelphia or possibly Baltimore
**Side Chair,** one of a pair, c. 1808
Yellow poplar, oak, maple,
eastern white pine
34 1/2 x 20 x 20 1/2 (87.6 x 50.8 x 52.1)
The Bayou Bend Collection,
museum purchase with funds
provided by the Agnes Cullen
Arnold Endowment Fund
B.90.9.1

**17.38** Shop of Aaron Willard, Sr.,
American, 1757–1844,
or Aaron Willard, Jr., 1783–1864
Boston
**Wall Clock,** 1802–30
Eastern white pine, basswood,
mahogany, cherry
40 x 10 1/4 x 3 7/8 (101.6 x 26 x 9.8)
The Bayou Bend Collection,
gift of Alice C. Simkins
B.79.290

**17.39** Charles Willson Peale,
American, 1741–1827
Philadelphia
**Self-Portrait with Angelica and
Portrait of Rachel,** c. 1782–85
Oil on canvas
36 1/8 x 27 1/8 (91.8 x 68.9)
The Bayou Bend Collection,
gift of Miss Ima Hogg
B.60.49

**17.40** Charles Willson Peale,
American, 1741–1827
Philadelphia
**Landscape Looking Toward
Sellers Hall from Mill Bank,**
c. 1818
Oil on canvas
15 x 21 1/4 (38.1 x 54)
The Bayou Bend Collection,
gift of Mrs. James W. Glanville
B.98.12

**17.41** James Peale, American,
1749–1831
Bloomsbury, New Jersey
**Pleasure Party by a Mill,** late 1780s
Oil on canvas
26 1/4 x 40 1/8 (66.7 x 101.9)
The Bayou Bend Collection,
gift of Miss Ima Hogg
B.62.16

**17.42** Rembrandt Peale, American, 1778–1860
Philadelphia or Baltimore
**Portrait of Henry Robinson,**
c. 1816–20
Oil on paper, mounted on canvas
21 5/16 x 17 1/4 (54.1 x 43.8)
The Bayou Bend Collection, museum purchase with funds provided by the Theta Charity Antiques Show
B.77.17

**17.43** James Peale, American, 1749–1831
Philadelphia
**Still Life with Vegetables,** 1826
Oil on canvas
20 x 26 1/2 (50.8 x 67.3)
The Bayou Bend Collection, museum purchase with funds provided by the Theta Charity Antiques Show in honor of Mrs. Fred T. Couper, Jr.
B.85.2

**17.44** Probably French or German, painted decoration probably American
**Presentation Cup and Saucer,**
c. 1850
Porcelain
Cup 3 1/4 x 5 1/8 x 4 1/8
(8.3 x 13 x 10.15)
Saucer 1 3/8 x 6 5/8 (3.5 x 16.8)
The Bayou Bend Collection, museum purchase with funds given in memory of Florence Prickett Warren Hershey
B.97.16.1,.2

18 Rienzi

**18.1** Attributed to William Hallett, Sr., English, c. 1707–1781
**Settee,** c. 1735
Walnut and upholstery
39 x 67 x 39 (99.1 x 170.2 x 99.1)
The Rienzi Collection, museum purchase with funds provided by Mr. and Mrs. Harris Masterson III
95.84

**18.2** Attributed to John Vardy, English, 1718–1765
**Stool,** one of a pair, c. 1759
Limewood, gilt, and upholstery
17 x 26 1/2 x 22 (43.2 x 67.3 x 55.9)
The Rienzi Collection, gift of Mr. and Mrs. Harris Masterson III
94.903.1

**18.3** Attributed to Giovanni Pisani and Brothers, Italian
After Antonio Canova, Italian, 1757–1822
**Venus (Venere Italica),** c. 1817
Marble
66 3/4 x 20 3/4 x 16 3/4
(169.5 x 52.7 x 42.5)
The Rienzi Collection, museum purchase with funds provided by Mr. and Mrs. Harris Masterson III
95.201

**18.4** see 1.35

**18.5** English
**Side Chair,** one of a set of 12,
c. 1740
Walnut, leather, and brass
39 1/2 x 25 3/4 x 26 (100.3 x 65.4 x 66)
The Rienzi Collection, gift of Mr. and Mrs. Harris Masterson III
94.1197.1

**18.6** Attributed to Marsh & Tatham, English, active 1803–11
**Console Table,** one of a pair,
c. 1805
Unidentified wood, parcel gilt, jasper, and marble
34 x 56 x 30 (86.4 x 142.2 x 76.2)
The Rienzi Collection, gift of Mr. and Mrs. Harris Masterson III
94.1194.1

**18.7** George Romney, English, 1734–1802
**Lady Blount,** 1760s
Oil on canvas
49 1/2 x 40 1/4 (125.7 x 102.9)
The Rienzi Collection, gift of Mr. and Mrs. Harris Masterson III
96.1209

**18.8** Attributed to Pierre Langlois, French, active London 1759–81
**Commode,** c. 1770
Mahogany, rosewood, calamander, unidentified woods, and ormolu
28 1/2 x 19 3/4 x 15 1/4
(72.4 x 49.2 x 38.7)
The Rienzi Collection, gift of Mr. and Mrs. Harris Masterson III
96.1238

**18.9** Joshua Cristall, English, 1768–1847
**Latona and the Lycian Peasants,**
c. 1817
Oil on canvas
50 1/4 x 66 (127.6 x 167.6)
The Rienzi Collection, gift of Mr. and Mrs. Harris Masterson III
96.1210

**18.10** Matthew Boulton, English, 1728–1809
**Candelabrum,** c. 1772
Bluejohn and ormolu
14 x 14 3/4 x 5 1/8 (35.6 x 37.5 x 13)
The Rienzi Collection, gift of Mr. and Mrs. Harris Masterson III
94.1093

**18.11** English
**Pier Table,** one of a pair, c. 1770
Unidentified woods, rosewood, and gilt
36 x 55 1/2 x 23 1/4 (91.4 x 141 x 59.1)
The Rienzi Collection, gift of Mr. and Mrs. Harris Masterson III
94.1086.2

**18.12** Meissen Porcelain Factory, Saxon (German), established 1710
Modeled by Johann Joachim Kändler, German, 1706–1775, and Johann Friedrich Eberlein, German, 1695–1749
**Plate** from the Swan Service,
c. 1737–41
Hard-paste porcelain
2 1/2 x 14 13/16 diameter (6.4 x 37.9)
The Rienzi Collection, gift of Mr. and Mrs. Harris Masterson III
94.950

**18.13** Worcester Porcelain
Manufactory, English,
established 1751
**Wine Funnel,** 1753–55
Soft-paste porcelain
4 1/4 x 3 9/16 x 3 9/16 (10.8 x 9 x 9)
The Rienzi Collection, museum
purchase with funds provided by
Mr. and Mrs. Harris Masterson III,
in honor of Mr. Isaac Arnold, Jr.,
Mr. and Mrs. Elliot Cage, Jr.,
Captain and Mrs. Clifton Iverson,
and Mr. and Mrs. Lloyd Smith,
by exchange
92.161

**18.14** Worcester Porcelain
Manufactory, English,
established 1751
**Cream Boat,** c. 1755–58
Soft-paste porcelain
2 9/16 x 4 1/4 (6.5 x 10.8)
The Rienzi Collection, gift of
Mr. and Mrs. Harris Masterson III
85.210

**18.15** Worcester Porcelain
Manufactory, English, established 1751
**Teapot and Stand,** c. 1770
Soft-paste porcelain
Teapot 5 3/16 x 8 1/16 x 4 9/16
(13.2 x 20.5 x 11.6)
Stand 7/8 x 5 15/16 (2.3 x 15.1)
The Rienzi Collection, gift of
Mr. and Mrs. Harris Masterson III
87.108.1.A,.B, 87.108.2

**18.16** Worcester Porcelain
Manufactory, English,
established 1751
**Figure of a Sportsman,** c. 1770
Soft-paste porcelain
7 x 3 3/8 x 2 3/4 (17.8 x 8.6 x 7)
The Rienzi Collection, gift of
Mr. and Mrs. Harris Masterson III
84.513

**18.17** Worcester Porcelain
Manufactory, English,
established 1751
**Sportsman's Companion,** c. 1770
Soft-paste porcelain
7 1/8 x 4 3/4 x 3 (18.2 x 12.1 x 7.6)
The Rienzi Collection, gift of
Mr. and Mrs. Harris Masterson III
90.429

**18.18** Flight Barr & Barr,
active 1814–40
Worcester Porcelain Manufactory,
English, established 1751
**Plate** from the Stowe Service,
c. 1813
Soft-paste porcelain
1 1/8 x 9 1/2 diameter (2.9 x 24.1)
The Rienzi Collection, gift of
Mr. and Mrs. Harris Masterson III
96.1146

**18.19** Royal Porcelain Factory
(KPM), Prussian (German),
established 1762
**Tazza,** c. 1840
Hard-paste porcelain
15 x 23 diameter (38.1 x 58.4)
The Rienzi Collection, gift of
Mr. and Mrs. Harris Masterson III
in honor of Miss Harriet Bath
74.205

1 Ancient and European Art

**1.26a** Hans Memling,
Netherlandish, 1430/40–1494
Portrait of an Old Man, 1468–70
Oil on wood
10 3/4 x 7 5/8 (26.4 x 19.4)
The Metropolitan Museum of Art,
Bequest of Benjamin Altman, 1913
© All rights reserved,
The Metropolitan Museum of Art

4 Prints and Drawings

**4.20a** Photograph of
Arshile Gorky, c. 1935
The Newark Museum/Art Resource,
New York

**4.29a** Richard Bowditch
Eric Fischl
© CORBIS/Richard Bowditch

6 American Painting, Sculpture,
and Decorative Arts

**6.8a** Film still from
She Wore a Yellow Ribbon, 1949
© Turner Broadcasting
Photograph courtesy Bill Howze

**6.10a** Vanderbilt House
on Fifth Avenue, from
Mr. Vanderbilt's House and Collection,
by Edward Strahan
4 vols. Boston, New York, and
Philadelphia: George Barrie,
1883–84

**6.12a** John Singer Sargent (detail),
c. 1885
Archives of American Art,
Smithsonian Institution
Photographs of Artists—
Collection I

**6.13a** Attributed to
Susan Macdowell Eakins
Thomas Eakins at about age
thirty-five, leaning against fence
(detail), 1880
Gelatin silver print
6 7/16 x 4 1/2 (16.4 x 11.4)
Courtesy of the Pennsylvania
Academy of the Fine Arts,
Philadelphia. Charles Bregler's
Thomas Eakins Collection.
Purchased with the partial support
of the Pew Memorial Trust
1985.68.2.34

**6.14a** Postcard of Giverny
Courtesy Emily Neff

**6.15a** William Merritt Chase
giving a landscape demonstration
before a group, probably
Shinnecock Hills, c. 1902
Gelatin silver print
The Parrish Art Museum,
Southampton, New York
William Merritt Chase Archives
75.C.2

**6.16a** F. Gutenkunst
photographers, Philadelphia
Henry Ossawa Tanner, c. 1900
Albumen photograph, mounted
on carte de viste
5 5/8 x 4 1/4 (14.3 x 11.4)
The Philadelphia Museum of Art,
courtesy Dr. Rae Alexander-Minter

**6.31a** John S. Bradstreet in Japan
The Minneapolis Institute of Arts

7 African Art

**7.3a** Rainer Köhler
Drum with female figure
Courtesy Ernst Winizhi

**7.4a** Doran H. Ross
Swordbearer
Courtesy Doran H. Ross

**7.6a** Doran H. Ross
Swordbearer with gold pectoral
Courtesy Doran H. Ross

**7.7a** Carol Beckwith and
Angela Fisher
Adioukrou woman of Cote d'Ivoire
Robert Estall Photo Agency

**7.11a** Doran H. Ross
Akan chief
Courtesy Doran H. Ross

**7.17a** Marilyn Houlberg
Yoruba woman using a plastic doll
as an ere ibeji, 1970
Courtesy Marilyn Houlberg

**7.21a** Christol
Kuosi society members with
elephant masks and costumes
Collection Musée de l'Homme

**7.24a** Richard Fardon
Chamba bush-cow masks
being danced during royal
death rites at Yeli
© Richard Fardon

**7.26a** Paul Freed
Pangolin from southwest Cameroon
Courtesy Paul Freed

**7.30a** Susan Mullin Vogel
Woman of Kouassikouassikro
village, Côte d'Ivoire
Courtesy Susan Mullin Vogel

8 Asian Art

**8.9a** Kevin R. Morris
Buddhist monks
© CORBIS/Kevin R. Morris

**8.14a** Jan Butchofsky-Houser
Borobudur
© CORBIS/Jan Butchofsky-Houser

**8.15a** Mark Lindquist
Cord-marking patterns
Courtesy Lindquist Studios,
Quincy, Florida

**8.16a** Diagram of Haniwa
placement, Futatsuyama Tomb,
Gunma prefecture, from
History of Japanese Art,
by Penelope Mason
Published by Harry N. Abrams, 1994

**8.19a** Miyashita Zenji, 1997
Courtesy Joan D. Baekeland

**8.28a** Raja Yoseph Djoewa
Dobe Ngole
Koninklijk Instituut
voor de Tropen, Amsterdam,
The Netherlands

9  Pre-Columbian Art

**9.6a**  Donald Cordry
Huastec woman wearing
a *quexquemitl*
Photograph from
*Mexican Indian Costumes,*
by Donald and Dorothy Cordry
© 1968, by permission of the
University of Texas Press

**9.9a**  Rollout photograph
© Justin Kerr 1994

**9.12a**  Rollout photograph
© Justin Kerr 1994

**9.13a**  Anne-Louise Schaffer
Palace at Palenque
Courtesy Anne-Louise Schaffer

**9.16a**  Anne-Louise Schaffer
Courtyard of Quetzalpapalotl Palace
Courtesy Anne-Louise Schaffer

**9.35a**  Felipe Guaman Poma
de Ayala
Illustration from the codex,
*Nueva Corónica y Buen Gobierno*
Published by Institut D'Ethnologie,
1936

**9.35b**  Edward Ranney
Machu Picchu
© Edward Ranney

11  Oceanic Art

**11.4a**  Caroline and Donald Yacoe
Chief Tofor in Fanla village
Courtesy Caroline and Donald Yacoe

**11.9a**  C. W. Collinson
Malaita chief wearing a *kapkap,*
from *People of All Nations,* vol. 2
Published by The Fleetway House,
London, 1925

12  20th-Century Art

**12.7a**  Henri Matisse, 1932
© UPI/CORBIS-BETTMANN

**12.12a**  Timothy Greenfield-Sanders
Lee Krasner, 1980
Photo © Timothy Greenfield-
Sanders

**12.21a**  Pablo Picasso and
Jacqueline Roque, 1961
© Baldwin H. Ward/
CORBIS-BETTMANN

**12.22a**  Bill Hinds
Cartoon for the *Houston Post,* 1970
Courtesy Bill Hinds

**12.29a**  John Bryson
Niki de Saint Phalle and
Jean Tinguely, 1960s

**12.34a**  Timothy Greenfield-Sanders
James Rosenquist, 1986
Photo © Timothy Greenfield-
Sanders

**12.40a**  David Anderson
Nancy Graves, c. 1970
Courtesy Janie C. Lee Gallery

**12.49a**  Naoya Hatakeyama
Richard Long, *East West Circle,*
Installation at the Setagaya Art
Museum, 1996
Courtesy Setagaya Art Museum

**12.52a**  Installation photographs
of *Abesti Gogora V,* 1966
From *Eduardo Chillida,* 1966
Published by the Museum of
Fine Arts, Houston

**12.53a**  Frank Stella directs two
artists in Brown Pavilion, 1982
Archives of the Museum of
Fine Arts, Houston

**12.54a**  Robert Ziebell
Installation photographs of
*Houston Triptych,* 1987

**12.55a**  Installation photographs of
*Can Johnny Come Out and Play?,* 1991
Registrar's office of the Museum of
Fine Arts, Houston

**12.60a**  Karen Weinman
Joe Havel working on *Curtain,* 1999
Courtesy Karen Weinman

Joe Aker
Installation photographs of *Curtain,*
1999

**12.61a**  James Turrell
Computer-generated preliminary
study for *The Light Inside,* 1999

13  20th-Century Decorative Arts

**13.4a**  Mangbetu women arranging
a headdress, c. 1910
Neg. # 224436
Courtesy Department of Library
Services, American Museum of
Natural History

14  Film and Video

Photographs on pp. 392–93
courtesy of the Museum of
Modern Art Film Stills Archive

15  Textiles and Costume

**15.2a**  Girl wearing Day Dress
Cybil DeLancev, "Le Mode et
Les Modes" Les Modes (Paris:
Manzi, Joyant & Cie), no. 103
(July 1909), p. 20

**15.18a**  Jacqueline Kennedy, 1961
© UPI/CORBIS-BETTMANN

17  Bayou Bend Collection

**17.10a**  Bill of Sale,
Fletcher and Gardiner Pitcher
Photograph courtesy John Kollock

**17.11a**  Griswold Showroom in
New Orleans
Williams Research Center
The Historic New Orleans
Collection

**17.23a**  Thomas Frye
**Maria, Countess of Coventry,**
1761
Collection of Colonial
Williamsburg Foundation

## General
## MFAH Publications

The Museum of
Fine Arts, Houston:
A Centennial Portrait*
*Preface by Peter C. Marzio*
2000

Rafael Moneo,
The Audrey Jones Beck
Building of the Museum
of Fine Arts, Houston*
*By Martha Thorne*
2000

The Museum of Fine Arts,
Houston: An Architectural
History, 1924–1986
*Bulletin*
1992

A Permanent Legacy:
150 Works from the
Collection of the Museum
of Fine Arts, Houston*
*Introduction by Peter C. Marzio*
1989

The Museum of Fine Arts,
Houston: A Guide to
the Collection
*Introduction by
William C. Agee*
1981

## Art Collection Areas

### American Art
Frederic Remington:
The Hogg Brothers
Collection of the Museum
of Fine Arts, Houston*
*By Emily Ballew Neff
and Wynne H. Phelan*
2000

American Decorative Arts
and Paintings in the
Bayou Bend Collection*
*By David B. Warren,
Michael K. Brown,
Elizabeth Ann Coleman,
and Emily Ballew Neff*
1998

American Painters in the
Age of Impressionism
*By Emily Ballew Neff and
George T. M. Shackelford*
1994

### The Sarah Campbell
### Blaffer Foundation
French Painting of the Ancien
Régime from the Collection
of the Sarah Campbell
Blaffer Foundation
*By Renaud Temperini*
1996

Masterpieces of Baroque
Painting from the Collection
of the Sarah Campbell
Blaffer Foundation*
*By George T. M. Shackelford,
with Colin B. Bailey,
Susan J. Barnes, and
Katherine T. Brown*
1992

Aspects of British Painting
1550–1800 from the
Collection of the Sarah
Campbell Blaffer Foundation
*By Martin Butlin*
1988

Five Centuries of Italian
Painting 1300–1800 from
the Collection of the Sarah
Campbell Blaffer Foundation
*By Terisio Pignatti*
1985

A Golden Age of Painting:
Dutch, Flemish,
German Paintings
16th–17th Centuries
from the Collection
of the Sarah Campbell
Blaffer Foundation
*By Christopher Wright*
1981

### European Art
Masterworks of European
Painting in the Museum of
Fine Arts, Houston*
*By Edgar Peters Bowron
and Mary G. Morton*
2000

The Collection of John A.
and Audrey Jones Beck*
*Compiled by
Audrey Jones Beck*
1998

The Body of Christ in the Art
of Europe and New Spain,
1150–1800*
*By James Clifton, with
Linda Elaine Neagley
and David Nirenberg*
1997

Italian Paintings from
the XIV–XVI Centuries
in the Museum of
Fine Arts, Houston*
*By Carolyn C. Wilson*
1996

A Gift to America:
Masterpieces of European
Painting from the Samuel
H. Kress Collection
*By Chiyo Ishikawa,*
*Lynn Federle Orr,*
*George T. M. Shackelford,*
*and David Steel, with*
*Edgar Peters Bowron*
*and Marilyn Perry*
*1994*

The Masterson Collection
of Worcester Porcelain
*Bulletin by Katherine S. Howe*
*1985*

## Photography

The Sonia and Kaye Marvins
Portrait Collection
*By Anne Wilkes Tucker, with*
*Maggie Olvey, et al.*
*1995*

Quest for the Moon and
Other Stories: Three Decades
of Astronauts in Space*
*By Anne Wilkes Tucker, with*
*Dennis Ivy*
*1994*

The Allan Chasanoff
Photographic Collection:
Tradition and the
Unpredictable*
*By Anne Wilkes Tucker, with*
*Vince Aletti and Charles Traub*
*1993*

The Galveston That Was
*By Howard Barnstone,*
*with photographs by*
*Henri Cartier-Bresson and*
*Ezra Stoller*
*1993*

Songs of My People: African
Americans: A Self-Portrait
*By Eric Easter, Michael Cheers,*
*Dudley Brooks, and*
*Sylvester Monroe*
*1992*

Money Matters: A Critical
Look at Bank Architecture
*By Susan Wagg, Brendan Gill,*
*Robert Nisbet, and*
*Anne Wilkes Tucker*
*1990*

## 20th-Century Art

Texas: 150 Works
from the Museum of
Fine Arts, Houston*
*By Alison de Lima Greene*
*2000*

The Lillie and Hugh Roy
Cullen Sculpture Garden
of the Museum of
Fine Arts, Houston*
*Bulletin by*
*Alison de Lima Greene*
*1996*

The Art of John Biggers:
View from the Upper Room
*By Alvia J. Wardlaw, with*
*Edmund Barry Gaither,*
*Alison de Lima Greene, and*
*Robert Farris Thompson*
*1995*

## Education Topics

A Place for All People*
*By Beth B. Schneider, with*
*Marsha Dorsey-Outlaw,*
*Janet Landay, and*
*Mercedes Perez-Meyer*
*1998*

Education in the Arts*
*Bulletin by Beth B. Schneider,*
*with Daniel J. Gorski, Joseph*
*P. Havel, and Norma R. Ory*
*1995*

## Teaching Materials

(Slide sets, with texts about
artworks from many areas
of the MFAH collection,
are available to teachers.)

Learning Through Art
at The Museum of
Fine Arts, Houston
*Multidisciplinary*
*curriculum kits*
*1997*

The Art of John Biggers:
View from the Upper Room
*Slides/study prints/text*
*1995*

Beyond the Limits:
Creative Art Solutions for
People with Special Needs
*By Lisa Ottman, with*
*Eileen Callan, Diane Koehnk,*
*Donna Surles Lindsley, and*
*Lucy Matte, O.T.R.*
*1995*

*Available for purchase
in the MFAH Stores.

Teaching materials are
available for purchase or
loan from the MFAH
education department's
Art-To-Go Resource Center.

All other titles are
available in the MFAH's
Hirsch Library.

To ask questions about the museum that are not answered here, call (713) 639-7300.

For tickets, call (713) 639-7771, (888) 733-6324, or (888) SEE-MFAH.

The Spanish Information Line is (713) 639-7379.

## Location

The Museum of Fine Arts, Houston, comprises two exhibition buildings, two house museums, two art school buildings, and a sculpture garden. Locations, addresses, and the contents of each area are indicated on the map on pp. 542–43.

## Museum Parking

The parking garage is in the MFAH Visitors Center, located on Binz at Fannin, just east of the Beck Building. Hourly rates apply.

Free parking is available in two outdoor, street-level lots north of the Law Building along Main Street: one at Bissonnet and one at Oakdale.

Bayou Bend, Rienzi, the Glassell School of Art, and the Glassell Junior School have limited free parking areas nearby.

## Hours

**The Audrey Jones Beck Building**
**The Caroline Wiess Law Building**
Tuesday, Wednesday, and Saturday, 10:00 a.m.–7:00 p.m.
Thursday and Friday, 10:00 a.m.–9:00 p.m.
Sunday, 12:15–7:00 p.m.
Closed Monday, except Monday holidays
Closed Thanksgiving Day and Christmas Day

**Bayou Bend**
**Rienzi**
Bayou Bend and Rienzi have different admission fees and hours. Call the numbers at right for information and to make reservations.

**The Lillie and Hugh Roy Cullen Sculpture Garden**
Open daily, 9:00 a.m.–10:00 p.m.

**The Glassell School of Art**
**The Glassell Junior School**
The art schools have different hours. Call the numbers at right for information.

## Museum Admission
$5 Adults

$2.50 Senior adults (65+), students with ID, and children (6–18)

Free for MFAH members, children 5 and under, and Glassell School students

Thursday, 10:00 a.m.–9:00 p.m., museum admission is free for everyone.

Certain special exhibitions may require an additional admission charge.

Admission is free to visit the museum's restaurant, library, shops, sculpture garden, and art school exhibitions.

## MFAH Shops

Visit the shops near the lobbies of the Beck and Law buildings for art books, exhibition catalogues, jewelry, souvenirs, art-related gifts for children, and gift items inspired by the museum's collection and exhibitions. MFAH members receive a 10% discount on most of the merchandise.

## Restaurant

Enjoy full meals or snacks at Café Express in the lower level of the Beck Building. Open for lunch and dinner.

The museum's Web site at www.mfah.org provides up-to-date listings about activities, classes, films, and exhibitions, as well as information about artworks.

MFAH Mailing Address (all locations):
P. O. Box 6826
Houston, Texas 77265-6826

## MFAH Membership
Enjoy all the benefits of MFAH membership, including free admission. Members are invited to exhibition previews and special lectures, and they receive member discounts in the MFAH Shops. To join, visit the membership desk or call (713) 639-7550.

## Hirsch Library
The MFAH's art research library, located in the Law Building, is open free to the public.
Tuesday-Friday,
10:00 a.m.–4:45 p.m.
Thursday,
10:00 a.m.–8:45 p.m.
Saturday,
12:00 noon–4:45 p.m.

## Works on Paper Study/Storage Center
Scholars, school groups, and collectors may make appointments to study prints, drawings, and photographs from the museum's collection. Call (713) 639-7352.

## Photography and Sketching in the Galleries
Visitors may photograph or sketch works of art that belong to the MFAH, but not works on loan from other institutions. To take a photograph, ask for a permit at one of the admissions desks. Groups may sketch if they have advance reservations; call (713) 639-7324.

## Tours, Lectures, Programs, and Films
The MFAH offers guided and self-guided tours for student and adult groups. Tours are available to sight- and hearing-impaired visitors by appointment. To schedule a tour, call (713) 639-7324.

Lectures, public programs, and family programs are offered year-round; for information, call (713) 639-7300.

For weekly updates on film screenings, call the Film Information Line at (713) 639-7515.

## Accessibility
Wheelchairs are available on a first-come, first-served basis for all museum locations.

Assistive listening devices can be reserved for tours, lectures, and other public programs, as well as for films.

For reservations and questions concerning accessibility, call (713) 639-7389.

To access TDD/TTY for the hearing impaired, call (713) 639-7390.

For special tours, call (713) 639-7324.

## MFAH Phone Numbers at a Glance
*Main number*
(713) 639-7300

*Bayou Bend*
(713) 639-7750

*Café Express*
(713) 639-7370

*Film Information Line*
(713) 639-7515

*Glassell Junior School*
(713) 639-7700

*Glassell School of Art*
(713) 639-7500

*Library*
(713) 639-7325

*Membership*
(713) 639-7550

*Rienzi*
(713) 639-7800

*Shops*
(713) 639-7360

*Spanish Information Line*
(713) 639-7379

*Tickets*
(713) 639-7771
(888) 733-6324

*Tours*
(713) 639-7324

*Volunteer Office*
(713) 639-7578

*Works on Paper Study/Storage Center*
(713) 639-7352

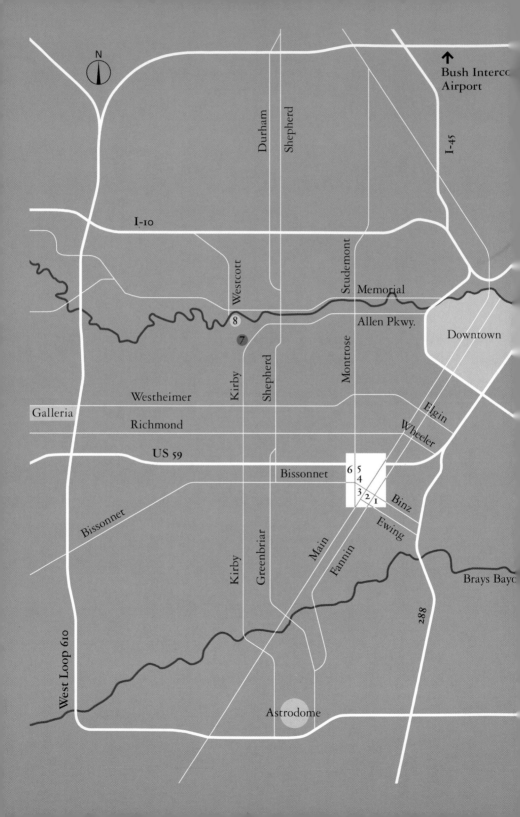

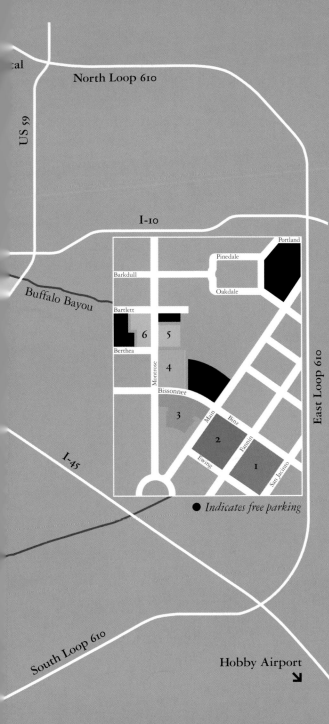

1. **MFAH Visitors Center and Parking Garage**
*Entrance on Binz*

2. **The Audrey Jones Beck Building**
5601 Main Street
*American Art to c. 1945,*
*Ancient Art, European Art*
*to c. 1920, Photography,*
*Prints and Drawings,*
*Works on Paper Study/Storage*
*Center, Changing Exhibitions,*
*Café Express, MFAH Shop*

3. **The Caroline Wiess Law Building**
1001 Bissonnet Street
*African Art, Asian Art,*
*Oceanic Art, Pre-Columbian Art,*
*20th-Century and Contemporary*
*Art, Changing Exhibitions,*
*Brown Auditorium,*
*Hirsch Library, MFAH Shop*

4. **The Lillie and Hugh Roy Cullen Sculpture Garden**
Montrose Boulevard at
Bissonnet Street
*Sculpture from the late 19th*
*century to the present*

5. **The Glassell School of Art**
5101 Montrose Boulevard
*Exhibitions of contemporary art,*
*and of student and faculty work*

6. **The Glassell Junior School of Art and MFAH Central Administration Building**
5100 Montrose Boulevard
*Exhibitions of student and*
*faculty work*

7. **Rienzi**
1406 Kirby Drive
*European decorative arts*
*and gardens*

8. **Bayou Bend Collection and Gardens**
1 Westcott Street
*American painting,*
*decorative arts, and gardens*